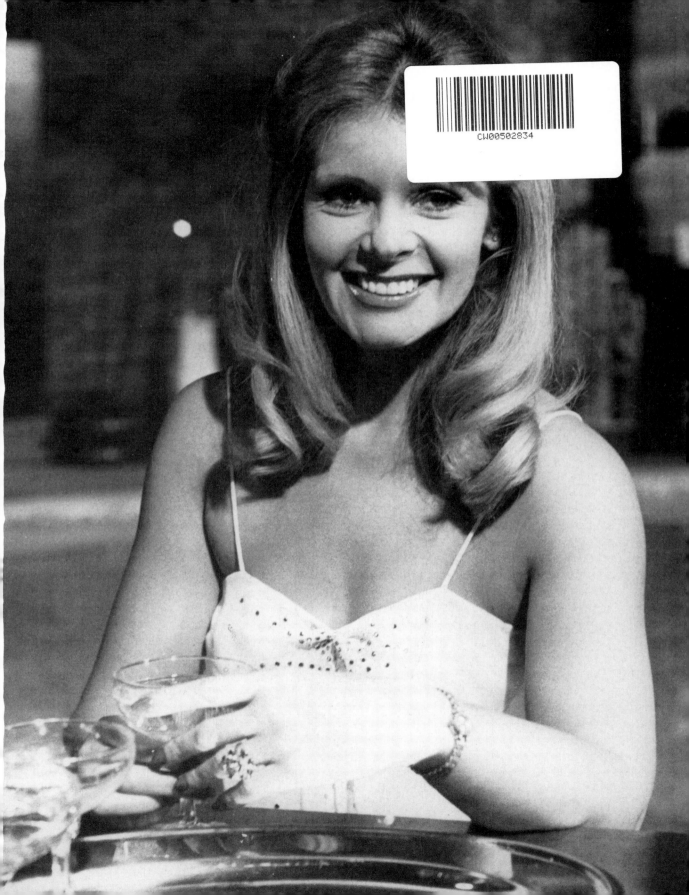

COME PLAY WITH ME
The Life and Films of Mary Millington

First edition published July 1999
by FAB Press

FAB Press
P.O. Box 178
Guildford
Surrey
GU3 2YU
England, U.K.

(email: harvey@fabpress.demon.co.uk)

Designed by Harvey Fenton, David Flint and Simon Sheridan
Layout and Typesetting by Harvey Fenton and David Flint
Image scanning by Adrian Luther-Smith

Front cover illustration:
Original artwork from the 'Come Play With Me' cinema poster
Front flap illustration:
Original artwork from the 'World Striptease Extravaganza' video sleeve
Frontispiece:
Promotional photograph of Mary taken during the making of 'The Playbirds'

A CIP catalogue record for this book is available from the British Library

ISBN 0 9529260 7 5

Come Play With Me

The Life and Films of Mary Millington

Simon Sheridan

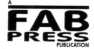

A FAB PRESS PUBLICATION

MARY MILLINGTON 'meets' SUPER STUD

ENGLAND in a sensationally funny film for both sexes

FEATURING
ALAN LAKE
GLYNN EDWARDS
MARY MILLINGTON
ANTHONY BOOTH
KENNY LYNCH
ROSEMARY ENGLAND

BERNIE WINTERS

AND
DIANA DORS

Confessions from THE DAVID GALAXY AFFAIR

LATE SHOWS EVERY NIGHT

Mary in the foyer of the Eros cinema
Piccadilly on 28 June 1979

contents

For
Jonathan Davis
because you've been there from the start

Acknowledgements

Many thanks to all those people who have given up their valuable time to help with the production of this book. Notably Geoffrey & Susan Quilter and their children Denise and Richard, also David Sullivan, Harvey Fenton, John M. East, Willy Roe, Dick & Margaret Wolfe, Linzi Drew, David Flint, Lillo Militello, Joe D'Morais, Tom Chantrell, Jim Adamson, Geoff Holder, Gill Hubbard, Steve Chibnall, Ian Hunter, Norman J. Warren, Paul Hennessey, Chris Voisey, Martin Coxhead, Richard Dacre at *Flashbacks*, Albert Tilley at *Tilley's Vintage Magazines*, Kenneth Eriksen, Nick Thomas, Sheila Ryan, John Penn-Symons and the late George Harrison Marks. To those who preferred to remain anonymous ~ you know who you are!

Photographs

All photographs are from the author's private collection except those kindly supplied by the Quilter Family, Steve Chibnall, Louis Ravensfield and Marc Morris. David Sullivan generously gave permission to reproduce his 1970s publications. The author and publishers would like to express their appreciation of all the photographers who worked with Mary over the years. All illustrations are reproduced here in the spirit of publicity, and whilst every effort has been made to trace the copyright owners, the author and publishers apologise for any omissions and will undertake to make any appropriate changes in future editions of this book if necessary.

Special Thanks

Special thanks to my parents, Pamela and Michael, for their patience and very considerable help. I could not have done this without you. Also thanks to Anne, David, Cap and Rosemary.

This book would not be complete without particular mention of my wonderful friends. I was truly blessed to have had unflagging encouragement from all of the following during the writing of this book. (In no particular order) Linda Morris, Alex Ryan, Philip King, Jessica Begbie, Tracy Knight, Michaela & Geoff Thompson, Katie Holt, Anne Parr, Heidi & Martin Bulled, Liz Davies, Rachel Jones, Hilary Arnott, John Clements, Dan Jenkins, Christopher Parr, Tom Sharkey, Becs Davies, Steven Morris, Annabelle Willox, Stuart Knight, Hilary Lynn, Kenneth Sutherland, Gary Towers, Jo Pearson, Jane Stephens, Sonia Friend, Hannah Hart, Oliver C. Bradbury and Mr Rodger Harries.
An extra special 'thank you' goes to Mark Powell for giving me strength and support when I needed it most.

A big **DING DONG** to you all!

author's preface

The 1970's. I love them. The years of my childhood when all my memories begin and the decade where most of this curiously true story takes place.

How do I look at those times? With perverse fascination perhaps. The sounds and colours vividly swirl around me. It's intoxicating and sometimes I could almost choke at the thought of it all. ABBA and Sister Sledge playing on my sister's tinny record player; Darth Vader 20 feet tall at the local Odeon; the death of Sidney James; the never-ending drought; the trade unions continually on strike; Harold Wilson's pipe; Mike Yarwood with everything; the suicide of Britain's most famous porn star. It could all have happened yesterday.

But of course it didn't. 1979 is actually a very long time ago. Think about it. The cult of Princess Diana hadn't even been invented; nobody would have dreamt of a disease like AIDS and the prospect of a Tory government for eighteen long years was unimaginable.

How, as a small child, could I ever have comprehended the profound impact of Mary Millington on my life? What could have possibly been the attraction? And yet as I look back today, she has always been there. At first I never realised it, but now it seems obvious.

Mary's story is a lot about me.

Simon Sheridan June 1999

Mary in July 1978, enjoying a ride at Hastings Racecourse

a tribute to Mary

Most women in the sex industry are never allowed to escape the shadow of other women's judgement. They are seen as 'cheap and degrading', 'letting the side down' or 'coming in through the back door'. These notions are carried on generations through. Meanwhile the players in the sex business, still mainly men it has to be said, continue to exploit their models over and over again. It is small wonder that these women stick to their employers like glue. They offer a reliable income, some tenderness, even maybe something to boost the ego; whilst all the time the only alternative is scathing ostracism from 'proper' women.

Then I think of Mary Millington. My Auntie Mary.

Mary came with a message. We are still living in an age where women in some societies cannot leave home without their heads uncovered or speak their own minds. I imagine this, and then think of Mary standing outside 10 Downing Street, her blouse undone, and grinning from ear to ear. This was Mary's message. She still represents that freedom of spirit she carried all her life.

I miss Mary so much, even after all these years. There are so many things I would like to say to her, to share with her. I would have loved her to have seen my children. To be here with us today.

For now, I have my wonderful memories and the knowledge that her hand is still guiding my life. God bless you, Mary.

Denise Laurence

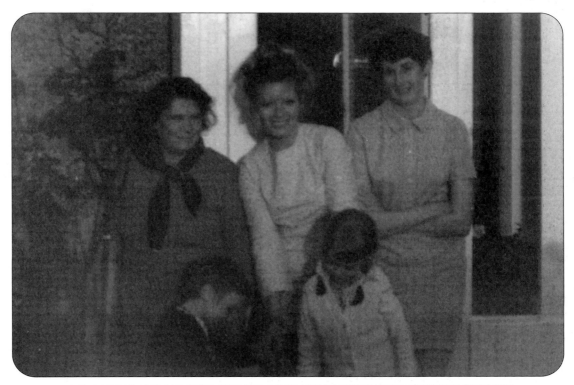

clockwise from top left: Joan Quilter, Mary, Susan Quilter and her children Denise and Richard, Easter 1969

a tribute to Mary

I had already seen Simon featured on a television documentary on Mary Millington's life a year before he turned up on our doorstep and politely introduced himself. His genuine interest in writing an accurate account of her life, warts 'n' all, shone through and secured my family's assistance in writing this book. I had no hesitation in digging through our family albums to find photographs of Mary before she was famous. These pictures appear in this biography.

Although Mary died when my sister and I were relatively young, she had an incredible impact on us when we were children. She was a glamorous, beautiful and generous woman who used to play with us and give us little gifts whenever we visited her. To us, she lived like a princess in a palace and although Denise and I had an idea of what she did for a living we never really understood quite how deeply involved in the sex industry she was, nor, how it would ultimately lead to her downfall.

I still remember being told that she had taken her own life. I was completely shocked and helpless. As I have grown older I wish I could have been there to help her through her darkest hours, but that just wasn't meant to be.

I am, however, left with a lot of good memories, some sadness still, but overall a feeling of pride that Mary Millington was my Auntie.

Richard Quilter

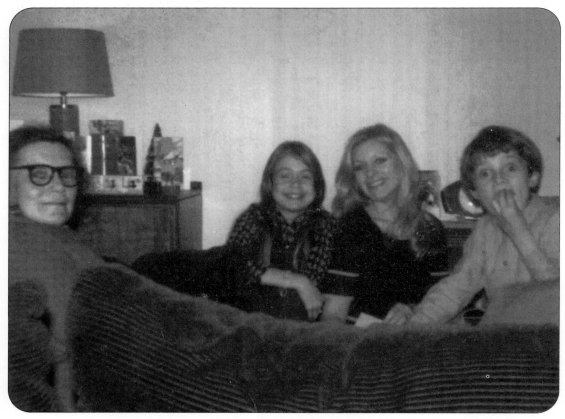

left to right: Joan Quilter, Denise, Mary and Richard, Christmas 1973

foreword

In the early hours of August 19th 1979 a thirty-three year old blonde with a true love of life, tragically killed herself with a cocktail of drink and drugs, and people all over the UK mourned the loss of the petite bundle of sexual energy they had come to know and love as Mary Millington.

To those who knew Mary well she was far more than just Britain's most profitable X-rated film star; a sex superstar, a pioneer in the British sex industry, and a vociferous campaigner for the legalisation of pornography. Mary was warm and vivacious, a tireless charity worker with a great devotion to animals, in particular her beloved dogs. She saw every aspect of sex as a celebration, something to be savoured and enjoyed, not something dirty to be swept under the carpet.

As a young woman in her early twenties Mary stumbled upon the sex industry purely by chance and, through her own talents and enthusiasm combined with a brilliant marketing strategy, she went on to become one of Britain's greatest sex symbols. *Come Play With Me*, Mary's most popular film, broke box office records all over the country and netted the movie's producer a cool five million quid. But, in Mary's case, her huge success came with a price. Although she was earning a small fortune from a profession she obviously adored and was enjoying a lavish lifestyle mixing with the 1970's showbiz elite, she also began dabbling in drugs. In Mary's suicide notes she blames the constant harassment of both the police and the Inland Revenue for the despair and unhappiness that finally led to her untimely death. In particular, taunts from the police convinced her that she was about to lose everything and end up alone, penniless and physically abused in Holloway prison.

When I was asked to pen this preface, I had little idea that I had so much in common with Mary Millington, aside from the fact that I have a liberated attitude towards sexual matters, and, in my early-thirties, I too was a glamour model editing a girlie magazine, often getting up on my soap box to campaign for the rights of consenting adults to enjoy sexually explicit material if they should so choose. Since reading Simon Sheridan's book I have learned that when I was thirty-three, the same age when Mary died, I lived only a few miles away from her Surrey home, and also had dogs which I doted on. In

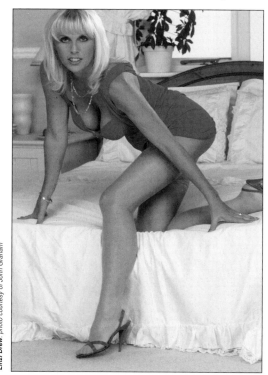

Linzi Drew: photo courtesy of John Graham

addition to these coincidences, I too was under scrutiny from both the police and tax man. Rather ironically I did end up in Holloway prison on obscenity charges just a couple of months before my thirty-fourth birthday!

Sadly, I never had the pleasure of meeting Mary Millington, but I've a feeling that we'd have got on famously. When Mary was living out the final days of her life, my modelling career was just beginning, and indeed I remember many of the names mentioned in this book from my early modelling days. If Mary hadn't taken her life that summer night two decades ago, our paths would have undoubtedly crossed. In the early Eighties I landed myself a cameo role in the film *Emmanuelle In Soho* - a 'B' movie originally planned as another vehicle for her. It was a starring role that Mary didn't live long enough to play out, but I imagine if she had, she would have added a generous sprinkling of her famous Millington magic!

Linzi Drew
May 1999

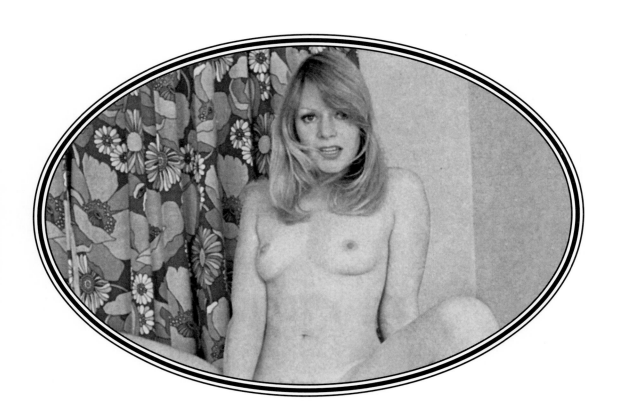

*"I was born respectable,
but I soon decided I wasn't going to
let that spoil my life."*

Mary Millington (1978)

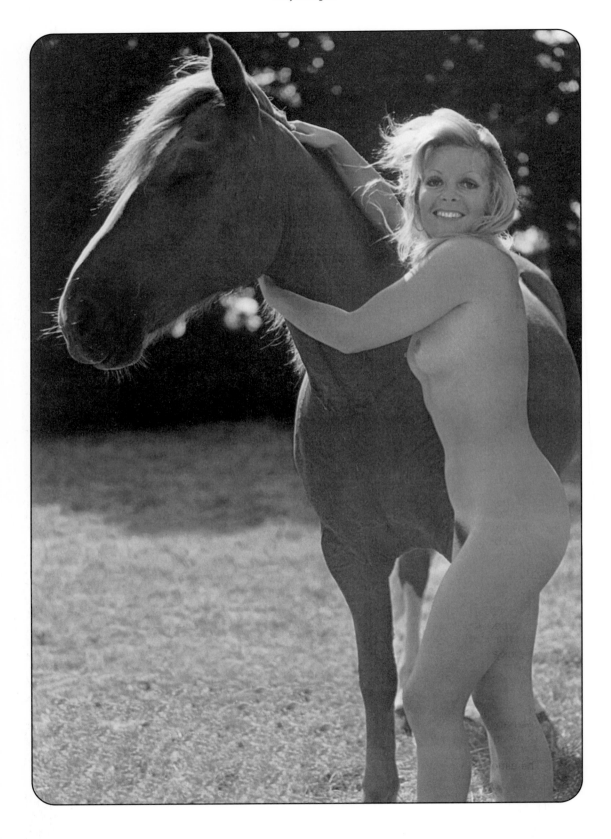

introduction

To even the most casual of observers it was obvious that the funeral at St Mary Magdalene's Church was no ordinary one. The sheer volume of mourners, perhaps two hundred or more, swamped the tiny church yard and lined the paths to the entrance of the pretty 16th century building. The crowd stood silently in the vain hope of hearing the service from inside. But there was no music, no hymns, just hushed voices and empty air. One man constantly dabbed his eyes; another stared fixedly at his shoes, his young face drained and inconsolable.

The waiting was interrupted by idiotic chattering from a pack of reporters and photographers. One female journalist in particular looked agitated and impatient. She pulled a pad and pen from her handbag and approached an elderly woman who was holding a bunch of lilies. What had she thought of Mary? Had she really become involved in pornography to pay for treatment for her dying mother? She asked the questions without pausing to take breath. The woman looked stunned for a moment, brushing strands of wispy white hair from her reddened eyes, before speaking slowly and tearfully,
'Whatever life she led, we didn't care. She was a lovely girl who was devoted to her mother.'

The reporter scribbled down the woman's words, glanced at the message attached to the flowers, 'Mary, bloom in God's garden. Love will always be with you', before deciding to concentrate her attentions on somebody else.

Suddenly the heavy church doors opened, immediately prompting the press to abandon their small talk and, instead, push forward, clutching cameras and notebooks. The Reverend Patrick McNeice was shocked at the size of the waiting crowd, but still managed to give a gentle smile to those who had waited. The procession snaked out of the church and along the gravel path. Behind the coffin stumbled a sandy haired man dressed in grey. Hardly able to stand, necessitating the physical support from a male friend, he wept loudly and uncontrollably. But such is the nature of celebrity, the focus of the photographers was not on Mary's husband.

It was a warm sunny August day, none lovelier, but the sight of Diana Dors in a black fur coat excited the gaggle of pressmen. Looking anything but anonymous, her bleached hair unflatteringly pulled back into a pony tail, the movie star shielded her eyes behind big oval sunglasses as the cameras feverishly clicked away. Alan Lake, tears streaming down his cheeks, clung onto the arm of his famous wife. Somebody's whispered comment that Dors was 'well past her best' was met with an angry frown from a mourner.

The funeral party gathered around the graveside as the tiny coffin was lowered into the earth. The plot already had a stone, a rectangular plaque of grey marble. It was dedicated to 'Joan, Darling Mother Of Mary', but beneath it was a space reserved for another name.

Mary's husband laid a heart shaped wreath of red roses by the grave. It read 'Darling we miss you already. We will never forget you. All our love, Bob, Reject and Tippi'. As Bob was led away, followed by the persistent female reporter, a sallow faced young man came forward, no older than nineteen or twenty. He surveyed the one hundred or so bouquets that lined the entire length of the church yard. The mass of bright blooms and cards was incredible by any stretch of the imagination. He knelt quietly by the blooms and began to read the messages. There were pink roses from George Harrison Marks; yellow chrysanthemums from John Lindsay and, dominating all else, three feet high by six feet wide double M initials in pink and white carnations. The accompanying card read 'With love from David Sullivan'. The names meant little or nothing to the young man, but they played a bigger part in his life than he realised. He had masturbated over girlie photos taken by Harrison Marks; had watched hardcore pornographic films in a Soho cinema owned by Lindsay and was a regular visitor to one of Sullivan's numerous sex shops. But he was unmoved by these mens' names. It was only Mary that he cared about.

She had died so tragically young, only 33 years old and yet the majority of those that missed her were not mourning the passing of Mary Maxted. Her fans, her public, and her lovers had lost another Mary.

The almost mythological Mary Millington. An enigma barely four years old.

devoted

London 1945. Pregnancy was proving to be a solitary and enlightening experience for Joan Quilter. Supposedly close friends avoided the subject; work colleagues whispered and pointed; and the family, well they looked plain shocked. To be expecting a child, unmarried and alone in the capital was a humbling experience indeed. The head of her department had summoned Joan to his office and in no uncertain terms asked if the rumours were true. Was she pregnant and if so what did she intend to do about it? The manager was blunt and unpleasant and the conversation made her feel queasy and embarrassed. She bit her lip and stared him straight in the face before confirming his suspicions. Yes it was correct and yes she intended to keep the baby. Her superior's eyes widened and he clutched his pencil tightly in his fist.

Joan was tearful and desolate as she caught the bus home that evening. She had served the Foreign Office loyally ever since she left school, over a decade before. And now at the age of 31 she was informed that there was no longer a position for her there. The manager had expected better from her than this, he had said. She was supposed to be an intelligent woman. What had gone wrong? Her future looked so promising. It was true, Joan had progressed quickly through the ranks of the civil service and now held the position of higher clerical officer. Her talent for languages - she spoke five - had encouraged her departmental head to recommend that she be stationed at the British Embassy in Paris, working as a translator during the late 1930s. It was an experience she'd relished, and so the outbreak of World War Two had been a huge irritation, as it resulted in her being returned to London.

She was reluctant to go straight home to her lodgings in Imperial Way, Kenten, that night, because the landlady seemed to be constantly on her back at the time. The old busybody heard her being sick on several occasions before she left for work and had seemingly put two and two together. Now she kept dropping hints and wanting explanations for why the 'perfectly good breakfast' she'd prepared was going untouched day after day. Her lodger blamed a stomach upset but the woman was smarter than that. Joan lit a cigarette and gazed out of the window, the rain was coming down in sheets and looked the way she felt. Somebody rang the bell and the double decker ground to a halt. How relieved she was to be seeing her father, he would know what to do.

Eldred Quilter's house was dark and rambling. Piles of paperwork and rolled up canvasses littered the hallway and overflowed into the lounge. He preferred to keep the curtains shut on cold days and was happy to sit hunched over his small trestle table most of the time painting for hours on end with his brow heavily furrowed. Failing eyesight was to be expected for a man of his age, but the steadiness of his seventy year old hands was remarkable.

He liked to keep his mind active and his daytime hours creative, and by painting he was able to do both. Born in 1875 his talent for art was noticed from a very early age. His teachers were impressed with his innocent charcoal drawings and suggested to him that becoming a commercial artist might be the right decision to make. When he was 22 he ran away to the continent to study painting in Paris and Venice but returned a few years later having achieved very little. His individual style was not suited to landscape painting and he found imitating the methods of the so-called 'fashionable' artists frustrating and infuriating. A friend, looking at his very precise drawings, suggested that he might take up heraldic work and following that advice he had spent much of the rest of his life as one of the most sought after heraldic artists in London. Eldred worked on everything from coats of arms for hanging above fireplaces to minute shields designed to adorn the sides of black limousines. He was incredibly talented, with all his work fastidiously done by hand.

Eldred had lived alone for the best part of ten years - his beloved wife having died of cancer at the age of fifty two - but he never seemed to be on his own for too long. His marriage had been blessed with three wonderful children. Leslie, the eldest, was a college lecturer; next came the headstrong Frank, a well paid executive at Lloyd's Shipping Registry, but his favourite was the youngest, the baby of the family, Ivy Joan. She hated her first name with a vengeance and, since school and the death of her mother, she had dispensed with it. This had amused her family and in time they had grown to accept the change. From then on, she was 'Joan' to everyone.

The death of Eldred's wife was a terrible shock to all the family, none more so than Joan who

was barely a woman herself. She missed her mother desperately but this longing only brought her closer to her father. Now the only female in the family, she adopted a more revered role within the Quilter's. Her elderly father adored Joan and Leslie and Frank protected her and looked after her interests. The family were close-knit and Joan felt safe, but when the time had come to tell them of her pregnancy she was terrified. It would have been so much easier to tell her mother first, but with her gone it had to be her father.

Fortunately, Eldred's reaction was studied and thoughtful. His main consideration was for her wellbeing and not her reputation. His love and forgiveness gave Joan the strength she needed to confront her brothers. The look of shock upon their faces was without comparison. Leslie was initially horrified then disbelieving; Frank was just furious. A barrage of questions followed, mainly focusing on the identity of the unborn child's father and whether he would be marrying their sister. Joan explained that the man could not because he already had a wife and family. Frank exploded and Eldred suddenly found himself in the role of mediator between his three children, managing, to a certain extent, to diffuse the situation.

Eldred knew it was his daughter's intention to keep the baby and it was a decision he accepted. So a couple of months later, when a bedraggled and wet Joan turned up on his doorstep to tell him that she had been asked to leave work because of her pregnancy, he was incensed. Sitting down with a cup of tea, he reassured her that everything would be fine and invited her to move in with him at his house in Lechmere Road, Willesden Green when the baby was due. After drying her eyes, Joan agreed. It would be a mutually beneficial arrangement, Eldred loved his daughter dearly and welcomed the company. He was certainly not a poor man and would be able to provide for Joan during the last months of her pregnancy.

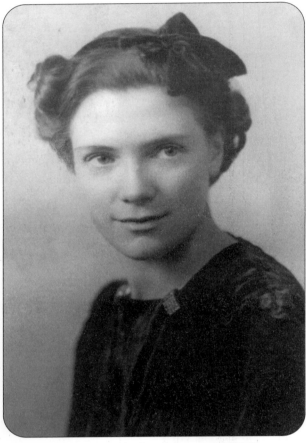

Ivy Joan Quilter, aged 21 (1935)

Joan was a highly educated woman, a lover not only of Shakespeare and the classics, but a voracious reader of practically anything she could get her hands on. One of her favourite haunts was the British Library reading room where she would spend most of her lunch breaks and the majority of her weekends pouring over the heavy, leather-bound books. Reading really was her overpowering passion and her admiration for the academics, whom she watched, their heads stuck between the pages of heavy tomes, was unabashed. Her hero-worshipping glances at the men who made words their living were rarely reciprocated, and even when they were Joan would shrink back to her desk and blush. She was painfully shy and terribly under-confident with the opposite sex. Though not stunningly pretty - she followed her father's looks rather than her mother's - she nonetheless had an open face, beautiful complexion and petite slim figure. At the Foreign Office she attracted her fair share of male admirers but never followed up their advances. She knew only too well that she was naive and often felt frustrated at herself for putting on such a quiet and unassuming front. Inside she knew she was far more passionate. In her mid twenties she had experienced romance with a young businessman called William Walker to whom she later got engaged. Eldred and her brothers greatly approved of the successful Walker with his bright personality and well-to-do demeanour and before long 'Uncle Willie', as Leslie and Frank's children called him, became an established face in the Quilter clan. The couple's happiness was short lived though, when Walker died suddenly, without warning, from a brain haemorrhage.

Since then there had been no men in Joan's life, though she yearned for male companionship outside of the constraints of her family. All this was set to change with the attentions of one particular gentleman in the British Library. For several months Joan had noticed a large, thickly set man in a sports jacket who regularly offered a delightful smile as he strolled past her, briefcase in hand, to the music room. She was not instantly attracted to him but his distinguished air and friendliness captivated her. Aside from her love of literature, Joan also showed great enthusiasm for classical music and from time to time liked to read about her favourite composers. Joan listened to Mozart and Chopin so loudly on her record player in her Kenton lodgings, that she would regularly fall foul of the landlady knocking on the door and asking her to turn the sound down. One morning she deliberately followed the man into the music room and secretly watched him from the corner of her eye as he intently studied volumes on opera. Sometimes he would look up and smile again, other times he would venture a quiet 'Good afternoon'. This tentative relationship continued for some weeks until one Friday lunchtime the scholar asked if Joan would care to take tea with him. She agreed, surprisingly, without hesitation and they enjoyed a pleasant hour of each other's company, without the distraction of books and librarians, in a tea shop off Great Russell Street.

At the age of 45, John William Klein was fourteen years older than Joan and a man of considerable wealth and intelligence. He lived in a fine five bedroom house in Crescent Road, Wimbledon and travelled up to Bloomsbury each day to study the passion of his life, opera. Since the 1920s he had contributed essays to a wide range of publications including *Musical Times*, *Opera Magazine, Music & Letters* and *Musical Opinion* and was extremely well respected in the field of the Italian *verisimo* school and all nineteenth century subjects in particular. He meticulously studied the documents and scores of his favourite operas at the British Library and often surprised his contemporaries with lively and controversial opinions about these works and the composers' lives. In some cases his learned friends despaired of his role as an ardent advocate for seemingly lost causes and obscure musical variations. As well as opera he admired the composer Bizet, so much so that he wrote a critical but appreciative biography about him.

Being a gentleman of leisure with artistic sensibilities, and a doctor of philosophy no less, Klein became Joan's fixation. His stories of meetings with musicians, opera singers and conductors impressed her, but it was not just music they had in common. His mental capacity matched hers, which she found wonderfully refreshing, and they talked non-stop about the classics, architecture, nature, fine wine and the theatre. Joan felt as if she had met her soul mate.

These lunchtime assignations became more frequent and eventually led to trips to the Windmill Theatre in the evening and strolls around Kew Gardens on a Sunday afternoon. With each consecutive meeting Joan started to feel increasingly attached to her diligent suitor. The more she gazed at his face with its baggy eyes, serious mouth and dark wiry hair the more she loved him and the more she wanted to be with him. It was not long before they embarked on a sexual relationship but finding a place to make love was far from simple. Klein's house was out of bounds and it was too dangerous to use Joan's room in Imperial Way, so Klein paid for hotels and B&Bs on the edge of town. In many ways Joan was an innocent, but from the outset of their courtship she knew that he was already married. Klein made no attempt to conceal his wedding ring but never elaborated much on his personal life or family history. He reluctantly admitted to being in an 'unhappy relationship' but was never prepared to say much more. Joan was obviously both intrigued and disheartened by this but never pressed the point too far. The truth of the matter was that Klein had been married for over twenty five years. Born in Altrincham near Manchester in 1899, the son of a rich businessman, he met his wife, Florence Kismet, after having moved to London in his early twenties. Together they had five children, two boys and three girls, the youngest of whom was coincidentally called Joan. Klein was not content in his marriage. He had grown apart from his wife and they led relatively separate lives. But part of Klein's separate life was seeking the company of attractive younger women. By his eldest son Richard's own admission, his father was famed for being a bit of a 'womaniser'.

Joan knew nothing of Klein's reputation, instead basking in his attentions and loving every minute of it. She noticed that he could sometimes be a little distant, almost keeping her at arm's length, but at other times he could be generous, kind and affectionate. However, there was absolutely no doubt in Joan's mind; she was head over heels in love, even if the experienced Klein was more realistic about their complicated situation. Then in March 1945 something happened which was to bind them together for the rest of their lives. Joan fell pregnant.

If Joan's brother Frank's reaction to her pregnancy was less than favourable, then his attitude to the already married father of the unborn child was even more antagonistic. Frank's son Geoffrey Quilter well remembers his father's attitude. 'He didn't like the situation at all. And he didn't like John Klein either. It was mainly because he refused to divorce his wife and marry Joan. Also at that time, with Klein being Jewish he couldn't have possibly married her, so it complicated things.'

Klein was horrified that his girlfriend was pregnant. When Joan once asked him whether he would ever leave his wife for her, he was furious that she even had the nerve to ask. The answer was a definite and resounding 'No'. How could he, Klein reasoned, when he was the father of five children and Jewish to boot? Joan was understandably upset by his attitude and broke down in tears. But she learnt never to ask Klein again.

A baby would change things, she thought, it would link her and Klein inextricably. She refused point-blank any sort of suggestion that she might give the baby up. She wanted it and that was that. Nobody would dissuade her and the subject was deemed closed, but her strength and determination surprised all those around her and gained her the loving admiration of her father, Eldred.

'She must have been a very tough cookie to keep hold of that baby, as it was so very common in those days for children to be adopted as soon as they were born. Her attitude really would have been quite something,' Geoffrey Quilter comments. 'On the few occasions that my Auntie Joan and I spoke about Klein she implied that he was the love of her life and that having his baby was incredibly important to her. I always got the impression that he was a bit of a philanderer though.'

● ● ●

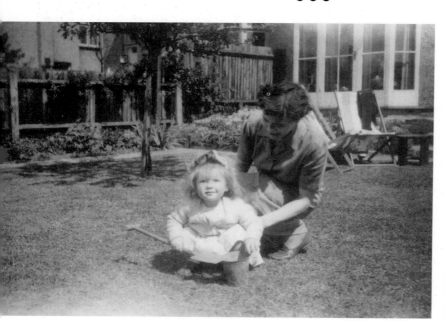

Mary aged two, with her mother

Joan gave birth to a baby girl in the early hours of 30th November 1945 at the sprawling Willesden Maternity Hospital, North West London. It was a difficult labour for her and she'd been frightened, with little idea of what to expect. Throughout it all she was well aware that Klein was back at home in Wimbledon with his family and she was alone. In recent months the couple had come to more of an understanding about their relationship. Klein planned to see as much of Joan and his child as he could, but living together or even having their names linked was never going to be a consideration. In particular Klein would find it impossible ever to publicly claim his new daughter. There were those in the Quilter family who wondered if he was the father of any other children, from additional extra marital affairs.

Joan called the tiny infant Mary Ruth, names she had always loved, and the date of the baby's entry into the world was especially gratifying to her. November 30th was the same date as her nephew Geoffrey's birthday and also Winston Churchill's, a man she much admired. In later years it would prove to be a coincidence that Joan never allowed her daughter to forget. Mary was not registered as a Klein. The ever loyal Joan made sure his name was kept off the birth certificate. The spaces to be filled with the name and occupation of the father were left conspicuously blank.

Klein did collect his new family from the hospital in Honeypot Lane and the three of them returned to Joan's room in Kenten. He was anxious to see his daughter, and holding her in his arms, was relieved to see that she had inherited her mother's sparkling eyes. But within a matter of days, mother and child said goodbye to their claustrophobic room in Imperial Way. Joan was glad to leave and she got the impression that her interfering landlady was rather relieved too.

Taking a room at the front of Eldred's house in Lechmere Road, Joan felt safe and well looked after. Being asked to leave work had been humiliating and the constant questions about the identity of Mary's father were exhausting. Here at least Joan was comfortable and protected from the outside world. 'She had rather a rough time. Eldred was happy to take her in and there was absolutely no question of her being disowned by her family. There were never problems like that and though my father Frank was quite old fashioned he was extremely fond of his sister,' Geoffrey Quilter clearly recalls.

From the very beginning the family was entranced by Mary. She became the focus of attention for everybody. Visitors for mother and child were near enough continual but Joan was soon anxious to return to some kind of work. She employed the services of a childminder, and, with the considerable help of her father, was able to start a part time job in a bookshop in

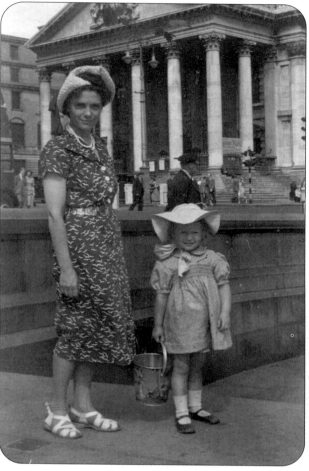

Joan and Mary in Trafalgar Square, 1951

Charing Cross Road. The job's appeal was obvious but she really needed to earn more money to support herself. Finances were always tight and Klein was less than forthcoming with assistance. 'Joan never got much financial help from John Klein, she never seemed to have much money,' says Geoffrey. 'She wanted to buy a house but it was out of the question at that time.'

Indeed the only way Klein was able to help was by discreetly pulling some strings at the British Library, eventually securing Joan a clerical job in the Reading Room. The money was chicken-feed compared to what she had earned at the Foreign Office but it was better than nothing and at least she had the opportunity to have regular contact with the man she so cared for.

As Mary grew, the visits from her father became more sporadic. Eldred and his sons disliked Klein intensely but tolerated his occasional presence because they realised the little girl needed to have some awareness of who her father was. Mary enjoyed the love and attention of men from a very early age, particularly from her uncle Leslie's sons Douglas and Peter, who played a large part in her early upbringing, but it was the time she spent with her mother that she valued the most.

Geoffrey clearly remembers the interplay between mother and daughter, 'With Klein not really being around it made the relationship with her mother so much stronger. They were incredibly close, absolutely devoted,' he says.

Without fail, when family and friends recall the closeness between Joan and Mary the word 'devoted' comes up again and again. It was as if Joan could think of nothing else but her child. She was resigned to the fact that Klein would never be hers, but her daughter was something quite different.

Sometimes described as a little 'eccentric and scatterbrained', Joan's feet were planted firmly on the ground with the unexpected arrival of her little girl. In the absence of a husband or boyfriend, Mary provided the stability she yearned for and moreover a reason to live. 'Mary was,' Geoffrey says without any uncertainty, 'the apple of her eye.'

Geoffrey did not get to meet his tiny cousin until 1948, when he returned from service in Burma. He was twenty six and she was barely three. He knew all about his Aunt Joan's baby through letters from his father Frank, but nothing had prepared him for the bundle of mischief that awaited him on his return to Lechmere Road. 'I was greeted by this pretty little girl, bounding with energy and life. She was charming, quite precocious, but utterly charming.'

Mary learnt how to switch this charm on and off from a very early age. High spirited and continually buoyant, almost to the point of disbelief, she had a curious and effective way of securing anything she wanted, particularly with men. Her beautiful hazel eyes, long dark blonde hair and almost exhausting dynamism mesmerised all who met her. She played to her audience with a carefree innocence and was shockingly self aware, overflowing with childhood confidence.

'Mary loved to make up stories. She had such a fertile imagination and could be terribly dramatic for such a little girl,' Geoffrey reminisces, 'but that was just how Mary was.'

The quick-witted little menace knew exactly how to torment her child-minders and a long succession of middle aged women passed through the doors of Eldred's house, each one claiming that the innocent faced child was uncontrollable. Even at that age Mary had no patience for strangers, playing them up without pausing for breath. Her grandfather was old and slow and found it hard to devote enough time to the tiny whirlwind. She patiently waited for her mother to return home from work each day and nobody could be a substitute. When told that she would soon be going to school, Mary was distinctly unimpressed, but as she got older her sense of fun continued unabated. Brimming with energy and with a zest for life second to none she had only one goal: to have a good time, often to the detriment of her schoolwork.

'She was not the easiest of pupils. I met some of her mates from school and they really were a terrible bunch. Essentially she mixed with a bad lot and was in no way academic,' remembers her cousin. 'How that was so with her mother and father being so clever, is quite amazing. She just liked to laugh and have fun all the time.'

Not having inherited her parents' intellectual capacities, Mary made up for it with an infectious effervescence. She was popular at school with the troublemakers in her classes but she lacked perseverance with her studies and regularly returned home with school reports informing her mother that Mary 'must try harder'. The truth was she loathed every moment she spent at school, often playing truant, literally counting the hours until she could be back home with her beloved mother. Returning to Eldred's house each afternoon she would often have to wait another two or three hours before Joan arrived back from the British Library. Mary found the wait frustrating and her impatience sometimes led to fights, and eventually bouts of sulking, between her and her grandfather. But coming straight back to Willesden Green was always infinitely preferable to staying on late at school, waiting for her mother to collect her on the way back from work.

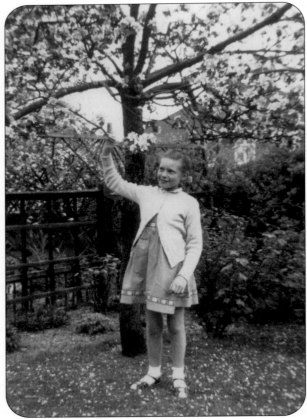

Mary aged 12

Mary's strong views on her schooling never once altered. 'Most children can find some sort of release at school. I could not', she remembered. 'I hated it and they hated me.'[1]

Joan seemed unconcerned by the unflattering reports from Mary's form teacher although, as Mary herself cheerfully admitted many years later: 'My mother used to say, 'Don't worry dear, you were born on the same day as Winston Churchill and he was terrible at school, so there might be hope for you yet!'[2]

Sitting at her school desk, Mary was regularly chided for staring out of the window and daydreaming. She would fantasise about becoming a film star or marrying into the Royal family. Her biggest crush was on actor and singer Anthony Newley and she kept a photograph of him, cut out of the *Evening Standard*, in her drawer. If a teacher dared to tell her off she would say a prayer to God that same night asking for her school to be burnt down or for the teacher to be killed horribly. Apart from the 'bad lot' she sometimes hung around with, Mary had surprisingly few special friends of her own age, but tried hard to be liked by using her natural wiles.

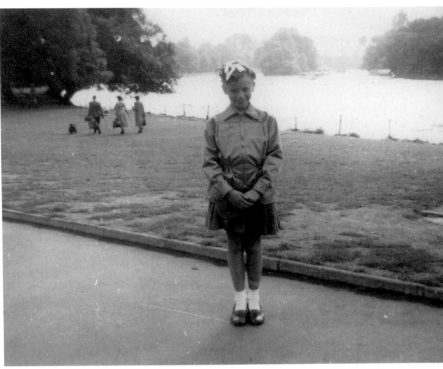

Mary aged twelve, in Battersea Park

'My teacher said I was very organised. In fact during my schooldays I once arranged for all the kids to run away because I thought they were unhappy. I found a barn we could all go to because I really did think they were unhappy at home. I hated school. I lacked any kind of concentration, I was always thinking about animals and things,' Mary joked many years later.[3]

Mary's love of animals was to be an overpowering passion throughout her life. Through gritted teeth Eldred tolerated a long procession of animal companions including hamsters, goldfish, dogs and, in particular, a very fertile cat. The little girl doted on her feline friends, dressing them up in dolls' outfits, taking them out in her toy pram and tucking them up in bed each night. Her attachment to the creatures was a great source of amusement to the entire family, but in fact was a more deep seated indication of something else. 'Without a shadow of a doubt she identified with the vulnerability of animals. They needed looking after just like she wanted to be looked after,' Geoffrey believes. 'That's all she ever wanted.'

The effect on Mary of an absentee father can never be overstated enough. It was to haunt her throughout her childhood and well into her adult life. When schoolfriends asked her about her daddy Mary, ever the storyteller, would invent conflicting tales to explain his whereabouts; that he was divorced from her mother; that he worked in another part of the country; even that he was dead, killed during the war. His absence was never more apparent than at parent evenings or at school sports days. Certainly Mary was not the only child in her class with one parent, but whereas some of her contemporaries had valid excuses for a missing father or mother, Mary did not. Klein was determined to stay in the shadows when it came to being part of his illegitimate daughter's life.

Time and time again Joan would tell her demanding offspring that her daddy did not live with them because it was 'just difficult' or that he was 'very busy'. These throwaway excuses were continually questioned but in time she began to reluctantly accept them.

'It was incredibly hard for Mary. She lived with a very old man and her mother was out at work all day. It really affected her. The lack of a proper father figure made an incredible difference to her upbringing,' says Geoffrey.

There is no doubt that Mary looked forward to her father's sporadic visits, when he would bring her sweets and take time to look at her animals. And though she could tell that her mother loved him, the uneasy feeling that Klein provoked from the rest of the Quilters was all too apparent to her.

By now over ten years had passed since Joan and Mary had moved to Lechmere Road and Eldred was over eighty. Virtually housebound and relying on his daughter and granddaughter to look after him more and more, Eldred still managed to paint for a few hours each day, but even this was becoming less frequent. He had been losing his strength ever since his eldest son, Leslie, had died suddenly from a heart attack in 1955, an incident that dwelled on his mind continually. For some time Joan had seriously considered moving out and finding a place of her own, making it easier for Klein to visit her and Mary, but with her father's health deteriorating she thought better of it. Eldred needed her help around the house, often for the simplest of tasks. In July 1958 he was suddenly admitted during the night to Neasden Hospital with breathing difficulties and died a couple of days later, at the age of 83. Joan knew it had been coming, he'd been suffering from palpitations for a long time and the doctor had told him his heart was weak. His passing was upsetting, but after the sudden and premature deaths of her mother and eldest brother, as well as William Walker, Joan managed to remain calm and realistic about the situation.

Eldred had certainly not been a poor man. He was the owner of several properties in North London left to him by his family many years previously and his will made clear provision that they, in turn, should be left to his children. Frank was given a house in Kingsbury; Leslie's widow Ada was left a house in Stroud Green and Joan, his favourite, was bequeathed two properties, their home in Lechmere Road and another freehold property in Crouch End.

Joan and Mary remained in the house for six months. Following Eldred's death the way was cleared for a number of less stressful visits from Klein but Joan was not comfortable about entertaining him in the house where her father had lived for most of his life. In November 1958 she put the house on the market and decided to find herself a base nearer to Klein's home. She settled on Fulham and a small apartment in a tall brick building in Ifield Road. Almost from the outset she realised she had made a mistake. Although conveniently situated next to West Brompton Station she felt isolated, and Klein's promise of more visits to see his daughter never materialised. The big Victorian house was cold and draughty and the absence of a garden made her deeply unhappy.

Joan loved the outdoors and had particularly enjoyed the beautiful garden at the back of her father's house. There she spent many hours with Mary at the weekends, planting out flowers and tending the borders. Geoffrey Quilter recalls well Joan's dissatisfaction with her new home; 'One of Joan's hobbies was gardening and once she was established at Ifield Road she realised what she was missing. Suddenly she wanted something with a decent plot. She had always loved the countryside and desperately wanted a garden to relax in.' In Fulham the only green on offer was the depressing sight of an overgrown graveyard. The house backed onto the sprawling Brompton Cemetery and Joan was unhappy with Mary playing there as she dawdled back from school, especially in the dark evenings. Her daughter hated everything about this new part of London and the flat in particular, mainly because she had to give up her beloved animals, and she wasted no time in reminding her mother of the fact. Despairing of the situation she had got herself into, Joan made a momentous decision. They would move, not within the confines of London again, but to the countryside.

fields

In the late 1950's the pretty Surrey village of Mid Holmwood was a settlement of barely one hundred homes. Situated just over two miles south of the busy market town of Dorking, the village was quaint and unspoilt, the smallest of the three Holmwoods. Unlike its siblings, the village was unusual, in that it lacked a church of its own Instead it provided home for a corrugated iron chapel on stilts. There was, however, a bricks and mortar pub, The Norfolk Arms, run by a notoriously mean landlord named Stan Pocock who would object to any of his customers putting more than four lumps of coal on the fire at any one time. *Bond's*, the village shop, was a popular destination because the proprietors always allowed purchases on 'tick'. And the village hall was a regular venue for jumble sales, public meetings and small events. The houses followed a disorganised pattern surrounding the central area of wild grasses, or goose 'common' as it was known, but it was chickens, not geese, who laid their eggs in the long grass as damp washing blew in the air above them.

It was in this perfect idyll, so different from the dirt and noise of Fulham, that Joan and Mary decided to make their new home. The fact that the village was so tiny suited Joan just fine. Its delicious offerings of peace and tranquillity coupled with the smells and tastes of the countryside were irresistible to her. She had seen a property overlooking the common and backing onto woodland with a stream running beside it. In fact visitors had to tread on a flagstone over the trickling water before entering the house. The locals were cliquey and Joan was warned that they almost always resented newcomers, but this failed to deter her, after all she had little or no desire to make new friends anyway. The cottage, 'Woodlands View', was to be the oasis that Joan and Mary had been looking for. From the moment they first laid eyes upon the creamy-coloured house they were in love. After the war, Joan's nephew Geoffrey had resumed work as a chartered surveyor and was more than pleased to take a look at the property. Within a matter of months it had been bought for the princely sum of £2,500. The money came in part from Joan's savings and the proceeds of the sale of Lechmere Road, though Klein also helped a little. He fully approved of the move as the village promised seclusion and privacy. He was still incredibly sensitive about being seen with Joan in the city, but here in the heart of the Surrey countryside he would remain near enough anonymous.

The little semi-detached house was simple, with three small cramped bedrooms, a bathroom, dining room and kitchen. Unremarkable, but it was the undeniable appeal of the neat and tidy garden with a fish pond at the front, and the glorious spread of fields as far as the eye could see, that was most seductive.

Not long before Joan and Mary moved to Mid Holmwood at the end of 1959, a young married couple, Dick and Margaret Wolfe, had also made the village their home. Initially, Margaret had disliked the taciturnity of the established villagers, and was pleased to see the arrival of some other 'outsiders', and Dick offered his services to help Joan with improvements around the cottage. In order to make more living space he removed the chimney-breasts in the dining room and front bedroom, much to Joan's relief as her vast collection of books, records and Victorian furniture from Eldred's house filled every available corner. When the house flooded with water from the stream, Dick was there with sandbags to stem the flow and over time the two couples became close friends, or at least as close as Joan would allow. Dick remembers her as being a person who relished her privacy and precious time with her daughter. 'She was a very, very private person who kept herself to herself. She seemed really quite shy and you'd never see her gossiping or talking to anybody in the village,' he recalls. 'I can never remember her passing the time with anybody, except with us and maybe her neighbour Mrs Orchard.' Joan's daughter, however was a totally different kettle of fish. She was an explosion of colour and life that Mid Holmwood had never experienced before. It was not long before everybody in the village came to know the vivacious thirteen year old dynamo called Mary Quilter.

Mary took to the countryside immediately. She loved running in the fields, the escapism of climbing trees and watching the wildlife. Apart from the stuffed specimens she had winced at in the Natural History Museum, Mary had never before seen so many birds and horses; and until then rabbits and foxes had been unknown to her. Joan was delighted to see her daughter so happy and although Mary was still having to commute to school each day her attitude to her education seemed far more

positive. Unfortunately, this had more to do with the fact that Mary knew it was only a matter of time before she would be able to leave once and for all. Eldred, and Frank in particular, had always been concerned at her lack of success in school and despaired at her ever finding a useful career, but as usual all Mary desired was happiness. Once in a while she would casually drop into conversation that she might like to become a designer, pop singer or model, but after seeing Mary's aptitude for looking after four-legged companions Joan had suggested that her true vocation might be with animals.

The move to a new home with a spacious garden had encouraged Mary to pester her mother about getting a new pet and it wasn't long before she was the mistress of a small black and white mongrel dog she named Hector. The pretty blonde schoolgirl with scruffy little dog in tow became a familiar sight around the village, but such was Mary's unusual life, even the dog was far from straight-forward. Margaret Wolfe remembers a peculiar conversation with the animal-mad youngster.

'Mary said to me that her mother had sent Hector to a special veterinary hospital in Cambridge because she wasn't sure of his sex, you know whether he was male or female,' she recounts, 'anyway he went away and had this surgery and to be honest I can't remember what sex he turned out to be in the end, but I later bumped into Mary and asked how her dog was. She turned to the animal and said 'Show Margaret your operation Hector' and the dog immediately lifted his leg and showed me his stitches. That funny sort of thing was always happening to Mary.' But apart from her visible devotion to animals Mary was quickly acquiring another sort of reputation in the village.

It wasn't until she moved out of London and into the countryside that Mary started to become aware of her burgeoning sexuality. Noticing that her body was changing, and constantly comparing herself to older girls, Mary began to take a closer interest in clothes. Saving up her pocket money she splashed out on some tight-fitting sweaters and short flared skirts, winkle-pickers and big round sunglasses. Disappointed with the rate her chest was developing, she cheekily stuffed her training bra with tissue paper pinched out of the bathroom. It seemed incredibly easy to attract the attention of boys in the village with her new look. It was a constant source of fascination and amusement to her the way men would suddenly become interested the minute she put on some make-up and a short skirt, but she was only too happy to play along with it. She had her first kiss at the age of thirteen and lost her virginity the following year to a teenage boy from Dorking. Her first sexual experiences were not much different from other teenagers'. It was awkward, fumbling and messy, but Mary was entranced by boys' bodies, and their penises in particular. Joan had never explained the facts of life to her daughter and Mary entered into her new-found sex life with a wide-eyed naivety that excited her boyfriends. Previously, Mary's experiences of men had been rather one-sided. She had lived most of her life with an old-age pensioner, her father was seldom there and her Uncle Frank was strict and old-fashioned, but now here she was in the countryside, lapping up the attention of a wide variety of good looking teenage boys from the youthclub in nearby South Holmwood. She had learnt her first valuable lesson: you could use sex to get what you wanted. And what Mary thrived upon was attention.

Even though she admitted with cheerful candour that she considered herself a bit of a 'flat chested midget' the queue of young boys who wanted to sleep with her seemed endless. Mary was far from shy when sexual variations were suggested to her and she accepted them without hesitation. As she became more experienced it suddenly dawned on her that *she* was in the position of power; *she* was teaching them how to do it. In later years she remembered her early sex experiences, but revealed the sadness that sometimes lay hidden behind them.

'I was fucking a lot and had become popular, although inside I was still feeling lonely and unwanted. I had virgin boys, blowing their minds and showing off like mad, teaching them all I knew about straight, oral and anal intercourse.'[1]

Eventually Mary settled on a more stable relationship with a boy in the village whose father was a mortician. He impressed her, not only with his lovemaking skills but also with gruesome stories of the funeral parlour that hungrily fed her fertile imagination. Her mother would not talk about death or sex, but Mary was intrigued by both. After the deaths of her uncle and grandfather she wanted to know as much as possible about 'what would happen to their bodies?'. Her frank questioning had disconcerted Joan, who quickly glossed over the matter.

However, as much as Mary was gaining confidence in her sexuality, her childish innocence about her body still remained. Most noticeable was her total lack of inhibitions about nudity.

'During the summer Mary would sunbathe totally nude on the goose common,' Margaret Wolfe laughs. 'The dustmen would come up the lane to collect the bins and make Hector run off barking. Mary

would rush after him shouting, 'Hector come here!' with absolutely nothing on. The dustmen just stood there with their eyes popping out. She didn't care. She had no inhibitions.'

If Mary wanted an ice cream she might cover herself up a little and dash across the village to *Bond's* store. 'She would arrive at the village shop in a very skimpy bikini and the men would nudge each other and say 'Look it's Mary', before she'd dive to the bottom of the freezer and the chaps would stare at her bum. All the men knew exactly who she was,' says Margaret.

On one occasion, her preference for nudity very nearly got her into hot water with her Uncle Frank. 'She became very sexually aware,' recalls Geoffrey Quilter. 'I remember on one particularly hot day in 1961 I took my parents, who were quite old at this time, down to Dorking. We used to go quite regularly and when we got to Joan's house Mary came to the door topless. It nearly caused my father to have a heart attack! She was just so uninhibited, no problem with nudity at all. Her attitude was very free and easy.'

Geoffrey's wife Susan also noticed how blasé she could be about nudity but thinks it was purely harmless.

'It was more naivety I think. She wasn't doing it purposefully to cause an effect or stir or anything', she says. 'It was just natural to her. If it was hot she'd take her top off. It was as simple as that.'

Joan attempted to be strict with her daughter when it came to spending time with the opposite sex, but generally she knew very little about Mary's escapades, and even if she did hear something untoward about her behaviour she would discount it. 'Joan idolised Mary,' Dick Wolfe says, 'and she would never hear a word said against her. As far as she was concerned Mary could do no wrong and whatever she wanted to do Joan went along with it.'

Mary in Mid Holmwood, 1963

One thing Joan was persuaded to push Mary into was secretarial college. As expected Mary emerged with dismal results when she left school at fifteen and Frank was especially worried about his wayward niece. It had always been Uncle Leslie's wish that once Mary left school she would enrol in a secretarial course at Clark's College, Cricklewood, where he had been a tutor. Joan encouraged Mary that it would still be a good idea but, unsurprisingly, her flighty teenager was not at all convinced.

'She did do it in the end. The family wanted her to have training for some sort of career, but she bounced off it very quickly.' recalls Geoffrey. Mary was fed up with the constraints of a classroom and tired with the daily grind of catching a bus to Dorking and then a train into London. The course lasted a year, twelve long months of unadulterated boredom for Mary. Her typing skills were poor and as for shorthand, she really didn't have the slightest idea. She left Clark's College with less than satisfactory results, but by this stage her eyes were firmly set on a completely different career path; she was going to become a famous fashion designer.

Enrolling at Reigate School of Art in 1962, her patience was severely tested again when she was informed that the course was a two year programme and in her first year she would be required to study pottery, sculpture, fine arts and sculpture. Admittedly it sounded better than maths or sitting at a typewriter but Mary didn't feel especially drawn to any of the subjects. Nevertheless she persevered and initially rather enjoyed her time in Reigate; it afforded her considerably more freedom than she had ever experienced before. But Mary being Mary her tentative enthusiasm for the course waned and her involvement in extra-curricular activities blossomed. Before long she was bunking off her classes, hanging around coffee bars with several of the other girls she met

and going to London for the afternoon on 'Ban The Bomb' marches. Her studies suffered and by the time the summer vacation came around she was already certain she would not be returning for her second year. In typical *Jackanory* fashion, Mary later claimed she'd been expelled for performing oral sex on a handsome male model in her life drawing class, much to the disgust of her tutor; but it was all fantasy.

As always, Joan reassuringly told her daughter that 'everything would work out in the end' and 'something else would come along'. She never, ever pressurised her daughter into doing anything she did not want to do, instead offering a shoulder to cry on and a comforting chat. William Klein took even less interest in his daughter's fortunes when he came to visit, often overlooking her completely. He would travel down to Mid Holmwood most weekends, usually on a Saturday afternoon. Neighbours Dick and Margaret Wolfe were never officially introduced to him but they clearly remember a heavily built man in a smart suit always carrying a leather attaché case. These brief visits were intended as an opportunity for Klein to spend quality time with his daughter - after all, he was able to see Joan most days at the Reading Room, but invariably they translated into something quite different. Klein would bring a bottle of red wine and he and Joan would retire to the lounge to smoke and listen to classical music. Poor Mary felt thoroughly abandoned and these lonely incidents would prey on her mind for a long time to come. 'At weekends my father would come around to the house,' she wrote later, 'and he and my mother would lock themselves away and the sad strains of classical music would echo through the house. I was left to my own devices.'[2]

Even with the onset of old age, there was little relaxation in the relationship between Mary's parents. If anything Klein demanded more privacy and still continued to be terrified that an outsider would discover the true nature of his association with the Reading Room assistant and her daughter. Joan's loyalty to her lover was unwavering and she was almost as protective of his identity as he was. During one visit to Woodlands View, Klein had suddenly decided to stay over for the night; the following morning he and Joan travelled to Dorking and caught the train into London. Klein had paid for the tickets but needed to get off first. Only after he had left the carriage did Joan realise that he still had her ticket in his attaché case. In order to protect him Joan preferred to be fined by the ticket collector rather than giving Klein's name and address to explain the situation.

By the early 1960s Mary started to notice a change in her mother. The stress and deception in attempting to keep her lover at a safe distance seemed to be taking its toll. She was frequently out of breath, tired and complaining of discomfort. After months of constant nagging from Mary her mother eventually went to her GP in Dorking. On Joan's return she made light of the appointment, telling Mary the doctor could find nothing that a bit of rest wouldn't cure, but Mary was convinced something was amiss. It wasn't the fact that her mother drank so much, but Joan regularly smoked up to 80 cigarettes a day. Mary disliked the habit; it made her queasy and light-headed, and her mother's continual coughing and spluttering fits encouraged Mary to say something. Joan dismissed her daughter's fussing but this did not detract from the painful fact that Joan was clearly not well. She looked old for her years and her slim figure had began to look far rounder, especially at the waist. The long hours at the British Library were also wearing her down. Each day she would have no choice but to rise at 5.30am in order to get ready for the bus and train journey and in the evenings she rarely returned home until after seven. Joan carried on regardless and continued to allay any worries about her health. Within a few weeks the question marks over her well-being were not even a topic of discussion at Woodlands View, but Mary had started to pay closer attention to her mother's behaviour.

Although she tried hard to do as much as she could around the house Mary still needed a proper job. She adored pets with such a passion that she began to think more seriously about working with animals. A zoo was out of the question, but helping at a veterinary surgery was more achievable. Even without qualifications Mary's house became the first port of call for any villagers having problems with their pets. 'She was just marvellous with animals,' remembers Margaret Wolfe, 'and always had time for them.' An elderly woman called Gladys Eade lived nearly opposite the Quilter's house at number eleven and her little dog Bimbo was a special favourite of Mary's. She would often take Bimbo and Hector for walks together in the fields and could think of nothing she would rather do than play with her canine companions. One Sunday afternoon Mrs Eade came knocking on Mary's door in a terrible state. She was crying because Bimbo had a huge shard of glass stuck in his paw and was yelping loudly. Mary rushed over to number eleven, comforted the dog, removed the glass and bandaged its paw. Within two days Bimbo was up and running again. Mrs Eade was delighted and congratulated Joan on having such a wonderfully caring daughter.

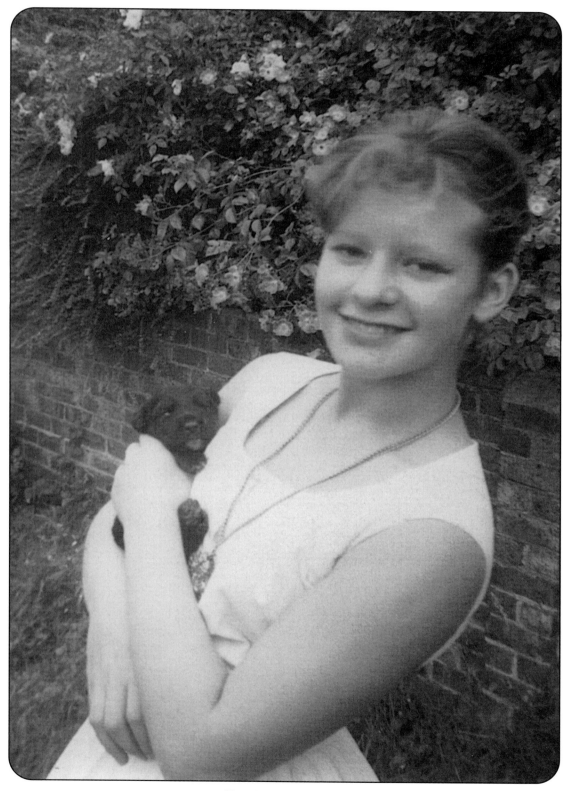

Mary with Hector as a puppy

This seemingly insignificant experience had a profound effect on Mary. She found a veterinary surgery in the nearby village of Cranleigh willing to take her on and train her as a nurse, For a time, it looked as if she had found her true vocation in life. Her enthusiasm for the job and her rapport with the four-legged patients greatly impressed both the vets and the clients and soon she had progressed from the more menial jobs such as acting as receptionist and dealing with reps, to giving injections, cleaning animals' ears and helping out in the operating theatre. Mary stayed there for well over a year and her family finally thought she was settled in a career. 'She thoroughly enjoyed it and talked about it endlessly,' says Geoffrey Quilter, 'but of course she didn't stick with it which is such a pity.'

As with her previous occupations, Mary became restless in the job and lacked the staying power and patience to continue. Once again she was daydreaming about clothes, boys and being famous. She happily admitted her reasons for leaving; 'I had thought seriously about becoming a veterinary surgeon, but it meant training for some years. I had to live on something and earn money for clothes and things,' she explained.[3] With any thought of a proper career firmly tossed out of the window, Mary endeavoured to earn as much money as possible by working double-shifts behind the bars in several Dorking pubs and acting as waitress, which she loathed, in a local restaurant.

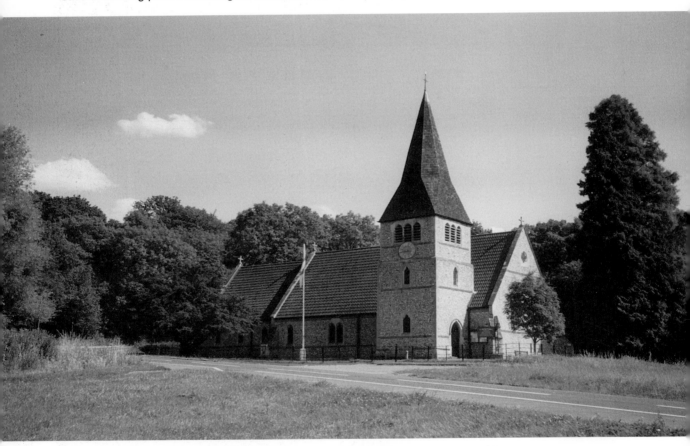

St. John The Evangelist, North Holmwood, where Mary was married in 1964

Mary was never short of boyfriends; acquaintances found it hard to keep up with her conquests, but in 1963 she met the man who would consistently play the biggest role in her life. Robert Norman Maxted was four years older than Mary and worked behind the counter at Chitty's Butchers in Dene Street in Dorking. The eldest son of a plastic moulder, he still lived at home with his family in Hart Road, tucked away off the main shopping street. It seems peculiar that an ardent animal lover such as Mary

would fall for a butcher's boy, but fall she did. The youngsters met through a mutual friend and hit it off immediately. Bob, as he liked to be called, was attracted to her naive beauty and coyness. She would blush when he looked at her for too long and he would laugh at her clumsy mannerisms. Mary, in turn, found Maxted instantly attractive. She liked tall men and although he was no giant, (but then again anyone was tall to the petite Mary), she liked his shape, especially his angular face, big hands and strong shoulders. She learnt to spot his sandy blonde hair and big smile a mile away and they rapidly became inseparable. Joan too was taken with his confidence and warmth and took to him almost as quickly as her daughter. He offered Mary all the things she had always wanted from a man, but had never properly received: companionship, attentiveness and above all, love. One of their mutual friends described Mary's huge affection for him; 'With Bob it was absolute love. Right from the beginning Mary needed a man in her life, and that man was Bob. They were so, so close. Like soulmates; the real deal.'

When Maxted proposed Mary needed no time to think. She knew their romance had been a whirlwind from the outset but she realised very early on that Bob was the one for her.

Mary became a Maxted on the bright spring morning of April 4th 1964. She was only eighteen years old and Bob barely twenty two. With the absence of a church in Mid Holmwood, the couple made their vows at the Parish Church of St John The Evangelist in North Holmwood with Joan and Bob's brother Trevor acting as witnesses. It was the proudest day of Joan's life as she watched her beloved daughter walk down the aisle wearing her beautiful white lace dress topped with an extravagant veil. When Bob lifted it from her face during the ceremony several members of the congregation were surprised to see Mary's trademark blonde hair dyed with a ceremonial pink rinse! In fact, in her black and white wedding photos, her hair looks almost totally dark.

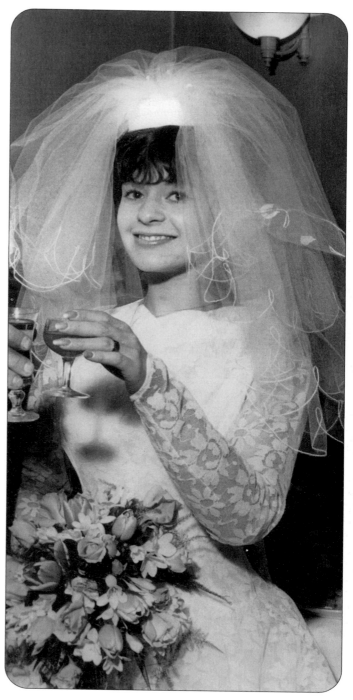

Mary on her wedding day

It was a forgone conclusion that Klein could not and would not attend. Uncle Frank took his place in giving Mary away, a fact that saddened both bride and mother. Amazingly, even at this stage in Mary's life, many of the couples' friends had no idea that the bride even had a father still living. Joan was still careful not to say anything to people outside of the immediate family which might incriminate her lover. The turn-out for the event was greater than even Mary could have possibly imagined. Friends from the village, from Dorking and from her time at Reigate Art School and the veterinary surgery all came to join in the big day. Mary was positively glowing. Geoffrey Quilter remembers the occasion as if it were yesterday; 'It was an extremely good wedding, the turn-out was superb and Joan was absolutely thrilled to bits, but I'm sure that secretly she would have loved to have seen Mary's father there,' he says.

After the reception in a hotel in the village Bob and Mary returned to Woodlands View. Long before the wedding they had carefully discussed living arrangements with Joan and she had been extremely keen on Bob moving in with her and her daughter. Mary, too, had expressed a need to stay with her mother especially as she was still not convinced of how healthy she really was. 'Joan was adamant on Bob and Mary staying at the house, they couldn't afford much and by living with Joan it was a hell of a lot cheaper,' says Susan Quilter. 'Joan liked having a man around the house too and preferred not to be on her own. She wouldn't have coped if Mary had moved away. In the end Bob looked after her as much, if not more so, than his own wife.'

Joan adored her new son-in-law and was grateful to him for the huge improvements he made to the tiny cottage. Bob could turn his hand to anything and was extremely practically-minded. Joan regularly remarked to Mary that she could not have married a better man. The mix of mother, daughter and husband, not forgetting Hector, was perfect beyond even Joan's wildest dreams.

'It worked out superbly. Joan was devoted to Bob, and him to her. That side of it worked out exceedingly well,' Geoffrey explains, 'but it is just as well because it was all Mary and Bob could do. They had nowhere else to live and absolutely no money to buy somewhere of their own.'

The young couple sometimes yearned for slightly more privacy in the compact little house, but for the main part they counted their blessings at falling soundly on their feet. Unfortunately, to begin with, Bob Maxted did not always see eye to eye with some of his new neighbours in Mid Holmwood. Despite being a Dorking lad, to the established villagers he was yet another stranger who didn't 'fit in'. Some found him a little cocky and over-confident in his manner. This was borne out one day in a now almost legendary dispute over a public right of way through the village. Woodlands View stands by an unmetalled road now called Norfolk Lane, but back in the 1960s it was only as wide as a handcart and simply referred to as the 'track'. Much to some of the older villagers' annoyance, several new families had moved to Mid Holmwood at about the same time as Mary's wedding and attempted to stop others from using that part of the track that ran in front of their homes. There was a heated confrontation and Bob was nominated to lead a ramshackle demonstration through the village in favour of stopping the traffic. The opposing side, who demanded their right of way unchanged, clashed with him in the middle of the lane and some bystanders recall that it very nearly got quite nasty. Looking like a scene from an Ealing comedy the newcomers finally relented and apologised for disrupting the calm. Bob, himself, later personally said sorry to several of his neighbours, but the villagers being as they were, never forgot.

Apart from a temporary aberration such as this, life in Mid Holmwood was relatively quiet for the Maxteds. They struggled with money from time to time but for the main part they lived contentedly and at peace. However, the normality of their lives was very soon to change forever and in a way nobody could have possibly expected.

On the verge of a modelling career...

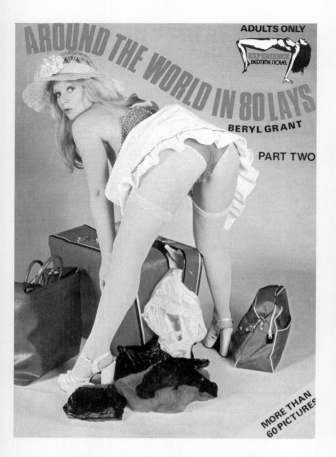

ADULTS ONLY

AROUND THE WORLD IN 80 LAYS

BERYL GRANT

PART TWO

MORE THAN 60 PICTURES

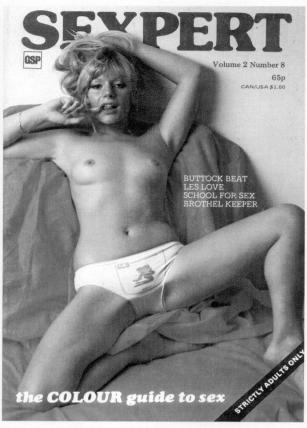

SEXPERT

GSP

Volume 2 Number 8
65p
CAN/USA $1.00

BUTTOCK BEAT
LES LOVE
SCHOOL FOR SEX
BROTHEL KEEPER

the COLOUR guide to sex

STRICTLY ADULTS ONLY

Vol 6 No 5 40p

Knave

MUST NOT BE SOLD TO PERSONS UNDER THE AGE OF 18

ROGER MOORE
SPEAKS OUT

THE GREAT
SIXTIES
SOUVENIR

SEX &
THE DIVORCED
WOMAN
WHO DOES SHE TURN TO?

CURE OF
THE GROUP
UNINHIBITED SEX TALK

THE KNAVE
PHOTO CONTEST:
THE WINNERS!

CAPRICE Plus 4

FOR SALE TO ADULTS ONLY 60p

Party Girls
Erotic Dream
Prostitution
★ *Contacts*
★ *Letters*

new
DIRECTION

GSP

VOLUME 5 NUMBER 8

65p
USA $1.50

PUBLISHED BY DAVID SULLIVAN NOT FOR SALE TO PERSONS UNDER 18 YEARS OF AGE. VOLUME ONE NUMBER ONE 75 PENCE

PLAYBIRDS

MARY MILLINGTON IN LEEDS

HUW 86N

FREE
£15 SEX PACK AND SAUNA OFFER

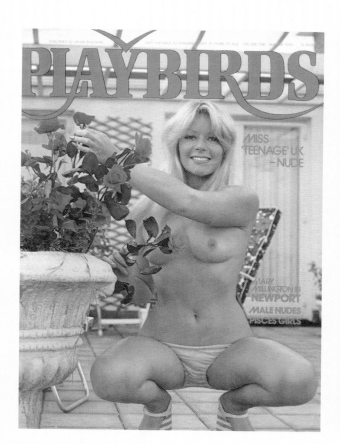

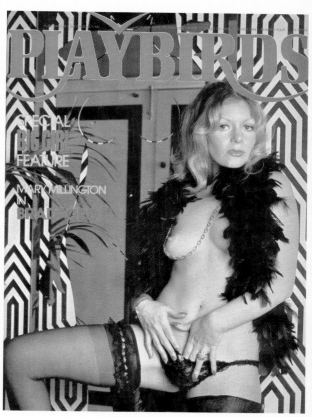

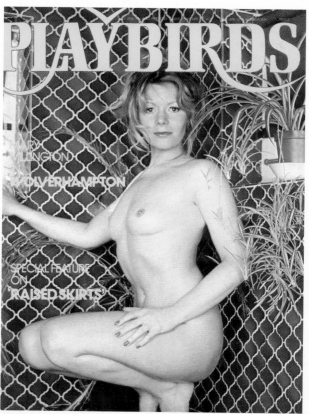

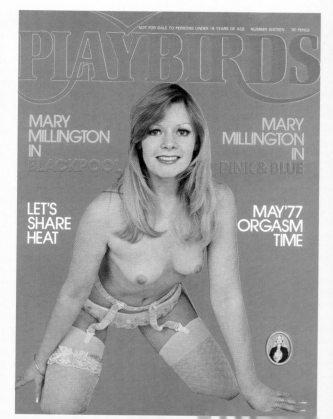

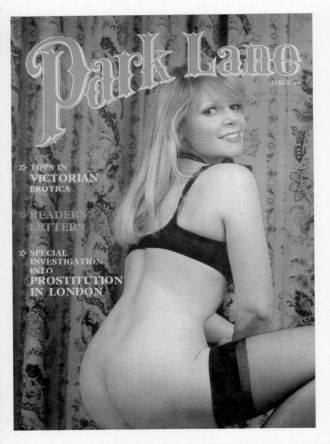

Park Lane

ISSUE 15

✦ TOPS IN VICTORIAN EROTICA

✦ READERS LETTERS

✦ SPECIAL INVESTIGATION INTO PROSTITUTION IN LONDON

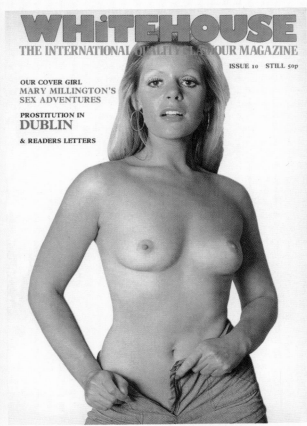

WHiTEHOUSE
THE INTERNATIONAL QUALITY GLAMOUR MAGAZINE

ISSUE 10 STILL 50p

OUR COVER GIRL
MARY MILLINGTON'S
SEX ADVENTURES

PROSTITUTION IN
DUBLIN

& READERS LETTERS

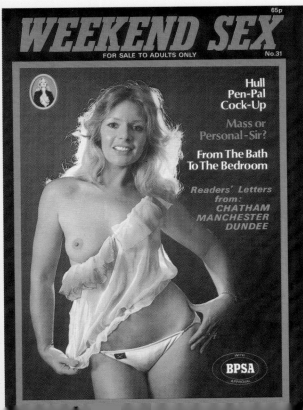

65p

WEEKEND SEX
FOR SALE TO ADULTS ONLY

No.31

Hull
Pen-Pal
Cock-Up

Mass or
Personal-Sir?

From The Bath
To The Bedroom

Readers' Letters
from:
CHATHAM
MANCHESTER
DUNDEE

BPSA
APPROVAL

The New Colour

Park Lane

FOR SALE TO ADULTS ONLY

75P

NO. 23

MARY'S
NIGHT ON
THE TILES

PUNK
SEX

FRESH FROM
DENMARK

READERS'
LETTERS FROM
SCARBOROUGH,
NOTTINGHAM,
PLUMPTON,
COVENTRY

PUBLISHED BY DAVE REED FOR SALE TO ADULTS ONLY VOLUME ONE NUMBER ONE 65p

LADYBIRDS

Naughty Phone No's!

My Blue Movies!

Mary's University Challenge

sex is my business

There was no denying that Mary had blossomed into a beautiful young woman, and Bob Maxted recognised the fact that his wife was one of the most talked-about and lusted-after women in Dorking. Men would stop and stare as the mini-skirted (or 'extra mini' as one male friend recalled) Mary wiggled down the High Street to do the weekly shopping, and you would be hard pressed to find one person who didn't recognise her eye-catching figure. But despite being the focus of wolf whistles and saucy compliments the only person who would not take them seriously was Mary herself. Lacking in self confidence and crazily body-conscious, she would still moan to her friends about her lack of cleavage, plain face and supposedly pointed nose. Her worries were met with exasperation and disbelief by those around her, and no amount of reassurance would pacify her. However deep-seated her lack of self esteem though, Mary still secretly harboured a dream. To be wealthy and famous. She had achieved a certain degree of fame some years earlier when she was persuaded by an amateur photographer, whom she met in a local park, to enter the annual 'Miss Dorking' beauty pageant sponsored by the local paper. She had been unsure about entering but her friends and, more importantly, Joan had told her that it might be fun. Not only that, but there was a cash prize on offer. Mary stepped onto the stage wearing a blue and white bikini, her blonde hair cascading around her face. Once she was up in front of the judges she clearly began to enjoy herself and played to the gallery with humour and sexiness. Much to everybody's surprise she was eventually placed third, a result that did nothing but compound her view of herself. Even today it is till a constant source of amazement to her family and friends that she failed to win. Following that incident she steered well clear of any sort of beauty contests, but her mother persevered with the compliments and positive thinking.

Thankfully her desire to look glamorous was not knocked back by the 'Miss Dorking' episode and by the late 1960s Mary had landed a job, which in her eyes, was very nearly ideal: deputy manageress in a boutique. The little shop, next door to the White Horse pub in Dorking High Street, specialised in teen and twentysomething's fashion and its hip and trendy image suited Mary down to the ground. She was given plenty of responsibility in the day to day running of the store, and the owner allowed her employee to influence what was sold, a perk which Mary found exceedingly satisfying. On days when she was left on her own to run the business she would sneak Hector in and get him to sit under one of the clothing rails.

It must be said that for all the delights a town like Dorking had to offer, Mary still enjoyed travelling up to London with Bob or one of her female friends on her days off to have a good look around the big department stores. She adored browsing around Selfridges and Harrods and enthusiastically hunting out bargains in Carnaby Street, the Kings Road and best of all, Kensington High Street. She was careful with her money, being only too aware of how little she had, but for her the one true motivation for earning money was to spend it on new outfits. On these numerous shopping sprees she would frequently tire herself out so much trying to cram in visits to as many shops as possible in one day.

One cloudy Saturday afternoon as she relaxed with a drink in a Kensington coffee bar Mary noticed, through the corner of her eye, a gentleman intently staring at her. This in itself was not an uncommon occurrence, but this man's gaze was unflinching in its intensity. Briefly turning around to face him and smiling half-heartedly, she returned to her coffee. Then suddenly her admirer was there, standing beside her.

'Have you ever thought about becoming a model?' the stranger asked in a broad Scottish accent. Mary looked back at him blankly, her eyebrows arched, in stark disbelief at his hackneyed chat up line. The man sat down on the stool beside her and handed her a small white card. She looked at it but the name meant nothing - *John Lindsay, Photographer*, followed by a telephone number. 'Really, I mean it,' he continued. Mary remained suspicious of his credentials, but inside was secretly rather flattered. She didn't really know what a photographer was supposed to look like. This chap wore jeans with a roll neck jumper and a waistcoat and his peculiar looking face was framed by unflattering rectangular glasses and wavy shoulder length dirty blonde hair. He was strikingly *un*attractive in his appearance but Mary was rarely impressed by good looks alone. Persevering, his patter sounded almost too well rehearsed but he explained that he was genuine, had a studio in the West End and was always

on the lookout for new girls for advertising assignments and magazine layouts. The longer Mary listened the more convincing his story became and the more carrots he dangled: his girls made a hell of a lot of money and photoshoots in Europe were commonplace. Initially Mary had no answer for him, she was overpowered by his fast talking and quick-fire tales about the glamorous world of modelling. 'Anyway think about it,' the pushy Scotsman said. 'You've got my card. Give me call and perhaps we'll see you in my studio soon eh?'. Then he was gone.

Three days later Mary found herself in the heart of Soho, standing in front of the unimpressive and grubby facade of 37b Berwick Street. She had telephoned the photographer the previous day and made an appointment but had not the slightest idea what to expect. One thing is for sure; she had put on too much make-up; her nerves and insecurities had got the better of her. Climbing the stairs to the first floor studio, Mary was confronted with a small brightly lit room, the stark white walls punctuated only by portraits of beautiful young women.

'Good to see you,' said the man. 'Please sit down.'

Unbeknown to Mary, John Lindsay was not just another jobbing fashion photographer. His main source of income came from something very different. Whether he liked it or not, Lindsay was soon to become the public face of British pornography. Indeed he had started out in the mainstream fashion field in the early Sixties, but after selling a set of topless photographs of one of his girlfriends he immediately realised that naked girls equalled big money.

Lindsay asked what sort of modelling Mary wanted to do and she answered him without much hesitation, 'Teenage fashion work'. It was the answer he had expected but it was now his responsibility to turn the conversation around to his way of thinking. He shook his head and wrote something down on a piece of paper, which unnerved Mary. He then asked if she knew what 'glamour' photography was, to which Mary answered that she did. In case there was any doubt Lindsay pulled out a copy of the top-shelf girlie magazine *Men Only* from his drawer.

'Let me explain,' he said. 'You are a very beautiful girl Mary but you must take on board that fashion models have to be pretty tall for the clothes to look good on them. How tall are you?'

'Four feet eleven,' she replied, squirming in the canvas director's chair.

'Right, well I'd love to use you but you see if I take a photo of you wearing a dress I can sell it maybe once because clothes go out of fashion, but if you take your clothes off I can sell it to maybe ten publications. D'you understand?,' Lindsay explained and pushed the copy of *Men Only* across his desk towards her, before opening it up to the centre spread. It showed a woman totally naked reclining on a brown velvet sofa. In the bottom left hand corner of the page it said *'Photos by John Lindsay'*.

'How do you feel about that?' Lindsay went on.

'No problem,' Mary replied, the words coming almost without her hearing them.

'Men are such suckers,' the Scotsman laughed. 'You know when it comes to pretty birdies, they take one look and their brain goes bang!'

Lindsay continued to extol the virtues of nude modelling and how profitable it was before going on at some length about how stupid men were to want pictures like these. Mary smiled sweetly and agreed with him.

'Well,' said Lindsay cheerfully, 'let's do a colour test then see how you photograph.'

Before Mary could even ask exactly what a colour test was, Lindsay was up and leading her to an even smaller room just off the main one, it was empty bar lights set up on tripods and a red fake fur rug crumpled on the floor. Without Lindsay's help, Mary unzipped her dress and it fell silently to the floor. For a split second she questioned the consequences of what she was about to do. Muddled thoughts flashed back and forth. She imagined Bob at work, her mother in the garden, the open countryside at Mid Holmwood. Then her mind went momentarily blank. Standing in just her bra, knickers and stacked heels she stared at the photographer for reassurance. Looking up from loading his camera he raised his eyebrows.

'That's fine. The rest would be great.'

As if dreaming, Mary removed the remainder of her underclothes and suddenly feeling rather proud of herself - realising she felt neither conspicuous nor cold - knelt down on the rug as Lindsay attempted to straighten it beneath her. As he did so Mary began to laugh nervously.

'What's the matter?' Lindsay asked.

'Nothing really,' she replied with a broad smile. 'It's just that five minutes ago I was outside in the street and now I'm stark naked here with you.'

The session lasted about a quarter of an hour, but felt considerably longer to Mary. Lindsay asked her to relax, but he was pleasantly surprised at her enthusiasm and openness as he suggested poses. He knew from past experience that sometimes it could be a hell of a lot harder than this. Mary joked to him that it reminded her of school gymnastics as she bent, knelt, stood and lay in a variety of silly positions. After finishing two reels of film and punctuating the silence with an endless stream of 'lovely's, 'wonderful's and 'beautiful's he told her she could put her clothes back on. The studio lights had been sweltering and even after this brief shoot Mary felt absolutely shattered.

Returning to Lindsay's desk Mary expressed surprise at the photographer's enthusiasm for her body. 'I've got such small boobs,' she said. 'Who on earth will want to buy my photos from you?'

'I wouldn't worry about that my love,' Lindsay replied brusquely, 'I'll be able to use them alright.'

An early modelling session, for **Rapier***, 1971*

Still disbelieving his apparent confidence in finding a buyer for her pictures, and comparing herself with the shots of stunningly attractive women displayed on his walls, Mary made a rash wager. She bet Lindsay that if he managed to sell the photographs within three months then she would not ask him for her modelling fee.

She lost her bet. Two days later they had been sold.

Mary soon became a regular visitor to the Berwick Street studios and each subsequent time Lindsay asked her to go just that little bit further.

'You've heard of 'hotter' shots haven't you Mary?' he asked her on her next visit. 'I mean I sell pictures all over the world and that often means I do stronger photos. Men go nuts over that sort of crap.' Lindsay had his craft finely tuned and used near identical lines on all of his models. Few actually refused; after all, as he repeated *ad nauseum*, it was the men who were getting exploited, not the girls. Weren't fellas crazy for wanting photos of naked girls? Lindsay told his models that he 'just couldn't understand it', knowing only too well that this sort of false ignorance would invariably pacify the most naive and innocent of girls.

Within weeks Mary was posing with her legs spread, holding her vaginal lips open, teasing her clitoris and nipples, even playing with sex toys. Lindsay remembers well that she never said no to any of his suggestions, however bizarre, and at times her complete lack of shyness surprised even his experienced eye. 'I believe in bodies being for looking at,' she commented, 'and see nothing obscene about them whatsoever.'[1]

Mary was only too happy to go through the motions for her new business associate and for the first time in her life actually started to take on board the compliments. After all, Lindsay once told her, if she was so unattractive 'then how come her photos sold by the bucketload?'

But Mary was never one to totally believe the hype and just got on with it. 'From the neck down I don't care,' she explained. 'I can express myself better below the neck. Not that I think I have the most perfect figure in the world. I haven't. I'd like to have a bigger bust. I'd like big boobs.'[2] Sometimes Lindsay would despair of Mary's self deprecation. As well as her breasts she would complain bitterly to him about her 'plain and expressionless face'. Years later she attempted to shed some light on this facial paranoia; 'It worries me all the time. I'm very conscious of it. I used to think before I became a model that if anyone saw pictures of my ugly mug they'd run a mile. I hate absolutely everything about my face,' she admitted, 'I think it must be a mental thing. I don't know. I try not to look at photos of myself. I always think I look so awful.'[3]

With Lindsay's help, Mary quickly learnt many of the tricks of the glamour trade. Now experienced, she could be called upon to hold her tummy in, stand with her shoulders straight, part her painted lips and push her bottom out, all without prompting. She also learnt with considerable amusement, that an ice cube rubbed on the nipples made them instantly erect for photos and that oil dribbled onto her vagina made her appear aroused even when she was at her most tired and bored.

Her photos were selling all over Europe (she was dismayed at being asked to shave her pubic hair for a series of photos for the German market), and gradually Mary had become Lindsay's most popular model, so much so that he was unable to keep up with the demand for new product. On Lindsay's advice she seldom allowed her real name to appear alongside the published photos, instead using a variety of pseudonyms like *Janet Green*, *Samantha Jones*, *June Taylor*, *Susan David*, *Karen Young*. On only a couple of instances she resorted to using her maiden name or the surname-less *Mary Ruth*. Occasionally Lindsay's schedule was so busy that Mary was forced to take on jobs from other sources, including shoots with a young Brighton photographer called Rex Peters.

But what explains Mary's popularity as a glamour model? What exactly was it that set her aside from the hundreds of other models?

'She was a very friendly person,' Rex Peters explained in 1980. 'I think this came over in her photos to a great extent. She knew what the customers wanted. She knew how to portray her sexuality. Over the years I've worked with hundreds and hundreds of girls and she was undoubtedly one of the best I've worked with. I think her major appeal was her lovely body and the lovely warm personality that came over, not only in her pictures but to the people who met her, it came over tremendously, very strongly. She could pose naturally in front of the camera for one hour or five hours. She was one of the few models, I think, that I've worked with, who turned up for every job fully made up and fully prepared. A very naturally sexy girl.'[4]

Lindsay also recalled his photo sessions with Mary. 'She made love to the camera,' he said. 'When I was photographing her she was fantastically sexy and I realised that I'd got a star here.'[5]

Interestingly, however much Mary enjoyed the attention from the photographer's lens, it was not this that motivated her to take her clothes off. It was a much more basic need. Money. She had cut down her hours at the boutique in Dorking High Street, regularly taking afternoons off to travel up to London to see Lindsay, and the cash he paid her for the jobs was unlike anything she had ever earned before. She could now afford to buy the clothes she wanted without worrying about being out of pocket, and treats for Bob and Hector came almost daily. It was mainly for Joan's sake that she worked though, and her reasons for moving into pornography have been a source of debate and conjecture ever since.

Mary's concerns over her mother's health eventually proved to be correct. Joan was sick, but far more so that anyone had initially thought. Since Joan's first health scare Mary had been keeping a close eye on her mother but she had noticed a significant decline from the time of her marriage onwards. Joan began to complain of chest pains and coming home from the British Library each evening, would retire to her bed almost immediately. The change in her was made most apparent by the fact that Joan had started to ignore the garden. Even kneeling down to do the weeding became too tiring for her and the watering was often left for Mary or Bob to do. She stubbornly refused to go and see her GP again, but after things came to a head, culminating in a serious lecture from her frantic daughter, she reluctantly agreed to go for a series of tests at Dorking General Hospital. The results were not good; a malignant growth had been found in her left breast. Mary seemed to be even more devastated by the prognosis than Joan, but the condition debilitated her mother so much that she was forced to leave work. Not only was Joan desperately ill but the third income in the household had been lost. Mary later remembered how desperate the situation had become:

'It was pretty obvious that my mother had left her illness very late, by always working and putting it to the back of her mind. She needed urgent treatment and possibly an operation to remove a lump. I needed all the money I could get.'[6]

Joan endured long stays in the hospital. Some nights Mary would sleep in the chair beside her bed, terrified to leave her side. One of the ward sisters commented to Mary that she had never seen such a strong bond between a mother and a daughter in all her life. Mary's reaction to this was simple. 'But I love my mother,' she had replied, 'why would I want her to be on her own?'

The operation to remove the lump was successful but the cancer had already spread to other parts of Joan's body. Through all of this, Joan rarely complained, instead taking strength and comfort from her 'beautiful little girl'. Klein's visits to Mid Holmwood, by now, were few and far between, and Mary resented his lack of involvement in their family life, but the truth is that Klein was also unwell. He was over seventy, frequently out of breath and suffering from heart trouble. The experience of having two gravely ill parents put a tremendous strain on Mary's mental state and, in turn, her marriage. But Bob Maxted was Mary's rock throughout. He diligently cared for Joan and when she became almost bedridden he would struggle to help her climb up and down the stairs.

Joan's refusal to give up her 80-a-day cigarette habit led to her contracting bronchitis on top of her cancer and her health seemed to grow steadily worse day by day. It seemed to Mary that for a long time her mother's health just seemed to hang in limbo. Joan got worse, but just refused to die, and Mary refused to accept it.

'I think she was probably ill even from when Mary was a teenager,' Geoffrey Quilter says. 'She was sick for years and years and Mary and Bob were wonderful in their care for her, but looking after someone can be incredibly expensive.'

The consultant recommended that Mary buy plenty of fresh fruit and vegetables for her mother. This coupled with a series of vitamins, gold injections and a high protein diet, might make her more comfortable, he explained, but that the outlook was poor. Desperate, Mary searched for information about any alternative remedies that might help and even considered hiring a private nurse for round the clock care.

Mary was thankful that modelling was so well paid and never refused a job. In the back of her mind she knew that the more money she earned the better the standard of life they would have in Mid Holmwood. She never gave up hope that a miracle would happen, that her mother would get better. Geoffrey Quilter's wife Susan recalled a conversation she later had with Mary around this time,

'Her mother's drugs were very expensive,' she says, 'and Mary told me that was partly the reason that she started posing for these nude pictures, but from there on it just escalated onto bigger things.'

Mary was determined that Joan would not find out where she was getting her money from. One benefit of her mother becoming ever more

reclusive and staying in her bed most of the day was that she had no idea that her daughter was not working in Dorking every day. Mary had no qualms about telling the rest of her family of her new found vocation, especially as the end result was to help her beloved mother.

'Mary used to tell us what she was doing but also used to say "For goodness sake don't tell mum",' Susan says. 'She did it for the money primarily. She told us it was a quick way of earning a lot of cash.'

Geoffrey and Susan Quilter's reaction to Mary's confession was positive. They were not shocked, but rather 'amused and totally surprised' by Mary's stories of Soho decadence. They were also broadminded enough to realise that, whatever she was doing, she finally had a job that she liked.

'When she started off she really enjoyed the nude modelling, that made it easier for her to do it. It was a bit of fun to begin with, but really it was all she could do. She wasn't especially brainy, but her personality was lovely, so she was more or less drawn to it as others were drawn to her,' Geoffrey explains.

The reasoning that Mary entered the porn business primarily to support her mother has often been heavily disputed. Surely there would have been easier ways to earn quick money? One man who is suspicious of Mary's motives is Jim Adamson, the writer-director of the acclaimed 1996 documentary *Sex And Fame: The Mary Millington Story*. He comments: 'She went into porn because she just *did*. It's as simple as that. There doesn't need to be an excuse for it. She was rebellious and genuinely saw it as a way of getting noticed, perhaps even changing attitudes about sex. You must remember she was extremely liberated sexually.'

The truth is probably an amalgamation of both. Mary was prepared to go to any lengths to help her mother. The relationship with Klein had mostly been a complete sham. In the past he had seemed to be more concerned about his mistress than his own child. When the three of them would meet up, Klein would greet Mary warmly, admittedly, before making a bee-line for Joan and more importantly her bedroom. Before Bob Maxted had come along Joan was virtually all the love Mary had ever known, the only person she could rely on and the one relationship she could fully trust. Now she saw that

relationship slipping away and Mary was going to do her very damnedest to keep them together. Her search for well paid work was made easier by her uniquely open mind. She thrived on excitement and attention, wanting little more than for men to find her sexy. This she was, and the thrill of posing nude for Lindsay's camera provided her with the release she had long dreamed of. Later on in her career she spoke frankly of the anomaly between her 'real' life and her popularity as a glamour model: 'People seem to think that because I take my clothes off for a living that I'm the most immoral person that ever existed. In actual fact I'm very moral but I'm a complete split personality. I'm very prim and proper in some ways, but the other side of my personality is the fact that deep down I really must be an exhibitionist'[7]

One day as Mary posed for Lindsay he noticed that she was a lot quieter than normal; usually he couldn't stop her talking. Asking her the reason for her long face Mary answered that she was very concerned about her mother and urgently needed more money. Lindsay knew a little of Mary's background from bits and bobs she had told him, but as a rule his models kept their private lives to themselves, and he preferred not to get involved. Sensing that her mind was going nowhere but elsewhere, he took one last shot and placed his camera around his neck before sitting down on the floor beside her. He pulled out a packet of slim cigars from his waistcoat pocket and lit one.

The early days of home entertainment

'You can earn really good money outside of modelling for magazines Mary,' Lindsay said. 'D'you know what a Swedish movie is?' he asked.

'Yes of course I do,' she answered indignantly. Mary understood all about Lindsay's other ventures. He was rarely subtle when it came to business.

'Well in other words it's a blue movie,' Lindsay continued. 'Films that show the lot. No faking, no simulated crap. Real sex Mary.'

Mary nodded, she wasn't stupid.

'Well you know I make those kind of films as well as take photos,' Lindsay said, before continuing in his usual vein. 'I think men are nutters, because obviously if you want a girl why not have one for real. Why look at a film? Y'know it's crazy. But anyway they do and that's what makes the money so who am I to question?'[8]

Mary pulled her legs up to her chest and fixed the photographer straight in the eye. She could almost predict his next line.

'What do you think about making a blue film for me Mary?'

She didn't even have to think.

'Fine,' she replied. 'How much money will I get?'

Lindsay always got around to asking all his models this same question, because not only was he famed for his photographs, he was also Britain's highest profile hardcore sex film director. Lindsay took tremendous risks with his business activities because unlike his European counterparts, Lindsay's *Taboo* film empire worked outside of the law in a country where the graphic illustration of sexual intercourse is a matter for police investigation.

The grandfather of all British sex laws is the 1959 Obscene Publications Act which states that the possession of obscene materials for monetary gain is a criminal offence. It gave the police increased powers to seize all forms of pornography but the wording of the law is cumbersome and outdated, hinging on the single word *obscene*. What is obscene to one person is quite acceptable to another. Is it really possible that, only in the UK, pornography really can 'deprave and corrupt'? It was the confusion that resulted from

Mary and her male equivalent Tim Blackstone, enjoying a baking session, circa 1973

the interpretation of the Act that encouraged Lindsay to produce his films undeterred. After all, the British market was flooded with illegal copies of sex films from the continent and there the pornographers were free to work undisturbed, left to their own devices by the authorities.

1967 saw the first stirrings of sexual liberalisation, with the gradual legalisation of all forms of pornography in Sweden and Denmark. Soon gaining a reputation as the undisputed sex capital of the world, Scandinavia became a by-word for 'filth' in the eyes of many, but within the next few years Spain, Germany, France and Holland had all followed suit. The rest of Europe eagerly waited to see who would be next. But it was not to be Britain. On the continent depictions of adults indulging in *real* sex flooded thousands of adults-only bookstores and cinemas. The early porn companies flourished, many of which are still in operation today, including the groundbreaking likes of Berth Milton's *Private* organisation in Stockholm; the Theander Brothers' *Rodox* in Copenhagen and Joop Wilhelmus' *Chick* in the Netherlands. Over in Germany, Beate Uhse became the first woman to make a fortune from marital aids after opening the world's largest sex shop adjacent to, of all places, a terminal at Frankfurt Airport. In the space of five years sex had become *the* biggest growth industry in Europe. By 1973 *Rodox* were producing over a million duplicated sex films annually on their infamous *Color Climax* label, and legendary porn director Lasse Braun, having moved from Italy to the friendlier climes of Denmark, was

able to sell 100,000 copies of each title from his vast back catalogue of blue movies. Selling sex had become big business, greater than anyone could have possibly imagined.

It wasn't just in Europe that pornography was suddenly becoming fashionable either. In 1972 a film was released that would revolutionise the way the world looked at sex. Gerard Damiano's *Deep Throat* cost less than $40,000 to make but went on to gross over $4,000,000 on its initial release alone. Premiering at the New Mature World Theatre in Manhattan's Times Square, the film played to enthusiastic audiences, who marvelled at seeing hardcore sex combined with a proper narrative, something never before imagined. It played 200 cinemas in 32 different cities across the USA. The sort of grainy black and white sex film that had previously only been available under the counter was now playing in glorious Technicolor in some of the most prominent movie theatres in America. The star of the picture, Linda Lovelace,[9] became a household name almost overnight, famed not only for the oral sex talents she displayed on film, but also because of the company she was keeping with some of Hollywood's biggest celebrities.

Back in Britain the authorities still refused to play ball, but that is not to say there wasn't an extensive porn industry hidden away. Scratch the surface of Soho and there it was. London's Soho district has been a centre of vice and prostitution since the 1600's. Back then, along with your cough mixture, chemist shops were happy to supply etchings of naked women to regular customers as part of the cure! From as early as the 1950s London pornographers had produced hardcore films, often using West End prostitutes who were paid to strip and have sex with their punters in front of a camera for a few pounds. Few of these early film makers were known by their own names, but others like Mike Freeman, Ron Davey, Charlie Brown and Evan Phillips (the latter, reputed to be the first Englishman to make a million from home-grown porn) rapidly became known to the Metropolitan Police's notorious Obscene Publications Squad (OPS).

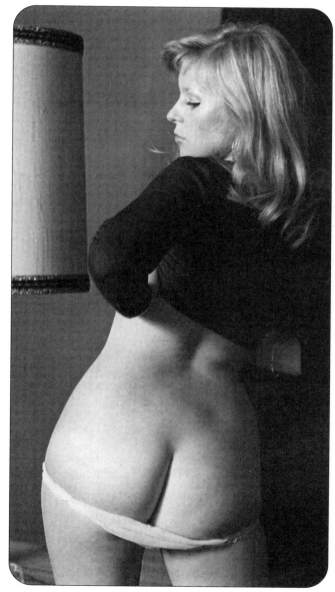

It was fairly difficult to lay your hands on home-grown British porn in 1960s London as the master copies were often smuggled to Scandinavia to be processed and duplicated, but within a matter of years the market was flooded with illegal material. UK based companies such as *Unique*, *Jackie Scott*, *Europa* and *Climax* were hurriedly producing and distributing films readily available through mail order advertisements in girlie magazines and from Soho and East End sex shops. Before the advent of video tapes, all the films made for private consumption were sold on Super Eight reels, in other words, 8mm wide film suitable for showing on a home projector. Invariably the porn directors shot on 16mm but when the films were duplicated they were reduced to the 8mm format simply because the majority of projectors could only accommodate smaller reels.

WHY BE CONNED?

TEENAGE FILMS

200ft Colour Films Super 8 only £20 each

SCHOOLGIRL SEDUCTION	1F 1M
SEX AFTER SCHOOL	2F 1M
SEX LETTERS AT SCHOOL	4F 1M

Personal callers may view films before purchase.
SHOP OPEN MON TO SAT 10am-8pm
**LONDON MOVIE CENTRE,
37b BERWICK STREET, LONDON W1**

A typical John Lindsay advertisement from the early 1970's

Once you had the equipment it was relatively easy to start your new hobby. From as little as £15 it was possible to buy your own mains operated projector with adjustable focus and enjoy hours of viewing pleasure in the privacy of your own home. The films themselves invariably ran for no more than fifteen minutes (again the constraints of the early technology), and came in a variety of formats: b&w, colour, silent or with sound. Depending on the type, the price of an individual film could range from £8 to £25 a piece. The films themselves were a mixed-bag of straight-forward heterosexual couplings, orgies, lesbianism and even the odd gay film, but not surprisingly the titles were often more fun than the films. Who could fail to warm to the flickering delights of *Angry Lesbians*, *Mouthful Of Love*, *Depraved Dolly*, *Caravan Kink*, *Lickity Split*, *Clitty Clitty Bang Bang* or best of all *Vacuum Cleaner Orgy*?

Soho really came into its own (if you'll pardon the pun) in the early 1970s with an excess of fifty sex related businesses in an area less than one square mile wide. The OPS had its work cut out policing the premises, many of them illegal, but police corruption was at an all time high.[10] Apart from the sex shops there was a proliferation of private cinema clubs pioneered, to a great extent, by John Lindsay. He realised that the British Board of Film Censors would immediately refuse any certificate for a hardcore sex film in a public cinema, but he discovered a loophole. Luckily for him, the 1959 Obscene Publications Act did not make provision for cinema clubs and even the 1952 Cinematograph Act let privately exhibited sex films off the hook. Interpreting the law in his own unique way, Lindsay expanded his business to include various 'members only' sex cinemas. His *Taboo Club* premises in Great Newport Street and later below his studio in Berwick Street brazenly advertised his home-grown hardcore pornographic films outside in neon letters. For as little as one pound anybody over eighteen could become a fully paid up member, but all patrons had to sign a form before entering, acknowledging that they were completely aware of the type of films they were about to see. 'I'm showing the real thing,' Lindsay told an interviewer in the mid-1970s. 'I have to make sure would-be members understand the exact nature of the movies at the *Taboo*. The last thing I want to do is shock some unsuspecting man or woman with this material. We emphasise that these are films which show every detail, every aspect of lovemaking.'[11] Open from 10am to 11pm, his cinemas offered air conditioning, continuous programming, a restaurant and a coffee bar. For those worn-out by the excesses of masturbation, Lindsay provided a 'rest room'.

Other clubs like the *Playboy* and the *Exciting* ('*London's Most Luxurious!*') in Greek Street quickly became part and parcel of Soho life. Whilst most had open auditoria, some offered more discreet, and delightfully named, 'wanking booths'. When the screen went blank the customer was required to pop another 50 pence piece in the slot so as to resume the action.[12]

John Lindsay will be long remembered as a British porn pioneer, a man who stuck two fingers up to the authorities and was only too happy to provoke a reaction whenever he could. Probably the best in his field, he never shied away from publicity and was even happy to appear in two cinema documentaries examining the sex industry in the early Seventies. The first was his friend Stanley Long's *Naughty!* in 1971 and the second his own pet project *The Pornbrokers* in 1973. Both pulled no punches in their desire to show a pornographer at work. Lindsay never actually liked to refer to himself as *pornographer*, instead he judged violence, quite reasonably, to be the true evil of society. He once famously recommended that the makers of the boys' toy *Action Man* should dispense with the action figure's gun and replace it with a bendy penis.

Seeing the sort of hardcore films made by the competition in Europe, Lindsay was determined that the quality of his work must surpass theirs. His search for models was ceaseless and he claimed that finding willing participants to star in his films in bars and night-clubs was 'absolutely no problem'. Finding males was trickier, so he often preferred his female models to recruit their husbands or boyfriends for movie work. He once asked Mary if Bob would be interested in playing opposite her but,

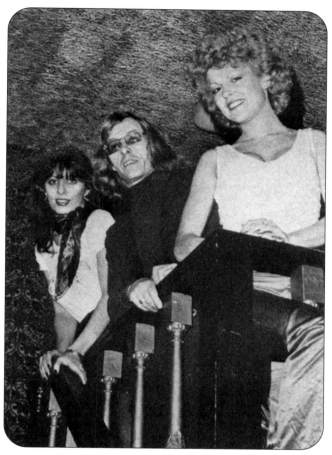

John Lindsay poses with a couple of popsies
on the Taboo premises

surprisingly, she had been appalled by the idea.

Lindsay was haunted by the fear of failure. He always demanded the best from his actors and could be a strict taskmaster. In *The Pornbrokers* he is seen frustrated at the failure of one of the actors to get an erection for his short film *Wet Dream*, and in *Naughty!* he startles the cast of *Sex After School* by shouting his directions:

'I want 100% action. I want everything. Sucking, licking, fucking, screwing, you name it I want it and I want it good!'

Lindsay's *Taboo* films became the flagbearer for British porn. They display a shockingly raw sexual energy with casts of men and women totally unapologetic about their participation; watching them is astonishing even by today's liberal standards. It was into this arena that Mary found herself, surrounded by a repertory company of far more experienced players. Using his regular actors several times over, Lindsay was able to establish a recognisable roster of faces in his films. He was the first to work with young Hungarian model Ava Cadell[13] in *Jolly Hockey Sticks* as well as launching the careers of Maureen O'Malley and Pat Astley, but throughout he realised the debt he owed his models. The media's refusal to understand him or his performers infuriated him. He says in 1971's *Naughty!* -

'I would like to stress that the girls I use in my films are nice girls. Because they screw and have it up here and up there and in their mouths and that, this doesn't mean to say that they're not nice girls.'

Despite his assurances to new models that many of his films were shot in 'luxury penthouses' and destinations like the Bahamas, the truth was quite different. The majority of Lindsay's work was created at quite ordinary addresses in London or the Home Counties but, in the early days of his film-making ventures, he regularly travelled to the more sexually enlightened climes of Europe. Studio and location facilities were more readily available in Holland and Germany, and Lindsay was able to direct and process his films without the interference of the police. Bearing this in mind, Mary was to make her hardcore debut on her very first trip abroad; the destination: Frankfurt.

'She had no hang ups sexually that girl,' Lindsay remembered. Before leaving Britain he had taken the time out once again to stress exactly what kind of movie-making he was into. He told her, 'They ain't no back street dirty films, they are top quality, pornographic hardcore blue films,'[14] Mary reiterated that she loved sex and joked to Lindsay that, in her case 'the more was certainly the merrier!'.

Mary's first pornographic film was called *Miss Bohrloch*, or in the English translation *Miss Borehole*, a rather unpleasant-sounding title that gave some indication of what was to come. Due to the constraints of the running times of 8mm, the films rarely bothered with much of a storyline, instead replacing a well-written plot with the maximum amount of sex as possible. *Miss Bohrloch* is no exception. Mary plays a trashy looking prostitute who lives in a flat with only her fur coat, stockings and suspender belt to keep her company. Two long haired men ring her up and make an appointment for a threesome later that evening. When the men arrive, Mary greets them excitedly and shows them a price list of sexual services available. Her guests feel so randy they can't decide what to choose so end up having

a 'full service', clearing out their wallets in the process. The film is just about as raw as porn could be at that time. The sex is relentless, as the three leads gallop along through the full gamut of sexual acts barely pausing for breath. Mary's performance, considering this was her first film, is confident and honest. She is only unconvincing when she is required to actually act or deliver a line (she was finally dubbed by an American actress for the finished version), but in terms or her sexual energy, she surpassed even her own expectations. Mary shows off the full range of her sexual repertoire as she indulges in oral, vaginal and anal sex simultaneously with the two men. Lindsay remembered that some of his models would draw the line at some sex acts but Mary was even happy to have the men ejaculate in her mouth, and at one point rather unexpectedly starts rimming one of them as he remarks, 'I've never had that done before'. As Mary's first taste of hardcore pornography, it was an intense experience. Lindsay could quite easily have scripted a more subdued story for her debut film, even introducing more female characters to take the emphasis off her. As it stands today, *Miss Bohrloch* is Mary's film; she dominates the proceedings entirely.

Immediately prior to filming, Lindsay had thoroughly discussed with Mary what she wanted, or did not want, to do on film. He was more than happy when she told him she was prepared to do everything on camera. She was neither embarrassed nor concerned about what she was asked to do, so much so that Lindsay often thought she was actually playing herself on film.

Miss Bohrloch was the showpiece for Lindsay's new discovery and almost as soon as the film was released in Europe the porn-buying public were demanding more from the anonymous blonde star. The film was a tremendous success, selling nearly 300,000 copies, becoming a huge hit on the continent and gaining a sizeable underground following back in England. To top it all it was awarded the coveted Golden Phallus Award (at the time the porn industry's version of the Oscar), at the Wet Dream Festival in Amsterdam. Seeing the obvious potential in Mary, Lindsay quickly featured her in a succession of other hardcore movies shot in Rotterdam, Amsterdam, Frankfurt and in the UK, and though an increased workload meant more time away from home it also meant a bigger bank balance. What had started out as a scheme to get quick cash had escalated. Mary was soon earning more money than she had ever expected, enough to improve the standard of living not just for her mother but also for her and Bob. Within a few months the tiny face of Mary Maxted was seen peering out from over the steering wheel of a new two-seater MG convertible.

Mary was anxious that her mother was never to find out her secret, but rumours about her career soon started to circulate in Mid Holmwood. Intriguingly, this gossip would often emanate from one person: Mary herself.

'Many of us knew that she was doing some sort of modelling work abroad', neighbour Margaret Wolfe remembered. 'She was always jetting off from Gatwick Airport and she'd say to me "I'm off to Amsterdam filming, Margaret, see you soon".' Mary was always in a mad rush to catch the plane and it was a common sight to see her tearing out of the village in her sports car. 'I'd be stood waiting at the bus stop and she'd be driving past putting on her eyelashes and applying lipstick, steering the wheel with only one hand,' says Margaret.

It was only when a visitor came to stay at the village that the cat was really let out of the bag with regard to the type of films Mary was appearing in. A family in Mid Holmwood had a cousin over from Canada who apparently knew quite a lot about European pornography. A contact in London had told him that his favourite 'film star' lived locally, and he was dying to meet her. Much to Mary's surprise and consternation he turned up on the doorstep of Woodlands View waxing lyrical about how big a fan he was and how he wanted an autograph. Mary hastily scribbled on the back of his cigarette packet before sending him on his way. The Canadian meanwhile ventured into the Norfolk Arms to regale the locals about the blue film star in their midst!

In all of Mary's porn films the sex was the same; enthusiastic and energetic, with the settings changed only to give the viewer some variety; the action in *Sex Is Our Business* occurs in a adult shop; *Oral Connection* in a hotel, *Betrayed* in a couples' flat and *Convent Of Sin* speaks for itself. In all Mary starred in about 18 hardcore shorts over the space of two years, but not just for the man who discovered her.

In 1973 she made her first film for Russell Gay's *Mistral* company starring in the 'girlfriend fantasy' *Response*. Gay was the owner of *Knave* magazine, but had branched out into film-making. Although his movies did not have the 'fly on the wall' quality of John Lindsay's, they possessed a undeniable classiness and professional quality. *Response* was not Mary's first lesbian film, she had done

one before in *Betrayed*, and once again the experience did not 'phase' her. She told friends that whilst working in the boutique in Dorking two years previously, she had participated in a real bisexual experience with a female customer who had seduced her in the changing room. Mary had put up little or no fight and had been forced to put the 'closed' sign on the door so that their lovemaking could continue undisturbed. The incident had not worried her in the slightest, if anything it had simply broadened her outlook on sex. Nothing shocked her, nothing disgusted her. Time and time again she would tell her detractors:

'I treat sex as something to be enjoyed, something to be savoured, something to cling to, something to be indulged in whenever possible. The old slogan of 'make love not war' was a very good one.'[15]

Mary certainly had no qualms about sharing tales of her sexual abandon with her husband. Bob really had no option but to go along with his wife's lifestyle. He knew her far too well to kick up a fuss, instead he blithely stood by. Mary just got on with being Mary. It wasn't just his acceptance of his wife's film-work or her extra-marital sex life that made their marriage unusual. Mary would flirt outrageously with men at every opportunity, even in her husband's presence. Geoffrey Quilter recalls that he invited the couple to a chartered surveyor's bash he'd organised, and that Mary blatantly flirted with 'every man in the room' right in front of Bob. Throughout, he kept himself busy helping behind the bar.

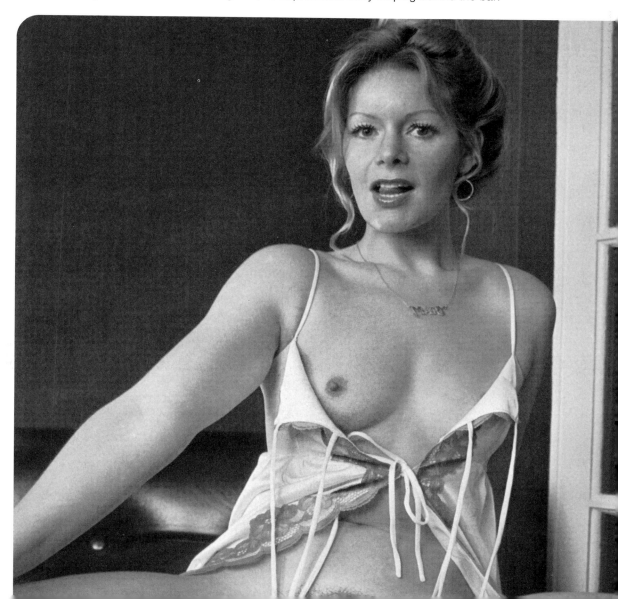

'Her sexual adventures and her flirting didn't seem to make any difference to Bob, it was most peculiar,' says Susan Quilter. 'He was just very tolerant and she did whatever she wanted. They enjoyed each other's company when Mary was at home but they'd be happy to do things together and apart. They had their own lives.'

Thankfully the marriage was solid and Mary rarely entered into any decisions about her career without first clearing it with her husband. Having said that, double standards existed in the marital home and Mary was sometimes deeply unhappy if Bob 'played away'.

'It was anything goes, yes, but only on Mary's side of it. It was totally one sided,' says Geoffrey. 'Bob was extremely patient, he loved Mary so much and put up with a great deal. Things most husbands wouldn't have coped with.'

'The impression we got was that she was making a lot of money from these blue films and Bob was jumping on the back of it,' one Mid Holmwood resident thinks. 'I mean a lot of husbands, if their wives got into that, well they wouldn't put up with it. But Bob just didn't seem to care.'

There is little doubt that Mary's new-found earning capabilities did help her husband to swallow the bitter pill of her sex film appearances. A friend of the couple is convinced by this. 'Of course he did love the money. Because of that he put up with most things.'

Geoffrey and Susan's son Richard disagrees with any suggestion that Maxted was simply a freeloader,

'Mary's work just kind of evolved and their marriage went with it,' he explains. 'Their relationship accommodated her career and only endured because they were married and stable before all of it started. Bob was not the sort of man who latched onto a bandwagon. In a way Mary saw it as a trip for both of them. From not having very much money, and a mother with an incurable disease who needed

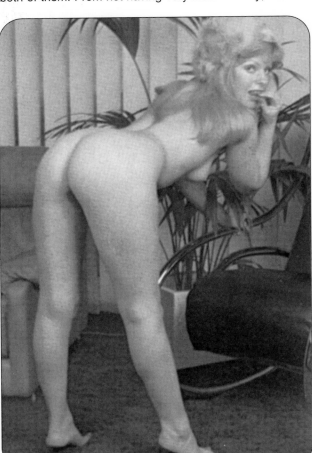

a lot of care, to a point where she was able to collectively raise their standard of living to a really, really good level. The thing is it was not just about her. In her list of priorities she would have been at the bottom and everyone else, Bob, Joan and the animals, were at the top.'

What cannot be disputed is how much Mary truly loved her husband. Many actually consider him to be the driving force behind her move into the world of hardcore porn. 'Some people have said that he was the little man in the background,' says Margaret Wolfe. 'It just wasn't the case. He was very influential and I really don't think she could have done it without him.'

playbird

If John Lindsay was the King of British pornography in the Seventies then David Sullivan was rapidly becoming the Emperor. Born to working class parents on a council estate in Penarth, Cardiff in 1949, Sullivan's rise to the top of the pornography tree was meteoric and breathtaking. His father served in the RAF and the family was forced to relocate around the country several times, eventually ending up in Essex. The young David was a bright young lad, he was accepted to Watford Grammar School and before long he had his sights set firmly on money making ventures. As a teenager he started a mail order business distributing football paraphernalia and his innate business ability encouraged him to think about taking an economics degree after leaving school. At London University's Queen Mary's College he met his first business associate, another determined and intelligent go-getter, Bernard Hardingham. After graduating the two set up their first business together, *Subdean Publishing Ltd* and it was this company that set Sullivan on the path of commercial sex. Sullivan and Hardingham were inspired by an article they had read about the American *Penthouse* founder, Bob Guccione, selling photographs of naked girls through the post. They quickly set about copying him. The ploy was such a huge success that before long the pair were making £800 a week and working from their own premises in East London. The office at 34 Upton Lane, Forest Gate eventually incorporated a sex shop below (called *The Private Shop*) to cater for personal callers. Seeing the corruption in the Obscene Publications Squad in Soho, Sullivan was able to avoid the huge costs of police protection by concentrating on mail order and deliberately basing his business away from the West End. Moving into the sale and distribution of sex aids as well as magazines, *Subdean* soon had well over 50,000 customers on their mailing list and, unbelievably, 90% of the British mail-order sex market. This remarkable achievement was due, in part, to the long hours Sullivan put in. He often worked seven days a week from 7am to 6pm. He had only one ambition: to become a millionaire.

Unfortunately, Sullivan's tactics for avoiding the attentions of the police did not always pay off and very soon his business was infamous. Such was their visibility that Lord Longford interviewed the business partners for his highly flawed 1972 report on pornography. Sullivan honestly admitted to Longford that if it were not for the fear of prosecution, he could be publishing much more explicit material. That was what '50% of their customers wanted',[1] but Longford was not impressed, using the interview as an opportunity to lecture them on the 'significant risks and dangers' of their chosen profession. Prosecution came sooner rather than later, when Sullivan and Hardingham were fined under the 1953 Post Office Act for sending obscene photographs through the mail. Thinking they had got off relatively lightly, they were then tried at the Old Bailey for the more serious offence of publishing obscene material for gain. Once again luck was with them when they were fined just £50 and released, but the stress of the trial had proved too much for Bernard Hardingham. He resigned from *Subdean*, got married and left his business partner to go it alone. From there on in David Sullivan never looked back.

Launched in 1973, *Private* was Sullivan's first attempt at creating a mass-circulation porn magazine. Realising that pornography was often the preserve of those who could afford it, in other words the upper classes, Sullivan decided that with *Private* he would tap the hitherto untouched and ignored working class market. He believed that American magazines like *Penthouse* and *Playboy* could be successfully challenged because their pages featured models that were way too perfect, far too beautiful, the sort of women his audience could never relate to. *Private* was aimed at readers who wanted to fantasise about women they honestly thought they had a chance of meeting and forming a relationship with. At just 30 pence *Private* was an affordable luxury for the man on the street. Its unpretentious title was defiantly low-brow and the readers could be assured of no hidden sexual agendas within its pages. In fact Sullivan pinched the name from the identically titled Swedish publication from Berth Milton. The Scandinavian version was strictly hardcore, but its 'under the counter' availability in the sex dens of Soho was legendary. Sullivan knew his *Private* would be unable to emulate its Swedish namesake, but the title alone would guarantee brisk sales. The advertising for his magazine sometimes cheekily claimed it was a 'British Edition' of its famous cousin![2]

The first editor of *Private* was Doreen Millington, a gap-toothed, curly haired 27 year old brunette. Originally from Wales, she later settled in Stoke-on-Trent as a sales representative before a chance

meeting with Sullivan led to her moving into publishing. Her new boss installed her behind the counter of his Upton Lane sex shop and splashed her name throughout *Private* at every available opportunity: in the editorial and letters page; in promotions for sex-aids and contact magazines, and best of all advertising her own range of underwear and a blow up doll. In fact adverts for the *'Sexy Doreen Doll'* would continue to appear in Sullivan's publications long after she actually severed ties with the business. By using Doreen's name and image over and over again Sullivan had hit upon a way of giving his magazine a recognisable friendly face, although the basic idea of female editors and columnists for mens' magazines was nothing new. Fiona Richmond had caused thousands of hearts to beat a little faster with her notorious sex 'road tests' in *Men Only*; glamour girl Patricia Rose was the figurehead of *Knave*, and *Rustler* was home to the jokily named *Miss Candy Hunt*.

Doreen Millington

Compared to its competitors *Private* was a strikingly *un*stylish mix of readers' letters, regional sex reports, articles on how to pick up girls, Victorian erotica and naked pin-ups squeezed rather uncomfortably between a proliferation of adverts for massage parlours, erection creams, 8mm films and the infamous *'Women & Animals'* magazines. Sullivan's 'bestial' readers were legendarily duped into sending off £4 for *'really beautiful magazines. Dogs, horses and sexy girls in fantastic group shots'*, only to later receive a brown paper envelope containing a copy of *Horse And Hound!*

Private was the young upstart in the world of girlie magazines, much derided by its competitors, but it was soon achieving just what Sullivan had intended: big sales amongst working class men in the 18-34 age bracket. *Private* looked, and even felt, different from the other top shelf titles and its consid-erable success surprised even the most hardened of cynics. Within eighteen short months Sullivan's policies had been validated; his company was now the second biggest publishing house in the pornographic magazine field.

Mary Maxted had found a new temporary home in the world of British sex magazines, often in the very same titles that talked-down *Private*'s triumph so much. Once again using a variety of pseudonyms, she posed provocatively amongst the glossy pages of *Knave*, *Game*, *Rustler*, *Club International*, *New Direction*, *Caprice Plus*, *Sex-Mates*, *Silk* and *Sexpert* to name but a few. From time to time she would be chosen as cover girl, an obvious bonus as it provided bigger exposure and a fatter cheque at the end of the day. Mary's magazine work had by now overtaken her hardcore film career. She was no longer in the employ of John Lindsay, not because she had wanted to retire, far from it, but because the market had changed. Her appearances in nearly twenty 8mm films had far surpassed any of her contempo-raries' but Lindsay now realised she had become a victim of over-exposure. His audience were looking for a new face and Mary was now 'old hat'. She had been seen doing every imaginable sex act in every possible variation and there was nowhere else for her to go. Reluctantly Lindsay had told her that their association would have to end. In actual fact Mary probably got out when the going was good, as over the next few years Lindsay was increasingly hounded by the OPS, leading to two celebrated high court trials where examples of his film work were shown to boggle-eyed juries.[3]

Utilising her bulging address book of porn contacts Mary decided to concentrate on more mainstream publications. Famous magazine titles like *Knave* were often better payers and from time to time she could enjoy photo shoots in a variety of foreign locations. She boasted that on travelling to the sunny climes of Greece, Italy, Spain, Portugal and the south of France she was able to top up her tan for six days and then model for the seventh. It was the sort of exotic existence she had long dreamed of.

David Sullivan had heard much about Mary through the grapevine. By now she was an established player on the porno mag circuit and he was keen to make her acquaintance.

'Everybody knew her simply as *'Mary from Dorking'* before I'd even met her. I'd heard about her for months before we actually met,' he explains. 'Everyone kept telling me what a nice person she was.' Sullivan, who had a liking for blue eyed blondes, and was rapidly gaining a bit of a reputation as a

ladykiller, did not have to wait long before the model he had previously only gazed at on the pages of *Knave* became a reality.

Sullivan loved to celebrate his birthdays in style and his 26th anniversary was certainly no exception. The hottest porn publisher in town had arranged a get-together in a restaurant in London's West End and invited a large group of friends and associates from the sex industry to join him. One of his closest confidantes at the time was a young model called Maureen O'Malley, who virtually overnight had become the star of Sullivan's second magazine *Whitehouse*. If *Private* had raised a few eyebrows then its stablemate was primed for the real full frontal attack.

Whitehouse was cheekily named after one of Sullivan's most fervent opponents and Lord Longford's best friend, God-fearing Shropshire housewife Mrs Mary Whitehouse. If ever there was somebody less well equipped to speak out on what British adults had the right to read, see or hear, it was her. A woman of almost unbelievable stupidity, her deplorable narrow-minded views brought her to the very forefront of the debate on censorship in the early Seventies and into the offices of every magazine publisher in the land, including Sullivan's. In the mid 1960s Whitehouse became unhealthily preoccupied with what she was watching each night on her television: the frank reporting of the Profumo scandal on the evening news; groundbreaking satirical shows like *That Was The Week That Was*; realistic social dramas such as *Cathy Come Home* and *Up The Junction*; and worst of all Johnny Speight's classic sitcom *'Till Death Us Do Part*. For the first time in her life Whitehouse's most cherished institutions were being challenged: the government, the monarchy, the family and, most shocking of all, the Church.

The Director General of the BBC at the time, Hugh Carleton-Greene became Whitehouse's enemy number one in her fight against 'declining standards'. She even had the impertinence to claim that, because of Alf Garnett, the word 'bloody' was now in 'common usage'. Thus began her *Clean Up TV Campaign*. Sadly, as Whitehouse became more *au fait* with the mechanics of television she realised that the real 'filth' existed not just in her sitting room, but in bookshops, cinemas and theatres across the land. Now with a broader remit for her campaign, the *National Viewers And Listeners Association (NVALA)* evolved in 1964. Recruiting a band of furious middle-aged Christian women in floral dresses, Mary Whitehouse soon became one of the most successful self-publicists of the Twentieth Century and a definite force to be reckoned with. Just in case she missed any offending TV programmes or films,

David Sullivan: porn mogul

Whitehouse had a faithful band of salivating churchmen and insomniac housewives to regale her with stories of the disgusting disregard for morals they had just sat through.

The NVALA's main concern was the 'manipulation of the young towards immorality, through their exposure to harmful influences including pornography'. In March 1970 Whitehouse was invited by Granada Television's *World In Action* programme to travel to Denmark to examine the consequences of sexual liberalisation and the legalisation of pornographic material. Considering that she had been campaigning for the past six years against the ills of society, Whitehouse's level of naivety was quite astounding. It is doubtful whether she actually knew what 'pornographic'

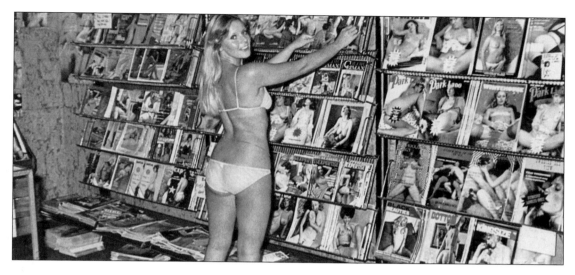

opposite top: Never were there such devoted 'sisters' - Mary and Doreen Millington

opposite below: An outdoor portrait from 1976

above: Dressed for the office - Mary often wore a bikini in the Whitehouse shop

below: Mary makes a friend at Horse Guards Parade

right: The most famous cover girl in Britain

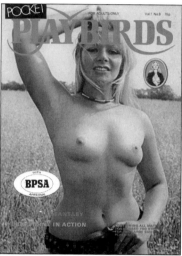

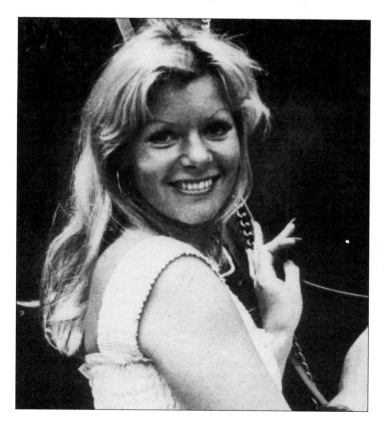

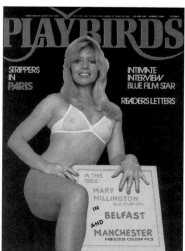

meant. One day as she was buying her English paper at a Danish bookstall, she happened to flick through an adults-only magazine on the counter. She was horrified at what she saw.

'I felt quite dreadful. I never imagined such photographs existed, or that people could possibly pose for them.'[4]

The experience left Whitehouse shaken and very upset, but it just hardened her resolve to prevent 'that sort of thing' from happening in the UK. Little did she know it already was. Many despaired of Whitehouse's attitudes and her unreasonable visibility in newspapers and on the television. Such is the secretive nature of the pornographic industry that few opponents actually wanted to stand up and be counted, but in his small tongue-in-cheek way, David Sullivan was determined to have some fun at her expense.

The 'other' Mary Whitehouse

Whitehouse the magazine was launched at the end of 1974, immediately causing a sensation in the porn magazine world with its *'bra bustin', spread-legged'* philosophy. Severely pushing the boundaries of what was, at the time, deemed acceptable, the magazine succeeded in gaining the maximum amount of good *bad* publicity. Though most definitely not a hardcore publication, *Whitehouse's* preponderance of gynaecological style photos, explicit male/female shots and lesbian fantasies were a mile away from its nearest competitor. Sullivan even took the unusual step of addressing his readership directly writing an open letter detailing his exact standpoint on pornography.

'I publish with basically one principle in mind, that is the simple logic that in a democracy, an individual has the right to decide what he reads. I believe that no government has the right to dictate to the individual over what is clearly a very personal matter. With this in mind I have just launched a new magazine. I have completely thrown out the old taboos. I come out in my true colours. I do not believe in censorship.'[5]

He had taken a massive risk, but one that was to pay off. The other top-shelf publications were left standing and within a matter of six months *Whitehouse* was selling in excess of 200,000 copies every six weeks. Not content merely with honouring Mrs Mary Whitehouse with his new magazine's title Sullivan went one step further by employing the services of a model to take on her name too. Maureen O'Malley was a young, sulky-faced, but extremely pretty pornographic model who had appeared in a dozen or so hardcore films in the UK but had then decided to concentrate on 'straight' modelling work. Sullivan persuaded her to change her name to *Miss Mary Whitehouse* for a series of explicit photoshoots and stories in his new magazine. Very soon his readers were revelling in articles like *'The Sexy Adventures Of Mary Whitehouse'* with the obligatory accompanying nude photos. It gave Sullivan the excuse to fill the magazine with the most pornographic stories and pictures possible, whilst at the same time repeatedly mentioning the name of Britain's most prominent 'anti-fornication' campaigner over and over again. It became the biggest 'in-joke' in porn publishing history.

Mary Maxted was well-acquainted with Maureen O'Malley, having worked with her on several jobs for John Lindsay, including his hardcore film *Sex Is Our Business* made two years previously. O'Malley told Mary about her new boss, and how keen Sullivan was to meet her, but more importantly she stressed that an introduction might be good for her career. Sullivan was certainly an influential man, Mary thought, and he was suddenly the biggest name in publishing. The fateful meeting took place on the 9th of February 1975 at Sullivan's party. Mary was far from instantly smitten with his looks. Sullivan was a short tubby young man with a round spotty face and lank hair, but his enthusiasm and good humour won Mary over very quickly indeed. Sullivan, however, needed no encouragement; he thought O'Malley's friend was simply beautiful. Entranced by her natural magnetism and sweetness the other party goers could not fail to notice the obvious attraction between the two, in fact it was almost embarrassing. Mary openly flirted as only she could and by the end of the evening Sullivan was hooked. The memories of their first meeting are still clear in Sullivan's mind.

'Of course I met her through another model,' he says. 'There were a load of us out on my birthday that night, but Mary and I just hit it off immediately. It was as simple as that. She was a pocket beauty.'

In the early days of Sullivan's magazine empire, it was only Doreen Millington and Maureen O'Malley's alter-ego that really shone out from the pages. Other models such as the elegant, pouting Dandy, teenager Liz Ford, curly haired performance artist Cosi 'Fanni' Tutti and 'Titty' Carter with her 51" chest all became members of the magazine's repertory company, but none seemed to have sufficient personality to go much further.[6] Many of the models liked to change their names as often as their knickers and appeared, as Mary had done, under a wide variety of fake names from one issue to another. Sullivan was always on the look out for new faces and upon his introduction to Mary the thought was foremost in his mind.

Mary made such a great impression that Sullivan immediately arranged to meet her the following day in order to talk business. It came as no surprise to anyone that it was not just the finer points of publishing that were discussed. The pair immediately began an extremely passionate affair. Sex was not the only thing they had in common, far from it. Mary adored Sullivan's company; his frankness and sense of fun refreshed and excited her. Increasingly spending time together the couple would go away for weekends or make love at Sullivan's lavish bachelor pad in the romantically named Sunset Avenue in Woodford Green. His way of life fascinated Mary and she was enthralled by his hi-tech bed, which had buttons to operate the headboard, dim the lights or even switch on music. Sullivan called their friendship 'a sort of business and pleasure relationship'[7] whilst Mary liked to tell her friends that he was the 'whizzkid' to her 'scatterbrained lady'.

Mary was at last experiencing a taste of the highlife. Sullivan allowed her to be herself, to be wild. Mary loved to go out and soon the pair were regularly seen at West End cabaret bars, at parties, or grooving at the *L'Hirondelle* night-club in Swallow Street. She especially liked dancing and when the Bee Gees or Abba were playing it was difficult for anybody to drag her off the dancefloor. For a time the couple were inseparable, but it was not only excitement Mary craved. She enjoyed the simpler things with her new beau as well, like a meal in a *Wimpy* bar or visits to the cinema.

'We used to go to the pictures on Bank Holidays,' recalls Sullivan, 'and Mary would pull me from one cinema to the next. We'd end up watching three or four films in one day. She loved movie stars.'

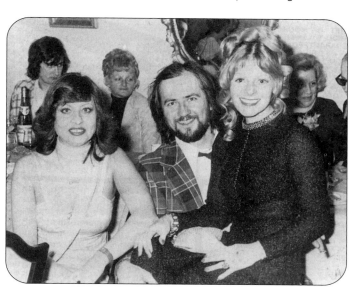
Mary, Doreen and the appropriately named 'Bert Shaft'

It was much harder for Bob Maxted to cope with his wife having a full blown affair rather than just one night stands or even making hardcore sex movies. Mary had really connected with Sullivan and was full of stories of the times they had together. This affair above all others put a tremendous strain on their marriage, but even when Mary recognised her husband was feeling less than happy about the situation she still persisted. It was not pure selfishness. Mary knew that Sullivan, in a bizarre way, was the ticket to bigger and better things. He could open doors for her and hopefully catapult her to greater prosperity, and that would benefit them all. Not everyone was so convinced by Sullivan's influence. 'I met him and thought he was the most unpleasant creep I'd ever met,' Geoffrey Quilter recalls, wincing. 'His handshake was clammy, cold and wet. Just horrible!'

In between the fun times they spent together David Sullivan still had his thoughts firmly focused on making his new girlfriend a big magazine star. From the beginning he knew that she would be able to make more money with him as her manager than she ever had done previously.

'I realised Mary's potential from day one,' he said in an interview in 1983. 'Her looks were sharp and pretty and her body, whilst not the hourglass type, was perfectly formed, eminently photographable.'[8] One thing that Sullivan had been acutely aware of from their very first meeting was

Mary's dissatisfaction with her nose, her most hated feature. Within a month he had booked her into a London clinic to have it reduced and reshaped. Mary was thrilled to bits, but not everybody was in full agreement.

'I actually think she looked worse afterwards,' says Susan Quilter. 'She lost a certain amount of character after that operation. She just became another glamour girl with another little upturned nose. It really changed the look of her face, I think.'

Before Sullivan could do anything more with Mary there was the small matter of her name; she would need a new one. Mary had carelessly used the surname 'Maxted' on one or two shoots but was later unhappy about the rash decision she had made. Any connection between her modelling career and her home life back in Mid Holmwood was still fraught with danger. Sullivan understood this completely, generally preferring his models to work under snappy recognisable names they were comfortable with.

Mary suggested using one of her old aliases like *Samantha Jones*, but Sullivan wanted to distance his new discovery from any of her previous incarnations. He already liked Mary's initials and being a big fan of alliteration he was reluctant to change them. Slipping into *double entendre* territory he says, 'I was always a great believer in double M's and double D's!' In fact a solution to the problem was only a side-step away. A new surname for Mary was already waiting in the wings.

Over the previous 18 months *'Millington'* had become an established name in the domain of girlie magazines, thanks to Sullivan's editor-in-chief Doreen. She was popular with the readers and inundated with fan letters, often requesting that she take her clothes off too and join the ranks of naked models in *Private* and *Whitehouse*, but Doreen was not that kind of girl and her blouse stayed defiantly buttoned.[9] Knowing that

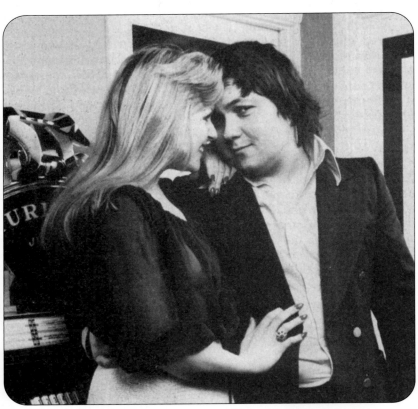

Mary and David - the look of love

familiarity with a product equals bigger sales Sullivan hit on the idea of giving Mary not only a new surname, but a totally new identity. She would become Doreen's younger, naughtier, sexier sister who was able to do all the saucy things Doreen could not. Sullivan put the idea to Mary, without first consulting Doreen (who was later extremely annoyed), and she immediately agreed, thinking it would be rather an amusing idea. The move was to be Sullivan's masterstroke.

Less than four months after meeting her new employer the new look *Mary Millington* made her debut, simultaneously, in the June 1975 editions of Sullivan's two magazines. So confident was he in his new model that *Private* Issue 21 was specially relaunched for the occasion. Doreen announced the arrival of her 'little sister' in her editorial slot, before letting her sibling introduce herself properly in a less-than-glamorous article about picking up men in public houses. Mary's words, composed by one of the publication's writers, would set the tone for the sort of image Mary would be expected to promote for the next four long years:

'Hello, I suppose you expect to see a carbon copy of my more famous sister, Doreen. Well I hate to disappoint you but I should tell you that although I love her dearly and although we are of the same flesh and blood we really are different people. We both have the same sexy measurements though, and this means we get our fair share of men. I love my oats and there is nothing I won't do to get them. But I should warn you that I am also bisexual and this means not even the girls are safe from my roving eye, grasping hands and clutching thighs!'

Mary as the predatory, insatiable, bi-sexual English Rose was an image that her readers would very soon come to love. If the no-holds-barred story and black & white photos that followed this introduction were not enough, *Whitehouse* Issue 7 also offered a full colour eight page photoset entitled *'Introducing Miss Mary Millington'*. The pictures, by photographer Barry Giles, showed a stunningly beautiful Mary posing in 'fur coat, no knickers' in Sullivan's Woodford Green flat.[10] From time to time the young playboy liked to make cameo appearances in his magazines and in both *Private 21* and *Whitehouse 7* he is pictured staring lovingly into Mary's eyes.

The readership took to Mary immediately, falling for the Millingtons-as-sisters scam from day one. It mattered little that Mary and Doreen looked nothing like each other (one was tall and dark and the other tiny and blonde). Even Sullivan himself had severely under-estimated the instant appeal of his new model. The amount of mail Mary generated overnight was phenomenal; she was soon receiving over 2,000 letters a week and her presence in the magazines would be felt more and more as the months went on. In the next issue of *Private* (number 22) she appeared in the middle 16 pages, an unprecedented amount of room for a single model, and she was eventually rewarded with her first two front covers, *Whitehouse* Issue 10 and *Private* Issue 28. Sullivan pushed Mary hard in his magazines but still claims that however much he promoted a new face it was 'the punters who decided if the girl would be successful, not me'. The readers just could not get enough of Mary and Sullivan puts this down to her great 'girl next door' appeal. In fact nothing could have been further from the truth. Mary was no longer a 'girl' at all. She'd come to glamour modelling relatively late in life, being 25 when Lindsay discovered her. By the time she became acquainted with Sullivan she was pushing thirty. Most models have a shelf life of barely two years, but Mary was able to prolong hers by pure hard work and the acceptance that if she was to stay in the business then she must be prepared to pose for stronger shots. Mary was conscious of her age and in the past had lied about it. She loved Sullivan enough to tell him the truth, but this did nothing to deter him from promoting her as 'just twenty-one' (not to mention the magazines' claims that she was 5'10" not 4'11" tall!).

Soon after Mary's debut, Sullivan launched his third bid to dominate the men's magazine market with the refined sounding *Park Lane*, but the new title owed more to the *Private* tradition than *Whitehouse*. Mary featured heavily in its pages but the magazine was not to be Sullivan's biggest success; for that he would have to wait a little bit longer.

Mary had been a late addition to Sullivan's publications and now he wanted a different angle, a magazine with Mary Millington stamped all over it right from the outset. Launched in November 1975, *Playbirds* was an up-market porn mag printed on glossier paper than Sullivan's other magazines, with a thicker cover and crisper photography (some, surprisingly, by Sullivan himself). From the outset it was an altogether classier read, with better written fiction and informative articles. Though prominently edited by Doreen Millington, the main attraction was most definitely her younger namesake. The first issue, featuring a topless Mary posing with Sullivan's Panther DeVille car on the cover, and in two layouts inside, sold-out completely. It was the first time any of Sullivan's publications had done so. In a hitherto unheard-of move to capitalise on the success of the first issue Mary was utilised as covergirl on the next three issues as well (of the first ten covers she appeared on no less than six). It seemed that her popularity knew no bounds. The most recognisable features in *Playbirds* were Mary's sexual travelogues, *'Mary Goes UK'*, for which she visited virtually every town and city in Britain in her attempt to have an orgasm everywhere. These fake 'sex tours' were nothing new. Model Fiona Richmond had been 'road testing' British males in Paul Raymond's *Men Only* for years, and even Maureen O'Malley had done something similar for Sullivan with her *'Mary Whitehouse Shows Herself In...'* series, but Mary was to make the coast-to-coast sex journey an art form. Whereas the other models' treks were purely make-believe, with faked photographic evidence, Mary's were not.

The texts of the *Mary Goes UK* stories were fabricated, but to give them some sort of realism Mary demanded that she was actually photographed in the various locations for the accompanying illustrations.

Mary Millington in

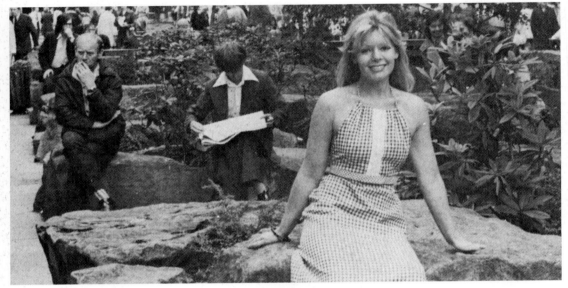

Bradford

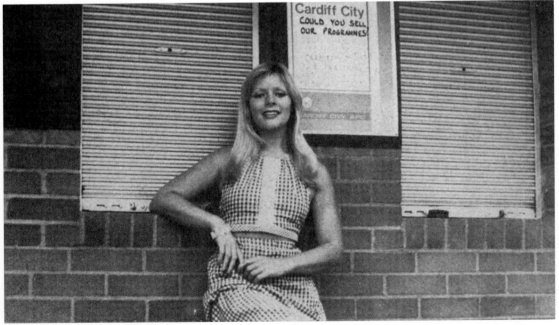

Cardiff

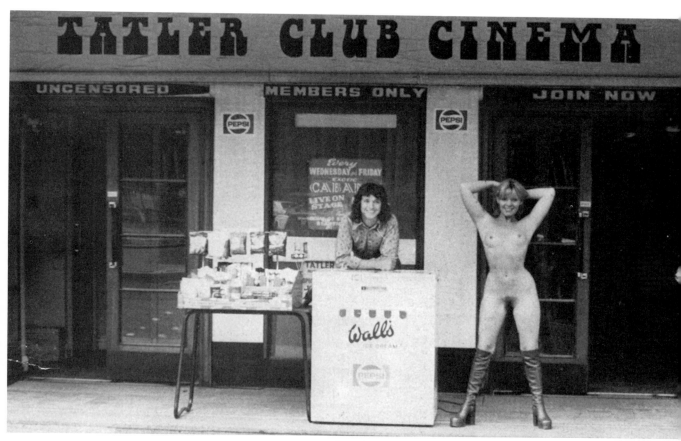

Leeds

Blackpool

Oldham

Oldham Metropolitan Borough

Libraries,
Art Galleries
and
Museums

Central
Library

Opening Hours

Monday Tuesday
Thursday Friday
10·00 - 7·00

Wednesday
10·00 - 1·00

Saturday
10·00 - 1·00

Art Gallery

Opening Hours

Monday Tuesday
Thursday

Friday
10·00 7·00

Saturday
10·00 - 1·00

66

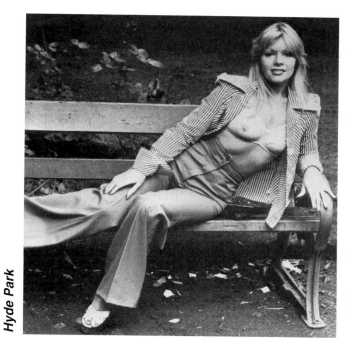

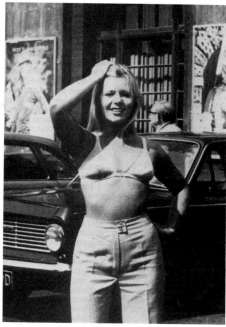

Hyde Park

Newport

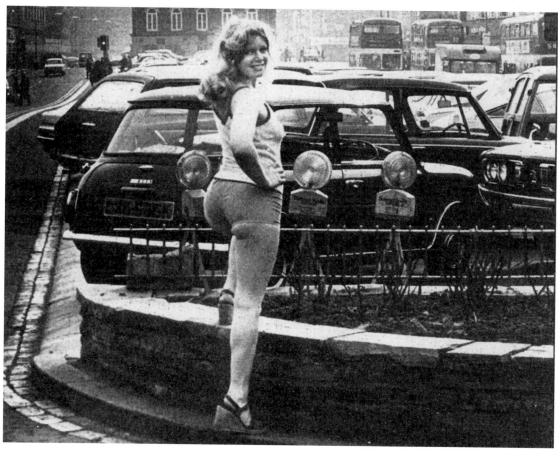

Stockton-on-Tees

As Sullivan explained, 'I once suggested to Mary that we run a nation-wide tour in which she purported to visit every major town and city. That wasn't good enough for Mary. She insisted on actually going and dragging some poor wretch of a photographer all over the UK!'[11]

It all started well with a trip to Leeds for *Playbirds* Issue One, when Mary was snapped totally nude with a sheepish-looking ice cream seller outside the Tatler Cinema in the City Square. Members of the public walked passed open-mouthed until she was reprimanded by the cinema manager for not asking for permission first![12] In Bradford she posed topless in a city centre phone box much to the consternation of those who needed to make a call and in Oldham she sported a see-through bra outside the art gallery and museum. In over forty issues of *Playbirds*, Mary visited just about everywhere, from Wolverhampton to Edinburgh and from Hull to Wimbledon (not to mention appearing in a similar series for *Private*), all in the name of sex. Sadly, Mary began to tire of the exercise and quickly found the countrywide trips more of a bore than anything else. With deadlines to meet the pictures had to be taken in the bare minimum of time and it was not long before they began cutting corners. Often it was all done in such a rush that there just wasn't time to venture into the town centre to find a local landmark for Mary to pose beside. Instead she

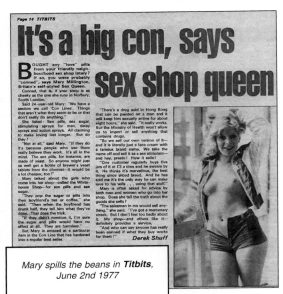

It's a big con, says sex shop queen

*Mary spills the beans in **Titbits**, June 2nd 1977*

would just stand next to a sign on the ring-road marked with the town's name!. Legend has it that on one occasion Mary and her harassed photographer made a whistle-stop tour of ten Northern towns in only one day!

With Mary firmly ensconced as *Playbird Number One* in the psyche of the sex magazine buying public, some of Sullivan's competitors attempted to lure her away or at least copy Sullivan's formula,[13] but Mary had absolutely no intention of moving anywhere. She found the working environment of *Private*, *Whitehouse*, *Park Lane* and *Playbirds* a comfortable one and was well aware that she owed her new found success, in the main, to Sullivan himself. He was the master of promotion and persuasion, and with Mary as his figurehead he just could not fail. Her continuing popularity was blatantly obvious with the sales of his publications going through the roof and the fan letters pouring in incessantly. Mary was overwhelmed, but Sullivan understood her appeal only too well. She had one characteristic that none of the other girls had. Mary was accessible.

Mary's fans perceived her as being easily the sort of attractive young woman they could meet down the pub, go on a date with to the Odeon, introduce to their parents and then have wild sex with in the back of a car. Her innocent hazel eyes belied her huge sexual appetite. She was, in her fans' eyes, the perfect fantasy girlfriend who would never say 'no'. The only other household name glamour model of the 1970s was the tall, brunette ex-*Playboy* Bunny Fiona Richmond, who had worked primarily for the wealthy publisher and property tycoon Paul Raymond. Her success pre-dated Mary's by a couple of years, but as soon as the young upstart came along Fiona's popularity waned. Mary could look naturally alluring and was the absolute embodiment of pure sexual liberation. Richmond on the other hand appeared less friendly, more remote. She was certainly a strikingly glamorous, figure possessing class and sophistication, but these factors, surprisingly, almost made her less 'fanciable'.

Nowhere was Mary more accessible to her public than when she was serving behind a counter in a shop. And a sex shop at that. Sullivan already had Doreen Millington working in the sex shop below his office in Upton Lane and now, taking advantage of his exclusive contract with Mary, he asked her to take charge of his second business in south London. *The Whitehouse Shop* situated at 1539 London Road, Norbury, was within easy driving distance of Mid Holmwood. When she was not modelling, Sullivan liked Mary to be available on the premises to meet the fans. The arrangement suited Mary down to the ground. She told Sullivan that she had always loved 'playing shops' when she was a child, and also that working in a sex shop was no different from serving in the boutique in Dorking. By installing his

magazine star in a place where anyone was able to come and meet her, Sullivan had created the ideal sales gimmick. Punters came in off the street desperate to speak to her or get an autograph and Mary would happily oblige, to an extent. Sullivan gave her a stake in the business as an incentive and Mary was keen to make it a success. She was able to sell anything. Mary only signed her autograph on copies of *Whitehouse* magazine that later had to be paid for; she sold kisses at a pound a time and was even happy to sell fake products that blatantly did not work.

'We have a section called *con-lines*,' Mary once explained. 'Things that aren't what they seem to be or that don't really do anything, like sex pills, sex sugar, stimulating sprays for men, delay sprays and action sprays. All claiming to make sex last longer. It's all in the customer's mind. The sex pills for instance are made of yeast. So anyone might just as well get a bottle of brewer's yeast from the chemist ~ it would be a lot cheaper too!'[14]

Sullivan's ruthlessness in his quest to make money had obviously rubbed off on Mary, but she was only too happy to admit it.

'The salesman in me would sell anything,' she said. 'I've got a mercenary streak, but I don't feel too badly about it. My shop, and others like it, definitely provides a service. There's a drug sold in Hong Kong that can be painted on a man and it will keep him sexually active for about eight hours. We sell our own version of it and it is literally just a face cream with a famous brand name. We take the name off it and sell it as a sex stimulant and hey presto! How it sells!'[15]

The ploy of putting Doreen and Mary behind the counter did wonders for the sex shop takings. Advertisements in Sullivan's publications asked readers *'Why don't you drop in on Doreen & Mary Millington when you are in town? They are always happy to see our customers, why not pop in and see them sometime?'* The allure of seeing their idols in the flesh was just too much for some of the fans, especially when Mary would insist on serving at *The Whitehouse Shop* in just a bikini when the weather was hot.

By 1976 no magazine in Sullivan's catalogue was complete unless it had Mary smiling on the cover or frolicking within the pages. Her influence and huge following was such that Maureen O'Malley and Doreen Millington were gradually squeezed out, with editorial duties falling to Mary. Issue fifteen of *Whitehouse* magazine proclaimed it was *'under new management'* as Mary became sole 'editor' and 'proprietor'. For a time, even the mast-head changed to the personalised, *Mary Millington's Whitehouse*. But Mary was no journalist; she never wrote a single word of any of the 'special messages' or supposedly 'true sex adventures'. (This dreamy deception was nothing new to Mary; years before she had posed as a red-headed 'letters editor' named Sally Stevens in little-known sex magazine *Vibrations*.) Unbeknown to her army of *Whitehouse* supporters, everything she was purported to say or do was actually written by Harry Knights, a balding 53 year old Nottingham man who Sullivan paid £2.50 for every one thousand words he delivered. But even if the fans had found out the truth, it is doubtful whether it would have made the slightest difference. They were just enjoying the fantasy.

The words *Mary Millington* had become the most famous brand name in the British sex business. Her face endorsed advertisements for Sullivan's saunas and massage parlours; her voice appeared on mail-order masturbatory sex tapes with titles like *'Lick Me, Lay Me, Love Me'*; she famously promoted dildos and vibrators with 'action' photographs; appeared in a series of *Mary Millington Porno Specials* and even had her own fan club. For a £5 enrolment fee readers got a membership card, signed photo, a dubious 'free sexpack worth £30' and discount vouchers redeemable at Mary's sex shop. If her fans were willing enough to part with their money then they could be well and truly fleeced.

Top and bottom: Mary hard at work in the Whitehouse shop

With the magazine business totally sewn-up, Sullivan was keen for Mary's name and reputation to make an impact outside of the sex industry. Sullivan knew that he could secure her name on every tabloid front page in the country by encouraging her to participate in a series of outrageous publicity stunts. Mary embraced the idea wholeheartedly, as it gave her an opportunity to show off again. Whilst on a brief modelling assignment to Nassau in the Bahamas she managed to 'smuggle' herself and her photographer on board the submarine HMS Otter, prior to its goodwill voyage to Florida. On being discovered the pair were not reprimanded by the Commanding Officer (Mary claimed he was 'constantly drunk') but rather encouraged to meet the crew. The resulting photographs show a stark naked Mary posing with half-dressed tattooed sailors in the engineering room and in the Captain's quarters. Mary later claimed she indulged in a gang-bang with the crew before returning to the bar of the Britannia Hotel where she was staying. Back home the Sunday papers were keen to run the story and saucy pictures, but, rather hypocritically,

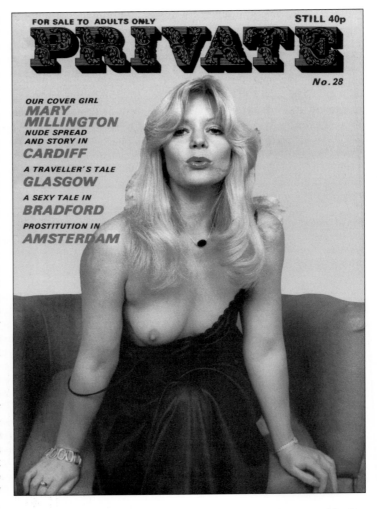

demanded an 'urgent government inquiry'. On her return to England Mary posed topless outside the Houses Of Parliament but her *pièce-de-résistance* was yet to come. In the days when a member of the public was free to walk down Downing Street, Mary was able to casually saunter over to the imposing black door of Number Ten and chat to the policeman on duty. What he didn't know was that a *Whitehouse* photographer was lying in wait opposite ready to take an incriminating snap. Whilst chatting to the policeman on duty, Mary suddenly pulled open her blouse and put her arm around him, all the time grinning at her partner in crime on the opposite side of the street. In the ensuing scuffle the policeman tried to confiscate the roll of film, but was fobbed off with a dummy one. 'The real one she had hidden up her pussy,' David Sullivan laughs, stopping short of revealing if *Boots* had the happy task of developing the film. For this stunt Mary was conditionally discharged and bound over to keep the peace.

Despite knowing full well that Mary was the main attraction in his publications, for some strange reason Sullivan failed to make her centre stage of his next magazine. *Private National News* was launched in May 1976, and was the precursor to Sullivan's *Daily Sport* newspaper a decade later. A girlie magazine with an emphasis on sex-related news stories, its aim was to 'investigate and expose the people behind the vice rackets' and promised to take on 'the might of the national press on their own terms'. The idea was novel, but it failed to ignite the public's imagination, even when Mary occasionally appeared on the cover. *National News* (as it became after issue two) never really achieved its dubious goals, instead trading on unpleasantly titillating court reports of sexual assaults and incest juxtaposed with female pin-ups. The so-called 'investigations' into contact magazines, saunas, lesbians in the armed

forces and male strippers were suspicious to say the least. Even the journalists' names were rubbish; after all, who could trust the reporting of *Trevor Brash* or *Barry Cock*? The publication was one of Sullivan's few failures of the 1970s and it folded after two years.

Sullivan returned to much safer terrain in August 1976 when he engineered his last big launch of the era, *Ladybirds* magazine. Helmed by Mary in the editorial role and with a front cover picture showing her bent over a chair, *Ladybirds* had the Millington stamp all over it. But the magazine ran into trouble as soon as it hit the news-stands. Legal proceedings by Ladybird's Childrens' Books (home of *Peter And Jane*) forced Sullivan to change the title to *Lovebirds*, in a costly and embarrassing about-turn. Whatever it was called, the magazine was a huge hit with readers, especially popular being the full-colour monthly focus on the editor, *'The Illustrated Mary Millington'*, which gave an added insight into Mary's career. In common with the rest of Sullivan's publications, *Lovebirds* went quite a bit further than many of its competitors, but it would be wrong to think that his magazines were verging on anything like hardcore. Sullivan could be brash and cocky about the strength of his titles, but his much-quoted 'publish and be damned' philosophy was actually a very hollow boast.

When *Playbirds* went on sale the previous year he had assured his readership that it was going to be *'the strongest magazine in Britain, BAR NONE! This is not a boast or an advertising gimmick, but a statement of fact!'* Sullivan often came across as a wheeling and dealing 'Arthur Daley' character. The twenty first issue of *Playbirds* commented *'Dave always delivers the goods! With him you know that there are no false promises!'* Sad to say, the promises were regularly falsified. Because hardcore pornography was technically illegal in the UK, the British porn industry routinely traded in dishonesty. Sullivan was able to ensnare his readers by essentially dangling a carrot in front of them. All his magazines promised that the next issue available would contain *'the strongest photographs ever published in a British magazine'* or that from the following month, they would be *'going hardcore'*. An innocent reader could easily be duped into believing this, especially if he did not understand what the boundaries of British pornography were. Another sneaky ploy was to feature an alluring model on the cover of, say *Park Lane*, only for the reader to get home and discover that she didn't actually appear in the magazine at all! A disclaimer inside would explain something along the lines of *'If you want to see more of covergirl Susie, then look out for her in the new issue of Whitehouse on sale now'* leaving the reader not only disgruntled at having been taken for a ride but also forced into buying yet another magazine.

Mary loved the way Sullivan operated. His considerable skill at making money by whatever means necessary appealed to her sometimes self-indulgent sensibilities. She had begun to adore working in *The Whitehouse Shop* more than anything, telling friends that it was more fun than modelling and that cashing up at the end of the day was 'better than sex'. Even her lover expressed

GIANT VIBRATORS

The Giant ten inch vibrator usually costs £4/£5, but we offer it to members of the society (price covers VAT) for just £2.25. This item can be used on any part of the body and is suitable for use on both male and female. Also available is the standard model 7'' long, approx 1½'' diameter, usually costs £3/£4, Special members price £1.75. **Special Offer – both vibros £3.75.** U.K. sales of this product exceeds 3 millions!

some amazement at the way she had taken to her new job. Others worried that perhaps she was getting obsessed with the accumulation of money. It was no longer just a question of providing for her dying mother or even for her husband; she now wanted money for money's sake. Mary had become virtually a one woman sex industry and her desire to be successful in the business meant she was also prepared to break the law. If a customer wanted hardcore 8mm films she would supply them, no questions asked, much to Sullivan's dismay. He was keen to avoid trouble from the police and Mary's careless attitude did nothing but aggravate them. This is especially surprising when you consider that *The Whitehouse Shop* was just a few doors down from Norbury police station.

The stresses of dating somebody within the porno industry soon began to tell on Mary. Rows between her and Sullivan erupted frequently, but throughout their difficulties they still enjoyed an active and experimental sex life; that is until she became pregnant.

In much the same way that Mary doted on animals, she also adored children, but she did not necessarily want a family of her own. Not long after she and Bob were married, and their friends had begun having babies, the couple had seriously considered starting a family. But the fact that they were living in a small house with a terminally ill woman had put Mary off the idea. Her mother, as always, came first. Mary knew in her heart of hearts that it would make Joan's everyday life more uncomfortable if there were an energetic toddler running around the place. Also, in the back of her mind, Mary knew that if she wanted to pursue a career in modelling then the petite slim figure she was so proud of would have to be preserved at all costs. Mary's decision not to have children of her own certainly never deterred her from spending time with friends' children. Her ex-schoolfriend Jill, who she remained close to, had two young children whom Mary made a terrible fuss of. She liked nothing better than letting the village children paddle in her fishpond during the summer months whilst she watched and laughed. When Dick and Margaret Wolfe's daughter, Donna, was born, Mary turned up on their doorstep with baby clothes and presents for the little girl. The couple were extremely touched by the gesture. 'But Mary was just so kind and considerate like that. It was in her nature,' remembers Margaret.

Another friend from Dorking also recalls Mary's affinity with local youngsters. 'She was like the Pied Piper,' she says, 'continually surrounded by children and their pets. Mary would spend more time with them than their own parents did. She could really relate to people younger than herself and never patronised them. They adored her.'

Mary had always been an excellent communicator and especially loved to engage in conversation with her young companions, none more so than Geoffrey and Susan Quilters' children, Richard and Denise. Visiting 'Auntie Mary' and 'Uncle Bob' was more than just a mere family outing for the children, it was an occasion to get very excited about.

'If we were told we were off to see Auntie Mary we would be washed and dressed at least half an hour before we were meant to,' Richard explains. 'It was very special going to visit Mary, she almost had an 'aura' about her. Sometimes it felt like I was going to see the Queen.'

To the young Denise, Mary was almost a second mother figure. 'Mary was a very important part of the family. Her and Bob were always our favourites,' she says. 'When we arrived at their house Mary and I would immediately disappear upstairs to play with her jewellery and make-up. She saw it as my rite of passage. Me getting older and becoming a woman.'

Mary adopted this same level of consideration for children wherever she went, but as the years went by the idea of becoming a mother herself became steadily more remote. As to the question of Sullivan's baby there was no hesitation. She had the pregnancy terminated.

'Mary told me several times that she didn't want a family. She made the decision to have the abortion and that was that. I felt that she wasn't terribly maternal, animals were always her substitute,' comments Geoffrey. His daughter partly disagrees. 'She was definitely a 'mothering' sort of person,' Denise recalls. 'It was more a question of her not having kids because of her career and the effect it would have on her body. But I do think she was very maternal because she could be so deeply, deeply insecure. Having a baby might have compensated for her upbringing and childhood. After all, all she ever wanted was to be cared for and to look after others.'

queen of the blues

By January 1976 Joan Quilter had been living with cancer for well over ten years, but her valiant struggle with the disease was nearly at an end. Radiation treatment was having no significant effect, except to make her vomit, and she'd begun to refuse food because she would only bring it up again. Joan still never complained to her daughter about her condition, but Mary only had to look into her eyes to see how much she was suffering.

In her last few days Joan spoke lovingly of John Klein and how she was looking forward to seeing him again in the afterlife. He had died in August 1973, and Mary always alleged that she and her mother had only discovered the news after reading his obituary in *The Times*. This is quite possible, as Klein had not been in contact with his mistress and youngest daughter for many, many months proceeding his death. His heart was so weak and his arteries were in such a terrible state that Klein's physician had advised him not to leave his bed and certainly not his house in Wimbledon. Klein's wife Florence had diligently cared for him, and any opportunity to see his 'other family' were completely ruled out; With his wife's continual presence, even using the telephone was impossible. Joan forgave him for everything and she would refrain from criticising Klein in front of her daughter, but Mary resented the man even more after his death and spent long evenings dwelling on the inadequate relationship she had had with him. Why couldn't he have been there for them? Had he ever really loved her? Joan was distressed by Mary torturing herself in this manner, telling her not to worry, but after Klein's death Mary noticed a distinct acceleration in her mother's illness.

Mary hated leaving her mother at home, but her work schedule was hectic. Neighbour Dick Wolfe often visited Joan and he could plainly see how much her condition was deteriorating. 'She was in agonising pain,' he recalls. 'She regularly downed two or three bottles of port a day just to deaden the pain, because it was so bad.' Joan was eventually admitted to hospital again because she was losing so much weight, and whilst there she underwent a series of four-hourly morphine shots. On top of everything else she suffered a stroke, and in the early hours of 17th May 1976 she died in her sleep at Dorking General Hospital. 'Mary was inconsolable after her mother's death,' remembers Dick Wolfe. 'She just couldn't cope with anything. It was so sad to see.'

'Joan's death was the turning point in Mary's life,' says Geoffrey Quilter. 'On the surface she tried so hard to cope and perhaps to some, there didn't necessarily seem to be much change, but underneath she was very, very upset. I'd say she was desperate almost. She was lucky to have Bob to look after her.' Joan was buried five days later in a tranquil sunny plot on the west side of St Mary Magdalene's Church in South Holmwood. Such was their bond that Mary had her will state that when the time came, 'my body shall be buried alongside my mother'.

Mary had long been fascinated by the dark aura surrounding death. Strangely, it was a subject she relished talking about with her close circle of friends, often much to their dismay. If somebody died in Mid Holmwood Mary would be the first 'round to their house with flowers and words of condolence for the grieving family. She would be full of inappropriate questions, intrigued to know how the person died. It was almost an obsession for her. One ex-villager says that there were only three things Mary was fanatical about; 'animals, money and death, not necessarily in that order'. Her teenage courtship with the village lad whose father was a mortician had fuelled her passion for death and decay. It was weird certainly, but then again Mary had experienced the deaths of many around her and not just humans either. Up until the death of her mother it was the loss of her dog, Hector, that'd had the most profound effect on her. 'When Hector died she got into such a terrible state,' recalls Dick Wolfe. 'She just couldn't stop crying. It was almost like she had lost a child. That dog was everything to her, but then, when her mother died she was totally beside herself with grief.'

Mary had always been able to keep her odd mania for death at a reasonable arm's length but her mother's passing really seemed to tip the balance in her mind. Suddenly her unusual obsession turned a new corner. In the months after Joan's funeral she briefly, but in all seriousness, considered leaving the sex industry and becoming an undertaker. 'In a way she honestly thought that by being an undertaker she would be closer to her mother,' one friend from Mid Holmwood remembers. 'She really was so desperately unhappy. Her mind was confused you see.'

Mary started her morticians' training at an undertakers near Dorking in June 1976, just four weeks after her mother's death. Her decision to do so was met with disbelief by many of those around her. Sensing the disapproval of her friends and colleagues, she made a conscious effort to keep her new career under wraps. She did, however, confess all to David Sullivan. He was left in the strange position of being the employer of a beautiful glamour model who posed nude for a London photographer in the morning then returned to Surrey in the afternoon to resume training in the fine art of embalming. 'She was totally fascinated by death,' Sullivan says, 'but for a thirty year old woman to decide to become an undertaker is a very bizarre thought process, I think.'

No amount of nagging would dissuade Mary from her new vocation, but one of her old character traits - her lack of concentration - unexpectedly curtailed her future plans. She found the intensive training too much to cope with; being an undertaker involved far more than simply dressing and laying out a body. There were certain complicated methods and procedures to follow, few of which Mary could actually remember. 'She never completed her training,' a friend reveals. 'But then she got it into her head to manage a funeral parlour. She visited several premises around Surrey and Sussex with the view to buying one.' This plan was not to bear fruit either, for the simple reason that Mary had not prepared herself for the huge costs involved in running such a business. By the end of 1976 the idea was forgotten completely, but Mary's mental instability, triggered by the death of her mother, became ever more noticeable.

The grieving process was especially long and upsetting for Mary, and living with Bob in her mother's house at Woodlands View only amplified the knotted emotions. Mary mentioned to Sullivan that she doubted that she had loved, or would ever love, any person with the same amount of intensity as her mother. 'It took her a long time to snap out of it,' says Margaret Wolfe. 'I think that was the beginning of the end. She was thinking about moving from Mid Holmwood, but I don't think she would have done so if her mother hadn't died. We noticed a change in her. She almost became a little wilder after Joan died. Her attitude became more one of 'I don't care'. When she moved away from here her life altered dramatically.'

The Maxteds eventually left the village in the autumn of 1976, selling Joan's cottage to a local coal merchant. Despite wanting to get away from Dorking and its surrounds, the couple did not travel far to their new home, a spacious semi-detached house in Ruffetts Way, a leafy cul-de-sac in Burgh Heath, itself an elongated suburb of Banstead. Mary's new home was asymmetrical, long-fronted and half clad with wooden slats, a rather unattractive prospect compared with the quaint cottage they had left behind. However, Mary had her heart set on a modern home and the new property offered her all the mod-cons so lacking in Mid Holmwood. Even the continual rumble of traffic on the fast, dirty A217 failed to dim her enthusiasm. The large enclosed garden at the rear was also a huge selling point for Mary, as the ardent animal lover was now the owner of a replacement for Hector, a dopey-faced pedigree alsatian bitch called Lea. The need for extra space became all the more apparent when Lea gave birth to a litter of puppies. Not just three or four either, but twelve energetic bundles of fur. Bob was pleased to see Mary's mind taken off her myriad of problems, but thirteen dogs proved to be more than just an affordable handful. (Their combined food bill was soon topping £40 a week, which wasn't actually very surprising considering their rich diet.) Mary cut no corners when it came to her animals, feeding the puppies on prime minced beef, eight pints of fresh milk a day, a dozen eggs every other day, as well as special vitamins.

An energetic publicity shot from **The Playbirds** *(1978)*

Initially she named the new arrivals after the months of the year and predictably announced her intention to keep them all, but after consultation with the local vet, finally decided to sell them through an advert in the newspaper. Prospective buyers were more shocked to be greeted at the door by a real-life porn star than to see a house over-run with alsatians. All the puppies sold except one solitary male. Mary kept him and gave him the nick-name of Reject. Ideally, Mary would have liked to have kept them all. She told David Sullivan, 'My ambition was always to have something along the lines of a mini safari park!'

With a successful move under her belt, as well as new 'babies' to dote on, Mary felt able to relax a little more and finally threw herself back into her tough work schedule as a glamour model. Sullivan had long been telling her that work was the only way to cope with her grief, and Mary had plenty to keep her busy. She had the launch of her new magazine *Lovebirds* to contend with, not to mention running *The Whitehouse Shop*. This wasn't all, as Sullivan had even bigger plans on the horizon for his number one model; he was going to make her a film star.

The permissive mood of the Sixties had happily spilled over into the following decade, bringing the sexual revolution to the cinema. Audiences were flocking to see a new wave of films not afraid to show nudity and sex. These were not low-budget underground movies, but mainstream pictures playing to packed houses throughout Europe and America. Films from the Continent, like the virtually plotless *Last Tango In Paris* (1972) with its notorious 'butter up the backside' scene and the well-made *Emmanuelle* (1974) and *Bilitis* (1976) really set the scene for more to come. *Emmanuelle* in particular was a hit of gargantuan proportions, appearing in the end-of-year UK cinema top ten for two years running. The story of a French woman's voyage of sexual discovery, it spawned a never-ending series of official and unofficial sequels, despite *Films & Filming* magazine saying that it looked like nothing more than a '92 minute Babycham commercial'.[1]

From America came the improbable 73" bust of Chesty Morgan in *Deadly Weapons* (1973); the silly sci-fi spoof *Flesh Gordon* (1974); a cheesy version of *The Happy Hooker* (1975) and more top-heavy lovelies in Russ Meyer's *Supervixens* (1975). The demand for flesh was such that even a compilation like *The Best Of The New York Erotic Film Festival* (1976) could enjoy a lengthy run at the Pigalle cinema in Piccadilly. All these movies were strictly softcore, showing simulated sexual shenanigans, but in some territories hardcore sex movies were already enjoying crossover success in mainstream provincial cinemas. *Deep Throat* (1972) had already scandalised middle America in much the same way as Jean-Francois Davey's *Exhibition* (1975) would later do in France. Lasse Braun, Europe's most famous 8mm director, produced the big screen *Penetration* (1974), the first hardcore title to be exhibited at the Cannes Film Festival. These films weren't all being made on the cheap either; Braun followed up *Penetration* with *Sensations* (1975), which became one of the most lavish and expensive sex films of the Seventies.[2]

Imported movies like *Emmanuelle* enjoyed extensive releases in the UK, but sadly our home-grown erotic features paled in comparison. Old trooper Ken Russell could always be relied upon to 'up' the nudity quota in films such as *Women In Love* (1969) and *The Devils* (1971) - the latter, incidentally, being Mrs Mary Whitehouse's least favourite film of that year - but whereas the film climate abroad was steadily hotting up, over here it was positively tepid. One thing the British have always been renowned for is laughing at sexual matters. Bearing this in mind, and the fact that British film-makers had a seemingly universal inability to create films with any genuine sort of erotic quotient, there was only one format left to make naked flesh palatable: sex comedies.

British sex films were notorious for their low budgets, poor production values and lame acting, but throughout the 1970s they played to enthusiastic packed houses in Odeons, ABCs and Regals throughout the country. The movies invariably originated from independent production companies based in London's film capital; Wardour Street, Soho. Companies like *Salon*, *Eagle*, *KFR* and *Pyramid* cheerfully churned out film after film, all of which did brisk business at the box office. Audiences seemed unconcerned by the movies' quality, after all there was not much opportunity to see such randy goings-on elsewhere. There really was no alternative. The sight of bobbling boobs on television is something

we now take for granted, but in the Seventies seeing them up close on a 100 feet wide cinema screen was a revelation! However, with a few notable exceptions British sex comedies were very poor indeed. They can be roughly divided into two categories; below average and crap. Then again, for film historians their failings merely enhance the enjoyment of watching. This eye-poppingly camp collection of sex films are often nothing less than mesmerising!

British sex films invariably focused on the adventures of a disparate bunch of woeful male leads, usually desperate to lose their cherries with an unending supply of randy housewives dressed in negligées. Because of plot constraints, the heroes tended to have restrictive occupations that would provide direct contact with members of the opposite sex. Therefore, the lucky British public were served up with, among others, *Secrets Of A Door To Door Salesman* (1973), *Confessions Of A Window Cleaner* (1974), *The Amorous Milkman* (1974), *The Ups And Downs Of A Handyman* (1975) and *Adventures Of A Plumber's Mate* (1978). Wherever possible, the films' producers usually kept to this tried (or 'tired') and tested formula of cheeky layabouts in a surburban sexual utopia.

One of the common strands that linked these films was their reliance on mainstream 'family' entertainers to boost the comedy element. Usually their scenes were commonly kept at arm's length from anything vaguely naughty, but the comedy actors' participation in X-rated films gave the proceedings almost an air of respectability. Joe Bloggs might be rather reluctant to venture into a John Lindsay members only cinema club in the heart of Soho, but popping into the local Odeon to view bare breasts and a bit of simulated slap and tickle with a top-billed Irene Handl was a far less intimidating prospect.

Septuagenarian comedienne Handl was one of the most prolific of the 'household name' character actors who padded out the sex comedies. Other 'usual suspects' included Diana Dors, Liz Fraser, Harry H. Corbett, John Le Mesurier, Graham Stark, Queenie Watts and Rita Webb. Television situation comedies were continually plundered for acting talent and as the decade progressed the roll-call of familiar faces grew ever longer. By 1978 you'd be hard-pressed to find a comedy legend whose curriculum vitae was not stamped with an X certificate. Many unlikely personalities were unable to resist the lure of a fat pay cheque. Witness wrestler Big Daddy in *The Sex Thief* (1973), Police 5's Shaw Taylor in *Adventures Of A Private Eye* (1977), Opportunity Knock's Hughie Green in *What's Up Superdoc?* (1978) and even 'big hearted' Arthur Askey as a wheelchair-bound bum-pincher in *Rosie Dixon ~ Night Nurse* (1978). One suspects that had old-timers like Will Hay and Max Miller not passed away already, then they too would have made the transfer.

In retrospect these actors may have regretted their involvement and it is all too easy to sneer, but it must be remembered that film production in the UK was at its lowest ebb during the Seventies.[3] Actors could not afford to turn down the work, even when it meant compromising their professional integrity. The chance to be associated with a big box office hit just could not be sneezed at. *Percy* (1971) a comedy about the world's first penis transplant, was the fifth most popular film of that year. *Confessions Of A Window Cleaner* (1974) really cleaned up, spawning three sequels; and *Adventures Of A Taxi Driver* (1975) had punters queuing up round the block on its West End opening. Sex, laughter and reassuring sitcom scenarios had become an irresistible mix for cinema-goers throughout the land.

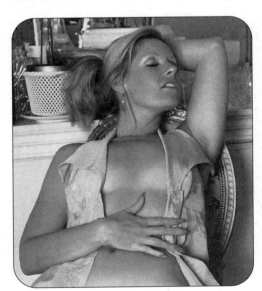

The film distributors were kidding themselves if they seriously thought that Doris Hare or Roy Kinnear were really the main attraction. They obviously were not. It was the girls who sold the films, and more especially naked girls. The British sex film boom provided excellent opportunities for glamour models to disrobe on the big screen. Many graduated from billboard advertising, girlie magazines, 8mm films, *The Benny Hill Show* or even page three of *The Sun*. Fiona Richmond, the naked star from the pages of *Men Only*, had already made the transfer, having appeared in *Barry McKenzie Hold His Own* (1974) and the excellent sex-thriller *Exposé*

(1975), but her success was almost unique. The vast majority of women who appeared in the films were not employed for their names or their acting ability. They were hired simply to take their clothes off. Few attained any sort of celebrity value, most were nothing more than anonymous pretty faces and that was that. To the British sex film connoisseur, girls like Nicola Austine, Suzy Mandel or Jenny Westbrook were probably recognisable, but they could on no account be relied upon to carry a film single-handedly. A careful balance between the naked models and the family entertainers had to be maintained at all times, neither group being allowed to overshadow the other.

For a time it seemed like everybody wanted a slice of the sex film cake. Individuals like *Crossroads* supremo Hazel Adair and veteran director Val Guest, not to mention big name companies such as Columbia and EMI, began to dabble in the murky waters of soft-porn. Film critic Quentin Falk observed that, 'Sex films are big box office and in some cases have even acquired a protective covering of respectability.'[4] By 1974, of the 506 films submitted to the British censor 249 had been rated 'X' for sexual content. Two years later, at the height of sex movie mania, actor-screenwriter David McGillivray summed up the huge money-spinning possibilities of the genre in *Screen International*, 'Exploitation films are a sound investment, in a business in which only the very rich or the very gullible generally dabble,' he wrote. 'But bring in a sex comedy for under £50,000, quite feasible, and you'll be very unlucky not to get your money back within eighteen months.'[5]

A certain sharp businessman called David Sullivan was undeniably 'very rich' and the commercial benefits of film production were never far from his mind.

Sullivan tells the story: 'I was 27 years old and was bored of my life, this is the truth. I was working all the hours of the day and night. I'd made my first million, that had been my ambition,' he says. 'But I was looking to do something with my life that I'd really enjoy, not necessarily to make a fortune on, but enjoy.' Knowing little about the mechanics of film making, Sullivan was preoccupied with one solitary thought, 'I just knew that if I put Mary in a film, with the power of my magazines backing it up, it just couldn't fail,' he remembers. 'I just had a feeling that we'd make money because we can promote it. It didn't really matter to me what the product was.' At the time, Sullivan didn't really know how to get a film off the ground, but he didn't have to look very far afield for inspiration.

George Harrison Marks was, for forty years, Britain's most famous photographer of nudes. His style was unmistakable. Marks' association with beautiful blonde model Pamela Green and their subsequent publication *Kamera,* established in 1957, put his name firmly on the glamour map. The couple soon progressed onto moving pictures, first on 8mm and then feature films with the nudist 'adventure' *Naked As Nature Intended* (1961). After their break up the same year Marks continued to publish photographs and make movies, including *The Naked World Of Harrison Marks* (1965), but two trials at the Old Bailey for sending obscene material through the post really knocked the wind out of his sails. The collapse of his empire came in 1971, with Marks virtually drinking himself to death over the next five years. His rehabilitation didn't really begin until 1976 when he managed to sell a number of colour transparencies of his nudes to David Sullivan's *Park Lane* and *Lovebirds* magazines. Sullivan liked his crisp sexy photographs but was unaware that Marks had been secretly harbouring a desire to direct another film (he had not made one since 1969).[6]

As fate would have it, the two men hammered out an unlikely deal that would eventually provide them with the biggest success of their respective careers.

The Morecambe and Wise of British sex films: Harrison Marks and Alfie Bass, as seen in **Come Play With Me**

'It was pure chance. I'd written a script called *Come Play With Me* three or four years prior to whenever it was,' Harrison Marks recalled. 'I'd hawked it about a bit, but it just gathered dust for a while. Dave came round one night to do a bit of business and we got talking. I asked him if he had any hobbies apart from work because it seemed to me that he worked 24 hours a day. Dave turned round to me and told me he wanted to get into films. He said 'George, you've made a few films in your time, why aren't you making them now?'. I replied, 'Well no-one's bloody asking me!' I wasn't in the position to be running up and down Wardour Street looking for finance but I mentioned that I'd got a very funny script. I told

him roughly the story about randy nurses at a health farm, and he liked it. He asked what sort of money it would cost and that was it. He was gone.'

Two days later Marks was surprised to receive a call from Sullivan. 'He said to me, 'Have you got those figures ready?,' recalled the director. 'I didn't know what the hell he was talking about, but it was *Come Play With Me* he meant. I said 'Oh my God,' it was a shock. Dave was serious. I telephoned my production manager immediately and told him to get his arse over 'cos we'd got a backer for a new film!' For the next three days Marks sat down and worked out a budget before ringing Sullivan and telling him that he needed £25,000 to start the ball rolling. That afternoon a motorcycle messenger

turned up at Marks' door with a cheque. Five weeks later, in the winter of 1976, they were filming at Bushey studios and on location in Oxfordshire and Sussex.

Sullivan's new company was christened *Roldvale Film Productions* and his offices were situated above the *Exciting* porn cinema at 18 Greek Street, in the heart of UK film-land. Movie-making, however, was still an unknown quantity to him. Twenty years on Sullivan admits only having visited the film set, the site of his huge investment, just twice. He may well have been innocent about the 'ins and outs' of film-making, but he was determined on one particular point; Mary was to be the star of *Come Play With Me*. 'Right from the beginning of casting Dave said to me, 'Mary Millington must be in it,' said Marks. 'To me she was just another of the girls, but there was absolutely no question of her being *the* star of the movie.'

The veteran director and photographer had taken photographs of the *Whitehouse* star before, but clearly remembered her mood at their first script-meeting. 'She was absolutely terrified,' he said. 'She took me to one side and said, 'George don't give me any lines to say will you?'. I said to her that she'd have to say something for Christ's sake. Once she got into it of course she was OK. She enjoyed it in the end.'

Mary had needed very little encouragement to appear in *Come Play With Me*; she certainly had no qualms about stripping off, but actually having to remember lines and act was another story altogether. 'She said to me 'I will do it just as long as I don't have to say anything,' says Sullivan. 'So I thought that's fine as long as we put *Starring* on the poster. It would be a novelty to have a star that never says a word! Halfway through filming she really got the acting bug and we had to rewrite some scenes to give her some lines. In the original script she had no lines at all!'

Mary's fear of having too much acting responsibility in Harrison Marks' film was predictable, after all she was terribly underconfident in all spheres of her career, but her reluctance was not excessive considering her previous form. Contrary to popular opinion at the time, *Come Play With Me* was not her first mainstream film. Mary had already held an Equity card for the best part of three years and had made good use of it whenever she could. Her early appearances in the sex comedies, *Eskimo Nell* (1974) and *I'm Not Feeling Myself Tonight* (1975) were brief and uncredited, but she had progressed to small speaking parts in subsequent films. In *Erotic Inferno* (1975) she had done quite well as a possessive lesbian stable-hand. She had relished the part, as it had really given her something to get her teeth into,

but on the film's release she was dismayed to see her voice had been dubbed. It had been a severe knock-back for the budding actress and one that she would not altogether recover from. On the opening titles of *Erotic Inferno* she is credited as 'Mary Maxted' but after her disappointment she never used the name again.

Although it had been Sullivan's bright idea to call her 'Mary Millington' it is surprising to note that he was not the first producer to exploit Mary's new identity on celluloid. Mary's 'golden handcuffs' contract with her lover and boss covered all aspects of publishing work but until *Come Play With Me* films were a different matter completely. The summer of 1976 had already seen Mary starring in two sex comedies, both with the 'Millington' surname. In *Intimate Games* she had made a disappointingly short appearance as a church choir singer, but the period set *Keep It Up Downstairs* had provided her with a bigger role as Polly, the saucy scullery maid. The latter film had been an almighty flop at the cinema, being taken out of the West End after only one week. Sullivan was determined that his first foray into film production would not share a similar fate. Before shooting was even complete he began to ruthlessly push *Come Play With Me* in every one of his publications. He promoted his movie in much the same way as he marketed his magazines: with the promise of 'hardcore' action. His marketing of *Come Play With Me* was, perhaps, one of the greatest confidence tricks of the century. Knowing that there were a dozen or more sex comedies also doing the rounds at the time, Sullivan decided to massacre the competition by making wildly inaccurate claims about his movie. He did this primarily by using one carefully orchestrated ploy: *Come Play With Me* would be the very first British film to show actual sexual intercourse and other unsimulated sex scenes; and not only that - the movie would be exhibited freely at everybody's

'Bovington Manor', the home of Britain's best loved sex film

local Odeon and ABC. Outside of a private member's only club, his film would be *the* strongest ever shown in Britain.

Sullivan's magazines were awash with extravagant claims about *Come Play With Me*. Mary was described as the 'new' Linda Lovelace and the movie dubbed 'the British *Deep Throat*'. Photo-spreads showed explicit scenes not even in the movie and throughout the spring of 1977 virtually every model who graced the pages of *Playbirds* or *Whitehouse* was billed as 'appearing' in the new film. If that had been the truth, the cast list would have easily run into the hundreds. One over-enthusiastic scribe in *Lovebirds* previewed the film by claiming that *Come Play With Me* included 'sex scenes on the sand at a beach close to the health farm, ten girls being screwed by ten guys at the same time culminating with a group of Hell's Angels coming to an orgy party!' Phew! In actual fact the film could not have been more different. The nostalgic plot concerns two aged bank note counterfeiters, played by Alfie Bass and George Harrison Marks himself, who, on the run from their East End gangland boss, escape over the border to Scotland. Once there they hole themselves up at a run-down health farm owned by Irene Handl, and attempt to conceal their identities. The glamour is amply provided by a troupe of eleven unemployed strippers managed by Handl's nephew. Despairing of making any money from the business, the nephew employs the strippers as 'nurses' whose bedtime manner provides the guests with 'extra services'.

Come Play With Me

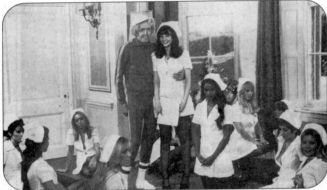

top left: *Sue Longhurst and Tommy Godfrey*

middle left: *Cardew Robinson, Suzy Mandel and chorus*

bottom left: *Suzy Mandel and the cream of British manhood (Godfrey and Ronald Fraser)*

above: *Mireille Allonville: from 'Come Play With Me' to '3-2-1'*

below: *Penny Chisholm*

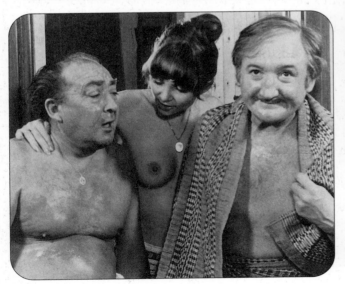

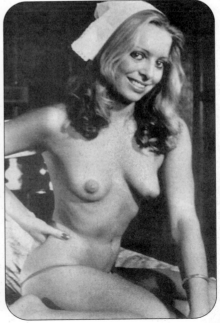

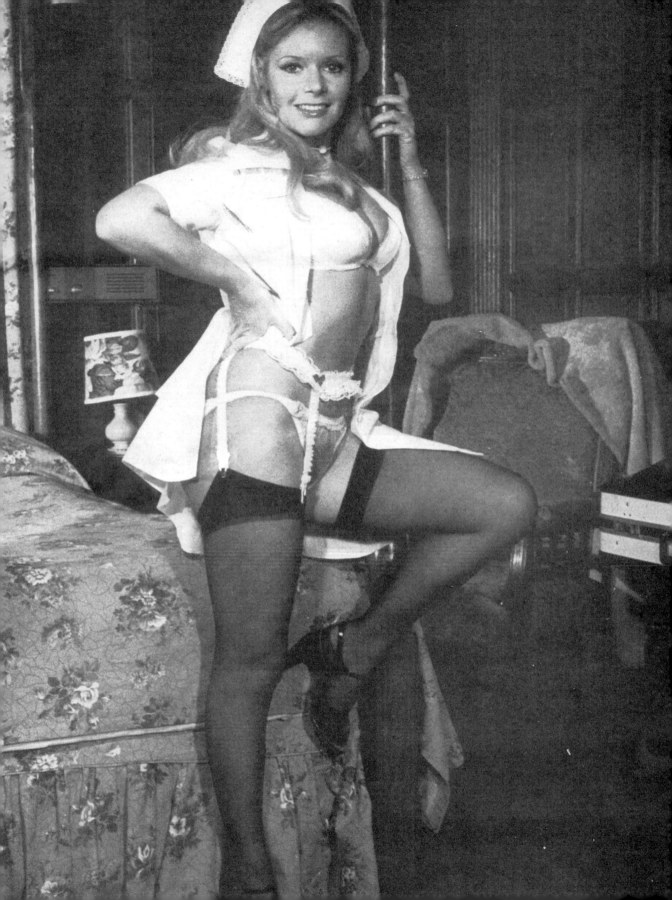

Come Play With Me comes across like a poorly written *Carry On* film with added full frontal male and female nudity. Although shooting was completed at the end of November 1976, the film was making news in the British tabloids even before it had been properly edited. For nearly twenty years rumour and myth has surrounded the film's production because of the supposed inclusion of hardcore pornographic sequences into the finished print. Lasting 94 minutes, Harrison Marks' first movie in seven years is actually a pretty innocuous affair, but only in its cut-down version. Sullivan liked to illustrate *Come Play With Me* in his publications with 'stills of the overseas, uncut version of the film'. Most were shots from other continental films blatantly masquerading as something they shouldn't be, but others actually seemed to have an aura of truth about them.

Splashed over the front page of *The News Of The World* on Sunday November 13th 1976 was the headline *'We didn't know it was a blue movie say stars'*. The story had been skilfully leaked by Sullivan and concerned the fury of several of the film's stars at the inclusion of stronger material in what they had thought was a 'harmless' comedy. Alfie Bass' agent claimed that, 'None of the leading artists were aware of these scenes. They certainly weren't in the script. It's a bit worrying because it wasn't supposed to be *that* sort of film'. The old mainstay of sex comedies, Irene Handl told reporters, 'Needless to say I have nothing to do with the nudie bits', before readers were

HOW WOULD YOU LIKE TO JOIN

MARY MILLINGTON AT A SEX ORGY?

Would you like to experience all that happens when MARY MILLINGTON and twenty or so of her nympho nurse friends hold an orgy at their luxurious health farm – Bovington Manor? The nurses really know how to satisfy the needs of EVERY man – they are trained experts in SEX! Since 'Bovington Manor' doesn't exist in the real world you can't actually go there – BUT you can SEE for yourself all that happens and LARGER THAN LIFE on the BIG SCREEN in Mary's Sex comedy 'COME PLAY WITH ME' – still showing at the Classic Moulin, Gt. Windmill St., Soho – 7 days a week; OR see page 3 or 8 of this magazine for a list of provincial release dates and towns.

helpfully told that Irene's co-stars, Tommy Godfrey and Bob Todd had not 'taken part in any of the blue scenes which show couples having intercourse and oral sex', and that mercifully the 'lesbian activities' did not involve the legendary Rita Webb.

It was just the sort of publicity Sullivan loved. The scandal escalated to such an extent that even Equity, the actor's union got itself involved. *The Daily Telegraph* reported on Tuesday November 15th that Sullivan had claimed the porno sequences would, 'make Linda Lovelace look like Noddy. They show the lot. Nothing is simulated', to which Carl Snitcher, the assistant general secretary of Equity, replied that his clients might 'have a case for damages'. The row did eventually blow over, but the 'damage' had already been done. Up and down the country cinema-goers were straining at the leash to see *Come Play With Me*.

Truth is often stranger than fiction and although some of the more hardened and suspicious observers of Sullivan's business activities believed the newspaper stories to be pure fantasy, they were actually honest. Well almost. Shortly before his death in June 1997 George Harrison Marks admitted that three hardcore sex scenes *were* filmed during one day on location at Bushey studios, with a further one shot on location in Croydon. Three featured straight couples, the fourth a lesbian duo. Oddly, neither Sullivan or Marks would take the blame for thinking up the idea.

'David Sullivan asked for them,' complained Marks. 'He told me 'We want something for the continental market you know. We'll clean up if we do.'

Harrison Marks motivates his cast

Sullivan adds, 'The hardcore was only for *Come Play With Me.* George said 'We'll make a fortune in Sweden if we shoot some porn.' He did shoot one day of strong stuff which never saw the light of day. It never sold anywhere.'

Both the producer and his director admitted that they never saw the completed hardcore sequences, guessing that film editor Peter Mayhew chopped them out at some point during post-production. Watching *Come Play With Me* today, it is easy to see where the cuts have been made. Each of the four sex scenes come to an abrupt end just as things get going. In particular, the amusingly flushed face of porn actress Penny Chisholm gives the game away in the abridged lesbian seduction scene. Even the most naive movie reviewer could see there was no faking here, but the scene eventually grinds to an almighty halt. Penny's co-star in this Sapphic sequence was, of course, Mary Millington.

Mary was increasingly being typecast in lesbian roles at this time. In three of her previous mainstream movies she had been called upon to make love to a woman, primarily because her obvious enjoyment of these scenes made them far more believable. Some actresses would refuse point blank to participate in such sequences. Others would make a meal out of it, like heterosexual Fiona Richmond in her saucy comedies *Hardcore* and *Let's Get Laid* (both 1977) Mary however was, by now, wholeheartedly bisexual and only too happy to oblige on film. She was happy to confess, 'I am bisexual. I do like ladies' bodies very much and find them beautiful and attractive.'[7] If anything, Mary's preferences had begun to encompass all forms of sexuality and her healthy, unstereotypical views on sex were to be commended. 'It may be going against convention to enjoy making love to a member of your own sex,' she wrote. 'I personally get turned on by a couple of good looking gay guys. I know some straight men are repulsed, but as long as the partners are agreeable, as long as they do no harm to anyone then I see nothing odd in it.'[8]

Mary's career was now far removed from the hardcore films of John Lindsay but that is not to say she had completely turned her back on them. Marks remembers her being 'incredibly relaxed' when playing the lesbian sex scene in *Come Play With Me* 'for real', and only a year previously, whilst modelling in Stockholm, she had accepted a part in director Paul Gerber's confusing sex melodrama *I Nöd Och Lust*, aka *Ceremony* (1975). The film's often interminable plot is only pulled out of the doldrums by a number of pornographic scenes. In one, Mary takes part in a bi-sexual threesome with her screen boyfriend and his female pick-up.

The promotion of *Come Play With Me* had reached fever pitch in the run-up to its release, with *Whitehouse* writing that the sex scenes were so realistic that the movie would be 'unsuitable for women'! Each successive advertisement for *Come Play With Me* became ever more ludicrous. In one, for the 'world's strongest movie', five gushing film reviews are quoted, unfortunately all the reviews come from Roldvale publications! Sullivan can now look back on these times and laugh. 'Like every horror film had to be the most horrific film of all time, *Come Play With Me* had to be the strongest,' he chuckles. 'I remember seeing advertisements for *The Pit And The Pendulum* when I was a kid. It said something like, £25,000 for the first person who dies of fright watching it. For my film we should have said £25,000 if you orgasm!'

With the groundwork firmly in place for the release of *Come Play With Me* Sullivan was confident that the movie could not fail. He was right, but just about everyone had underestimated how right he would be.

Come Play With Me's UK première was scheduled to coincide with the re-opening of the Classic Moulin Cinema in Great Windmill Street, Soho. The Moulin was totally rebuilt and revamped, becoming

the first 5 screen cinema complex in London, long before the advent of the multiplex. Four young girls in unfeasibly tight white t-shirts with *Moulin 5* stretched across their breasts distributed leaflets around the West End, just to remind anyone who might have forgotten that Mary Millington's new film was about to open. The Moulin had catered for the so-called 'dirty raincoat' brigade for many years, with a continuous programme of British and European sex films and there was certainly no change to the successful formula for its re-opening.

Come Play With Me finally debuted on 28th April 1977 and was an instant hit of astronomical proportions. Millington fans queued up round the block to be the first to see her in a film they had previously only been able to dream about. The Moulin had played safe, much to Sullivan's consternation, by putting Fiona Richmond's new movie *Hardcore* on the 250 seat Screen One and placing *Come Play With Me* on the smaller 134 seat second screen, assuming that Richmond would be a more 'bankable' name and the bigger draw of the two actresses. They ended up with egg on their face; despite being on a screen half the size, Mary's film took *three* times as much money as Richmond's and entered the London Top Ten Films at number nine. Press reviews for *Come Play With Me* were nothing short of diabolical, one claiming that 'it would be safer to play with a shoal of sharks than this lot', but Sullivan was unconcerned. He says: 'Some people criticised Mary's acting but my criterion of a good movie is the size of the box office takings.' The film's first week net of £6,449 (the equivalent of £50,000 today), was described in *Screen International* as 'really sensational'.

It was not just a London cinema audience that clamoured for the most talked-about British film of the 1970s. *Come Play With Me* was steadily released around the UK during the summer of 1977. In Leeds it gave the Plaza Cinema its biggest take for two years and it broke all box-office records in Manchester and Birmingham. The Classic cinemas in Edinburgh and Sheffield reported record business, with Bath and Liverpool soon telling a similar story. If anything Mary's fanbase was stronger in the North; her *Playbirds* magazine tour tended to concentrate in these areas, and at the Studio Cinema in Blackpool, the film broke Sunday, daily and house records, running for an incredible 17 weeks. Back at the Moulin, the film was running away with itself. By the end of the year it had taken a whopping £147,732 despite never budging from Screen Two.

Irene Handl (centre) the woman Harrison Marks thought was the real star of his sex film...

Come Play With Me was reissued provincially in 1978 and actually made more money the second time around. Sullivan and the film distributors, Tigon, were absolutely delighted, but no one was more shocked than Mary herself. Right from the first day of filming, Sullivan had made the decision to promote his girlfriend as the principal star of the picture. In actual fact she appears fleetingly and only makes an impact in the film's sexy set pieces. When the film opened Mary was horrified to see her name not only above the title but also third-billed after Irene Handl's and Alfie Bass'. She later told friends that had she known in advance that she was expected to 'carry' the film herself, she would have backed-out of the project immediately. *Come Play With Me*'s associate producer, Willy Roe, explains the simple reasoning behind the tactic: 'David was looking for an angle to market the film, and Mary was obviously somebody who he could cross-reference with his magazines. Therefore it was essential that we put her name up there to see it. After all you couldn't really sell a sex film using Irene Handl!'

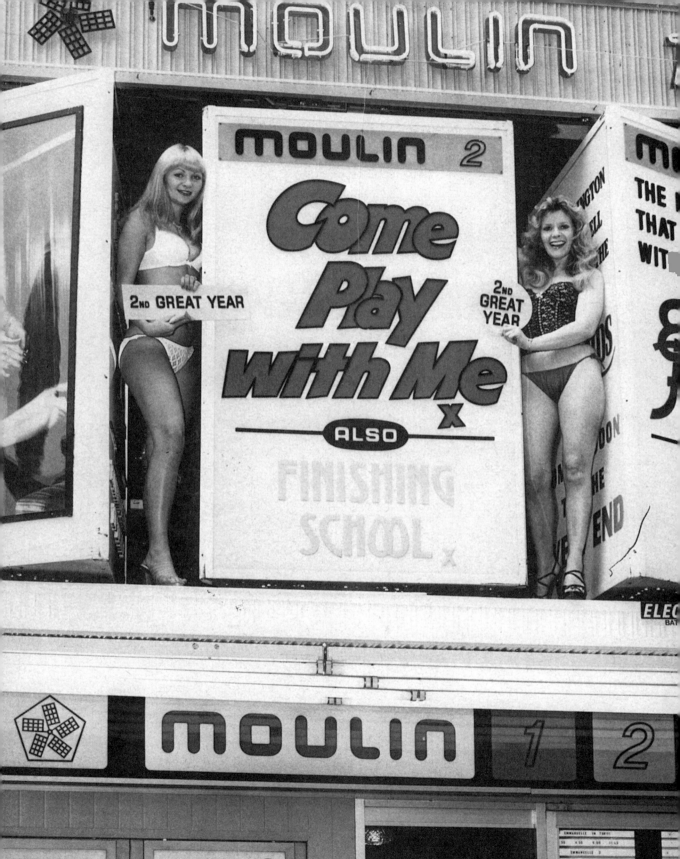

Come Play With Me had always been George Harrison Marks' 'baby' but the film titles were out of his control. He said that after seeing the first screening he was more than a little put-out to see Mary's name so prominently displayed at the beginning. 'I had no idea. I was absolutely amazed. Christ she's not doing anything in it really. Irene's the star, not Mary!' he complained.

Seeing the film making a huge profit at the British box office did nothing to change Sullivan's view of his director. The millionaire businessman had soon realised that Marks knew nothing about budgeting a film. Contrary to rumour, *Come Play With Me* did not cost £85,000, but had been re-budgeted by Willy Roe at nearer £105,000, and eventually cost about £120,000 in all. Sullivan was worried about the escalating costs, and this, coupled with the fact that about 40 pages of the script had been cut out to help keep down costs, had discouraged him from using Marks on any further projects. 'I'm not sure that George Harrison Marks actually knew he was making a sex film,' comments Roe. 'He really wanted to make something that was just more of a comedy. The script was probably written to be a different sort of film, a more expensive production. One night I had to reschedule the entire movie because we had so little film in the can.'

David Sullivan had been given a taster of how George Harrison Marks operated before shooting had even begun on *Come Play With Me*. 'George suggested to me that we have a party for the actors and the production staff before filming started. He thought it would be a good idea to get them motivated for, what was going to be, a very tight shoot,' he says. 'I agreed to pay for a little get-together, but I couldn't understand why so many of George's extended family were there. Then I realised I'd ended up paying for his wedding anniversary party!'

Whilst *Come Play With Me* was playing virtually every cinema in Britain from Ormskirk to Newquay, Marks asked his new backer if he would be interested in another script. 'Oh yes, so the money's bloody rolling in from my film, but Dave's got a reputation. If he could skin a sausage he would,' joked Marks. 'The script was called *The Reluctant Pornographer* but it was much more elaborate than *Come Play With Me*. I told him I'd write a part for Mary, but I couldn't even think of making if for under £250,000. We are still talking low, low budget by the way. Anyway, Dave nearly fell off his bleedin' chair when I told him. He said 'No way George. I wanted you to make something CHEAPER than *Come Play With Me*.' I told him that he'd got to be fucking joking. I nearly killed myself making that film and now it's making a bloody fortune and he wanted me to make something cheaper than that. I said do me a favour love, just find someone else. And that was it.'

It certainly was. Marks was never given another opportunity to direct a British feature film. The director sold his 25% share of *Come Play With Me* back to Sullivan and the two men parted company for good. With the film rights now totally in his hands, Sullivan set about preparing his next starring vehicle for Mary, but this time with his friend, Willy Roe, directing. In October 1977 he announced to the press his intention to produce a follow up to *Come Play With Me*, entitled *The Playbirds*, named after his top-selling magazine. It was a name suggested to him by Mary herself. Yet again Sullivan set his publicity machine in motion, with his stable of magazines foaming at the mouth with tall-tales about the new film. Much to Willy Roe's consternation, Sullivan decided to

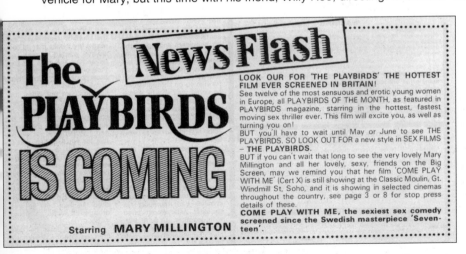

The **News Flash** **PLAYBIRDS** **IS COMING**

Starring MARY MILLINGTON

LOOK OUR FOR 'THE PLAYBIRDS' THE HOTTEST FILM EVER SCREENED IN BRITAIN!
See twelve of the most sensuous and erotic young women in Europe, all PLAYBIRDS OF THE MONTH, as featured in PLAYBIRDS magazine, starring in the hottest, fastest moving sex thriller ever. This film will excite you, as well as turning you on!
BUT you'll have to wait until May or June to see THE PLAYBIRDS. SO LOOK OUT FOR a new style in SEX FILMS – THE PLAYBIRDS.
BUT if you can't wait that long to see the very lovely Mary Millington and all her lovely, sexy, friends on the Big Screen, may we remind you that her film 'COME PLAY WITH ME' (Cert X) is still showing at the Classic Moulin, Gt. Windmill St, Soho, and it is showing in selected cinemas throughout the country, see page 3 or 8 for stop press details of these.
COME PLAY WITH ME, the sexiest sex comedy screened since the Swedish masterpiece 'Seventeen'.

have some fun with his new director by printing misleading stories testifying that *The Playbirds* was to be helmed by 'Ace porno director Wilhelm Roestein, Denmark's leading blue film maker'. Roe failed to see the funny side.

THE PLAYBIRDS

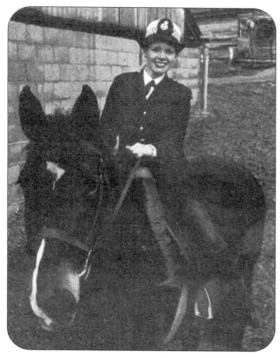

above: Mary and Foxy get better acquainted
below left: Dudley Sutton as serial killer, Hern

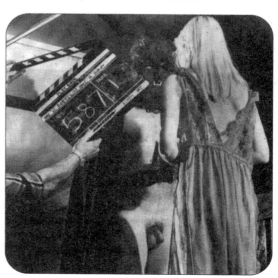

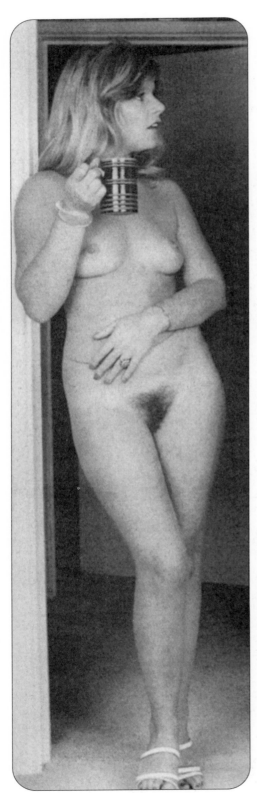

*Tea break during the filming of **The Playbirds***

Sullivan felt no shame about creating more outlandish lies about his next movie project. He had received a few letters of complaint about the non-materialisation of hardcore footage in *Come Play With Me*, but says with a glint in his eye, 'That's showbusiness. Deep down people knew it would be a con, but they had to go and see for themselves.'[9]

Sullivan instructed Roe that he wanted more girls, more sex and a smaller budget for the new film. Not only that, he also wanted 'a lot more Mary'. She had found huge satisfaction in the success of *Come Play With Me*. The picture had fired up her passion for 'serious acting' all the more. She 'wrote' in *Playbirds* magazine, 'It has made a lot of people in the film industry eat their words, they thought it would be a flop'. The experience of working with seasoned and helpful comedy troopers like Irene Handl, Ronald Fraser and Cardew Robinson had made her feel more at home in front of a camera. Mary was becoming more relaxed about her performances, and Sullivan was able to reassure her that taking centre stage in his new production would pose her no problems. Only this time she wouldn't be playing for laughs, because the script of *The Playbirds* promised modern thrills rather than old gags. Mary didn't bat an eyelid at the screenplay, even though her character gets murdered on the very last page. If anything, she was simply amused at the prospect of playing a 4'11" policewoman, required to go undercover as a nude model, investigating a series of grisly murders of covergirls. Her character is seduced by the magazine proprietor, played by Alan Lake (loosely based on Sullivan himself).

Mary's lack of formal acting training is jarringly obvious in all her movies but her determination to better her skills was unrelenting. The huge professional void between the professional cast and the 'glamour' girls often led to tension on the set. Whilst making *The Playbirds* in November 1977, director Willy Roe never allowed Mary to see the rushes of the day's filming because he feared they might put her off. Playing a policewoman on the trail of a killer was a much more substantial role for his star, but Roe never pushed Mary too hard. By quietly encouraging a performance from her rather than forcing it, Roe found Mary needed fewer takes, a factor vital in low budget film-making. 'When you are dealing with someone who doesn't really have acting experience or a wide range, you have to work out how best to approach them,' says Roe. 'You work around it, rather than getting them to do things that would take years of training for an actor. To have treated Mary like an actress would have actually demoralised her and she would have become more self-conscious.'

'Mary was not daunted by acting,' recalls Roe. 'She would always just get on with it. She probably felt a bit inferior at times, when she was working with these fairly well-known established actors. She was always very

keen to be directed though, but sometimes she just tried too hard. On *The Playbirds* she actually did OK. She wasn't looking at having drama lessons but she was having some sort of coaching.'

That coaching was amply provided by her close friend, co-star and soon to be publicist, John M. East. Born into a theatrical family in 1937 (his grandfather being silent film actor John Marlborough East), East was raised by his mother and the youngster's formative years were shaped by family friend and legendary comedian Max Miller. He idolised Miller, and it was through him that East was given his first taste of fame, on stage in Variety. He subsequently played in touring revue, pantomime, repertory and the West End stage, most famously as Polyte Le Mou in the Lyric Theatre's long running *Irma La Douce* from 1958. British television followed with East appearing in small roles alongside Tommy Cooper and Morecambe & Wise until 1962 when he entered radio at the BBC Features Department. East reckons that he has probably appeared in nearly 7,000 transmissions for syndication in the UK and overseas. It was whilst in the capacity of radio producer that he first met David Sullivan and later Mary.

East had read about Sullivan's success in London's *Evening Standard* when working on a 1977 radio series on British entrepreneurs. He went down to *The Private Shop* in Upton Lane for a friendly interview, but was instead met by a 'round, aggressive little guy'. In those days Sullivan did not suffer fools gladly and his impatience and bad temper were legendary. After the frosty initial exchange the two men actually began to get on quite well, East got his interview and a friendship was forged that has lasted until this day. Sullivan, fascinated by East's showbusiness anecdotes and vast experience of stage and television, thought it would be an excellent idea to introduce him to his big new star.

East recalls the early days of their unlikely friendship, 'David hired me to teach Mary the fundamentals of acting. She was working at *The Whitehouse Shop* in Norbury and I lived nearby. She would come over on a Friday evening after work and I would give her lessons. She was a minimal actress I'm afraid to say.' Mary's new coach would record her speaking voice onto tape and teach her to put more emphasis on certain words. He remembers that she had absolutely no trouble learning chunks of dialogue, it was just that she had problems with her delivery. 'She found it very difficult giving her lines 'reality.'

Mary's eagerness to please more often than not proved to be her downfall especially where her acting was concerned. Willy Roe remembers her nervous attempt at a 'professional' voice in *The Playbirds*. 'She came on dreadfully plummy,' he says. 'If we'd had the money then I would have liked to have dubbed her with her own voice after she settled down,' Regardless of her nervousness, Mary's acting had come along in leaps and bounds by the time *The Playbirds* was completed, but the notices she received when the movie was finally released in July 1978 were less than complimentary. Clyde Jeavons in the *Monthly Film Bulletin* said: 'Nude model Mary Millington, as a dedicated WPC, speaks her lines as methodically as she strips, while one or two good actors like Glynn Edwards stand around looking suitably shamefaced.'[10]

Because the Moulin had consistently refused to show *Come Play With Me* on its big screen, Sullivan defiantly had *The Playbirds* open at the rival Eros Cinema on Piccadilly Circus. Whilst the film was a big success, running for thirty four continuous weeks and taking over £177,000, it was still being overshadowed by its predecessor. In December 1978 it was announced that *Come Play With Me* had become the longest-running British film of all time, with over 18 months of non-stop showings at the Moulin Cinema. The rest of the film industry began to sit up and take notice, finally muttering in appreciative, but hushed tones about the considerable achievements of the Sullivan/Millington partnership. Mary, especially, had broken free from the limited shackles of girlie magazines to quickly become a name on everybody's lips. Newspapers wanted to interview her; mainstream film journals wrote about her; and thanks to her image on the posters for *Come Play With Me* and *The Playbirds* her face and name was plastered throughout the whole of the UK. She had surpassed the dreams of any glamour actress in the film industry, and her own personal ambition had been fulfilled. She had attained 'real' fame.

To her close family, the apparent change in her status was obvious. 'Without any hesitation I'd say she loved it when she finally became famous,' Geoffrey Quilter says. 'Without a doubt to her, fame was the attention she never received from her father. She craved attention all the time. She wanted to be noticed, mostly by men, but basically by anyone. It was natural to her and fame was part of it.'

Mary embarked on a series of personal appearances at the provincial cinemas where her movies were showing. One day she would be at the Odeon, Harrogate for a reissue of *Come Play With Me*, the next day at the Studio, Blackpool for the North West premiere of *The Playbirds*. The film fans would love

these appearances because it allowed them to meet their idol in person and Mary was happy to dish-out kisses and autographed photos. It wasn't just the public that looked forward to Mary's visits, but cinema managers too; Mary posing in the lobby meant bigger crowds and therefore bigger takings on the day she appeared, as well as providing the local press with endless photo opportunities. Her fanatical following in Blackpool was such that, whilst there on a promotional visit, she was asked to take part in the festivities surrounding the switching on of the illuminations. Mary thrived on the attention. The more people there were queuing outside the cinema to see her, the happier she was. The louder the voices shouting 'Mary, Mary', the wider the smile on her face. She was on her way to becoming a *bona fide* movie star and no-one was more surprised than her. Mary knew she owed her success, in the main part, to Sullivan. Nothing much had actually changed over the past two years to warrant this adulation from her public, but it was Sullivan's golden touch with publicity which had created her sudden change in fortune. He had his finger on the pulse of the working class male and had the knack of feeding their collective sexual imagination.

Mary and Suzy meet their fans

It is fair to say that Mary's cinema appearances were nothing more than a cynical ploy to get more money in Sullivan's till. Back in London he would study his film's takings around the country and if, say, *Come Play With Me* was flagging at the Cinecenta in Birmingham or the Empire in Morecambe he would deftly send out Mary in a bid to boost the takings and rectify the situation.

It was not only cinemas that benefited from the Millington touch either. In the late 1970s Sullivan embarked on an extensive programme of regional sex shop openings throughout England and Wales, trading under the *Private Sex Supermarket* or Scandinavian-sounding *Sven* banners. Invariably, Mary would be present at the openings, either doing the usual autograph signings or fighting off female anti-porn protesters. Whilst she was hugely popular with her male audience, women could often be quite hostile towards her. She was used to the verbal abuse in the street; the constant name-calling, being referred to as 'a slut' or 'a whore'. One day, while Mary was out driving in her MG Convertible she was forced to wait at a level crossing. Before the barrier went up and she could pass safely over the track a young woman nearby had screamed and shouted at her in a most violent manner. At one point, Mary thought her abuser was actually going to strike her across the face. The experience had been shocking, especially as Mary was unable to understand why any woman should perceive her as a threat. She offered a fantasy to her fans and honestly saw herself as some sort of 'living marital aid' to benefit men and womens' sex lives. She earnestly told her friend John M. East that she believed her magazines and films could actually stimulate healthier sexual relationships. In typically good natured style she said, 'If I can help in any way to relieve tension in any frustrated men, I'm very happy to do so.'[11]

Soon other organisations outside of the sex market were approaching Mary to endorse their products or image. She was invited to meet the contestants from the 1978 *Miss World* competition, and pass critical judgement. 'This isn't work!' she said at the time, before later confessing to a friend that she had fancied every one of the contestants! Mary was the guest of honour at boutique openings, pet parlours and new restaurants, all desperate for the whirl of publicity that followed her. She also attended various Variety Club lunches in London, mixing with fund-raisers and celebrities as diverse as Danny La Rue, Lord Delfont and Ron Moody. In an odd sort of way Mary was gaining a trait she had always said she never wanted. Respectability.

Charities like the Variety Club Of Great Britain were always close to Mary's heart and, if filming or modelling commitments did not interfere, she would always contribute to fund-raising campaigns for cancer research, under-privileged children or mistreated animals. The People's Dispensary for Sick

Animals (PDSA) was her personal favourite charity and through their Brighton office Mary regularly helped organise fund-raising activities. Bizarrely, in July 1978 she posed in a bikini on top of a car driven by her husband as it edged its way around Hastings Racecourse for a summer fayre. After waving to her fans she climbed down to man the PDSA pink elephant stall. Standing alongside the cardigan-clad middle aged volunteers, Mary sold items of bric-a-brac from a trestle table emblazoned with cinema posters for her two Sullivan-produced sex films, currently showing in Soho. The irony of the situation seamlessly passed over the heads of everyone present. Eight thousand people turned up to see her and she was more than happy to be interviewed by the local press and radio. Later that evening she continued her fund-raising in a nearby pub. Knowing the incongruous presence of a pornographic film star could help the coffers no end, the PDSA soon rewarded Miss Millington with her own personalised offshoot, *Mary Millington's PDSA Collection*, to which people could send their donations.

With both *Come Play with Me* and *The Playbirds* still pulling in the punters, Sullivan was keen to keep repeating the formula, but in a case of diminishing returns his next film was a glaring disappointment. *Confessions From The David Galaxy Affair* (1979) had liberally borrowed part of its title and one of Mary's co-stars, Anthony Booth, from Columbia Pictures' own money-making sex comedy series,[12] but any attempt to emulate their success was to be poorly rewarded. Mary plays a character called Millicent Cumming, a woman who has never experienced an orgasm despite having had hundreds of lovers. Her only hope of salvation lies at the open flies of crooked astrologer David Galaxy (played by the tediously unwatchable Alan Lake). Galaxy meanwhile is being fitted-up for a crime he did not commit by a sober faced Scotland Yard detective (Glynn Edwards). The convoluted plot lurches between the twin poles of the embarrassingly awful and just plain terrible. Even John M. East, who had a small role in the film, is dismissive. 'It really was a shambles that film,' he comments, 'I thought it was nothing short of absolutely dreadful.'

Mary raising funds for the PDSA (1978)

Following the criticism of her performance in *The Playbirds*, Mary was not even top-billed for *David Galaxy* and her screen time was limited to a couple of scenes late on in the film. But, she never looks anything less than beautiful and her sex scene with Lake is one of the most daring ever filmed for a British movie. This, however, was not enough to redeem it and by Sullivan's standards the film was a flop of monumental proportions. Even the same old flannel from *Whitehouse* magazine telling its readers that the movie was 'Britain's only *real* porn film' and that it was 'sure to be the biggest film of 1979 and perhaps of *all* time' did not cut the mustard this time around. Despite a personal appearance from Mary at the Eros Cinema where the film opened, *David Galaxy* was barely able to stay on screen for eight

weeks, a disaster compared to its predecessors. At the Classic cinema in Praed Street, Paddington it was withdrawn after two weeks. Watching from the sidelines was George Harrison Marks, who after being dropped by Sullivan was rubbing his hands with wicked glee. 'The only satisfaction I got after *Come Play With Me* was that *David Galaxy* was diabolical. It was bloody awful,' he laughed.

Sullivan was suddenly not a very happy film producer, but he managed to recoup some of the losses with his next picture, *Queen Of The Blues* (1979). The movie was a reasonable hit in the West End, setting a new house record at the Centa Cinema, Piccadilly, but if anything, from an artistic point of view, it was one hundred times worse than *David Galaxy*. Running for barely an hour the film features a top-billed Mary in the taxing role of a stripper in a West End night-club. Once again she looks sensational but her talents are only briefly on view. She has only one chunk of dialogue in the entire film, which is a shame because she delivers it rather well. The scene in which Mary and the other glamour girls bitch about each other has a definite ring of truth about it. 'She acted all the other strippers out of the picture in *Queen Of The Blues*,' says East, who also co-starred. 'She really came together in that one little scene. I must have rehearsed that thirty or forty times with her and she came over very well in the end.' Sullivan too, was forced to admit that his discovery had greatly improved. 'She was actually quite a good actress by then,' he adds.

David Galaxy aside, Mary had shown herself to be a very bankable film star but some of the more established 'straight' cast members she appeared with could be very disparaging. 'All these actors were sniggering behind her back, saying what a poor actress and a stupid person she was,' recalls East. 'What the hell, they were only down there on location to save themselves signing on at the labour exchange. They got an Equity minimum of fifty or thirty quid a day. What they didn't realise was if it wasn't for Mary Millington being there, there would be no film and certainly no thirty quid.'

A further Roldvale production, *Funeral In Soho*, was planned and in the meantime Mary had taken time out to appear in cameo roles in two other movies, but one film overshadowed all her other achievements: *Come Play With Me*. Her debut for Sullivan continued to baffle and confound its makers and critics alike. At one point it was even beating its closest rival, the multi million dollar *Superman* (1978) by £50,000. For tourists visiting the capital, going to see *Come Play With Me* at the Moulin in Great Windmill Street became almost as big a draw as Trafalgar Square or Buckingham Palace. The film seemed to have a life of its own, adamantly refusing to go away. *Come Play With Me* has a fascinating history, it still stands as the most profitable, longest running British 'B' movie in cinema history. When the film finally stopped playing at the Moulin it had run for a mighty 201 continuous weeks until March 1981, and had taken in excess of £550,000 at that one single cinema. In central London alone it had earned over a million pounds, and throughout the UK another four million. The film had played on 1,000 separate screens in England, Wales and Scotland. Whatever her critics said, Mary Millington's pulling power had been vindicated. She was Britain's biggest box-office draw of the 1970s and one of the most profitable British stars of all time.

prostitute

One of the most enjoyable perks of Mary's nation-wide trips to promote her movies was the adulation she received from the general public. People turned up in droves no matter where she appeared. She loved the fame that David Sullivan's films had brought her, but Mary was still hard pressed to understand why she was so popular. After all, as she stressed time and time again, she still wasn't a 'proper film actress like Brigitte Bardot or Sophia Loren'. Her fans couldn't care less, and it made little difference whether she was promoting *Come Play With Me* at the ABC in Aberdeen or the Classic Cinema in Tunbridge Wells, a sizeable crowd was always there to meet her and ask for autographs. (What Mary failed to realise was that she *was* a 'proper actress', more ingenious than any of her sex film contemporaries.) Mary played the game on and off screen, inside and out of magazines. Her entire career in the sex industry was based on a fantasy, but a fantasy she was totally comfortable with. Just as she did at *The Whitehouse Shop* back home in Norbury, Mary was pleased to reward her waiting admirers with the odd kiss or two or by posing for a photograph, but always for a price. Occasionally, if a gentleman took an extra special interest, Mary would indicate a little more than just kissing might be on the cards after the film showing. If the man had the right qualifications - money, not necessarily looks - Mary had no qualms about screwing him back at her hotel. She certainly saw nothing wrong in this. 'After all,' she once reasoned, 'my body is my way of making money and I enjoy what I do'. To her mind prostitution was no different from nude modelling or making porn movies, and this had been her over-riding attitude for a long time.

John Lindsay recognised that most of the women who starred in his hardcore movies had profitable side-lines as high class call girls. They were prepared to perform for money in front of the cameras, with their sex lives recorded for prosterity, so why should sleeping with a rich punter in *private* be that much more difficult? From her first tentative meetings with her hardcore co-stars in 1971, Mary had listened with huge interest to their incredible tales of sex with wealthy men, many of them celebrities. Making well in excess of £200 a night seemed like a day-dream to her but any scheme which might improve her cashflow worries sounded irresistible. Some of the other girls had shown her the ropes; the correct clothes to wear, the best London hotels to frequent and most importantly of all, the right money to charge, and for what. Mary took to prostitution like a duck to water, in fact she found it was a damn sight easier than having sex in front of a camera with Lindsay perpetually shouting instructions. The punters were usually respectable, middle aged and married but Mary was far more preoccupied with their bank balances than their physiques. Sometimes she would work alone, at other times with a friend and on several occasions had even taken part in orgies, both in London and the Home Counties; she much preferred these jobs as the money was better and it meant less work.

Mary's reputation as one of the best call girls in London brought her to the attention of a fair number of household names, but also to several London pimps. She had been advised to steer clear of the more organised structure of selling sex, but infrequently took bookings from a notoriously strict Madam based in Mayfair. Mary accepted these jobs only as a way of securing the company of wealthier clients; the fact that the Madam wanted a sizeable cut was hardly conducive to a worthwhile regular business agreement.

Mary's escort work was not just confined to British shores. When modelling abroad, especially in the Mediterranean, she embraced any opportunity to make a few more pounds in the evenings. By 1973 she had accumulated an impressive list of regular clients, some based in the UK and several in Europe. Celebrities and sportsmen were the best payers and Mary was increasingly amused by the great lengths to which these so-called 'family entertainers' went to protect their wholesome images. One elderly comedy actor always turned up for their assignations in disguise and another, a BBC sports commentator, would pretend that Mary was a 'visiting niece'. The famous clients paid well, mainly because they were anxious to shield their reputations, and for assured anonymity the 'names' (as the prostitutes called them) were prepared to shell out a very generous fee.

There was competition amongst the girls to see who could sleep with the biggest 'name'. Short of having sex with Prince Charles, Mary always had a thing about getting a politician and it would not be long before her dream came true with the ultimate MP, the Prime Minister, providing her with a story she

would dine out on for the rest of her life.

Harold Wilson's private life had been subject to speculation for much of the time he was in office. Despite being married to his long suffering wife Mary for 55 years, his relationship with political secretary Marcia Williams raised many eyebrows. Mrs Williams became a strong and all-pervading influence on the Labour leader from the moment he had appointed her as his private aide in October 1956. Wilson was practically and emotionally reliant on his 'office wife', and her public image was nothing short of controversial. The tabloids were obsessed with the 'true nature' of their closeness, fuelled more so by the break up of her marriage in 1961. Although Wilson could hardly be considered a ladies' man of the handsome variety, he did possess one particularly attractive personality trait; power. His wandering eye was legendary in political circles and at Labour Party conferences he could invariably be found chatting to attractive female delegates.

Only a couple of weeks after meeting her future employer and lover, David Sullivan, Mary was on a modelling assignment in Scotland accompanied by a photographer and another model, an ex-airline stewardess called Sandra. The three had touched base in Edinburgh and were staying in a large hotel just off the main shopping area, Princes Street. Mary hated Scotland because it had been so cold when she arrived, but whilst in the Scottish capital she very nearly changed her mind. She adored the shops, particularly *Frasers* the department store, and had spent an enjoyable afternoon strolling round the battlements of Edinburgh Castle (as a child she had fantasised about living in a stately home). The hotel where they were staying was extremely busy. A Welsh rugby team were also booked-in there and Mary could not keep her eyes off their tall muscular frames and barrel chests, so different from the men she normally attracted. The sportsmen paled into insignificance, however, when Mary spotted another altogether more exciting proposition: Harold Wilson.

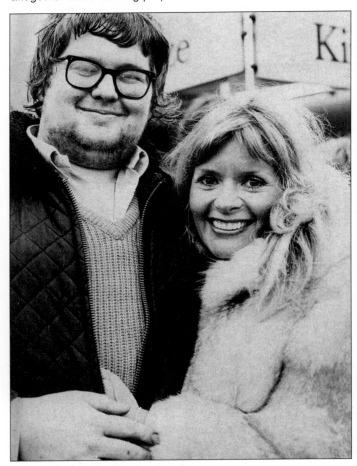

Mary meets a typical fan in Grimsby

Wilson was in Scotland on the 27th and 28th of February 1975 with a team of senior ministers, for general discussions with the Scottish Trades Union Congress. He was a regular visitor to the capital, especially as the question of devolution was once again a hot topic, but he found the meetings tiring and long winded. During the previous year he had addressed well over a dozen of the major Trades Unions throughout the UK, not to mention receiving many deputations from regional and local bodies. Wilson was staying at the hotel overnight and the instant Mary clocked his short chubby figure in the spacious lobby she made a bee-line for him. Wilson had not the slightest idea who she was (at this stage of course she was yet to become famous as 'Mary Millington'), but was startled by the young woman's energy and beauty. The PM was taking drinks in his suite near the top floor of the hotel and several of the rugby players had already been invited. Wilson asked if Mary would like to join them. She accepted the invitation without having to think twice; this would be some story to tell her friends back home, she figured.

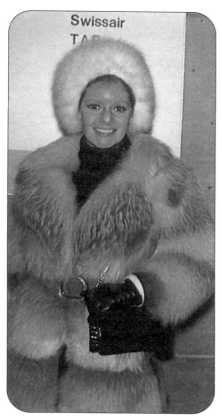

Mary Millington: jet setting call-girl

In Wilson's private rooms Mary managed to flirt around the PM with ease and very soon the politician realised exactly what sort of game the pretty blonde was playing with him. Mary later told several of her glamour industry colleagues that Wilson supposedly pinched her bottom and whispered in her ear that he would relish the opportunity to make love to her. Mary replied that she thought it would be a nice idea but cheekily added, 'Of course I'll have to charge you!' Later that same evening, after Wilson's other guests had left, she retired to his room and she and the Prime Minister allegedly had sex. The supposedly unshockable Mary was surprised at his preference for mild sado-masochism. He insisted on binding her wrists and ankles and gagging her before taking her from behind. It was not normally the kind of sex she enjoyed, but then again this was the highest profile client she had yet entertained. Mary didn't stay all night; she left after a couple of hours, but not before Wilson had promised to recommend her services to several of his cabinet colleagues.

Mary never met the Prime Minister again, but told her amazing story on dozens of occasions, usually over dinner to open-mouthed acquaintances. 'Mary was always telling that story,' one close friend remembers. 'I'm sure she embellished it from time to time, but there was some truth there. She said some very intimate things about him. Politicians are all the same aren't they?'

Remarkably, even without the PM's helpful introductions, on her return to London, Mary soon secured a client list brimming over with other prominent Conservative and Labour ministers, not to mention trade unionists and political lobbyists, but whilst the bedding of the most powerful man in Great Britain was quite an achievement it was not necessarily her greatest sexual 'success'.

Mary's friend and publicist, John M. East remembers Mary's free and easy approach to her own body. 'To her sex was no big deal,' he says. 'She would always want to pay back people's kindness to her. She did this in the only way she knew how, usually with a quick bonk or at least a wank.' Just as some people would buy a friend a box of chocolates as a thank you present Mary would happily offer them oral sex. When Mary visited East at his Norbury home she would make him tea and sit with him, chatting about life in general. One afternoon Mary noticed her friend looking a little down in the mouth after a long day working at the BBC. Sensing he needed relaxing Mary asked matter-of-factly, 'Would a blow job help?' East says, 'That was Mary. She was a great master of all things sexual.' Some of Mary's close friends really thought that, for her, sex was no different from going to the cinema. 'She didn't make a fuss about it, ever,' says David Sullivan. 'It was just something nice to do with people.'

It was through John M. East that Mary first became acquainted with the legendary *Concordia* in Bayswater, the oldest Italian family restaurant in London. In his capacity as publicist, East was hired to arrange celebrity parties at the *Concordia*, and soon got to know the owners, the Militello brothers, exceedingly well. The restaurant rapidly became

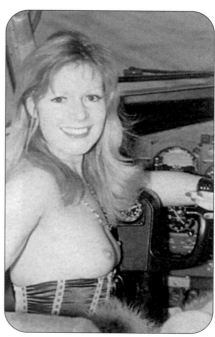

Mary's favourite place to dine out. The venue was a haunt of King Hussein Of Jordan, Earl Mountbatten, Joan Collins and hundreds of other high profile personalities and minor Royals. Mary loved rubbing shoulders with the rich and famous and told several of her friends how easy she had found it to meet prospective clients there. Over the months manager Lillo Militello began to notice this 'small, beautiful lady with a huge presence'. Mary always made a point of speaking with him. 'Whenever she came to the restaurant she would sit in exactly the same spot on the right hand side,' remembers Lillo. 'She would order simple food like prawn cocktail or Dover sole, but I was always surprised by the gentlemen she had with her. Always VIPs, many politicians. She kept coming back again and again with different famous names. At that stage I had no idea of her reputation. I thought she was just some sort of PR, entertaining these guests.'

One evening, East noticed her deep in conversation with a Middle Eastern-looking gentleman standing at the bar. When she came back to talk with her friend, East asked her whom she had been speaking to. 'That's a big deal there John. He works at the embassy and says he can set me up with some rich punters,' Mary chirped excitedly. The first 'big punter' to come out of that deal was the handsome Shah Of Persia, Royal playboy, friend of the Queen and already married with a very beautiful wife. Their assignation took place at the lavish Beau Rivage Hotel in Lausanne, Switzerland, overlooking the stunning Lake Leman. It was by far the most expensive weekend she had ever spent with a man and she found the Shah charming and attentive and, unlike Harold Wilson, he did not require anything remotely 'kinky'. As well as giving Mary a fat payment of £5,000 for her trouble, the Shah also rewarded her with a solid gold bracelet studded with diamonds. Mary was astounded at receiving such an elegant gift, but on her return to London she was straight down to a pawnbrokers in Hatten Garden - well known to prostitutes - where she sold it for more than £2,000.

Robert Maxted accepted his wife's prostitution as just another extreme aspect of her life in the sex industry, albeit the one he found most difficult to reconcile with their marriage. Mary was not insensitive however, when it came to protecting her husband from the harsh realities of her life in the business. Of all the facets of her job, she knew selling her body to men in hotels and bars had the potential for causing her immediate family the most distress. For that simple reason she kept these activities as close to her chest as possible. Talking about a photoshoot in a Berwick Street studio could be an acceptable topic of conversation over breakfast, sleeping with a middle aged playboy in a Mayfair bedroom was not. Even Sullivan's name could be openly mentioned in the house, but even then Mary knew the limits of her husband's patience. Inviting her lover over for a cosy dinner for three was definitely not a viable or sensible option.

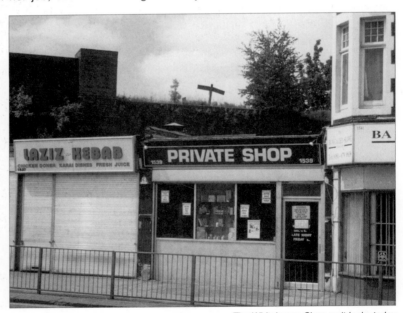

The Whitehouse Shop as it looks today

In fact by 1977 David Sullivan's position as Mary's employer-cum-boyfriend was in jeopardy. Sullivan had noticed a significant change in Mary's personality since her mother's death and her unhealthy recklessness, particularly in business, was beginning to concern him a great deal. Sullivan was determined to operate his business on the very fringes of the law; he wanted to push the boundaries of what was deemed acceptable as far as possible, but had absolutely no interest in antagonising the Metropolitan police. His attempt at avoiding police

harassment by basing his business well away from Soho had paid off to a certain extent, but his various companies were certainly not without their fair share of problems.

Throughout the 1970s the Obscene Publications Squad (OPS) continually raided any premises connected with the sex industry, including local cornershops that stocked 'top shelf' material, members-only porn cinemas, Soho sex shops, warehouses where magazines were stored, even the printing plants where pornography originated. As early as December 1975, 96,000 copies of *Park Lane* were seized by the OPS in a raid on a warehouse in Marble Arch. Scotland Yard were determined to make pornographers' lives as difficult as possible and to show the perpetrators they meant business in their crackdown on any type of porn. On this particular day, the futility of the police's strategy was especially well illustrated when, at the same time as dozens of policemen were carting off bales of girlie magazines, an IRA bomb went off without warning less than three miles away, killing two people and seriously injuring a further ten. Incidents such as this were not unusual. Our continental cousins watched the British law enforcers with open mouths. In their countries the police concentrated on solving and preventing serious crime, whilst in the UK the law seemed more concerned with controlling the supply of pictures of naked people having consensual sex.[1]

'Hardcore alley' in Norbury

Mary disliked the police, in fact, she *loathed* them with every bone in her body. Being such a high-profile woman in the British sex industry Mary laid herself open as an easy target for the law. Her shop in South London suffered continually from police raids, sometimes day after day, clearing out her entire stock. Working in the *Whitehouse Shop* so close to Norbury Police Station was not especially advantageous to a happy working environment but it often spurred Mary on to take even greater risks. Driving up from her home in Burgh Heath each day she would leave her car in the public car park behind the police station and walk down the alley-way that ran beside it, often carrying highly illegal material. She laughingly told John M. East that it gave her a tremendous thrill knowing that her handbag was stuffed full of hardcore porn as she passed by because she 'hated those fucking policemen'.

Since first being introduced to pornography by John Lindsay, Mary had come into contact with many of the big names in the sex business, some seedier than others. While she worked at Sullivan's *Whitehouse Shop* she continued to keep in touch with suppliers of considerably more explicit material which she held 'under the counter' for customers willing to pay a little extra. 'Mary had an attitude of 'I'll sell anything,' remembers Sullivan. 'If the public wanted it then she'd sell it to them, even if the law was on her back.'

There was one type of person Mary hated more than a policeman, and that was a hypocritical policeman. One of her early brushes with the law was in August 1976 when a police sergeant came into her shop, still in uniform, and bought two hardcore 8mm films *Goodnight Nurse* and *Danish Maid*. He had stopped and chatted with Mary about his sexual preferences and love of hard-to-get porn films before thanking her for her help and advice and leaving the shop. The experience had left Mary utterly amazed. Could there really exist understanding, professional officers? Sadly the answer was no. Only two days later her shop was raided and leading the assault was the very same Sergeant who had bought the films only a couple of days previously. He was so ashamed of his hypocritical actions that he was

totally unable to look Mary square in the face. Even with his head bowed Mary recognised him immediately and responded with a tirade of abuse.

During the summer of 1977 Mary became a scapegoat for British porn. Now infamous as the star of *Come Play With Me*, she was arrested on numerous occasions, not usually charged, but intimidated and warned off her burgeoning career, as porn squad officers thumbed through her magazines. 'In my fight against censorship I was carted off to Scotland Yard where I was told, how could I possibly do these disgusting things to which I made no reply at all and carried on,' Mary commented.[2]

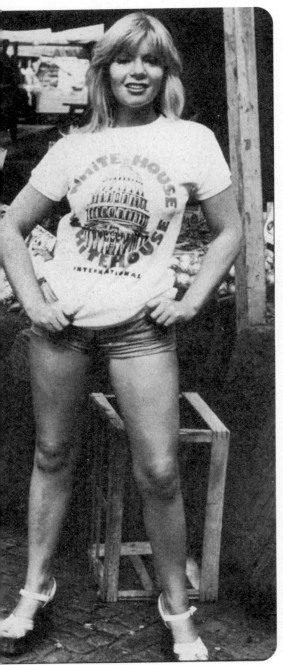

Sometimes the confrontations were quite upsetting. Mary would often take one or both of her dogs with her to work and twice officers warned her that if she refused to close her shop the animals could 'have a nasty accident'. She continually complained to her cousin Geoffrey Quilter and his wife Susan about police harassment, telling them that it was seriously wearing her down. 'She was basically persecuted for doing her job and she couldn't understand why they just wouldn't leave her alone. It all really worried her so much,' says Susan. Mary's only course of action was to tell as many people as possible, especially the press, about her brushes with the law. In a perverse way it also acted as an advertisement for her shop. 'I was getting fed up with the continual raids,' she said. 'It was really beginning to get on top of me. With all the violence in this country surely the police can leave us in peace. We even had policemen as customers! The more raids they make, the more they make people interested in seeing things themselves.'[3]

Mary repeatedly told her family and friends that the Porn Squad were asking for protection money from her in order to stall their raids. She had reluctantly paid up each month, but the more she shelled out the more regular, and often more frightening, the police visits became. Frustrated by the police impounding her stocks of magazines and films week after week, she complained to Sullivan that her takings were down and that she was exceedingly unhappy. The police had only one objective; to set-up Mary by any means and make her life as difficult as humanly possible. One time an officer planted marijuana in her hand bag, another time her car keys, passport and house bills were confiscated, (Mary later joked that the Gas bill was never returned, so she had hoped the OPS had paid it for her). Mary's car was even flagged down by the police as she drove up the London Road to Norbury on her way to work one day. When she pulled over an officer miraculously produced a deadly-looking kitchen knife from the glove compartment and demanded to know why she was in possession of an offensive weapon. Mary had never seen it before in her life.

The raids on the *Whitehouse Shop* could come at any time, from first thing in the morning to last thing at night. Sometimes through the front entrance, but more often than not through the back door that opened onto a small alleyway. In a comical attempt to forewarn her of potential raids (she was now

reluctant to take her dogs to work), Mary, in her own inimitable style, enlisted the help of a talking parrot. 'The old bird would be taken to Norbury most days and placed on its perch by the back door,' friend Dick Wolfe explained. 'Nobody could creep in through the back door without it screaming "Dirty old man, Dirty old man!"' Moments of light relief like this were few and far between at the Norbury shop, but however fed-up Mary became, she was defiant that nobody would scare her off. She adored working in the shop, and in conjunction with making a brisk sale she took the time to talk to her 'regulars' about their sexual anxieties. 'Customers aren't dragged in,' Mary argued. 'They come in because they want to buy stronger material and they want to be able to take it away and read it in the privacy of their own homes. They should have the right to do that.'

What annoyed the authorities most about Mary's activities was that she knew something that nobody else would dare mention: people enjoyed sex and they wanted more of it. During the last couple of years of her life, Mary seemed to be elevated to the position of sexual spokeswoman for a generation. She became the beautiful rent-a-quote girl for all the daily tabloid newspapers looking for a sexy angle in the ongoing porn debate. She was the antithesis of everything Mary Whitehouse's National Viewers And Listeners Association stood for and thus made extremely good copy. Here stood an eloquent attractive young woman who openly admitted to enjoying and appearing in sexually explicit publications and films, up against a frustrated middle-aged frump who universally branded everything connected with sexual expression as 'absolutely disgusting', whether she had the opportunity to see it or not.

Nobody could accuse Mary of being naive when it came to the law. She was extremely well-read on the obscenity laws in the UK and was acutely aware of the situation in the rest of Europe. She hated text books and broadsheet newspaper articles, but, all the same, had set herself the task of thoroughly understanding the arguments for and against censorship. Although she would have disliked being called 'political', that is what she was becoming. 'I despair at the silly laws in this country,' she once wrote. 'I want personal freedom of choice for everyone. Adults should have the chance to be able to make their own minds up about what they want to read and see, not have someone make it up for them.'[4] Her last big magazine launch for Sullivan, *Ladybirds* in 1976, was, without doubt, the most politically upfront title of her career. The centre spread of the debut issue was surprisingly not occupied by the

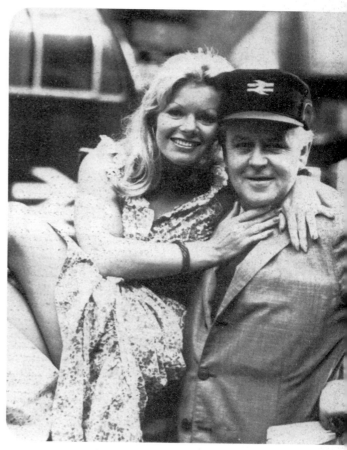

Mary at Euston station, 1977

reclining nude figure of Mary Millington, but rather by a sickening image. Banner-headlined: *'SHOCK! Just What Is Pornography?'* the centrefold showed a gruesome photograph taken during the Cambodian war, of a dead Asian girl, half her head shot away and her body splattered with blood. It was a brave step for Sullivan to make; the accompanying article compared the 'acceptability' of war with the lack of tolerance towards pornographic images. It was a tried and tested argument, but rarely had it been presented so sickeningly, or effectively. *'We publish this picture because it drives home an important point,'* argued the text. *'THIS is the real pornography, and not pictures of the kind you will find elsewhere in this first issue of Ladybirds. Adults are denied the right to choose for themselves. Explicit sex*

magazines being considered 'dirty' and 'degrading.' Pictures of splattered brains and severed limbs are there for the choosing, but a picture of a penis entering a vagina? Oh no sir, that's illegal.'

Mary encouraged her readers to demand an end to the Obscene Publications Act of 1959, and police raids on sex shops, by writing or phoning (addresses and telephone numbers were printed) Scotland Yard, the Director of Public Prosecutions and their local MP. Her role as a pro-porn figurehead was an image she revelled in and Mary was prepared to take on all-comers. 'She was a leading voice in the fight against censorship,' wrote Eric Miller, founder of the National Campaign For The Repeal Of The Obscene Publications Act. 'She used her body almost as a weapon.'[5] Unfortunately there was just one drawback in Mary's ongoing fight; her huge lack of confidence. 'She felt very, very strongly that the censorship laws in this country needed to be loosened very substantially,' says Geoffrey Quilter. 'She would have liked to have been at the very forefront of it because she felt so strongly about the entire issue. Sadly she just was not the sort of person to manage a campaign on her own. That saddened her. She was no public speaker, but at least she thought she might be able to make people think differently about pornography.' It infuriated and frustrated Mary that she did not have the confidence to stand up in public against the anti-porn lobby, and despite being such a well-loved and charismatic figure, her self-doubts engulfed her yet again. She could campaign to a certain degree, on a small scale through her magazines and in her shop, but if placed head-to-head with Mary Whitehouse or Malcolm Muggeridge in a TV studio, she would have crumbled. Because of her inability to stand alone she felt as though she had let down a large number of people. Mary was considered by many in the sex industry to be the best chance Britain had in redefining its archaic obscenity laws but she just didn't have the inner strength to see it through. For this she would never forgive herself.[6]

The increasingly anti-censorship stance of David Sullivan's publications had rather the reverse effect; if anything the Metropolitan police were gunning for him all the more. In the summer of 1976 *Thames Television* invited Sullivan and the head of Scotland Yard's Obscene Publications Squad Superintendent Smith to speak on a programme about pornography. They agreed to the discussion but argued on air. Twelve hours later five of Sullivan's premises had been totally cleaned out in systematic raids, and thousands of copies of *Whitehouse* magazine had been seized. The publisher's anger was intense, and

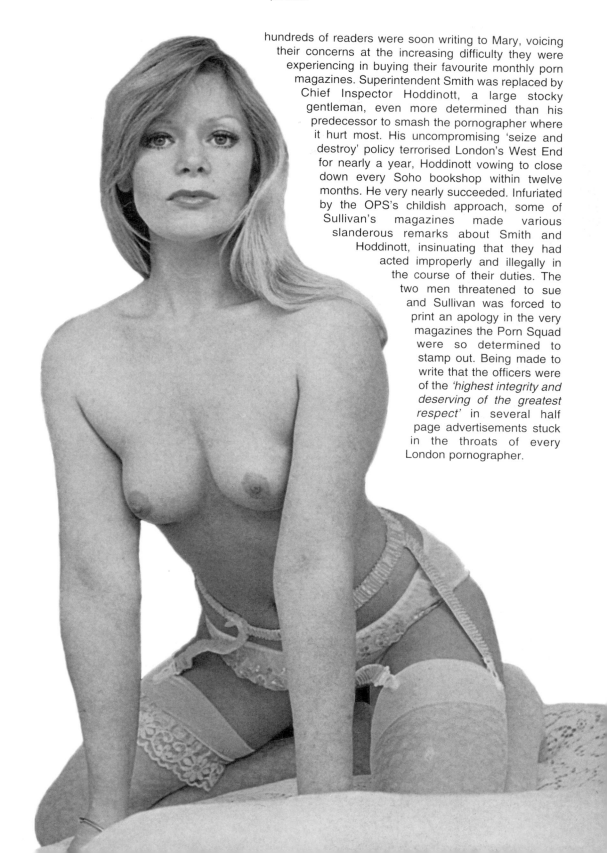

hundreds of readers were soon writing to Mary, voicing their concerns at the increasing difficulty they were experiencing in buying their favourite monthly porn magazines. Superintendent Smith was replaced by Chief Inspector Hoddinott, a large stocky gentleman, even more determined than his predecessor to smash the pornographer where it hurt most. His uncompromising 'seize and destroy' policy terrorised London's West End for nearly a year, Hoddinott vowing to close down every Soho bookshop within twelve months. He very nearly succeeded. Infuriated by the OPS's childish approach, some of Sullivan's magazines made various slanderous remarks about Smith and Hoddinott, insinuating that they had acted improperly and illegally in the course of their duties. The two men threatened to sue and Sullivan was forced to print an apology in the very magazines the Porn Squad were so determined to stamp out. Being made to write that the officers were of the *'highest integrity and deserving of the greatest respect'* in several half page advertisements stuck in the throats of every London pornographer.

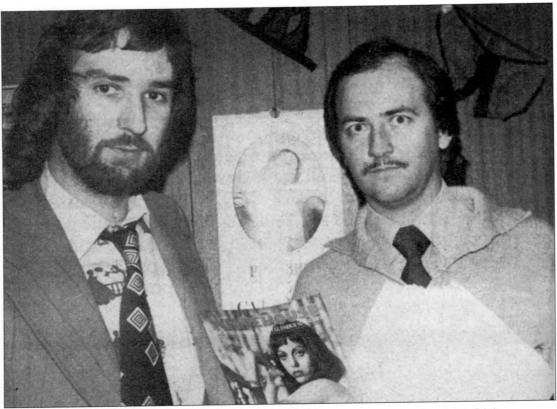

David Reed and Graham Baker - threatened with imprisonment for publishing sex education. Only in Britain...

Weary of his continual battles with the Metropolitan police, Sullivan attempted to take more of a back seat in his publishing business. His previous brush with the law in 1973, when he was tried and prosecuted along with his colleague Bernard Hardingham, was not an experience that he wished to repeat. The once prominent legend *'Published by David Sullivan'* steadily began to vanish from the covers of his publications and in her editorials Mary referred to him as her 'former boss'. But despite watching the operation from the sidelines, Sullivan was still firmly in control, now preferring to be known as a 'film producer'. His concerns about the way in which Mary was running the *Whitehouse Shop* had also come to a head by the summer of 1977. He warned her over and over again that she was playing a dangerous game stocking hardcore material in the shop. It did nothing but exacerbate the police and Sullivan pleaded with her to stop. Mary refused. She just could not understand why her customers should have their freedom of choice restricted. Terrific arguments about the business followed which eventually resulted in their separating. 'We only split up because we used to row about the business,' recalls Sullivan sadly. 'It was very amicable. We were best friends, but we weren't lovers anymore.' Mary was hurt by her boyfriend's decision but agreed that it was probably for the best. Things wouldn't actually have to change that much. After all, their relationship was never exclusive, Mary still had Bob and Sullivan had other girlfriends. The couple remained friends, they still cared for each other immensely and Sullivan had no intention of dropping her from his proposed film-making schedule. Regardless of any intimacy they had shared during their two year affair, Mary was still Sullivan's most valuable asset.

Two of Sullivan's new business associates were 30 year old editor Graham Baker and distributor David Reed, 25, both directors of his new publishing company *Kelerfern*. By 1977 their names began to appear in his magazines as quickly as his own name disappeared. In fact on the face of it, it looked as if these two men were wholly in charge of the girlie mag operation. By coincidence, Sullivan had acted in the nick of time to prevent his own name coming up in court once more, because by January 1977 his magazines were in trouble yet again.

That month Reed and Baker were visited at Sullivan's *Private Shop* office at 34 Upton Lane by two plain clothes officers from the Obscene Publications Squad, including second-in-command Inspector Higgins. The men were charged with seven counts of publishing obscene magazines for financial gain. The magazines in question included issues of *Private*, *Lovebirds*, *Weekend Sex* and *Whitehouse*. One particular offending issue was the six month old *Whitehouse* number 17, containing a part of the serialisation of *The Whitehouse Guide To Sexual Knowledge*, a series written by Doctor Of Psychology Gilbert Oakley.[7] The guide was, in all honesty, a serious, informative and groundbreaking report covering all aspects of sex and sexuality, printed with a disclaimer that the guide had been *'printed in the interests of the public good'*. However official it looked, the accompanying photographs of erect penises, vaginas in close-up and explicit images of actual sexual intercourse did nothing but aggravate a police force with time on their hands. Reed was furious with the charges and told *National News* of his disgust: 'I feel this whole prosecution is a complete waste of time and money. They should have much better things to do with so much crime and violence around.'[8]

Unfortunately, the prosecution of *Whitehouse* had serious repercussions for Mary. For a brief time she had acted,

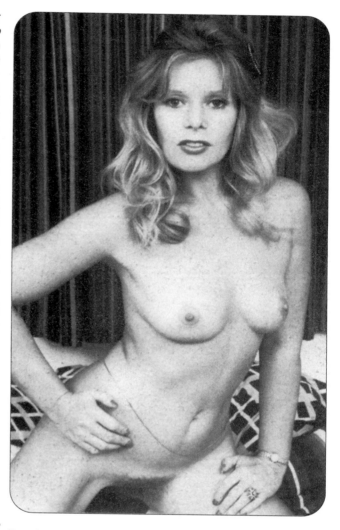

although purely on paper, as a director of Sullivan's *Kelerfern* company. Now alongside Baker and Reed, she too faced the uncomfortable prospect of appearing in court. The OPS had already been threatening Mary, informing her that she would wind up in jail 'sooner rather than later'. They told her alarmingly gruesome stories of life in Holloway prison, and how a pretty blonde like herself would 'not last five minutes' inside. Mary was absolutely terrified at the idea of going to court let alone jail, but Sullivan reassured her that she would probably get away with just a fine (and one he was prepared to pay in any case).

It was to be an agonising wait of nearly nine months for Mary before the case was heard in court number two at London's Old Bailey, November 1977. For several weeks before the trial, Mary would wake up in hot sweats in the middle of the night, tormented by nightmares about going to prison. She would spontaneously burst into tears in public, and some days she refused even to go out. The strain was unbearable, and nothing anybody could say would allay her fears. At least her mother was not around to see her so desperately unhappy. In court various people, recruited by Sullivan, gave evidence on behalf of the defendants, but the gruff old judge, Lawton Scott QC, refused a journalist the opportunity to define what was acceptable in magazine publishing and denied a doctor's evidence about the therapeutic benefits of pornography. Lawton Scott ruled their testimonies as 'inadmissible' because they offered nothing more than 'opinions and not facts'. He also ruled that the jury were not to be told that some of the very same magazines on trial had been cleared by another court earlier that year.

In an eloquent statement from the dock Graham Baker, speaking on behalf of himself and Mary, told the jury of eleven men and one woman that 'We do not see ourselves as criminals, as depravers or corrupters or the creatures of pollution. We are ordinary British citizens and if we were criminals our only crime has been to give a rich man's pleasure to the man on the factory floor for 75p. We ask you to uphold the right of our many adult readers in our free society to read this material.'9

When Mary took to the stand on that cold Wednesday morning of November 30th 1977, she was thankfully met by warm smiles from several men on the jury. One even cheekily winked at her. Looking up at the public gallery, Mary saw it was reassuringly packed with tabloid reporters and numerous fans and supporters. When the prosecution argued that pornography corrupted public morals and was inherently evil Mary, although visibly shaking, quickly hit back. 'You are dealing with a person with morals, an actress and a model,' she explained, 'and not a raving nymphomaniac! Sex is beautiful and in no way obscene.' She went on, 'I have worked as a model and have done so because I strongly believe in freedom of expression and that it is wrong to deny people from seeing what they want to see.'

Mary had made a bravura appearance and outside the court she posed happily for the hordes of photographers who had waited patiently to see her. In fur coat, knee high leather boots, but still

wearing her trademark *Come Play With Me* sunglasses, Mary spoke of her relief that the day was over, telling the assembled throng that she would continue to fight against the oppressive British censorship laws. On Friday 2nd December Mary was called to the stand again. Judge Lawton Scott made it abundantly clear that the prosecution had made a first class case against her, but when the foreman of the jury was asked his verdict, 'Not guilty' was the firm reply. Mary felt like running over to kiss him, but there was still the small matter of a decision to be made on Graham Baker and David Reed. Lawton Scott was a judge of old-fashioned Christian values. In his summing up he likened the act of 'sex without love' as being reminiscent of the behaviour of 'monkeys', which raised titters all round. Six out of the seven charges had been dropped due to lack of evidence, but much to David Sullivan's fury, his company was fined a total of £3,250 and both defendants were handed down suspended prison sentences on the seventh count. On leaving the court Mary was again besieged by the press. 'It's ridiculous,' she said angrily. 'This country is ten years behind the rest of Europe. We still cannot show what we want. It's got to be hardcore so that people can see everything. I don't do this for the money anymore, I do it to get the law changed.' If anything the acquittal had become Mary's very own *cause célèbre* and now, more than ever, she was fired up to take on the might of the British law: but ultimately, at what cost to herself?

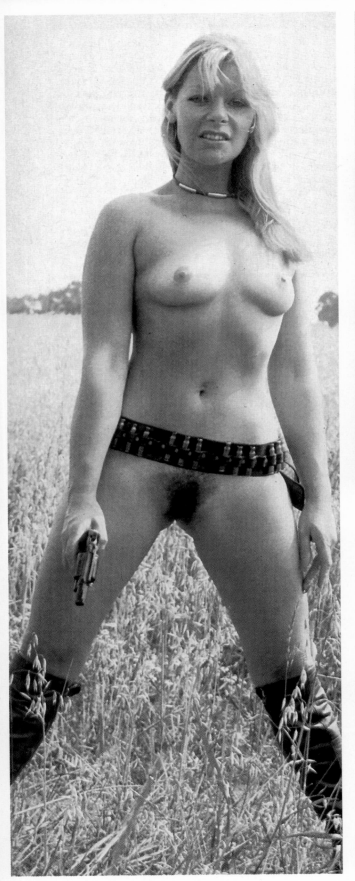
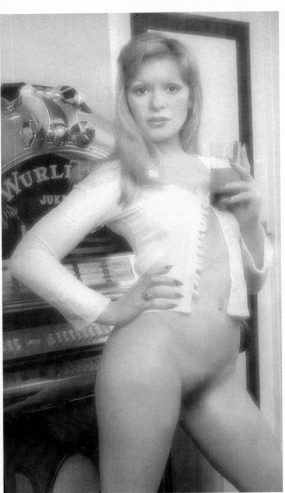
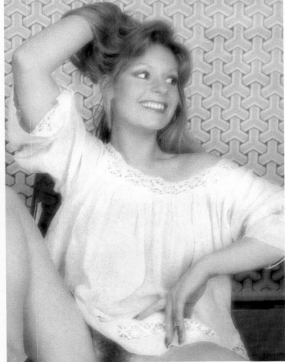

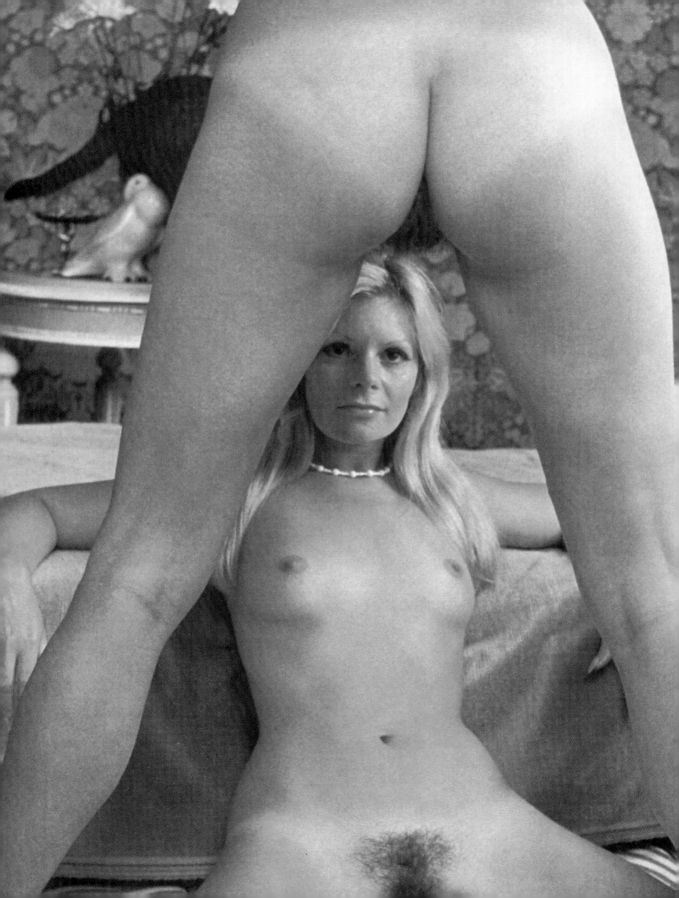

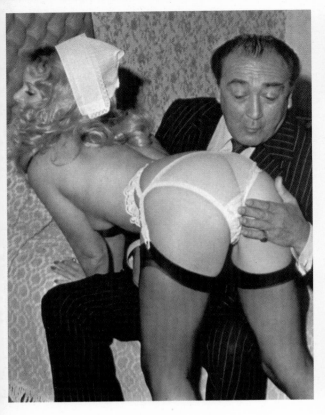

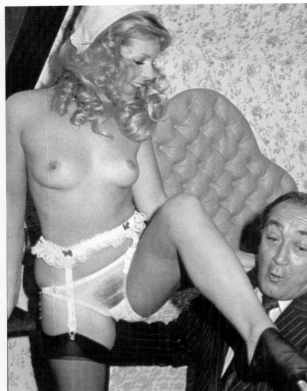

"I didn't know about these scenes. Certainly, there was nothing objectionable in the scenes I'm in. I wouldn't like to be implicated in anything like that, as I sometimes appear in childrens' TV programmes."
- Tommy Godfrey, quoted in the **News of the World**, and pictured above

right:
Mary gives Diana Dors cause for concern as she straddles Alan Lake in 'Confessions From The David Galaxy Affair'

below:
Mary with Penny Chisholm in their lesbian scene from the stronger version of 'Come Play With Me'

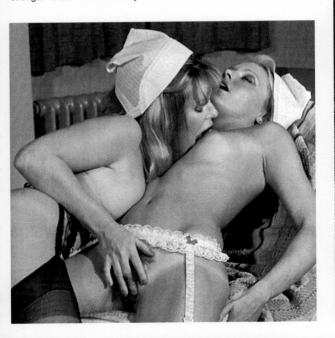

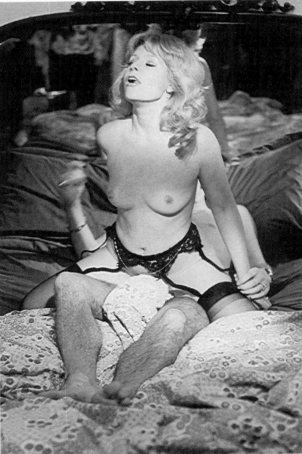

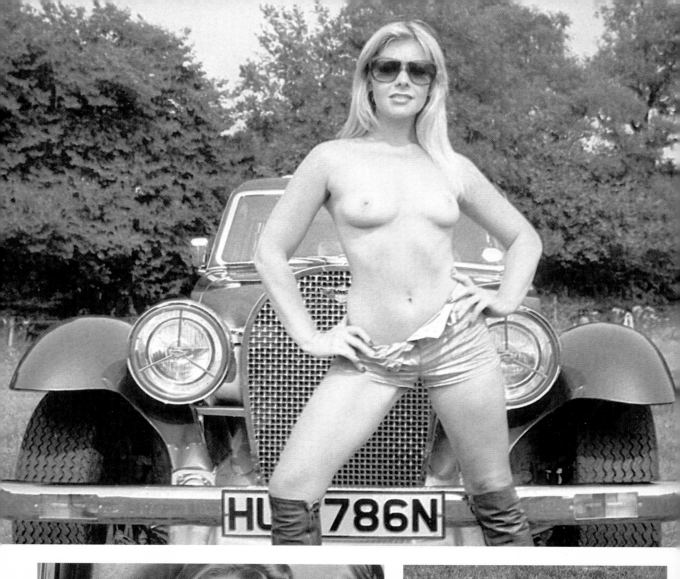

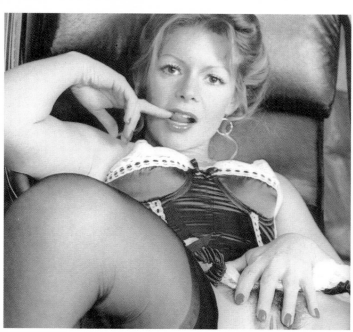

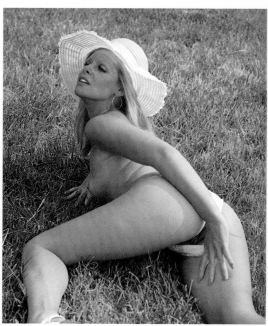

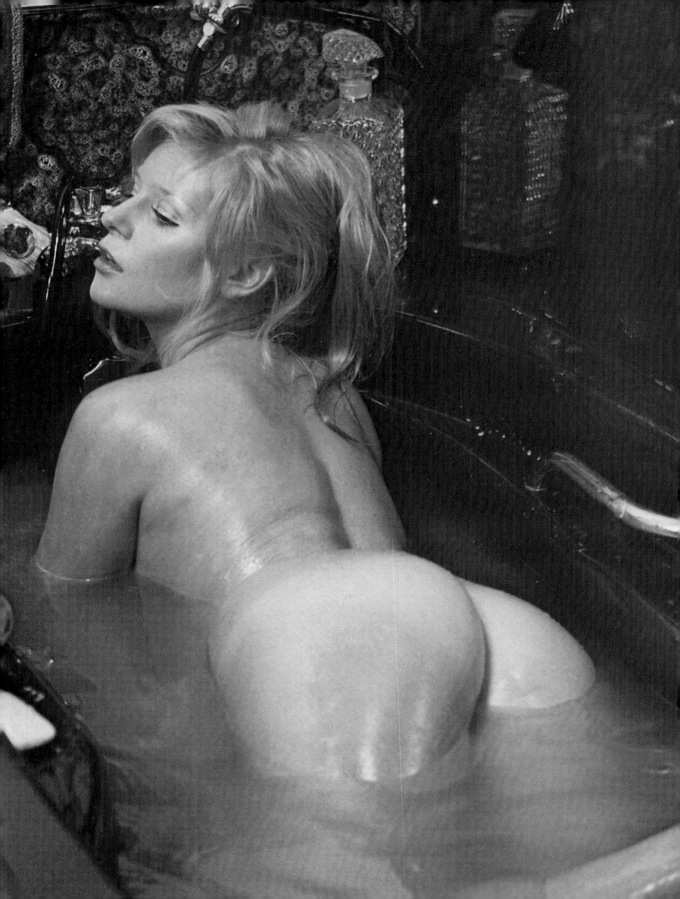

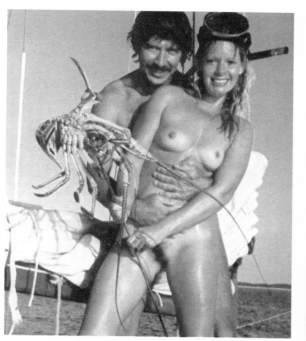
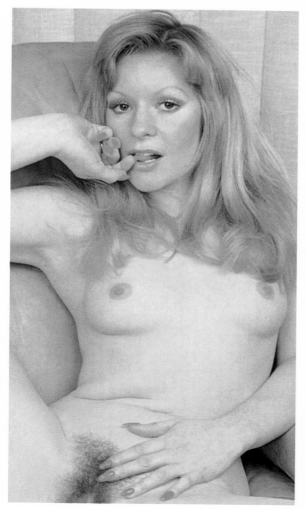
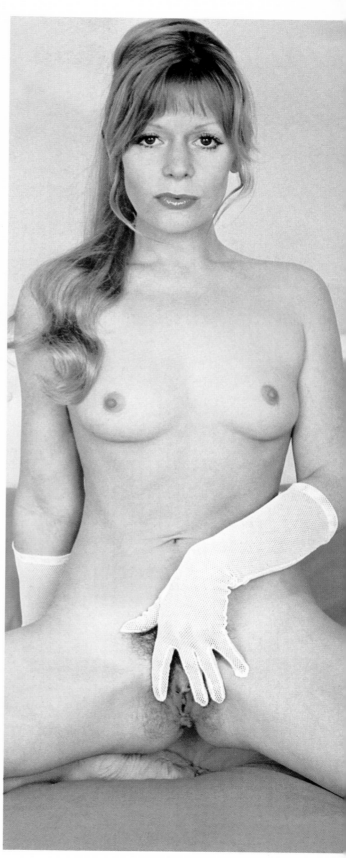

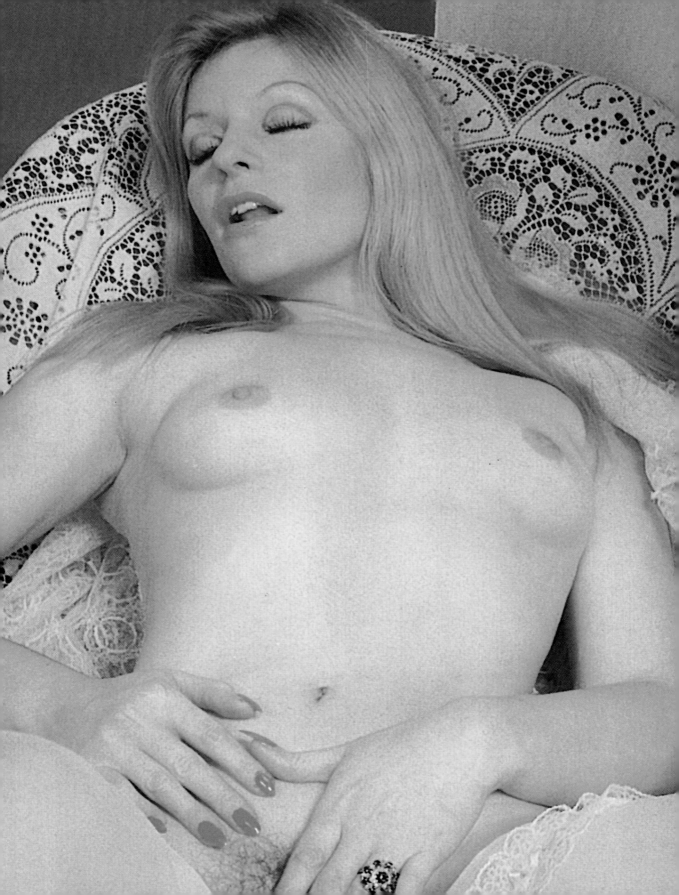

'the police have beaten me'

Mary had first been introduced to Diana Dors in 1976, on the set of Hazel Adair's period-piece sex romp *Keep It Up Downstairs*. Dors accepted her lead role - a good-time girl posing as a rich American heiress - as yet another undemanding part in another low budget movie, but by that time she was getting used to such uninspired casting; her recent cache of films hadn't been much better. She was a fat, faded film star with nowhere to go, regularly forced to accept sub-standard scripts just to help her pay the mortgage. For Mary on the other hand, her role in *Keep It Up Downstairs* was her biggest to date. Although she shared few scenes with the likes of William Rushton, Aimi MacDonald and Jack Wild, Mary was thrilled to be working with big name comedy actors in a movie filmed entirely on location at a beautiful stately home. This was really hitting the 'big time' she'd thought, but the greatest thrill for her was being in close proximity to one of the biggest British stars of all time.

Between takes Dors had noticed the novice actress quietly staring and so invited her to come and sit with her. Mary was awe-struck. Here she was sitting beside a real life, universally-known movie star and one of the best-loved actresses in showbusiness. What interest could Diana Dors possibly have in her? Surprisingly, the two got on well. The veteran performer was intrigued to know how Mary had got into film-making and in turn Mary excitedly enquired about how many Hollywood stars Dors had worked with. Dors loved the attention and mesmerised her young admirer with funny anecdotes about Joan Crawford and Betty Grable. Their friendship went no further at this stage and it would be two years before the two women would meet again, in much altered circumstances, with Mary as the headlining star and Dors' husband, Alan Lake, playing second fiddle.

By the mid-1970s Dors had failed to make a single decent film for well over a decade. The Fifties Blonde Bombshell, once famed for her beauty and figure, desperately tried to cling onto her seductive image as a sex symbol in later life, but failed miserably at her attempts at re-inventing herself. As she piled on the pounds the only parts that came her way were badly written cameos in British horror movies and sex comedies. Because of her size she was usually cast as big blowzy mothers, plump housekeepers and brothel madames in films such as *Theatre Of Blood* (1973), *What The Swedish Butler Saw* (1974), *Bedtime With Rosie* (1974) and *Adventures Of A Taxi Driver* (1975). She reached her nadir of frightfulness in 1977's *Adventures Of A Private Eye* playing a headscarf-wearing char woman, so bloated and jaundiced in appearance that she looked like a body dredged up from the bottom of the River Thames.

At the close of the Sixties, her looks gradually fading, Dors latched onto any man she could get her hands on, the younger the better. She had already got through two husbands and was continually on the lookout for new lovers. She first met actor Alan Lake on the set of the television series *The Inquisitors* in 1968 and became infatuated the moment she laid eyes on him. Lake, mercifully, didn't put up too much of a fight and after a whirlwind courtship of just seven weeks they were married. Despite Dors' frequent assertion that Lake was 'truly a magnificent actor', he quite clearly was not. Lake was nothing more than a second rate, film and TV bit part player, starring in productions even worse than the ones in which his famous wife was appearing. Attracted to his dark gypsy looks and youthful recklessness, Dors saw her new husband as validation that she could still attract a man many years her junior. Lake saw Dors as his meal ticket to what he assumed would be a higher profile in the world of acting.

However, the mutually beneficial arrangement did not go quite according to plan. Throughout the Seventies Dors' film career declined at an alarming pace, whilst Lake's barely even got off the ground. Any early promise he may have shown in John Mills' *Sky West And Crooked* (1965) soon ebbed away and he was lucky if Dors could negotiate supporting roles for him in her own movies. She was able to do this on a couple of occasions, but once again only on cheap sexploitation films. Dors wangled him parts in *Swedish Wildcats* (1974) and *The Amorous Milkman* (1974), two of the lowest points in their respective careers.

The period 1977 to 1978 had been an especially fallow time for the couple, Lake in particular had not scored a film role for the best part of four years. When David Sullivan's film company *Roldvale* offered him the male lead in a new British sex film, he jumped at the chance. The movie was *The*

Playbirds and Lake's co-star was to be a certain Mary Millington. The Lakes had read a lot about the Millington phenomenon in the newspapers, most notably since the release of *Come Play With Me*. At first Diana had little recollection of the timid little girl she had met two years previously on the set of *Keep It Up Downstairs*, but when Lake eventually re-introduced Mary to his wife, all the pieces fell together. Dors felt a mixture of emotions when she realised how close Mary would be working with her husband.

Jealousy reared its ugly head at first, followed by curiosity. After a long day's filming Dors would demand to know if her husband had filmed his bed scenes with the sex star yet, and if so, exactly what had happened. But Lake quickly tired of his wife's ceaseless questioning and more often than not lashed out at her. He was a manic depressive, mentally unstable and prone to violence, his condition made all the worse after he had been drinking - something Dors had noticed from the very outset of their relationship. Lake enjoyed a tipple as soon as he returned home and sometimes even while he was still at work. Mary had got to know her co-star a little during the four week shoot for *The Playbirds* and had noticed his hostile attitude towards to his fellow actors. During rehearsals for one scene, shot at a mansion in Surrey, Lake actually punched one of the film's extras and pushed him into the house's indoor pool. 'He was a very strange man, very belligerent,'

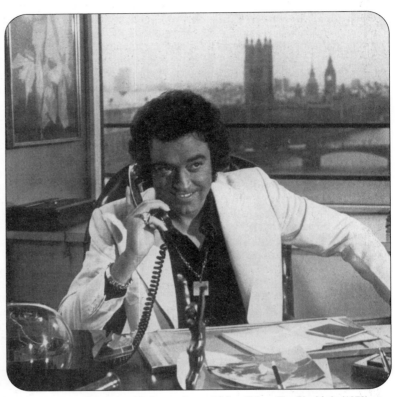

*Alan Lake - Mr Suave - in a publicity still from **The Playbirds** (1978)*

remembers one of Mary's friends who was on location that day. 'He would always be wanting to pick fights with people. Very strange chap. He probably had a lot going for him once, but he was an extremely difficult customer.'

When intoxicated Lake was terrifying company and he frequently humiliated himself in front of other actors. Many in the industry considered him nothing more than 'a joke' and referred to him as 'Mister Dors', a description that enraged him all the more. In public Diana pandered to her husband and habitually made long winded excuses for his highly erratic behaviour; in private she berated him for constantly shaming her when they were out with friends. Jealous of his wife's celebrity status and the huge affection she commanded from the general public, Lake would often make it his business to torment Dors, becoming like a spoilt child, incessantly demanding attention. Mary disliked Lake - he scared her - but through him, she was determined to get to know Diana better.

Over time the two actresses became quite close friends. Any initial jealousy on Diana's part soon disappeared and she became more relaxed in Mary's company. Being invited into the pink painted inner sanctum of the Lakes' home, Orchard Manor in Sunningdale, was perceived by Mary to be quite an honour, but once inside she realised all was not well in the life of the famous film star. Dors revelled in her wholesome 'family favourite' image, but in private the star-struck Mary learned the real truth. Her experience starring with Dors' husband in *The Playbirds* taught Mary to be mindful of Lake's temper and alcohol-induced hallucinations, but she had no idea just how threatening he really could be. Dors cherished her confidential chats with her new found friend. She told Mary how difficult it was to find

people she could honestly trust, who wouldn't sell their gossipy stories to the newspapers. Dors enjoyed the fact that Mary doted on her every word. She took advantage of the younger woman's naivety to such an extent that Dors actively relished telling her the most intimate details of her life, just so she could see her petite companion's eyes grow to the size of soup plates.

Dors explained that although the public were under the impression that she was blissfully happily married, the truth could not have been more different. It was good for her image to have Lake around but at home his behaviour was becoming increasingly unbearable. 'I sometimes honestly think he's possessed by the Devil', she told Mary. She understood Lake's deep psychological problems and knew damn well that the only reason he married her was because he craved a 'mother figure'. Mary noticed this odd mother and son type relationship on numerous occasions. If Lake had behaved badly then he would ask his wife for a 'punishment' and he childishly called Diana 'Humpty Dumpty', not just because she was overweight, but since, in the words of the nursery rhyme, he could always rely on her to 'put him back together again'.

Even though she knew her own marriage was far from perfect, Mary thought the Lakes' relationship was worryingly unhealthy. Dors admitted to her that her husband's violent outbursts were occurring with greater frequency, but she simply saw it as his way of getting noticed. Lake's desperate insecurities had led him to take a drugs overdose whilst Diana was pregnant with their son Jason, because she had not been 'paying enough attention' to his needs. Mary was amazed and disgusted, but no more so than when Diana admitted that Lake had once tried to kill her. Whilst working on location in Scandinavia, making the sex movie *Swedish Wildcats*, Dors had somehow succeeded in securing a tiny part for her husband in the film as a bodyguard to her bordello keeper. At first he was pleased to get the work, before his mood changed to anger when Diana took more than a passing interest in one of her young male co-stars, Urban Standar. Lake flew into a rage, and attempted to strangle her with his bare hands.

These stories were almost too much for Mary to take, but that was basically Diana's intention. She wanted Mary to realise how much she needed and valued her as a friend. Dors' new 'best mate' sympathised with the pain Diana was going through and begged her to leave Lake, but time and time again when Dors walked out on her turbulent marriage she would eventually come crawling back. Mary told another model, 'Diana is completely obsessed with her image, she's terrified of being on her own again.' The Lakes' marriage was hardly exclusive anyway: Dors enjoyed flirting with anything in trousers and she gave her husband free reign to have his extra-marital affairs too, though she doubted that he would actually get up to much. She complained bitterly to Mary that since she had lost her second child with Lake,

their sex life had become non-existent. He was virtually impotent and would frequently wet the bed during the night. She could not even bear to share the same bedroom with him.

Gossip mongers insinuated that Mary was having an affair with Alan Lake, based on nothing more than their sex scenes together in *The Playbirds* and Mary's next film *Confessions From The David Galaxy Affair* in 1979. Making the latter, Lake had disrobed completely for a multi-position sex marathon filmed with low lighting and the maximum amount of moaning from Mary herself. After their first film together Lake felt more comfortable being nude with Mary (despite the fact that she didn't necessarily feel the same way), but when Diana found out she was furious. Mary had to reassure her confidante that everything was totally above board and that she had not the slightest interest in her husband.

Diana had a cruel streak. She acted every inch the film star and liked nothing more than to have admirers pandering to her, and her relationship with Mary was no exception. She saw herself in the role of Mary's mentor, the Fifties Bombshell advising the Seventies Sex Queen, undoubtedly recognising that Mary was a younger, sexier version of herself. Just as Diana never took off her gold necklace adorned with the letters D.O.R.S, neither did Mary with her personalised M.M jewellery. Mary considered herself to be mixing with showbiz royalty and Diana was unquestionably the queen. Everything Diana said, Mary carefully took on board. Diana was wise, experienced and well-loved, all the things Mary aspired to be. Just as Lake saw his wife as a mother figure, so in time did Mary. This bastion of the British acting establishment was gradually becoming a kind of replacement for Mary's own mother, Joan. 'Mary was totally in awe of Diana Dors,' says David Sullivan. 'Without question she acted very much as Mary's svengali figure.'

Dors incessantly harked back to her years as a Rank starlet (or *wank starlet* as Mary liked to joke), and the 'good old days' of film-making. Mary adored hearing the stories, especially those about American film stars. The handful of early films Dors made in Hollywood were all flops, but Diana buffed up the glamorous tales for her attentive companion. Where movies were concerned, as in the rest of her life, Dors was a hypocrite of the very worst kind. She moaned to the press that the only scripts she was offered now involved sex as the main ingredient, yet she never turned one down. Despite being a

*Diana Dors (right) and the cast of **Keep It Up Downstairs** (1976)*

trusty mainstay of Seventies sex films, she still could not resist a public lament. 'We have no film industry,' she complained, 'and many of the films are of a high pornographic level. Good films lose money while pornographic romps make a fortune.'[1] In private she took an excited interest in Mary's hardcore films, asking her to bring around copies of her early John Lindsay movies to view on her home movie projector, and she loved to leaf through Mary's vast catalogue of pornographic magazines. Yet, at the same time, she lent her 'respectable' voice to a campaign attempting to ban girlie magazines from local newsagents.

Mary was straight with everyone she met. It was a case of what you saw is what you got, but Dors' twin personalities regularly confused and angered her. 'Why aren't you more honest with people?', Mary once asked her friend. 'Because I have a fucking *image* to uphold', she retorted angrily.

Dors was not only two-faced with regard to her attitude towards porn, she was also a flagrant hypocrite when it came to her own sexual experiences. Even though the actress's most loyal audience consisted largely of gay men and lesbians, attracted to her camp appearance and faded glamour more than her limited acting abilities, Dors was never a supporter of gay rights. She apparently told friends that the legalisation of homosexual activity in Britain in 1967 had been a 'terrible mistake' and despite flamboyant gay entertainer Liberace being the godfather to one of her sons, she would not acknowledge that gay men and women actually had sex. 'I refuse to call them gays', she wrote in one of her shoddy, badly written collections of showbiz reminiscences. 'When I imagine them in the act of having sex together, I'm afraid it does cast a somewhat dark shadow on my feelings towards the matter.'[2] Her

intolerance amazed even the closest of her acquaintances, (especially considering the showbusiness circles she moved in). However, Dors herself had deep-rooted fantasies about making love to another woman, and with Mary Millington on the scene they were very nearly realised.

It would be a mistake to call Diana Dors a closet lesbian or even a bisexual, but sex with other women enraptured her. Her sex life with Alan Lake had died long ago - his addiction to alcohol made him a useless lover - and Dors often sought comfort from different quarters. There are unsubstantiated rumours that Dors asked Mary to have sex with her unresponsive husband whilst she watched. This seems unlikely, as Mary was frightened of Lake's ability to suddenly turn nasty, but other friends do testify that Mary and her idol *did* indulge in a little lesbian lovemaking. Mary worshipped Diana, but did not find her sexually attractive. She preferred slim young women and Diana's terrific bulk did not especially arouse her passions. Dors enjoyed hearing tales of Mary's vast sexual history, but specifically homed in on her bisexual experiences. Their conversations invariably got around to the subject of Mary's female lovers, with Dors anxious to hear every tiny sexual detail. Mary was well aware of what her famous friend was angling towards and eventually the two blondes did share a bed together, for one night only. Mary recalled that the sex that evening had been 'disastrous'. Dors had been clumsy one minute then forceful and domineering the next. Mary had hated every moment. In the morning the friends did not discuss the previous evening's ill-fated lovematch and from there on in the subject remained strictly taboo.

Mary was disillusioned with straight sex more than ever. She had grown tired of men and their 'slam bam thank you ma'am' mentality, but her sexual appetite was as big as ever. Gradually, the men had been substituted by women in her life and she had briefly taken up with a bisexual Brighton-based glamour model and actress called Kathy Green. Kathy provided her with companionship, tenderness and an active sex life. John M. East remembers how important their relationship was to Mary. 'Kathy was very supportive to Mary and they were genuinely close,' he recalls. 'She turned to women increasingly because she was tired of sweaty men lying on top of her. She told me that she'd seen enough erect cocks for her time.'

Mary's marriage was practically sexless and she confessed to David Sullivan that whilst she still loved her husband deeply, their relationship was now more like that of 'brother and sister' rather than lovers. She had her doubts as to whether there was any point in continuing with her role as the 'dutiful wife' when all she wanted was to be with other women. Although it sat uneasily with his conscience, Bob Maxted himself was also enjoying the company of another woman. Her name was Davina Ellis, an old friend of Mary's who more recently had been hired by the model to clean around the house. Mary hated housework and invariably had no time to do it anyway. Employing

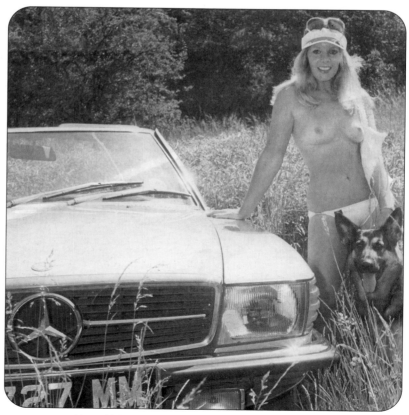

Mary with her dog Lea and personalised Mercedes, 1978

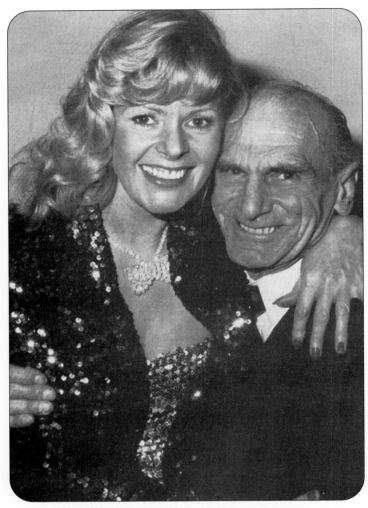

*Mary with Eric Godwin - manager of Tigon Film Distributors, at a party to celebrate the 300th screening of **Come Play With Me** at the Moulin*

someone she trusted around the house was a must and Davina fitted the bill exactly. Nevertheless, when Mary was out at work Davina sometimes had her mind on other, more pressing engagements. Returning home exhausted after a modelling session and seeing the house in a mess, Mary would berate her friend. 'Look Davina, I don't mind you fucking my husband,' she would say with typical good humour, 'but you've really got to do the cleaning and ironing first and then screw him in the afternoon!'

Mary's love of women notwith-standing, it would be wrong to say that she always refused sex with men, especially when money was involved. Around this time she had a financially beneficial 'arrangement' with a very famous South African boxer; was enjoying all expenses paid weekend trysts with a wealthy film producer and was purported to be having a relationship with actor Peter Sellers whom she had met at the Cannes Film Festival in 1978. Another lover was a very wealthy industrialist from Kent, who when not sleeping with Mary himself used her as a 'bargaining tool' with his clients. In return for securing valuable contracts from corrupt officials at the government's notorious Property Services Agency, he would send around Mary as a 'thank you'. If Mary ever had the desire to make some extra easy cash she would simply go 'on the pull' in London's West End, frequenting the stylish night-spots. One of her favourites was *La Valbonne* discotheque in Kingly Street. Famed for its heart-shaped swimming pool in the centre of the dancefloor and funky decor, the venue became *the* place to be seen in Seventies London. She had been introduced to the club and its owner Louis Brown by John M. East, who had been responsible for their PR since 1970. Mary enjoyed mixing with the 'beautiful people' and dancing energetically to the latest grooves from Donna Summer or Chic, but she was always on the look-out for new fee-paying punters.

Whilst Mary's lesbian adventures continued to make titillating reading in the pages of *Whitehouse* and *Playbirds,* the general public's over-riding view of Britain's most famous model was still that of a 'man-hungry harlot'. As Mary grew older this image both entertained and sometimes annoyed her. She was promiscuous, there was no doubt about that - she happily listed her conquests in their hundreds - but her appetite was a far cry from needing to have a different bed partner each night, as her salacious publicity would have the fans believe. She told John M. East that she was shrewd enough to realise that scandalous rumour lifted her into the limelight, but hated the fact that her 'slutty' reputation always preceded her. In 1978 Mary recorded a radio interview, never broadcast, with East at BBC

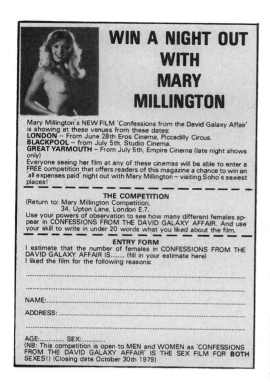

Broadcasting House in London and was shocked by some of the studio staff's reaction to her. 'Many married women think I'm going to pinch their husbands. I don't want to pinch their husbands!' she laughed. 'I was once invited to look around the BBC. When someone heard I was coming they said, 'You can't have her. You know what she'll do. She'll take off her knickers!' Is that what people really think of me? It's so stupid.'[3]

Mary's relationship with Diana Dors had soured slightly since their abortive attempt at becoming lovers, but one specific incident really hastened the weakening of their uneasy association. Mary's friends began to realise that Dors liked to manipulate her little playmate and was surreptitiously trying to take control of her personal life and career. 'It was almost like Diana was trying to relive her life through Mary,' admitted movie director George Harrison Marks. 'She would click her fingers and Mary would invariably come running. I saw their friendship at close hand and it was so sad to see. Just pathetic.'

One of Dors' main preoccupations was still the subject of homosexuality. Quite apart from the fact that she had flirted with the idea of having a female lover herself, she was often heard ranting and raving at Alan Lake, accusing him of being a 'fucking poof' because their sex life had failed. Her three sons' sexual preferences also became a fixation for the actress. Diana's two eldest boys were a product of her marriage to comedian and game show host Dickie Dawson with whom she lived in America during the 1960s. After a messy split, Dawson was surprisingly granted custody of the children and decided to stay in the USA, much to his ex-wife's fury. The sons hated Diana at the time and wanted nothing to more to do with her, believing that she had abandoned them by returning to England. Ultimately, after years of wrangling, bad feeling and a stream of unanswered letters from Diana, it seemed that at least one of her boys was coming around to the idea of having a mother back in his life. Gary was Diana's middle son, sixteen years old and a budding songwriter. In the spring of 1979 he wrote, asking if he could stay with her and Lake in Sunningdale because it was his intention to come to England in order to study music. Dors was delighted, but having been out of contact with her son for such a long period of time, she was immediately struck by his effeminate nature when they were reunited. In no time at all she began to harbour worries about her son's sexuality and, allegedly, hatched a bizarre plan to try and steer Gary in the 'right direction'.

Diana tearfully telephoned Mary one morning and explained that she needed to see her straight away. It was urgent and could not wait. As ever, Mary came running, initially imagining that her friend had suffered once again at the inebriated hands of Alan Lake. Instead Mary arrived to find a smiling Diana had laid on tea and biscuits. She hurriedly blurted out a sickening proposition for her friend, but when Mary heard Dors' idea she was absolutely disgusted. The wretched actress wanted her porn star companion to have sex with her son while she watched, simply so that she could ascertain whether he was really 'bent or not'. There was an almighty row and Mary stormed out telling Dors that she felt humiliated and exploited. The two actresses kept out of each others' way for some weeks after this episode, but Mary never forgot the depths to which her peroxide friend had sunk.

Drugs were always on the menu in Sunningdale. Lake had been a fan of cocaine since he was a young actor and his wild, boggle-eyed appearance did little to disguise his addiction. It was one of the few things Mary and Lake actually had in common, because by the late Seventies she was also a weekly user of the drug. After her split from David Sullivan, Mary had a brief love affair with a well-known *Capital Radio* disc jockey. Her new boyfriend was trendy and popular - something Sullivan had never been - and very well connected in the Seventies music scene. She loved the fact that he was able to get her virtually any new record she wanted, free of charge, and she enjoyed picking his brains about the latest industry gossip.

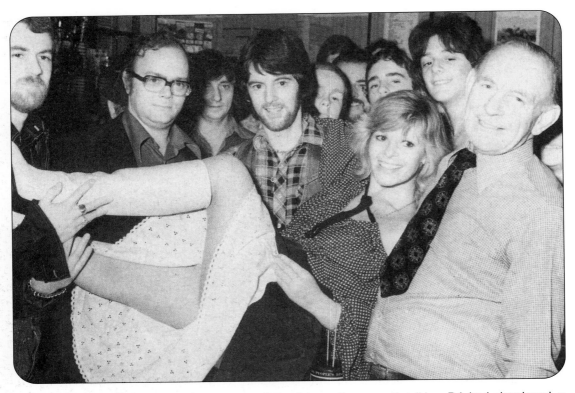

Habitually mixing with record executives and musicians, the smooth-talking DJ had developed a penchant for drugs, and cocaine in particular. Mary had briefly dabbled with smoking marijuana at art school in Reigate, but after her mother started to get ill with cancer, she was put off any kind of smoking. She and her new boyfriend regularly attended parties at which the use of cocaine was widespread. At the time - the summer of 1977 - she had been troubled by her upcoming obscenity trial at the Old Bailey and she thought drugs were a pathway to 'relaxation'. The first time she hated it. She sneezed continuously after her initial snort, but the more regularly she tried the drug the more she enjoyed its uplifting, but short lived, effects. Mary could be easily influenced, but the decision to join the cocaine culture was hers alone. She adored the fact that cocaine was the 'sophisticated' choice of her celebrity contemporaries. Snorting it through a rolled-up twenty pound note increased its appeal further for the model with money mania.

'She was not an obvious drug taker,' says Susan Quilter. 'She hid it well, but she told me that it was Diana Dors who had a lot to do with the cocaine.' Attending parties at Dors' Sunningdale Mansion, Mary did not have to look far for a fix, but she tried her best to keep her new 'hobby' as far away from her husband as possible. In fact, despite Mary taking cocaine for the last two and a half years of her life, Bob only found out six months before her death. He pointedly blamed her 'fashionable' new friends, but Mary pointedly refused to give them up.

David Sullivan recalls going for dinner with Mary one evening when she was far more giggly and girlish than usual. He asked her if she had been drinking heavily but she denied it, saying she was just high spirited. Looking into her eyes, Sullivan noticed that her pupils were wide and empty and he realised at once that she had taken to drugs. 'Mary was mixing with the wrong people after we split', says the publisher. 'She had a liking for fringe criminal types and she began to accumulate a weird circle of friends. I went to a party at her house once. There were a few hundred people there and they were a very shady bunch. There is probably a lot about Mary that nobody will ever know, but she mentioned to me that when she went abroad she would be carrying money for people. I think perhaps it might have been drugs.'

Everything was falling into place and by 1979 Mary was living the life of a bona fide premier division film star. The Maxteds had been regular visitors to the Lakes' opulent house and now, finally,

Mary was able to return the hospitality with a new home befitting her celebrity status. The property in Burgh Heath had been hastily sold, a move prompted by Mary's dislike of a neighbour. 'She'd walk around that house stark bollock naked all the time,' says David Sullivan. 'Once Mary told me that a very respectable neighbour of hers had tried to rape her and she wanted to move because the situation was getting out of hand. I told Mary the neighbour should move, not her, but she had to realise that if she answered the door naked then most guys will think it's some kind of come on. I said to her 'for you it's perfectly normal' but really it wasn't.'

Mary had begun to live on her nerves. She was convinced that the neighbour was surreptitiously watching her, but her utter contempt for the police prevented her from informing them of what was happening. The experience had left her shocked and angry and once again she began to spend long periods of time thinking about the loss of her mother. She instinctively felt that the lack of a family around her was to blame for her unhappiness. Consequently, for a short time, she moved nearer to the last blood relatives she had left, her cousin Geoffrey and his elderly mother Elsie. To realise this, Mary and Bob moved back into the London sprawl and set up home in a smart Victorian townhouse in Kersfield Road, Putney. However, the plan had not been carefully considered and proved to be short-lived, due in the main part to her dogs. 'Mary told me that she wanted to be more central,' says Geoffrey. 'It was almost like she missed having a family. I was working in Putney at the time and my mother was living there too, but it wasn't right. The house just wasn't big enough for all her stuff and there was no room for the alsatians. It was a bit of a mistake and she moved again quite soon after.'

The next move was far more suited to Mary's extravagant style. She had always been in awe of Dors' archetypal, but tacky, film star mansion and now, at long last, she was going to get the opportunity to live in her very own version. 'She moved again because she'd amassed a substantial amount of money and she no longer saw herself living in some little backwater. She wanted something considerably grander,' says Geoffrey. To get it meant moving back out into the country; the beautiful Surrey village of Walton-On-The-Hill to be precise. Walton is a model

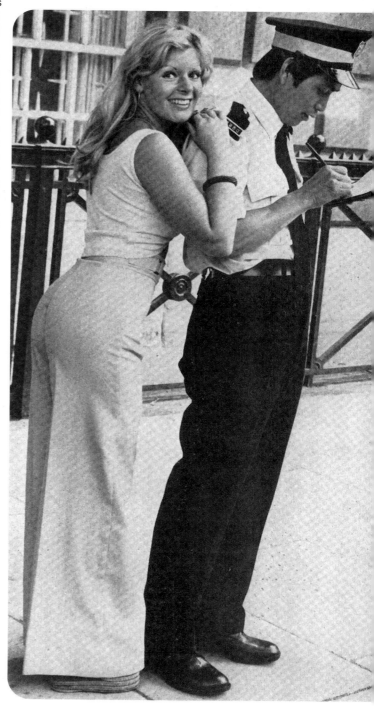

Mary's home at Walton-on-the-Hill

English village, replete with winding lanes, a village pond with swans, a local primary school, an old rectory and a quaint village pub. Mary loved the place and set her heart on a five bedroom house, in a leafy, secluded cul-de-sac called Greenways. The £160,000 price tag did little to deter her from buying. 'It was a beautiful house,' recalls Geoffrey. 'She loved the place and because of her image, having a big mansion was all the more important.'

Mary really lived the lifestyle at her new home. She had the interior lavishly decorated in bright modern colours, the back garden boasted a swimming pool and patio and the double garage was soon providing ample home to her Triumph Stag and a silver Mercedes sporting a personalised MM number plate. It didn't take long for the very upper class neighbours to realise just who was living in their midst. Mary was known to all who lived in the village. She was a regular customer at the local shop and could often be seen walking in fur coat and leather boots with her dogs. Her eldest alsatian, Lea, had died of old age and - not wanting her remaining dog Reject to be on his own - she bought another, this time a small Alsatian cross called Tippi from Battersea Dogs' Home. These two dogs in particular became her world. She treated them almost like children and could not bear to be parted from them for any great period of time. With the added space afforded by her new home there was room for even more animals. 'That house was like a mini zoo,' says Sullivan. 'She had cats, dogs, hamsters, doves, goldfish, even a mynah bird.' Mary's ambition of owning her own 'safari park' had very nearly been achieved.

Mary's great love of animals is a theme touched upon in her 'autobiography', published in September 1978. The book was given the modest sounding title of *The Amazing Mary Millington*. Amazing yes, since the book was an outlandish hotch-potch of half truths and fantastic fabrications, containing very little honest information about her real background and rise to the top. Co-writer David Weldon later claimed that, 'At times Mary was a little reticent about giving me personal information concerning her life story, but in the end there was simply nothing she didn't tell me.'[4] Well, it's what Mary *did* tell him that is so incredible. Mary merely added to the myth that surrounded her, plying Weldon with outlandish tales that never fail to surprise. Either she was high on drugs when interviewed for the book,

or she was merely having a laugh. Mary 'writes' that her father was a German mountain climber, her uncle an archbishop and her aunt a nun, and happily takes ten years off her life, implying that she was born in the early 1950s. From there on her stories get ever more ridiculous. Her grandfather Eldred gassed himself in the oven; her first lesbian experience was with a *Vogue* model who just so happened to be shopping in Dorking High Street and most laughable of all, she was once married to the French heir to a fine porcelain business!

The only time Mary comes clean is when she speaks about her hatred of school, her strong views on censorship and her relationship with, and the death of, her beloved mother. Even for Mary, that was one area of her life that remained sacrosanct. Weldon had first met Mary during her trial at the Old Bailey in the Winter of 1977. He was a probation officer then, and acted as a witness in her defence. Their friendship, if nothing else, grew out of Weldon's love of pornography. Tailoring the book to its perceived audience, he manages to pepper *The Amazing Mary Millington* with a measured quotient of explicit descriptions of her imagined sex life and masturbatory techniques. Mary's story sold well on its first print run and Weldon went on to write the novelisation of *The Playbirds* movie before turning his hand to the screenplay for Mary's unfilmed *Funeral In Soho*.

The Amazing MARY MILLINGTON!

Our very own Number one 'pin up' has now published her own TRUE life story in paperback with DOZENS of photographs illustrating it. Yes, every little detail revealed! A really fascinating novel for all Mary Millington fans – a really UNUSUAL BOOK! Read about her personal sexual experiences – both AC and DC! (fully illustrated)

ORDER a copy from your local newsagent or bookshop just 90p (Published by FUTURA) or.
Send £1 for a PERSONALLY SIGNED copy to: AMM OFFER 34, Upton Lane, London E.7 (Callers Welcome). In the years to come these HAND SIGNED COPIES might become rare collectors items.
WATCH OUT FOR MARY'S Great Feature film in your local cinema soon – 'THE PLAYBIRDS' – the best sex film of all time – look out for surprise PERSONAL APPEARANCES by Mary to promote BOTH 'THE PLAYBIRDS' and her book 'THE AMAZING MARY MILLINGTON' all over Britain.

By now there were very discernible indications that Mary was tiring of film-making within the constraints of the sex industry. After she had completed work on *Confessions From The David Galaxy Affair* she was approached by a German producer to appear in a hardcore lesbian movie. Mary refused to return the man's call. 'She turned down ten thousand pounds for that movie,' Sullivan remembers. 'I thought it was a good idea but she said to me, 'I've done all that before Dave and I shan't do it again now. I'm past all that.' It was strange.' Fair enough - Mary had left the world of hardcore behind, but she was also becoming disillusioned with the more mainstream comedy movies she was famed for. 'It got to the point where I don't think she cared anymore. She just wasn't interested,' says Sullivan. *Confessions From The David Galaxy Affair* had not fared particularly well at the box office on its release in June 1979, with takings well down compared to those for Sullivan's previous two movies. Ever the pessimist when it came to her acting, Mary blamed herself for the film's comparative failure. She figured that as it was her starring vehicle, it must be totally down to her if it flopped. 'Mary suffered from self depreciation,' says John M. East. 'Never once did she believe in herself. She was always full of self doubt, no question about it. She always had feelings that she was inadequate, that she wasn't good looking, that her boobs were too small. She would say to me, 'Why do people employ me when I'm clearly not an actress,' She had a constantly negative attitude about life.'

What Mary failed to realise was that *David Galaxy* would have been a truly awful film with or without her involvement. It was poorly scripted and the acting was contemptible (particularly that of Alan Lake). Mary was easily the best thing in it. However, the film's lacklustre box office performance made Mary even less sure about the outcome of her next movie, *Queen Of The Blues*, already in the can and awaiting imminent release, in which she had even less to do than in *David Galaxy*. Mary yearned for some meaty dialogue, a part to really get her teeth into. She knew full well that she was typecast as the 'glamour girl' in British movies but told friends she ultimately wanted to move away from this image. She had never minded appearing nude, but she would have liked the odd film where she was simply required to *act* and nothing else. 'She told me that she was getting pretty pissed off with it towards the end,' says Susan Quilter. 'All she wanted was to be an actress. Not a Shakespearean actress of course, but an actress who would be appreciated.' Unfortunately these more serious roles were not forthcoming and even the sex film parts seemed to be slipping from her grasp.

By the late 1970s the era of the British sex film was nearly at an end. Production of the saucy big budget *Confessions* movies had finished in 1977, with Stanley Long's copycat series soon following suit, petering out a year later with *Adventures Of A Plumber's Mate*. Between 1978 and 1981 audiences had a greater chance of seeing bums 'n' boobs on their television screens than at the Odeon. Sex at the

cinema was rapidly becoming old hat, or worse still, even naff, with the last British sex films being both weary and misconceived. In a last ditch attempt to rekindle their flagging audience the Carry On team returned after a two year break with *Carry On Emmannuelle* (1978) in which, after twenty years of being thwarted, the main players actually succeeded in achieving sexual intercourse, (as well as an AA rating). The comedy of frustration was gone, Kenneth Williams was seen with his underwear around his ankles and the public just couldn't stomach it anymore. Even Frank Launder's naughty schoolgirl series was resurrected with 1980's *The Wildcats Of St Trinians*, with the usually sexless pupils now posing topless for *The Sun*. It was definitely a case of more is less for indifferent British film-goers. They demanded sex for real, not spoofed, and if they were prepared to shell out hard cash they could get it. The video revolution had begun.

Home video machines had slowly started to come onto the market from about 1978 and could be rented from as little as £18 a month. For the sex movie connoisseur, video tape had a multitude of advantages over 8mm film. The new technology was portable, quiet and easy to use. There was no need to mess about loading a spool of film or erecting a four foot wide screen, and what's more the cassettes themselves contained full-length movies with guaranteed colour and sound. Sex film fans were turning away from the fleshpots of Soho in their droves and the porn pedlars were flooding the market with heavy-duty pornographic video tapes. Where audiences were once content to see some simulated jiggery pokery on the big screen, they now wanted hardcore in the privacy of their own homes. As usual, the new development in movie entertainment took the government by surprise and for the next six years hardcore porn videos were changing hands at an alarming rate until the introduction of the Video Recordings Act of 1984.[5] Never one to be left standing, David Sullivan quickly began releasing his movies onto video, with *Come Play With Me* retailing at the ridiculous price of £99!

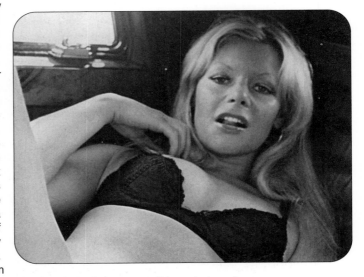

Despite the video tape boom, by the end of the 1970s Sullivan was virtually the only film producer still churning out sex movies for cinema release, but even he was scaling down his production. *Confessions From The David Galaxy Affair* was to be his last full length 90 minute movie. The costs of film-making were escalating by the month and he was more interested in producing shorter movies, filmed entirely on location, which could be released as part of double or triple bills with cheap imported European or American sex flicks. Thus *Queen Of The Blues* was his first 'sixty minute quickie'. In a bid to save money all his subsequent films were of a similar format or shorter, but regardless of length Sullivan was hardly giving Mary much scope for character development. The prospect of shooting her next film *Funeral In Soho* (later to become *Emmanuelle In Soho*) did little to curtail her obvious fears.

Mary's greatest apprehension was losing her looks and being ousted by a younger, more competent actress. She was continuously looking over her shoulder, waiting for the next girl to replace her. But if she parted from Sullivan's huge sex marketing machine, where could she go? Could an ex-hardcore porn actress ever really be assimilated into the mainstream of the showbusiness world? The vicious circle of sex films was a difficult one from which to escape and for Mary there honestly seemed no alternative. She confessed to John M. East that she knew full well that she was living on 'borrowed time' in the sex industry, but was at a loss to know what she would do with herself when the film work eventually dried up. Would she just quietly retire and open a nature reserve? But Mary had already tasted the seductive power of fame and didn't want to lose the benefits that came hand-in-hand with it. One of Mary's friends remembers a particularly distressing meeting with the star. 'Mary was very depressed. She told me that she thought her only value was her body. She kept saying nobody wanted her for anything else. But when her boobs dropped what would she do?'

Mary's heavy reliance on cocaine had many noticeable drawbacks, but the one most apparent to her friends was also the most worrying: her intense paranoia. For some time Mary had been carefully watching from the wings and monitoring another of Sullivan's models. Rosemary England was another manufactured star of *Whitehouse* and *Playbirds* magazines. In reality she was an ex-magician's assistant from Bournemouth called Jada Smith, but she possessed all the qualities Mary considered to be desperately lacking in herself. Rosemary was a successful beauty queen with a string of titles behind her; she had youth on her side, still being in her early twenties; she was well educated and her huge breasts left Mary feeling inadequate.

Since Rosemary's introduction into the Sullivan fold in late 1978, Mary had noted how much space in the magazines was being given over to photospreads of the new girl. For once Mary's concerns were not totally without foundation. Rosemary was extremely popular with the readers and her fan mail was increasing week on week. She was promoted as 'the rising young star' and one of the 'most attractive girls in the country', but Mary knew that Sullivan's publications only had room for one big name model. Mary complained to friends that she was being steadily usurped and was infuriated when Rosemary was awarded her own column, *Rosemary England ~ Roving Around Great Britain*, in *Lovebirds* magazine in the spring of 1979. Although Mary had no claim on the format - she never even wrote her sexual travelogues anyway - Rosemary's series was a blatant rip-off of her own *Mary Millington Goes UK* column in *Playbirds*.

Insult was added to injury when a huge amount of emphasis was placed on Rosemary's youth. 'She's young beautiful and unspoilt' wrote a smitten contributor to *Lovebirds*, whilst *Whitehouse* pitched Mary versus the newcomer and debated 'Who is the sexier star? What's your opinion? Please write to us and let us know'. 'Rosemary is Britain's most popular young model' claimed the editorial, 'and she is

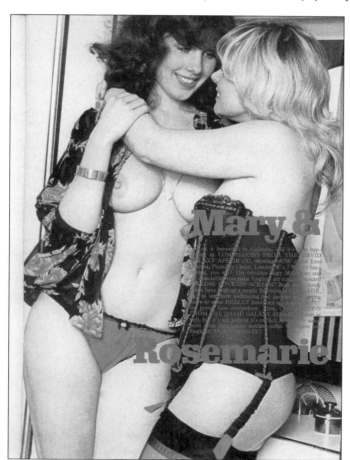

ten years younger than Mary!' The more Mary saw of the magazines - her 'home' for such a long time - the more agitated she became. Mary's magazine layouts were also increasingly merged with those of Rosemary's and the two women were regularly photographed together, draped around each others' bodies. One day, during a shoot at Mary's own house in Walton-on-the-Hill, she moaned to the photographer, 'Why do I have to keep doing duos with *her*? Don't you want to take pictures of just *me* anymore?' What had started off as rivalry had now become a complex for Mary.

Dejected and humiliated, Mary was resigned to the fact that Rosemary was becoming a mainstay of Sullivan's movies too. It happened sooner rather than later, with both women co-starring in *Confessions From The David Galaxy Affair* and *Queen Of The Blues*. Even more discomforting for Mary was seeing Rosemary's name emblazoned across the cinema posters almost as big as hers. She was convinced that in time she would be phased out entirely in favour of her younger brunette replacement. In truth the thought could not have been further from Sullivan's mind. Mary was still the most famous and bankable glamour model in the UK, but no amount of reassurance would boost her confidence.

Part of a layout from one of Sullivan's magazines, pairing Mary and her 'rival' Rosemary England

Mary maintained contact with her fictitious 'sister', Doreen Millington, who had long since parted company with Sullivan's companies but continued to bear a grudge against him due to their unceremonious split. She recalled speaking to Mary in June 1979 and listening to her dread of being 'squeezed out'. 'She phoned and told me David was trying to get rid of her,' Doreen recalled. 'She said David told her she couldn't act. She was heartbroken,'[6]

Mary's paranoia meant that it was increasingly difficult for her to separate fact from fiction. Her stories were often contradictory and it got to the stage where it became far easier to read between the lines. 'She was always telling us these stories about things happening to her,' explains Geoffrey Quilter. 'But what was actually true I don't know.' What was undeniable was that Mary was letting herself go in quite a dramatic fashion. In her later photoshoots she looks pale, drawn and tired, with her usually bright smile looking forced and her eyes glazed and circled. Her addiction to drugs had the knock-on effect of making her lose her appetite and she was noticeably losing weight.

John M. East was still acting as her publicist and chaperone and managed to secure her a casting for a new, non-Sullivan film. When East met her at the casting director's hotel in Pall Mall he was shocked by her dishevelled appearance. 'She looked quite dreadful,' he remembers. 'Her body just decayed. The roots of her hair were black, she had just given up in a matter of months, but she didn't seem to worry.' East advised her to pep herself up and put on some make-up in the ladies toilet, but if anything this made her look even worse. East had previously told the casting director what a 'sexy blonde' Mary was and that she would be perfect for the film. However, when she walked into the room, he was less than impressed. The director called Mary 'a joke' to her face and within minutes she and East were back on the street. The irony of the situation was that the job was for a 'straight' film where her clothes would have stayed on. Just what she had been waiting for.

Money had never been more important to Mary than it was by late 1978. David Sullivan remembers how she adored seeing, smelling and touching banknotes whenever she could. Her vast accumulation of cash - from her modelling career, films, public appearances, prostitution and the sex shop - was counted meticulously, but Mary's predominant problem was that she had no idea what to do with it. She had an unfounded mistrust of banks, but this paled in comparison to her aggressive attitude towards paying tax. Due to the nature of the business in which she worked, Mary's earnings often remained unrecorded. She hated cheques, preferring to be paid in used notes, cash in hand. Mary had little or no understanding of how the Inland Revenue operated, nor did she care to. She felt, however naive it may sound, that as she had worked so hard in carving a career for herself the money she made should be hers alone. She was damned if she would give a huge percentage back to the government.

'Her main aim in life, towards the end, was to make as much money as possible,' comments Geoffrey Quilter without hesitation. 'To make money she had sex. She honestly felt that it was the only way to do it, but she wasn't a canny businesswoman at all.

Mary at Redcar Races, with a horse Sullivan named after her

She had absolutely no thoughts on how to deal with all the money she made.' Since moving to the mansion in Walton-on-the-Hill Mary was more visible than ever, but when the Inland Revenue examined their records they discovered that she had not paid a penny in income tax since 1969 and they very soon set about claiming what was owed to them. Mary refused to reply to the tax department's correspondence, despite dozens of letters arriving addressed to her, and she promptly hung up on any phonecalls concerning the matter. Even Bob was unaware of the lengths to which his wife was going in order to avoid paying tax, that is until the inspector started making personal calls to the house.

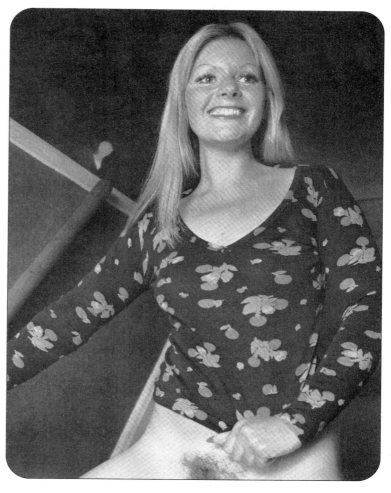

Sometimes Mary would attempt to pass herself off as the cleaning woman and deny any knowledge of 'a Mary Millington' living at the address. The Inland Revenue inspector would rarely fall for this ruse, so she would respond with unadulterated ignorance, claiming that she did not know what the hell he was talking about. Mary hated the particular inspector assigned to her case with a vengeance. Her persecution complex was such that she refused to refer to him by name, preferring to call him 'the nazi' or 'that religious fanatic'. She told friends that she was convinced that the tax man was in cahoots with the police and that they were going to nail her for something. Day after day the Inland Revenue contacted her, but Mary refused to budge. The money was hers and it was staying that way. 'She got herself into such terrible problems with the tax man,' says Susan Quilter. 'She resented him, but I wonder whether that is more an indication that she was tiring of doing the sex thing. After all, she had done all this sex work, which was mentally and physically tiring, and now they wanted to take all the rewards from that away from her.'

Mary's failure to respond to the Inland Revenue eventually led to her being handed a demand for back-dated taxes totalling one million pounds - outrageous by most film stars' standards, let alone an actress and model working in the lower budget end of the market. Mary had indeed made hundreds of thousands of pounds over the years, especially since meeting David Sullivan, but her earnings came nowhere near that over-inflated amount. The tax people knew this, they would have happily settled for a fraction of that sum, but their main objective, rightly or wrongly, was to frighten her into paying attention. 'She was very rich and very successful, but what always worried her were the tax people,' says Sullivan. 'They said she owed a million quid which was absurd. She made plenty of money but not as much as that. The trouble was that she was naive in such matters and could not cope with the methods of the Inland Revenue. She didn't know the tax people demand an inflated sum and then negotiate a reasonable sum.'

Her refusal to play ball with the tax man remained, even after she was verbally threatened by them, but after speaking with Diana Dors she discovered a way to keep her savings well protected. 'She told us that she had been depositing huge amounts of money abroad in Swiss bank accounts,' remembers Susan. 'She had endless accounts all under different aliases, but Mary being Mary she could never recall the serial numbers of them all. To the best of our knowledge they're probably still there untouched.'

Mary also believed that by investing in property and expensive possessions, her money would be safe. She had always loved the sun and the sea, and was particularly fond of the Mediterranean. Geoffrey and Susan Quilter were always getting postcards from Spain, Portugal and the Greek Islands. Oddly, going on holiday with her husband was not a consideration; she chose instead to go on trips abroad with her current 'flavour of the month', whether they be male or female. Despite being prone to regular food poisoning in sunnier climes, she decided to buy a permanent base for herself in Spain, telling Sullivan that it could be 'somewhere to escape to'.

Mary chose a two bedroomed villa, 84 La Cortijera in Mijas Costa, Fuengerola. It was a stunning white-washed house overlooked by palm trees and only a short distance from the bustling centre of the seaside town of Malaga. Mary asked her cousin Geoffrey to sort out the financial side of buying the property, and they met in the centre of London to discuss the transaction. Geoffrey was shocked when his cousin handed him her carpet bag stuffed to the brim with £5 notes. 'Here you are,' she said, 'will that be enough?' Mary had walked through the centre of the city with a bag containing several thousand pounds, seemingly unconcerned by the risk. The sale of the villa went through, but despite Mary instructing Geoffrey and his family to spend as much time there as they wished, she herself only visited her investment once.

Mary hoped that police harassment would stop after she curtailed her involvement in *The Whitehouse Shop* business in March 1978, but she could not have been more wrong. If anything her problems increased ten-fold. She had enjoyed managing a sex shop more than any other aspect of her career to date and was keen to invest in another outlet, this time totally separate from Sullivan's operations. Searching for premises in the south of London, so as to shorten the journey to work each morning from Surrey, Mary discovered a small, badly-run sex shop at 216 Tooting High Street, called 'The South London Adults Cinema Club'.

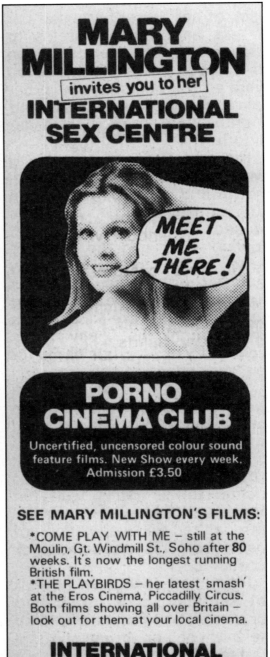

The shop had been open since the summer of 1977. The site was perfect she thought, and as far away from Norbury police station as possible. Sadly, avoiding the attentions of the police was not as easy as just moving from one district of London to another. This particular bunch of bent coppers were like locusts, but with even fewer redeeming features.

Almost as soon as the deal had been made and the freshly painted sign put above the door - the rather grand sounding *Mary Millington's International Sex Centre* - the authorities were once again paying close attention to Mary's activities. The premises were much bigger than the single storey *Whitehouse Shop* and included an adults only cinema club on the upper floors. For Mary, having the dual responsibility of overseeing the films playing upstairs as well as the retail side on the ground floor was a fantasy come true. The shop was open from 11am to 8pm six days a week and Mary not only employed a full time manager, but also her husband, who helped out from time to time when his wife's engagements took her elsewhere.

The same old blue-suited figures from Norbury reappeared within days of the new business

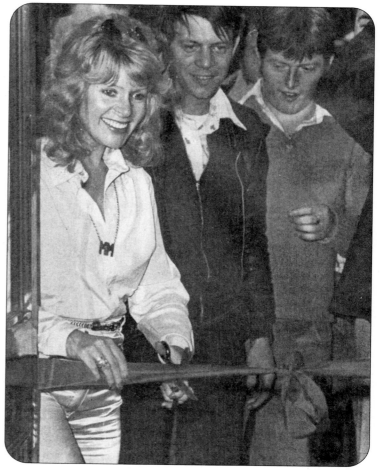

opening in Tooting. When Mary saw them walking through the door she winced. 'Movin' up in the world are we?' one particularly repellent officer asked her, before reminding Mary that wherever she was based, her Metropolitan 'friends' would never be too far away. She was also reminded that the small matter of protection money was still applicable. 'In fact,' one of the constables later told her, 'now you've got a flashier shop you can afford to give us a bit more, can't you?' Mary was shelling out hundreds of pounds each month to crooked policemen in South London, but yet again the shop became a target for regular raids. Each time the shop's contents were cleared from the shelves and the pornographic films confiscated from the cinema, resulting in yet more frustration, anguish and loss of income. The constant harassment left Mary drained and depressed. 'I love the business but because I'm happy doing it they see me as a threat,' she told Sullivan. 'They're determined to ruin me.'

Unfortunately, during the last few months of Mary's life it wasn't just the sex shop that was under close scrutiny from the police. Outside of the confines of the sex industry Mary's personal problems were causing added concern. It had always been in her character to be a little light-fingered whilst out shopping. Geoffrey Quilter recalls her habits even when she was a very small child. 'Right from when she was a little girl things used to appear in her schoolbag,' he says. 'She'd pop into *Woolworths* and come out with things she hadn't paid for.' Throughout her teenage years Mary would regularly steal make-up from a chemist in Dorking, but her compulsion to rob did not wear off as she grew into a woman. Strangely, the older and wealthier she got, the more she felt the need to steal. By her early thirties Mary was very well-off indeed, able to afford whatever she wanted, but often high on cocaine, she increasingly enjoyed the thrill of stealing even the most mundane of items. She didn't necessarily have to be in a shop either; she would steal from anywhere.

During her trip to BBC Broadcasting House with John M. East they had stopped off in the staff canteen for a cup of coffee. East recalls her wandering off for a moment then returning with her handbag bulging with BBC knives, forks and spoons. She told her publicist that they would be a 'nice keepsake' of her visit, but the incident left East bemused. Mary's journalist friend Colin Wills, from the *Sunday Mirror*, tells a similar story of a lunch date they enjoyed together. Wills was in negotiations with Mary over a possible newspaper series on her life and career in pornography. 'It was a pleasant meal and she was in cheerful form,' he recollected. 'We both got into a taxi, I was going to drop her off somewhere and I noticed that the carpet bag that she always carried everywhere was full to bursting. I looked in it and she had kidnapped the entire restaurant. On her way back from the loo, she'd picked up napkins, pepper pots, salt cellars. All had gone into this bag, as well as virtually the contents of the Ladies'; Soap, towels, it was all bulging in this carpet bag.'[7]

From small, inexpensive items such as cutlery, Mary soon progressed onto larger or more expensive objects. In her confused and depressed state, stealing brought Mary comfort. 'I feel so empty inside,' she told a friend sadly, 'but when I pinch something I feel great.' The shoplifting increased at a dramatic rate and Mary got away with it on so many occasions that it would be impossible to guess just how much stolen goods she actually amassed. One evening Mary agreed to meet John M. East at Broadcasting House and the couple walked arm-in-arm down Regent Street on their way to *La Valbonne*, where Louis Brown was expecting them. Mary seemed agitated and her eyes were fixed on every shop window. Approaching *Liberty's* department store, Mary saw a window display showcasing a dining room table with an ornamental lamp. She turned to East as if in a trance and said, 'John I've got to steal something.' 'Jesus Christ what are you talking about Mary?' East replied. 'I'm going to nick that lamp,' she answered. Mary rushed into the prestigious store, emerging seconds later with the table lamp concealed beneath her fur coat, plug and cable dangling below the hem. East was lost for words. He had never seen his friend behave in such an outrageous fashion before, but Mary was unconcerned by anybody's reaction. On their arrival at *La Valbonne*, Louis Brown looked quizzically at Mary's gift. 'Who do you think you are, Florence Nightingale?' he joked. 'I've just nicked it,' Mary beamed. 'It gave me such a thrill.'

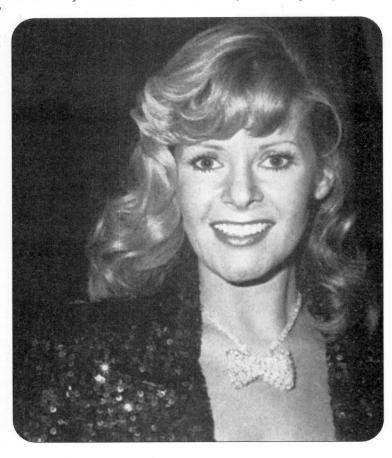

Mary's shoplifting sprees could not continue unchecked forever and it wasn't long before she was apprehended by the authorities. By now the Metropolitan police had amassed quite a fat dossier on Mary's activities, but had been unable to nail her on anything definite. So catching Britain's most famous lawbreaker for something as mundane as shoplifting was, for them, the breakthrough they had been looking for. In June 1979 Mary was detained and roughly-handled by an undercover detective in a Surrey department store not far from her home in Walton-on-the-Hill. She had been stopped leaving the shop with a brass lamp and a dress, both unpaid for. The police were immediately called and whilst the shop

owner was prepared to let off Mary with a warning (after all he was a fan no less), the police encouraged him to press charges. Mary alleged that the officer in charge quietly informed the owner that Mary needed putting away 'for her own safety'.

After being formally charged with shoplifting at a police station Mary was released on bail and permitted to call her husband. When Bob arrived he was shocked to see her covered in bruises. 'They beat me up,' she said sobbing, 'and now I'm going to have to go back to court.' The experience at the Old Bailey in November 1977 had left a permanent scar on Mary, and the thought of another trial filled her with gut-wrenching dread.

Her court appearance was scheduled for Tuesday 21st August, but full of denial, confused and relying heavily on drugs (supposedly to calm her), Mary refused to even mention it. That is until she claimed police officers had started to ring her up in the middle of the night, tormenting her with threats that it would not be long before she was sent to Holloway Prison. A few weeks after her arrest, the Inland Revenue finally obtained court orders to seize and examine her bank account records and personal papers. There was no escape for Mary, she was trapped down a one-way alley and there was nowhere left to run. Working herself up into an increasingly frantic state, she refused to talk to anyone and ignored the advice or reassurance offered by her friends. Many had already given up on her and Mary's reckless indiscretions were alienating her from even her closest friends. She had called in all her favours.

'She needed help and it was just shameful,' believes Geoffrey Quilter's daughter Denise. 'Mary had got herself in a mess, but there was no guidance from anybody. Everyone had screwed her and now, when she needed help most, they had washed their hands of her.'

Mary Millington's International Sex Centre was raided again during the first week of August, and this time the police left nothing, not even the cash register. Susan Quilter recalls seeing Mary just after the last raid, and she was distraught. 'She told me it was all getting too much and that a police officer had thumped Bob this time too,' she says. The next day Mary was booked to model for photographer Rex Peters, but her usual bubbly effervescence was elsewhere that day. She posed absent-mindedly with fellow model Louise Bloem, her thoughts evidently elsewhere. Both Peters and Bloem could tell that something was amiss, but Mary declined to talk about her problems. The say the camera never lies, and the photographs from that final modelling shoot show Mary pale, hollow-eyed and distracted. They were to be the last photos she would ever pose for.

Mary fought to control her kleptomania and had started to admit that she did have a problem. She made an appointment to see a Harley Street psychiatrist in a bid to get to the root of her emotional problems, but to those closest to her, one factor was easy to pinpoint. She still missed her mother desperately. The shoplifting had escalated since her mother died in 1976, but Mary was unable to see the correlation herself. 'She never *ever* recovered from the death of her mother,' believes Sullivan. 'I have always said that a part of her died with her mum and I just couldn't understand how she couldn't snap out of it. She was very, very close to her.' Just when Mary seemed to be facing up to her worries and her suffering could get no worse, her life turned an irreversible corner.

On Saturday August 18th 1979 Mary decided to get up early and spend the day shopping. She had a positive outlook that morning and was resolute in her aim to cheer herself up. She popped into Dorking first, bought a bunch of flowers and took them to her mother's grave in South Holmwood. After a few minutes of quiet contemplation she then drove to nearby Banstead. The town was a favourite of Mary's; she could always get a parking space and the shops were uncrowded and friendly. Walking down the High Street she paid a visit to a new jewellery shop, one she hadn't noticed before. Once inside, the 18 carat gold bracelets and necklaces in the glass counter were the first to catch her eye. She was dazzled by the full array of sparkling merchandise available and asked for a closer look. The shop was virtually empty and the temptation was just too great. Mary momentarily distracted the shopkeeper and made a grab for a pretty, twisted gold bracelet. She stuffed it into a bag but another customer, who had been furtively watching her and trying to recall where she recognised Mary from, instinctively grabbed her arm. 'She's trying to steal from you,' the public-spirited woman shouted and within minutes the police had been called. The rest of the day was a blur for Mary. She was immediately carted off to Banstead Police station, interviewed, intimidated and charged once again with theft. Mary protested her innocence, repeatedly claiming she was the victim of an elaborate set-up, but the arresting officer had no doubt in his mind that she was guilty. 'You know Mary, you are nothing short of disgusting,' a sergeant known to Mary told her. 'You are immoral and no better than an animal. Now you're definitely going to Holloway.' The policeman continued in a similar molesting vein, assuring Mary that she would be raped

by the prison warders once she got inside and very probably killed. The threat of being incarcerated terrified Mary more than anything. Lillo Militello clearly recalls her telling him late one night at the *Concordia* that the police had told her she would be murdered if she ever set foot in a prison. 'They don't take kindly to glamorous porn stars in there,' they had laughed.

When Bob collected Mary from Banstead police station, her faced was stained with tears and she was barely able to stand. 'She was in such a terrible state,' he later told reporters. 'She could not cope with the thought of prison. She was a woman with an illness, not a criminal.' By the time the couple returned home it was early evening and Mary was physically and mentally exhausted. After the day's drama Bob encouraged his wife to retire to her bed and get some sleep. They had both slept in separate rooms for over six months and Mary had chosen the spacious back bedroom overlooking the garden and swimming pool. She was understandably quiet that night, propped up in bed watching Les Dawson on *Seaside Special* on BBC1. There was little else to watch as a strike had halted programmes on ITV, but Mary was not really concentrating on television; she had bigger, more important things on her mind. At about 9pm Bob went into her room with a cup of tea, gave her a kiss on the forehead and returned downstairs to watch late night television alone. He had noticed that she was writing something on a pad when he entered the room, but Mary had hidden the paper as he approached the bed and he hadn't thought twice about it.

Meanwhile, in Norbury John M. East was preparing for bed after a long day working on a new series of radio broadcasts. Just as he was about to turn out the lights his telephone rang. He picked up the receiver and a voice immediately spoke. 'It's Mary here,' she said abruptly. East could tell straight away that things were not right. 'What is it Mary?' he asked. 'It's very late.' The two friends had not been as close recently, but Mary valued East's experience and advice and liked to think of him as some sort of 'protector'. She loved his funny jokes and stories and on one memorable day he had actually saved her life. They had arrived together for a modelling assignment at the *Daily Mirror* building in High Holborne just when an armed hold-up of the wages van was taking place. A security guard was shot in the stomach, showering Mary with blood, but East was quick-witted enough to push his horrified little companion to the floor and lay on top of her. She was terribly shaken, but afterwards had repeatedly thanked East and smothered him in kisses.

Of all her friends, nobody will ever know why it was East in particular she decided to call that fateful night. Mary began to get hysterical on the 'phone, explaining that she had been arrested again and placed in a police cell. A policewoman had hit her and split her upper lip and now the tax man was going to get her too. She had just about had enough, she no longer had the strength to continue. East had heard about her problems a thousand times before but tried his best to comfort her. Mary, however would not respond. Perhaps rather unhelpfully East added, 'You're ill Mary, mentally ill, you need psychiatric treatment.'

There was a pause before she asked East to sing to her. The friends had often enjoyed trips out in the silver Mercedes to the seafront in Brighton and the New Forest and Mary usually asked East to sing to her. It reminded her of her mother singing at her bedside when she was a child and Mary loved East's soothing *sotto voce*. On Mary's request he began to sing 'Goodnight Sweetheart' down the telephone to her, but he did not think it especially odd. As he sang *'Goodnight sweetheart sleep will banish sorrows. Goodnight sweetheart we will meet tomorrow,'* Mary interrupted. 'There isn't going to be a tomorrow,' she said tearfully and suddenly hung up.

Bob Maxted had made a conscious decision to let his wife lie in on the following Sunday morning. She needed all her strength for the next few days, especially as she was due to appear in court on the Tuesday for her first shoplifting offence. At around midday, having still not heard any stirrings from her room, he set about waking her up. On opening her bedroom door he saw Mary sprawled on the bed, Tippi and Reject lying either side of their mistress. On the bedside table was a half-full gin bottle and an empty carton of paracetamol tablets. By her right hand were scattered four crumpled sheets of paper. Mary Millington had died in the early hours of August 19th 1979.

'Bob rang us straight after finding her body,' recalls Geoffrey Quilter. 'I could not believe it. We were all in such a state of shock. It left us totally raw.'

'It was numbing,' says David Sullivan. 'I think she was just so depressed about being arrested that day for shoplifting. I spoke to her for an hour and a half on the Friday before. She did not seem upset, but she really hated the police. They had threatened to take her bail away, but there was no sign of anything like her killing herself.'

'I was devastated,' admits John M. East. 'David rang me up and told me. I was so fond of the little soul. I felt really guilty that I hadn't done more. I hadn't had the foresight to realise that she was so drastically ill. I thought why didn't I ring her up more and comfort her. Perhaps I could have counselled her and put her on the straight and narrow.'

'If I had someone ringing me up and asking me to sing 'Goodnight Sweetheart' down the 'phone and then saying to me 'There isn't going to be a tomorrow and I didn't think to call right back or 'phone for an ambulance...,' argues Richard Quilter, '...well as far as I'm concerned that's a criminal act.'

Many observers have analysed the reasons behind Mary's sudden and shocking death, but only her suicide notes gave a full picture of the extent of her Mary's and unhappiness. She left four separate letters, all written on monographed notepaper she had stolen from a hotel in Marbella. The notes are rambling, intensely poignant and heartbreakingly sad, quite obviously all written whilst the mixture of pills and alcohol were taking effect. Her last words speak volumes about Mary's life. Her hatred of the police and the tax man, her fight to see pornography legalised, her anxiety about the direction in which her career was heading and, finally, her great love of animals.

'The police killed me with threats. I have never liked people, only animals. Any spare cash after everything is sorted that Reject and Tippi don't need must go to Battersea Dogs Home,' she wrote in her letter to her husband's solicitor Michael Kaye. 'The police have made my life a misery with frame ups, even though I have paid bribery money to them. I can't go on any longer.'

In a note to journalist Colin Wills she explained that she was sorry to cancel their lunch meeting on Thursday. 'I wish I had the chance to act,' she wrote, 'but they never gave me a break. Not that I was ever offered a good part, but that was what I was looking forward to.'

To Bob she made two last requests. 'Can I have all photos of Tippi and Reject with me and let me keep my jewellery on. I would like it with me.'

Her note to David Sullivan was perhaps the most disturbing. 'The police have framed me yet again. They frighten me so much. I can't face the thought of prison. They've said I'll definitely go to Holloway and told me how bad it is there. I do so hope that porn is legal one day, they called me obscene names for being in possession of it and I can't go through any more. The Nazi tax man has finished me as well. Please print in your magazines how much I wanted porn legalised,' she wrote, 'but the police have beaten me.'

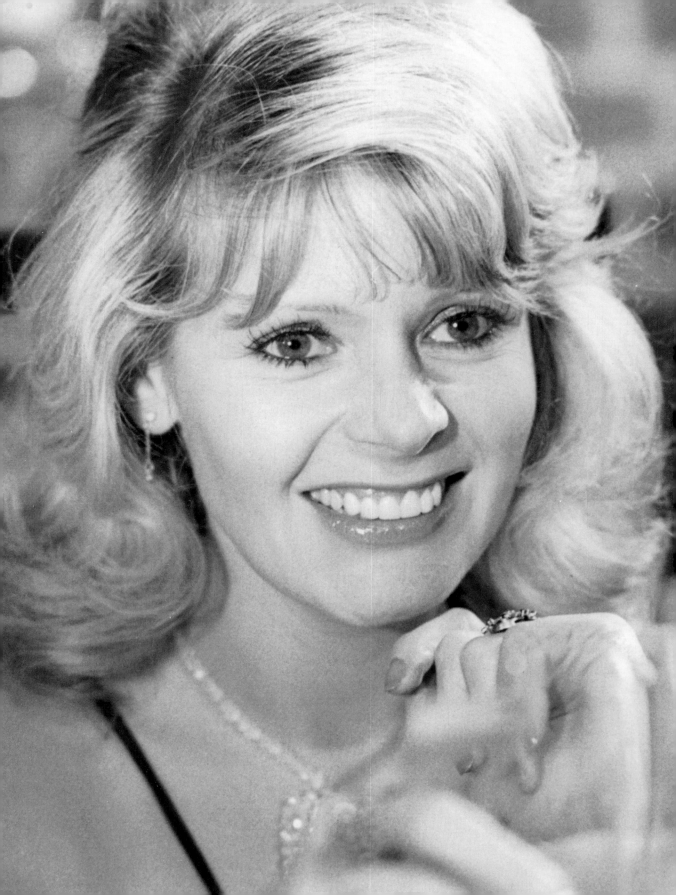

saint mary

Mary's funeral on Friday 24th August 1979 received an unprecedented amount of press coverage. The usually quiet churchyard of Saint Mary Magdalenes, South Holmwood was besieged by both news-hungry reporters and grieving admirers, but for Bob Maxted the occasion was almost too much to bear. Since her death had been announced the previous Sunday evening, journalists had camped outside the Maxteds' house in Walton-on-the-Hill, lying in wait for a statement from Mary's husband. Unsurprisingly, it was Mary's publicist John M. East who was the first to speak to the press. 'I have spoken to her manager and publisher David Sullivan and to Bob,' he said, 'and we feel the shoplifting trouble preyed on her mind so much she did not know what she was doing. She certainly had no financial worries. She was making a lot of money.'[1] There is no denying that the feelings of guilt were all-pervading amongst her circle of friends. Some stayed manifestly silent, others were quick to lay the blame firmly at the feet of those they considered at fault, namely the police and the taxman.

'What killed Mary was the harassment of the taxman who said she owed £1 million on her earnings from sex films and magazines,' David Sullivan told journalists. 'For the past year her life had been made utter misery by Gestapo-like tactics.' Everybody connected with Mary was desperately searching for answers. Why had she burnt out so young? Did no one really suspect that Mary was prepared to kill herself? Michael Kaye, Maxted's solicitor, read a statement from his office clearly outlining his views on the matter, but said that 'depression as a result of cocaine abuse' was the real cause of her suicide. Diana Dors recalled speaking with Mary four days before her death but was at a loss to make sense of the situation. 'She was in fine spirits when I met her for dinner,' the actress told *The News Of The World*. 'I'm sure nothing was further from her mind than suicide. She was a beautiful girl, with brains, lots of money and the means of making a lot more.' Interestingly, Dors, like many of Mary's friends, preferred to focus on her money-making capacity in the sex industry, rather than talking at length about Mary, the person.

However, it was only when the man closest to Mary - her husband - spoke, that the full scale of the tragedy could be measured. Eventually responding to the constant door bell ringing and tapping on windows, Bob opened the door of the mansion he had shared with Mary, grimly posed for a photograph, and invited the jostling journalists inside. Visibly shaking, he led them into the lounge and slumped on the huge leather sofa with a gin and bitter lemon in his hand. Tippi and Reject sat by their master, unnerved by the flashing cameras. Red eyed and shell-shocked, Bob motioned the reporters around him and began to speak. 'My Mary,' he said weakly staring into space, 'she was the most beautiful person you could ever hope to meet. She was absolutely devoted to her animals, they were her babies.' Pausing to take a sip from his glass Bob continued. 'She was a free thinker and definitely led the fight for sexual freedom, but I won't be keeping any of her pin-ups. I'll just remember her as my Mary, the simple girl I fell in love with.'

As a touching mark of respect, all the sex shops and porno cinemas in London's West End closed on the day of Mary's funeral. John Lindsay's *Taboo* chain was one of the first to announce its intention to shut. 'We decided to close purely as a matter of respect,' he said, before adding what everybody knew already but was too ashamed to say. 'After all, Mary made us all an awful lot of money.' Perhaps the saddest and most telling aspect of Mary's funeral was that none of the men who discovered, promoted and cashed in on her fame actually attended the service. John Lindsay was abroad, filming; George Harrison Marks was in his studio photographing a model; and John M. East was working on a radio programme at the BBC. ('I'm a broadcaster,' he says. 'It was over, and there was nothing I could do about it.')

Perhaps a mixture of guilt, shame, even bewilderment kept those men connected with the porn business away that Friday. It is difficult to say. Most noticeable by his absence was David Sullivan, but being the most high-profile of Mary's colleagues he knew he would be an easy target for vilification from the press. Far more importantly, Sullivan had been left totally devastated by Mary's death. He cried for days, for weeks. The workaholic was unable to work for the first time in his life; his pain was quite unbearable. He told friends over and over again he wished that he had forced Mary into a drugs clinic, but now was too late for regrets. Contrary to modern myth, Sullivan loved Mary profoundly, even after

their separation, and by staying away he gave her family the space they needed. Mary recognised the need to keep her husband and her lover apart in her lifetime. Why then would she have needed them together in death? Sullivan paid his respects in the only way he could; by sending the most flamboyant floral tribute of the day, the two pink and white carnation M's, and by remaining at home in quiet contemplation.

To give them due credit, the only famous faces on show at Mary's funeral were Diana Dors and Alan Lake. Both adamantly refused to speak to reporters, but this was mainly because Diana had told her husband to keep his mouth shut even before they had arrived in South Holmwood. Par for the course, he had been drinking all morning and was relying on the bulky figure of Diana for support. Lake embarrassed Diana once again at the wake, held in a pub in the centre of Dorking later that day. In the company of Mary's family and friends, he drunkenly staggered onto a bar stool and raised a toast to his 'freedom fighter' friend. Half way through his speech Lake slipped backwards onto a table, sending a dozen people's drinks flying. Dors had been shown-up by her childish husband at numerous public events, but never before at a funeral. She immediately called a cab and the two briskly disappeared with Dors haranguing Lake like a misbehaving schoolboy.

None of Mary's modelling contemporaries were to be seen that day either. The glamour world can sometimes be incredibly bitchy. A number of girls heartlessly considered that Mary had ruled the roost for far too long. After her death, one model was heard to say, 'Why didn't she just retire. Killing herself is going a bit too far'. There were dozens of new faces queuing up to take Mary's place in David Sullivan's publications, models like Julie Lee, Louise London and Vicki Scott, but none could hold a candle to their flamboyant predecessor. Magazines like *Whitehouse* and *Playbirds* seemed strangely characterless after the sudden departure of their biggest star. Those post-Millington issues are faceless, sad and eerily empty, but the ghost of Mary lingered on for some considerable time within the glossy pages of her old stomping grounds.[2]

The after-effects of her passing were remarkable, with Mary almost gaining a religious status. Gushing prose referred to her in a light never before seen in the pages of pornographic magazines. Even Sullivan's competitors could not help but print their own reverential tributes to the 'Queen Of Sex'. Mary's position as 'Britain's greatest sex symbol of all time' remained staunchly unchallenged, yet her role as 'ceaseless charity worker, fund raiser, animal lover and loving companion' was pushed even harder. As the myth of insatiable sexual libertine faded, it was replaced by another equally inaccurate image of Mary as some sort of latter day saint. Her death had caught everybody by surprise. Here was a beautiful, vivacious but insecure woman killed in her prime. Looking back at the events twenty years on it can seem that Mary had been elevated almost to the position of a pornographic Princess Diana. Amongst *her* public, men openly wept at the loss of their 'friend', flowers were laid at the door of her sex shop in Tooting, and Sullivan's offices at 34 Upton Lane received thousands of letters and poems of condolence by the sackload. Mary's supporters had experienced the very centre of their sexual, and often emotional, universe ripped from them.

One particularly moving piece of correspondence came from a prisoner named Graham, serving time at Dartmoor Jail. His simple words spoke for all of Mary's disbelieving fans. 'I am heartbroken, as I loved Mary so much,' he wrote. 'No matter how many tears we shed, it won't bring our Mary back to us will it? And I should know that because, by God, we all cried enough here today to sink a ship. I still can't believe it's happened. I wish it was only a dream but, God, I know it's not'. Letters like this one continued to arrive day after day, leaving the staff at Sullivan's string of sex shops throughout the UK totally overwhelmed.

The British press treated Mary's death sensationally. There was a scramble to find the most immoral angle to her story, mainly concentrating on the twin tabloid favourites of prostitution and drug abuse. Many 'lost' or unpublished photographs from her modelling career were swiftly resurrected. To a certain extent David Sullivan's publications were forced to come clean because of the revelatory newspaper reports. The falsehoods surrounding Mary's life were suddenly and violently exploded. Mary and Doreen Millington had never been sisters; the happy-go-lucky goodtime girl had become, in reality, a severely depressed drug addict and, most damning of all, the seemingly carefree 'nymphomaniac' was actually married, and had been for fifteen long years. Mary's admirers had to contend with her loss, but also with the death of her 'myth'.

Charges of exploitation still hang heavily in the air today. It's a word that has always walked hand-in-hand with the sex business, but David Sullivan readily admits to everything. 'A lot of people

accuse me of having exploited Mary,' he said in an interview in 1983, 'and it seems to surprise them when I readily agree. Mary had a driving ambition to succeed in life. but I think it is fair to say that without my publicity machine she would have got nowhere. Of course I exploited her, Mary wouldn't have wanted it any other way.'[3] Many of Mary's other friends testify to this unholy union of sexploitation. 'Mary knew that being *Mary Millington* was all a gimmick,' says one. 'David cashed in on her fame, but she was well aware of that. She understood everything that was going on around her. It was a partnership and they both got rich out of it.' Others are less willing to accept this view. 'She was exploited, there was no question of that,' says her cousin Geoffrey Quilter. 'She hadn't the worldly knowledge to exploit anyone. Men just used her because she was such a kind-hearted person.'

Today Sullivan is more philosophical about his relationship with Mary. 'I think that had she hung on for a couple of years longer and not got involved in drugs she could really have crossed over into the big time,' he says. 'She had the chance because she loved the sex industry and she was so easy going. If she was alive now I think she would still be involved in the sex business. That was her nature.' He then adds thoughtfully, 'Of course then again she always preferred animals to people. That's the one thing that never quite tied up for me. How she killed herself leaving her dogs behind is strange. She doted on them. It didn't quite add up.'

Mary was fortunate enough to have had a family who did not judge her purely on her non-conformist lifestyle. She was unconditionally adored and respected and the loss to all who knew her was immense. The tattered ends left by her tragic premature death make her passing all the more poignant, but to many Mary remains an enduring enigma. 'Looking back it was all so awful,' recalls Susan Quilter. 'If we'd known what was going to happen we could have stopped her, but we're still so proud of Mary. I don't think it matters what she did with her life because she was a truly good person, affectionate and kind to others. She made her choice in life and though we thought it was probably some sort of phase and that she'd move onto something else, she really did achieve something. She wasn't a hard and calculating person. She enjoyed her life and her career. She was naive, yes, but that was the point. Her enduring appeal was just that. She was like forbidden fruit, but was so incredibly sweet. We all loved her and now we miss her terribly.'[4]

Dr Gilbert Oakley, who devised the controversial *Whitehouse Guide To Sexual Knowledge*, had known Mary Millington quite well during his stint as a contributor to her magazines. He was well placed to identify the real essence of his friend. 'Instead of placing herself on a pedestal like most models and actresses, Mary was available to many men who fancied her,' he wrote in *Playbirds* in 1979. 'Some would call her promiscuous, but she was what she was, a London girl with a liking for sex. And what in this unfortunate world of ours is so wrong with that?'

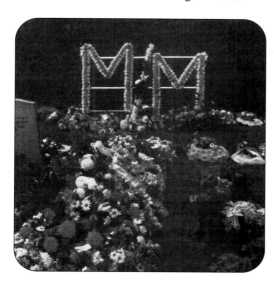

Floral tributes at Mary's graveside. The three foot high MM display which dominates was sent by David Sullivan

postscript

Barely two months after Mary's suicide the long awaited findings of the Home Office Committee on Obscenity and Film Censorship were finally published. The report, commissioned two years previously, in July 1977, by the Labour Prime Minister Jim Callaghan, was charged with reviewing the laws concerning 'obscenity, indecency and violence in publications, displays and entertainments'. The committee worked under the educated gaze of eminent philosopher Professor Bernard Williams and included experts from a variety backgrounds including a bishop, a high court judge, a journalist, a psychiatrist and a former chief constable.

Over a twenty four month period the members heard evidence from those who campaigned fervently against pornography as well as those who were involved in its production and distribution. The Williams Committee carefully studied the product both in print and on film and by the time the report was finally ready the members had seen depictions of every known form of sexual activity known to mankind. Their conclusions were reasonable, well-informed and surprisingly enlightening. The committee found no evidence to back up the claim that pornography had 'harmful side effects' and stated that if people wanted to view pornographic pictures and film, then let them. It advocated the widespread use of unlicensed sex shops and rubbished the 1959 Obscene Publications Act, claiming its use of terms like 'deprave and corrupt' had now been rendered out-dated and were no longer helpful.

Needless to say, Mary Whitehouse's National Viewers And Listeners Association were outraged by the committee's 'very *un*British' findings. Whitehouse herself called the report 'extraordinarily unimaginative and almost unbelievably naive', which was a bit rich coming from her. Although the report was debated in parliament its recommendations were never voted upon and by the time of its completion in October 1979 Jim Callaghan and his Labour government had already been ousted from power. Margaret Thatcher was now in charge, liberalism was a *very* dirty word indeed and the UK become a 'nanny state' all over again.

Bernard Williams' report was a lost opportunity, forgotten and left on a shelf to gather dust.

Twenty years after Mary Millington's death the United Kingdom is the only country in Europe where the sale of consensual hardcore pornography is still illegal.

mary millington

£1.25

WHITEHOUSE
& PLAYBIRDS

Present A Tribute To Mary Millington

FOR ADULTS ONLY.
NOT FOR SALE
TO PERSONS
UNDER 18 YEARS
OF AGE

NOTICE TO
THE NEWSAGENT:
DISPLAY THIS
MAGAZINE OUT OF
THE REACH
OF CHILDREN.

WARNING
We would like to warn all potential purchasers of this magazine that it contains explicit photographs of both male and female genitals; and material of a highly erotic nature, only suitable for extremely broadminded adults. We warn you of these facts as it is not our intention to solicit orders from anybody who may be shocked or offended by this type of material.

A SPECIAL TO
THE
GREATEST MODEL OF
ALL TIME FROM
WHITEHOUSE
PLAYBIRDS
MAGAZINES

SPECIAL
TRIBUTE ON
THE FILM DEDICATED
TO MARY –

"Mary Millington's True Blue Confessions"

FULLY UNCENSORED

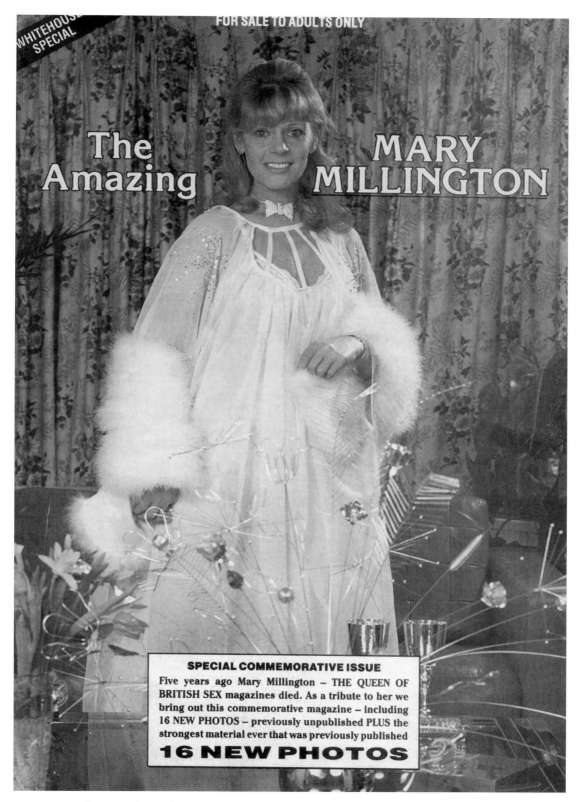

Five years after her death, tribute magazines dedicated to Mary Millington were still being published

mary millington

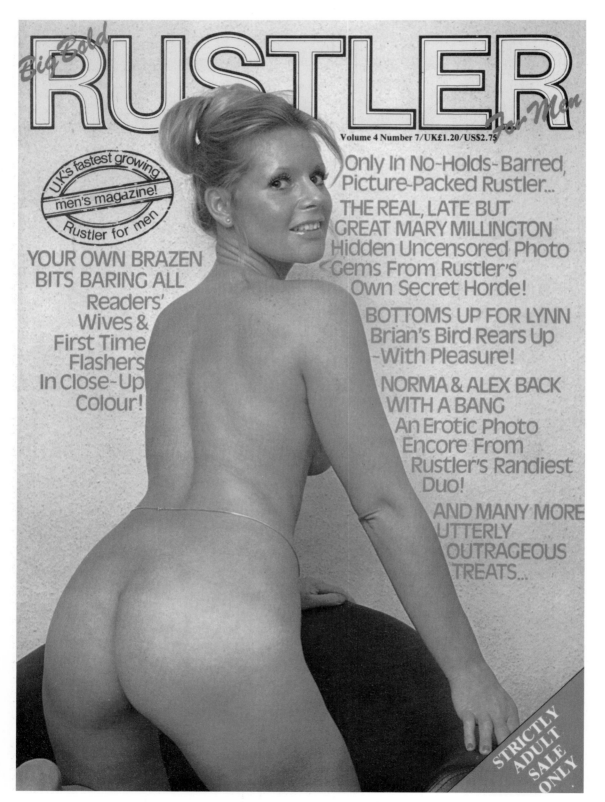

Even rival publishers paid tribute to Mary through their magazines

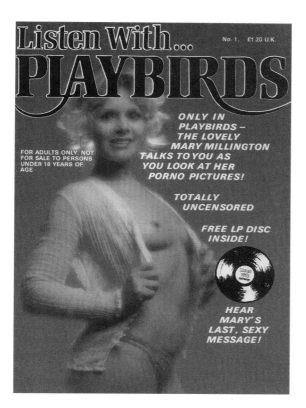

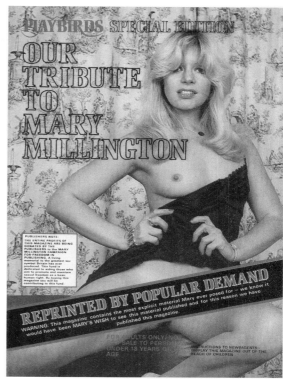

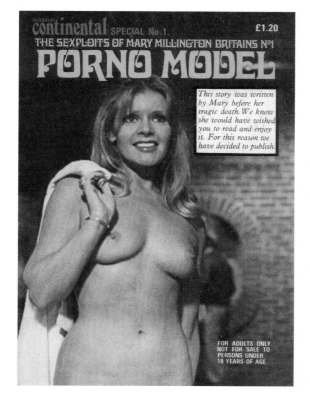

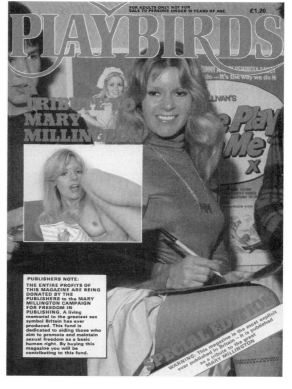

films

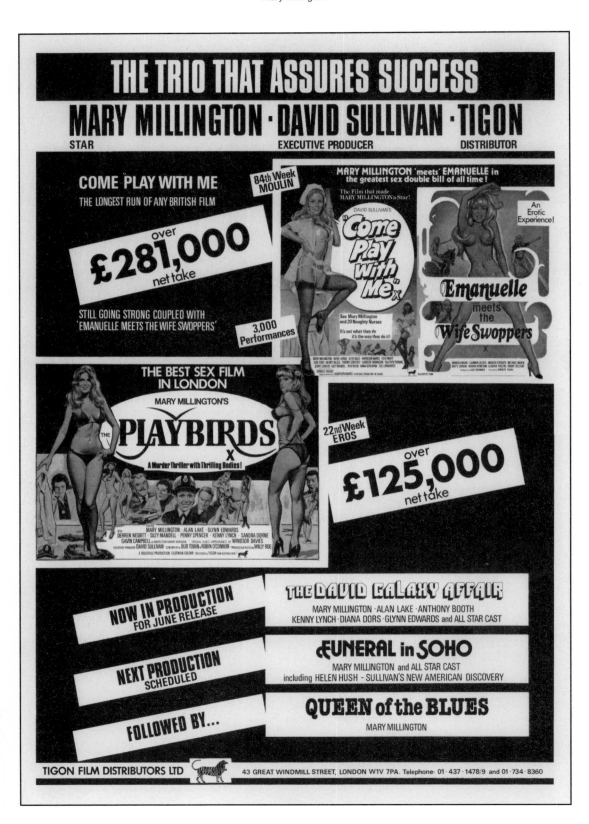

films introduction

Few, if any, actresses can lay claim to a celluloid career encompassing everything from hardcore pornography to European arthouse, clever satire, 'B' Grade thrillers, hoary old British comedy, and even a punk rock documentary. Come to think of it, most would not actually want to. It is a dubious distinction perhaps, but nonetheless one unique to Mary Millington. Her roles were, admittedly, terribly clichéd (sexpot nurses, night-club strippers and so on), but however small the part, however seemingly insignificant her role, Mary brought an irresistible charm to each of the films in which she appeared. It was this charm that was responsible for her remarkable cinema track record. For nearly seven years from 1975 to 1982, without a break, Mary always had at least one or more of her movies playing in the heart of London.

Presented here for the first time is the Millington filmography, from her early 'blink and you'll miss them' walk-ons to her later above-the-title starring roles.

The films are presented chronologically in order of their initial London West End release. Included are full cast and credit listings, background to the movies, contemporary magazine reviews (although you'd be hard-pressed to find one critic that actually had something nice to say about British sex films), mini-biographies on those connected with her career and an indispensable section on Mary movie related trivia.

Advertisement from an early 1980s video magazine

the hardcore films

By definition, real hardcore pornography leaves little to the imagination, invariably dispensing with any semblance of cohesive plot in favour of the depiction of actual sex. The 8mm short films Mary made between 1970 and 1974 are certainly no exception. The 18 or so titles she appeared in like *Betrayed*, *Miss Bohrloch*, *Triangle Of Lust* and *Convent Of Sin* don't shy away from the raw reality of desire and sexuality, but pornography dates badly. Few punters want to see a twenty year old film, featuring now dead performers, especially if a brand spanking new one is the alternative. Unlike Mary's more mainstream films from the period 1974-1979, her hardcore history has not been preserved for posterity. Some of the films are lost forever, consigned to the rubbish bin of sexual excess; Mary's participation is always anonymous, making identification of her films difficult. Some of the movies themselves have had their titles changed on numerous occasions, thus rendering them virtually untraceable. It would be frivolous to even attempt to catalogue them all, not to say inappropriate and gratuitous to document the contents of each individual film, after all sex is sex and there are obvious limits to how you can vary the look of it. Here though, as a taster, are just three of Mary's most typical, and famous, 8mm films from her hardcore past.

Miss Bohrloch
Great Britain / 1970 / 14 mins

British pornographer John Lindsay certainly threw Mary into the deep end for her very first celluloid experience. Filmed in Germany, *Miss Bohrloch* became a yardstick by which all other contemporary pornography was measured. The film is an intense, unrelenting and animalistic experience with Mary in the title role as 'Miss Bohrloch' the seemingly insatiable prostitute. Two affable young men, one blond, one bearded (looking like Benny and Bjorn from *Abba*) ring her up from a public call box with the intention of popping over for 'some drilling' (bohrloch unfortunately means 'borehole'). The chaps duly arrive at Mary's apartment, consult her price list and tot up what they can afford on a handy pocket calculator, before eventually deciding upon a 'full service'. The three soon get down to business with the constantly smiling Mary enthusiastically taking part in all the sexual activities.

Lindsay's direction is, as ever, workmanlike and often crude. At one point the blond man looks past the camera, shrugs his shoulders and appears to wait for further instructions from the film-maker. These 8mm efforts were often shot as seen, with Lindsay editing as he went along, always filming without live sound. Dubbed back in the UK, Mary's character ended up speaking in a vampish Southern Belle accent. Her two customers became Irish-American, but like all porn, the dialogue is excruciatingly banal. One of the guys breathlessly tells Mary *'I've never come so much in all me life!'*, but the film does somehow manage to finish with a joke (of sorts). Realising that they did not make allowance for Mary's 11% service charge the men, now somewhat embarrassed, explain that they are short of cash. Mary simply smiles and leads them off screen laughing *'You've been well fed, now you can wash the dishes!'*

Oral Connection
Great Britain / 1971 / 9 mins

As with most of Lindsay's films, the opening sequence of *Oral Connection* is heralded by a flurry of trumpets as if announcing a medieval jousting match, before the legend *'A Karl Ordinez Production'* flashes up. During the early 1970s Lindsay regularly spoke about his mysterious 'German backer' (sometimes he was Swedish too), but Mr Ordinez was ever the elusive faceless film producer, and there is some doubt as to whether he actually existed. Lindsay liked to film in Frankfurt and London, but also shot pictures in The Netherlands. Amsterdam is the unidentified location for 1971's *Oral Connection*.

It's a Saturday afternoon and Mary and her friend Jill have been dropped off at their hotel room by their two hippy boyfriends. Sadly, Jill's fella seems to be far more interested in the antiquated old bedroom than her, *'Hey nice pad. Lovely old beams,'* he quips, feeling the woodwork. The lads disappear down the pub and leave the girls to bathe, dress and do their hair. Mary, anxious for some 'plating' later spends an inordinate amount of time spraying her fanny with deodorant. Jill on the other hand, is a terrible bore and trades inane lines with Mary, such as *'You're*

hair looks lovely. It's dried very quickly!' The chaps return just in time to cut the conversation short. Of course it all ends up with a lot of snogging and Mary's big hulking lump of a boyfriend panting like a rabid dog. The title *Oral Connection* is a bit of a misnomer as there's certainly no more oral sex on offer than usual. In fact the film seems to focus on straightforward shagging yet again, even if the distractingly jolly musical soundtrack seems more akin to an early Seventies Terry Scott sit-com.

Response
Great Britain / 1974 / 8.5 mins

Mary did not work exclusively for John Lindsay's *Taboo* set-up, and as he started to use her less frequently Mary sought work from other directors. Russell Gay, famed glamour photographer and publisher of *Knave* magazine, began making moving pictures in the early 1970s with his company *Mistral Films*. Mary's first film for Gay was *Response*, a sort of 'hard' softcore movie. There are no erections on view, no ejaculations, no explicit vaginal shots, but the film is nonetheless a highly effective piece of British erotica, and a darn sight stronger than much available in the UK today.

Mary plays a secretary working with her little brunette friend Zoe in a funky Seventies office. The desk clock shows the time to be 12.50, and Zoe is about to go home for lunch. She has a boyfriend but detests having sex with him, preferring to fantasise about her female colleague. Mary is left with the rather peculiar job (but then again perhaps not, as this is a porn film after all) of sorting through some black and white photographs of girls in lesbian clinches, when Zoe suddenly reappears and starts to take an avid interest in the material. Soon the two women are stripping off, kissing and making love on the customary leather office couch. Mary undeniably takes the lead in a scene which is more tender and affectionate than any of those in her previous loops, her obviously relaxed demeanour really coming across on film. In later years Mary would admit that she preferred working with her female co-stars rather than with her urgent, ungainly male counterparts.

The scene ends and Mary is shown clothed and standing at the filing cabinet. The time is 12.49 and Zoe cheekily glances over her shoulder at her friend before leaving the room. At the end of *Response* Russell Gay has left the audience with a little mystery. Did the girls really make love? Was it all a fantasy in Zoe's mind? And did the clock really turn back?

*Mary and Zoe in a rare shot from **Response***

Tit Bits

● *Miss Bohrloch* became notorious amongst real porn aficionados for one particular scene. When Mary's character answers the telephone she gives her address (the odd sounding *'6 Pop Street'*) to her clients and immediately, without relevance or warning, a ping pong ball pops out of her vagina and bounces on the floor. The film subsequently became known in porn circles as 'the one with the ping pong ball'.

● Despite not actually performing in it, Mary's face cropped up in a big budget French porn film called *Paris Intim* (aka *Intimate Paris*) in 1975. The film's hero, Jerry Brouer, is waiting for his girlfriend in a hallway when he comes across a copy of David Sullivan's *Private* magazine, issue 22. In an blatant bit of movie padding, the camera lovingly pans over Mary's photographic poses in stark close-up.

● English porn fans found *Miss Bohrloch* a bit too difficult to say, let alone write, so it enjoyed a variety of odd spellings back home including *Miss Borlock, Miss Bawlock, Miss Borehole* and even *Miss Bollock.*

● Getting cocky following two unsuccessful prosecutions at the hands of the British legal system, John Lindsay started to flaunt his unique reputation in the opening credits of each of his 8mm films; *'John Lindsay was prosecuted at Birmingham Crown Court in 1974 and at the Old Bailey, London in 1977, under the Obscene Publications Act 1959 & 1964. I was acquitted in both cases and the jury found my films not to be obscene under the aforementioned Act.'*

● *Response* was reissued in 1979 on 8mm as *Go Down My Lovely* and was later transferred to video with other Russell Gay shorts in 1981 under the titles *Rustler Connoisseur's Collection* and *The Best Of Blue Movies*. In the meantime Lindsay was compiling his own 8mm back catalogue onto video and selling individual tapes for a fat £45 each.

Eskimo Nell

Great Britain / 1974 / 82 mins / Cert X

"It doesn't matter whether it's England, America, Italy, Japan. Doesn't matter. You get a bird up there pulling her knickers down and it's something they all understand. Well it's logical isn't it? I mean which would you rather see? An arty crafty film or a bloody great pair of tits?"
(Benny U. Murdoch in *Eskimo Nell*)

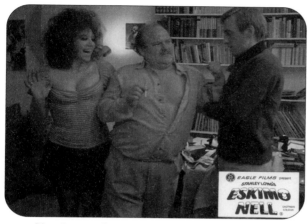

Diane Langton, Roy Kinnear and Christopher Timothy

Ironically, Mary Maxted's first mainstream sex film is actually a comedy about the movie industry in which she found herself so deeply embedded. A clever satire on the mechanics of nursing an X-rated feature from script to screen, Martin Campbell's debut is impressive and very funny stuff indeed. The film is merciless, gleefully taking revenge on the absurd system that sponsored the British sex comedies, in the process making a mockery of the performers themselves.

The hero of the piece is Dennis (Michael Armstrong). Naive, over ambitious and fresh out of film school, he haplessly attempts to flog his ideas down Wardour Street to no avail. Rebuffed by all the major players (*Columbia*, *Warners*, *United Artists* etc), he finds himself on the doorstep of down-at-heel *BUM Film Productions*. Managed by Benny U. Murdoch (Roy Kinnear), *BUM* is the home of such filmic treats as *Dirty Knickers*, *Randy Revolution* and *Cowboy On The Job*, but seeing no other opportunity open to him, Dennis reluctantly accepts Murdoch's offer to direct a movie based on the famous erotic poem *'Eskimo Nell'*. In order to finance the project Murdoch secures separate deals with three backers who each see *Eskimo Nell* in a completely different light. 'Big Dick', a brash American film mogul demands a hardcore version; educated Ambrose Cream wants a kung fu musical and ageing playboy Vernon Peabody envisages the first all-gay Western, with his young lover in the title role. When Murdoch suddenly nicks off with the cash, Dennis is forced to find a fourth backer, this time the mother of his upper-class girlfriend. Lady Longhorn is the chairperson for the Society Of Moral Reform, and agrees to put money into the project on the condition that *Eskimo Nell* is presented as a wholesome Christian family film.

The laughs come thick and fast as each of the backers, unbeknown to the others, tell Dennis and his virginal scriptwriter Harris Tweedle (played by *All Creatures Great And Small* actor Christopher Timothy), how they envisage the finished film. The look of utter shock and dismay on the faces of Armstrong and Timothy when 'Big Dick' describes his outlook on film-making is one of the most cherishable high points in Seventies comedy. *'What I need is 90 minutes of good solid hardcore pornography, none of that simulated crap,'* he bellows, *'I want to see everything. So you shoot it for real. I want to see girls being whipped, plenty of flagellation, bondage, rubber appliances, leatherware, chains, lesbianism, kinky gadgets and you can throw in a bit of bestiality at the same time. Then in the second scene we'll make....'*
Unwisely attempting to keep everybody happy, the young protagonists get themselves into an almighty mess, producing four distinct versions at break-neck speed. The action culminates with a mix-up involving the film processing which results in the hardcore *Eskimo Nell* being shown at a charity premiere at the Odeon, Leicester Square in the presence of Lady Longhorn and Her Majesty The Queen.

Produced by sex film veteran Stanley Long, who had the invaluable insight to think of the idea in the first place, *Eskimo Nell* is seen by many critics as the *only* worthwhile British exploitation film of the 1970s. It is inspired yes, original certainly, not only because it presents a sex film within a sex film but also as the reality of the situation never seems to be too far away. Writer/performer Michael Armstrong is great as the pretentious would-be *auteur* but

151

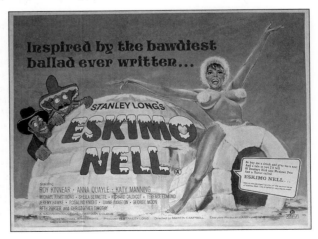

Mary makes her movie debut!

the real scene stealers are Roy Kinnear, having a ball playing the breast-obsessed Benny, and Diane Langton and Beth Porter (as Kinnear's well upholstered girlfriend Gladys, and Big Dick's porno protégé, respectively).

An unbilled Mary appears half way through the film as a traffic warden auditioning for a part in Dennis' cinematic epic. She is on screen for barely ten seconds, during which time she takes part in an amusing high speed strip, kicking off her shoes and flinging her clothes about with great enthusiasm. Hardly an auspicious or memorable start for a movie career. Mary may not have got the part in the 'pretend' *Eskimo Nell*, but in real life her seemingly inconsequential appearance caught the eye of more than one Wardour Street hustler, eventually leading to nearly a dozen more movie roles.

Reviews

'*Eskimo Nell* is a sustained satire on the film industry in general and the British market in particular, and unashamedly wallows in our great comic heritage. It is neither a sex film nor an offensive film, and it is miles from being the customary tatty product which it wittily knocks. If the makers had trimmed the odd 'fuck' or 'cunt' which creep in the second half (not among the film's funniest lines anyway), they could have doubtless achieved an AA rating, thus gaining the extra audience for a work which lies in the mainstream of *Carry On* humour. Some day the intelligentsia will acknowledge the fact that bawdy comedy is part of this country's heritage, and stop being ashamed of it.'
Films & Filming. September 1975.

'Not only for the bawdy comedy regulars, but also the broadminded who know enough about this side of the business to enjoy the send up. The bawdy jokes are of the broadest and the lowest [kind] and there is no shortage of obliging nudes, but the rollickings are enlivened with shrewdly observed caricatures.'
Cinema TV Today. 18 January 1975.

Tit Bits

● Katy Manning, who plays Michael Armstrong's annoying girlfriend in the film, was well used to over-acting as she had previously enjoyed a stint, screaming and tripping over in limestone quarries, as the girlie companion to Jon Pertwee's *Doctor Who*. On leaving the series in 1973 she attempted to shake off her goody two shoes image, but it wasn't just her role in *Eskimo Nell* that raised teenage eyebrows. She also famously posed nude with a Dalek in a British porno mag, much to the consternation of the BBC.

● Despite *Eskimo Nell's* impressive critical success it was not actually a very big hit at the British box office. Stanley Long's production company *Salon* had to wait until the following year for their really 'big' movie with the release of *Adventures Of A Taxi Driver* starring Barry Evans in the titular role as a randy cabby. Coming hot on the heels of the rival *Confessions Of A Window Cleaner* (1974) and aping its formula, the film became one of the most popular comedies of 1976 thanks to the tastes of the saucy British public. It was also an unexpected hit in Australia and New Zealand.

● Christopher Neil, who had a small part in *Eskimo Nell*, took over as the lead in the sequels, *Adventures Of A Private Eye* (1977) and *Adventures Of A Plumber's Mate* (1978) after Barry Evans declined to renew his contract. Twenty years later Neil was having adventures of a wholly different kind as multi-million selling Canadian songbird Celine Dion's record producer. At the other end of the showbiz spectrum, Evan's acting career declined steadily throughout the 1980s. Ironically, he was even forced to become a real-life taxi driver in order to make ends meet. He was found dead, in mysterious circumstances, at his home in Leicestershire in February 1997. He was only 52.

● On its initial London outing *Eskimo Nell* was released on a double bill with the Italian sex comedy *The Visitor* aka *Cugini Carnali* (1974) and later with an American 'thriller' called *Cry Uncle* (1971), retitled for the more sophisticated British audience as *Superdick*.

ESKIMO NELL

Great Britain / 1974 / 82 mins / cert X

CAST

Michael Armstrong...Dennis Morrison
Roy Kinnear...Benny U. Murdoch
Terence Edmond...Clive Potter
Christopher Timothy...Harris Tweedle
Diane Langton...Gladys Armitage
Gordon Tanner...Big Dick
Beth Porter...Billie Harris
Richard Caldicot...Ambrose Cream
Prudence Drage...Millicent Bindle
Jeremy Hawke...Vernon Peabody
Raynor Bourton...Johnny
Rosalind Knight...Lady Longhorn
Katy Manning...Hermione Longhorn
Anna Quayle...Reverend Mother
Jonathan Adams..Lord Coltwind
Christopher Biggins...Jeremy Longhorn
Stephen Riddle...Simon
Christopher Neil...Brendan
Sheila Bernette...Actress at casting
Lloyd Lamble...The Bishop
David Toguri...Kung Fu artist
George Moon...Nightwatchman
Tony Sympson...Grandfather
Beatrice Shaw...Grandmother
Jenny Short...Maggie
Mike Worsley...Charlie
Nicholas Young...Deadeye Dick
Lewis Barber...Mexican Pete
Graham Ashley...Projectionist
Dave Carter...Laboratory man
Connie Brodie...The Queen
Bill Maelor-Jones...Cinema manager
Mary Maxted...Traffic Warden stripper
Charles Pemberton...Policeman

CREDITS

Director...**Martin Campbell**
Producer...**Stanley Long**
Executive Producer...**Barry Jacobs**
Assistant Director...**Roger Simons**
Photography...**Peter Hannon**
Editor...**Patrick Foster**
Sound Recording...**Stan Phillips**
Musical Director...**Simon Park**
Choreography...**David Toguri**
Stuntman...**Paul Weston**
Screenplay...**Michael Armstrong**
Based on an original idea by **Stanley Long**

A SALON PRODUCTION Film

Distributed by EAGLE

Opened 17th January 1975
Scene Cinema, Wardour Street

come play with
martin campbell

The son of a New Zealand sheep farmer, Martin Campbell was determined not to follow in his father's footsteps; instead his overpowering ambition was to become involved in the serious business of film making. Travelling half way around the world to England in order to achieve his wish, he found the realities of being a camera operator at Elstree somewhat less than satisfying. Becoming a director, he figured, would be infinitely preferable. To better his chances of being noticed in an already overcrowded market, he produced a twenty minute long 16mm film, cheerfully showing it to anyone who would care to take a look. His actions eventually bore fruit, but in a most unexpected way. The fruit turned out to be sexploitation films.

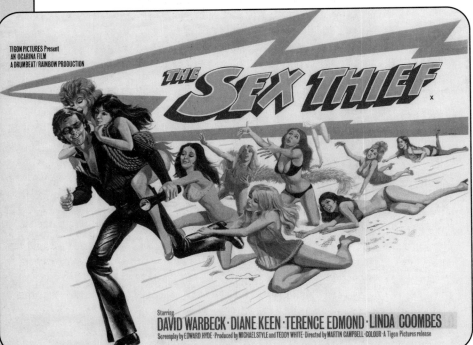

TIGON PICTURES Present
AN OCARINA FILM
A DRUMBEAT/RAINBOW PRODUCTION

THE **SEX THIEF**
x

Starring
DAVID WARBECK · DIANE KEEN · TERENCE EDMOND · LINDA COOMBES
Screenplay by EDWARD HYDE · Produced by MICHAEL STYLE and TEDDY WHITE · Directed by MARTIN CAMPBELL · COLOUR · A Tigon Pictures release

1973's *The Sex Thief* gave Campbell his first taste of cinema and proved to be the beginning of a long association with jack-of-all-trades film-maker Tudor Gates, aka Teddy White (with whom he later made two further movies). Campbell's debut was stylishly different from much of the sex film fare around at that time and was sufficiently successful at the box office for him to be noticed by legendary producer Stanley Long, who hired him to direct one of the high points of British sex cinema, *Eskimo Nell.* After the critical success of that film he badly burnt his fingers with the follow-up. Released in 1975, the long-forgotten *Three For All* sounded like an exciting *ménage à trois* sex film, but in fact was a Spanish comedy musical starring fresh young faces Paul Nicholas, Robert Lindsay and er... Arthur Mullard. Returning to the more profitable ground of soft porn in 1976, he scored well with *Intimate Games*, this time acting as production supervisor and leaving the directing to his friend Tudor.

After working on the production side of three British movies in the late Seventies, Campbell moved to television, directing episodes of *The Professionals*, *Minder* and *Reilly Ace Of Spies*, culminating his small-screen career with the BAFTA award-winning *Edge Of Darkness* in 1985. There followed a period working with George Harrison's *Handmade Films*, but it was Campbell's move to the USA that marked his big screen renaissance. 1989's *Criminal Law* (starring Gary Oldman) was a big hit, and got his name noticed across the Atlantic. Then he really hit paydirt with the helming of the long overdue return of James Bond in 1995's *Goldeneye*, the most financially successful entry in the franchise for well over a decade. In recent years Campbell has been more than a little reticent in recalling his sex film past, but who else has a CV boasting both 007 and Mary Millington?

Martin Campbell's filmwork includes: *The Sex Thief* aka *Her Family Jewels* (1973) (dir), *Eskimo Nell* (1974) (dir), *Three For All* (1974) (dir), *Intimate Games* (1976) (prod sup), *Red* (1976) (prod sup), *Black Joy* (1977) (co-prod), *Scum* (1979) (assoc prod), *Criminal Law* (1989) (dir), *Defenseless* (1991) (dir), *Cast A Deadly Spell* (TV1991) (dir), *No Escape* (1994) (dir), *Goldeneye* (1995) (dir) and *The Mask Of Zorro* (1998) (dir).

Erotic Inferno

Great Britain / 1975 / 80 mins / Cert X

Erotic Inferno enjoys a rare distinction among British sex films. It actually has quite a bit of sex in it, in fact almost three quarters of the film's running time is devoted to the characters' continual pokings and pawings. Coming across like an overblown soap opera with added nudity, the film is populated by unpleasant men and women who do very little to gain the sympathy of any cinema audience worth their salt. Stereotypes are the name of the game here; the chaps are big, butch and dominant. Or, in other words, manipulative sexist pigs with huge libidos and a penchant for calling their wives and girlfriends 'bitches', usually whilst delivering a friendly slap. The women are submissive, weak and sexually compliant; unable to say no to their detestable partners.

Everybody has sex with everybody else and although no-one is innocent as to the meaning of the word 'infidelity', the men are easily the biggest sluts of all. The quite considerable action takes place on a large country estate, and in particular in the vicinity a beautiful riverside manor house. When the rich and degenerate old Mr Barnard is reported missing at sea, presumed dead, his solicitor, the pious Eric Gold (Michael Sheard) informs his client's two sons of the tragedy. Martin (Christopher Chittell) is the violent older brother who treats his gentle fiancée Brenda (a dubbed performance by Jeannie Collings) shamefully, and never gave a monkeys about his father anyway. His younger sibling is a deeply unattractive, wimpy smart-arse called Paul (Karl Lanchbury).

Gold tells Martin and Paul that their father's will is to be read on the estate the following weekend but on no account must they enter the manor house in the meantime; instead they must stay in the adjacent lodge with the

A sulky-faced Mary is infuriated by her girlfriend's flirting with the opposite sex

sleazy womanising estate manager, Adam (Michael Watkins) and his girlfriend, the housekeeper Nicole (played by *Benny Hill Show* regular Jenny Westbrook). None of them get on but this does nothing to deter them from having a weekend together jam-packed with recreational sex. Martin especially is a real charmer with a love of impersonal quickies and a fine line in sensuous chat. *'Oh you little hot sex kitten. This is what you want isn't it?'* he tells a bemused Brenda, before later attempting to shag Nicole over the kitchen table whilst she lays it for breakfast. He even tries it on in the stable block with the stupid Gayle (Heather Deeley), explaining to her that, *'The smell of horses drives me crazy!'* A dinner party later that night provides all the characters with ample opportunity for flirting, exchanging meaningful glances and some groping under the table. By the finale Brenda and Adam have come out tops, each having had their wicked ways with three of the others. The incessant sexual gymnastics rather get in the way of any further plot development; suffice to say that old Mr Barnard's death has all been a cunning ruse. He has been holed up in the locked manor house for the duration of the weekend, enjoying the company of a couple of blonde popsies, with the peculiar intention of observing his sons' reaction to his 'demise'.

Erotic Inferno marked a significant step up from the brevity of Mary's part in *Eskimo Nell*. Her role as lesbian stable hand Jane is miles away than anything she had done previously (even though her voice was later dubbed, much to her subsequent dismay). She had never looked more elegant or sexy on screen before; in the dinner party scene in particular the subdued lighting makes her look absolutely stunning. Dominating her screen girlfriend (Heather Deeley), Mary displays a nasty, moody, jealous side, unhappy with her partner's frequent flirting and blatant bisexuality. In a vain attempt to protect her girlfriend, her character treats the film's men with understandable contempt and disdain.

Jenny Westbrook is menaced by Michael Watkins in **Erotic Inferno**

More concerned with sexual hi-jinx than any mucking out the stallions, Mary and Deeley enjoy some uncomfortable foreplay in the straw before retiring for a prolonged sex session back at their lodgings. To be honest *Erotic Inferno's* only erotic moments are reserved for the tenderness of this lesbian love making, which is in stark contrast to the heterosexual 'slam bam, thank you mam' shagging the movie revels in.

Review

'Strictly for male voyeurs. A humourless farrago reeking of sexist attitudes. The effort of cramming so many copulations into the time proves too much for the coherence of the nebulous plot and prevents the cast from injecting any humour and warmth into the wrigglings and wranglings.' **Cinema TV Today. 17 May 1975.**

Tit Bits

● Ten years after playing the wicked Martin Barnard in *Erotic Inferno*, actor Christopher Chittell was back in the English countryside starring as ruthless Eric Pollard in popular soap opera *Emmerdale*, a role he still enjoys today. But *Erotic Inferno* was not Chittell's only foray into porn. In 1974 he, allegedly, featured in several hardcore sex scenes in the Swedish movie *Let Us Play Sex*. Chittell followed this with another, *Country Life* in 1976, again directed by Scandinavian sex maestro Torgny Wickman. When confronted with stills from the latter in March 1994, the embarrassed actor told David Sullivan's *Sunday Sport* that he did the movies because he was 'stony broke and they were the only work I could get'.

● Another of *Erotic Inferno's* players, Michael Sheard also went onto much bigger things, although he was forever typecast as villains. His career path took numerous twists and turns and five years later he was co-starring alongside Darth Vader in *The Empire Strikes Back* (1980) before eventually landing the role he was most remembered for, the tyrannical teacher Mr Bronson, in the BBC children's television serial *Grange Hill*.

● 1975 was certainly Heather Deeley's year. At the age of only nineteen the press were heralding the *Erotic Inferno* actress as 'Britain's new succulent sex star!' Before the year was over pretty, doe-eyed Heather had completed work on four more movies: *Girls Come First*, *Secrets Of A Superstud*, *Sex Express* and Mary Millington's next hit *I'm Not Feeling Myself Tonight*. Her sixth big screen film release of 1975 was to have been David Grant's *Pink Orgasm* in which she played the female lead opposite legendary US hardcore porn actor, and *Deep Throat* star, Harry Reems. The film's production was troubled with problems from the very start and, although most of *Pink Orgasm* was actually completed, the movie never saw the light of day. Heather's high profile in the British sex industry meant she was much sought-after for film work (she had not objected to performing in hardcore scenes in the export version of *Sex Express*), but her subsequent cocaine addiction only fuelled rumours that she was becoming difficult to work with.

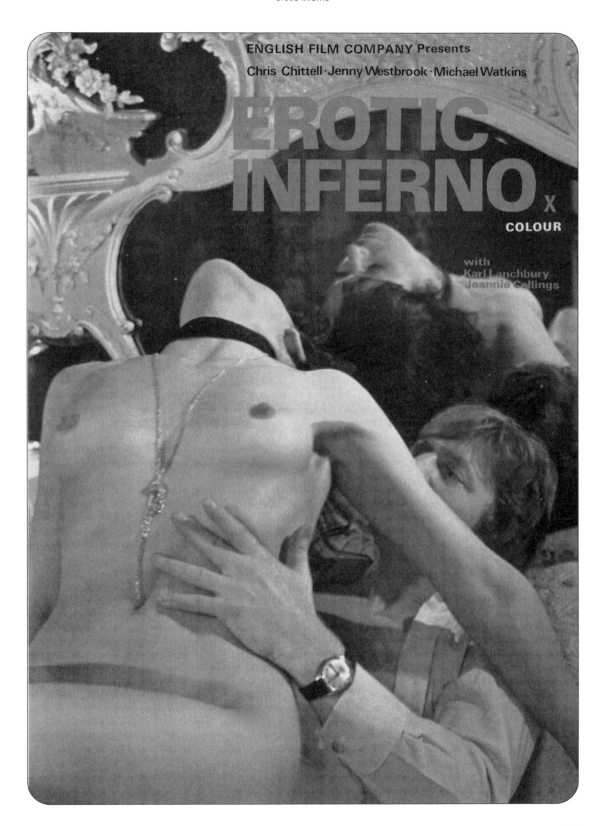

Christopher Chitell (pictured above with Jeannie Collings)
now stars in Yorkshire Television's hit soap opera
Emmerdale

Deeley appeared in only two further films - as a bisexual student in *Intimate Games* (1976) and a voyeur in *Hardcore* (1977) - before eventually reappearing, in somewhat reduced circumstances, as a stripper in a seedy Soho club.

● In February 1976 it was reported that G. & W. Walker Limited, the landlords of Soho's Astral Cinema where the film was showing, had sought a High Court order to stop its screenings. Their grounds were that *Erotic Inferno* was 'lewd and pornographic' and in breach of a covenant on the building's lease. This foolhardy move was unsuccessful (after all this is Soho we are talking about), and three years later the movie was still happily playing on the site. In the Willy Roe produced *Boys And Girls Together* (1979), the film's hero takes an 'educational' stroll around the West End and is distracted by the *Erotic Inferno* poster outside the Astral.

● The going rate for a jobbing exploitation writer in the 1970s was hardly excessive. Jon York was paid a paltry £250 for his script for *Erotic Inferno*. Actually, it was probably more than he deserved.

● The film was called *Adam And Nicole* during production but this was later dropped in favour of the more generic *Erotic Inferno*. The original title was retained for distribution in the US, but for a later video release the film was re-named again as *Naked And Willing*.

EROTIC INFERNO
Great Britain / 1975 / 80 mins / Cert X

CAST
Michael Watkins...Adam
Jenny Westbrook...Nicole
Chris Chittell...Martin Barnard
Karl Lanchbury...Paul Barnard
Jeannie Collings...Brenda
Heather Deeley...Gayle
Mary Maxted...Jane
Michael Sheard...Eric Gold
Brian Hawksley...Vicar
Anthony Kenyon...Old Mr Barnard
Monika Ringwald...Girl in hotel bed
Lindy Benson...First blonde
Lynne Worral...Second blonde

CREDITS
Director...**Trevor Wrenn**
Producer...**Ken Coles**
Executive Producer...**Bachoo Sen**
Assistant Director...**Barry Langley**
Photography...**Dudley Lovell**
Editor...**John Rogers**
Sound Recording...**Brian Marshall**
Screenplay...**Jon York**

Produced & Distributed by
THE ENGLISH FILM COMPANY

Opened May 1975
Astral Cinema, Brewer Street

I'm Not Feeling Myself Tonight

Great Britain / 1975 / 84 mins / Cert X

If there were a competition for the very worst British sex comedy, then *I'm Not Feeling Myself Tonight* would surely take the gold medal. If the hackneyed story of a 'sonic aphrodisiac', or sex ray (yes really!), which instantly gets women all hot and bothered was not enough to make you slit your wrists, then the fact that the film-makers fail dismally to flesh out the plot with anything resembling 'jokes' should just about finish you off.

Viewers with weak stomachs and itchy palms did not actually have to wade through the full 84 minutes to catch a glimpse of Mary in all her glory. Her unbilled cameo helpfully appears during the pre-credits sequence. After that it's safe to say that the 'man in the mac' was probably better off leaving the cinema, safe in the knowledge that he had already seen the best bit.

As Mary's last bit part in a British film before she became a fully fledged Millington, she appears, not unexpectedly, as an insatiable sex-pot. Wiggling down a London street in stacked heels, denim mini-skirt and tight white top, she is obviously a woman with only one thing on her mind. Even her T-shirt screams seduction, emblazoned as it is with the logo from 1974's sex-fest *Emmanuelle*. Spotting unprepossessing office cleaner Jon Pigeon (Barry Andrews) from behind her trademark huge sunglasses she licks her lips in typical sex comedy fashion and he responds with the obligatory English 'phworr'. Sadly for Andrews, he doesn't act quickly enough, as Mary is suddenly and improbably whisked into a striped workman's tent by a randy hole digger. In true *Benny Hill* style we see the tent tremble excitedly before the camera is invited inside to watch some knicker removing, French kissing, sucking and obviously simulated rodgering. If this unrelated scene seems rather ill-at-ease with the rest of the movie, then you wouldn't be wrong.

*Conscientious boss James Booth carefully inspects his workforce in **I'm Not Feeling Myself Tonight***

Originally written by exploitation work-horse David McGillivray, *I'm Not Feeling Myself Tonight* suffered badly from extensive re-writes undertaken by its disillusioned director Joe McGrath. Mary's scene was tacked onto the front of the film just before its release, without McGillivray's knowledge and in a desperate attempt to increase the flesh quotient. When the screenwriter went to see the finished film at the cinema he was hard pushed to recognise any of his dialogue, let alone the plot.

The rest of the story, for what it's worth, is set at the Hilderbrand Institute Of Sexual Stimulation And Research, managed by the cruel megalomaniac Mr Nutbrown (James Booth). Most of Nutbrown's staff seem to spend their time running after naked women and the tannoy blares regular announcements like *'Doctor Smith to the ejaculation room please'*. In the lecture theatre Bill Maelor-Jones is teaching his eager beaver students about erogenous zones, whilst a naked couple have intercourse on the table right in front of him. The aforementioned Barry Andrews (who sadly lacks the comic timing of Robin *'Confessions'* Askwith) plays the film's archetypal sex-obsessed male lead, who never gets the girl but has, frustratingly, got himself a job as a lowly janitor at the institute. To cut a long, and ridiculous, tale short he and his dim-witted sidekick Keith (a cute, underwritten Billy Hamon) accidentally invent a sex ray - fondly called Agnes - in their broom cupboard. The device is able to arouse people with sound waves but, far from running smoothly, chaos soon ensues. Andrews is invited to one of Nutbrown's summer garden parties and is intent on using the sex ray to lure elegant secretary Cheryl (Sally Faulkner). Naturally his plan fails and the entire event is reduced to a free-for-all sex orgy. Realising Agnes's sensual possibilities Nutbrown and his boss, Trampas B Hilderbrand (Ben *'Hi-De-Hi'* Aris) steal the invention and attempt to pass it off as their own. Unfortunately it explodes before they have the opportunity to exploit its pulsating pelvic power.

The title is easily the best thing about this film. *I'm Not Feeling Myself Tonight* is up there with *Can You Keep It Up For A Week?* (1974) and *Girls Come First* (1975) as classic British double entendres, but aside from that if the idea of watching veteran actress Rita Webb (as the institute's tea lady) making a grab for Andrews' crotch is just too distressing a thought then this definitely ain't the movie for you (or your friends, for that matter).

A workman's tent proves to be a hotbed of passion for Mary

Review

'Satisfaction eludes [the hero] in much the same way that entertainment eludes the audience. It is depressing to see David McGillivray writing scripts like this or actors like James Booth acting in them.'
Films Illustrated. February 1976.

Tit Bits

● This was not co-producer John Lindsay's first mainstream sex film. In 1971 he wrote and produced *The Love Pill,* a cheap and rubbishy comedy about a corner-shop contraceptive tablet that turns women into, surprise surprise, nymphomaniacs. The movie's only half-decent gag involves a parallel Soho world where women solicit male prostitutes on street corners and wear dirty raincoats to all male peep shows. Lindsay's credit was stupidly removed from the titles of *I'm Not Feeling Myself Tonight* after his obscenity trial, where he was found not guilty, in Birmingham in 1974.

● One of Lindsay's hardcore porn stalwarts, Tim Blackstone, makes an impromptu appearance in *I'm Not Feeling Myself Tonight* as a randy participant in the orgy sequence. Male sex film performers have been traditionally rather thin on the ground in the UK and Blackstone was one of a rare breed of recognisable faces (and bodies) during the 1970s. The hardcore equivalent of Robin Askwith, Blackstone was about the nearest Britain had to a male Mary Millington. He graduated from anonymous 8mm sex films to small roles in saucy mainstream comedies like *The Hot Girls* (1974), *All I Want Is You...And You...And You* (1974), *Sex Express* (1975) - in which he gets murdered by Heather Deeley, *Under The Bed* (1976) and *Let's Get Laid!* (1977). Tall,

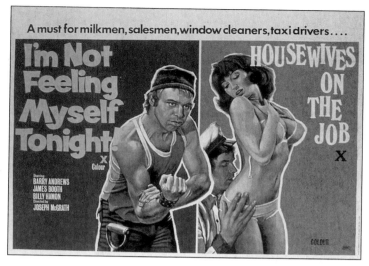

blond haired and blue-eyed, Blackstone was a cut above his middle aged, beer-gutted male contemporaries and became a naked mainstay of porn magazine layouts for the best part of the decade. He was used extensively by *Whitehouse* and *Playbirds* magazines for the racy promotional photographs for *Come Play With Me* despite not actually appearing in the movie. In 1981 Blackstone made a comeback in David Sullivan's *Emmanuelle In Soho* playing Julie Lee's bisexual lover, Derek. As always, he was cast as a slimy, cocksure, arrogant stud, or as Lee's character comments: *'A once in a lifetime screw'*.

● Legend has it that director Joe McGrath hated sex comedies so much that he directed some of the scenes in *I'm Not Feeling Myself Tonight* with his back to the performers. However, his dislike of the genre didn't stop him from also taking the helm of *Girls Come First* (1975). The film's stale jokes were described by *Monthly Film Bulletin* as having been 'scraped from the dustbin of British rubbish'. He wisely decided to use the pseudonym 'Croisette Meubles' on the credits, but nobody cared anyway.

● Fervent anti-porn campaigner Mary Whitehouse was an easy target for ridicule and Seventies sex film producers were only too keen to parody her. In *I'm Not Feeling Myself Tonight* actress Geraldine Hart plays a thinly-veiled character called 'Mrs Watchtower' from the 'Clean Up The World Campaign'. After getting a blast from the sex ray, Watchtower strips to her underwear and suddenly becomes a sex crazed gin-swigger with a penchant for hardcore porn films. (*'This one's so much more technical than the others,'* she comments. *'And so much more corrupting!'*) A similar ploy is used in *Hardcore* (1977) when frumpy moral crusader 'Norma Blackhurst' (Joan Benham) is tricked by Fiona Richmond into saying 'fuck' live on a television talk-show.

● Against impossible odds, the film (released as one half of a double-bill with German rubbish *Housewives On The Job*) was a colossal hit when it opened at Soho's Moulin cinema in February 1976. It ran for fifteen weeks, taking £53,820 before being replaced, coincidentally, by Mary's next film, *Intimate Games* on 16th June.

Postman loses trousers - only in a British sex comedy

161

I'M NOT FEELING MYSELF TONIGHT
Great Britain / 1975 / 84 mins / Cert X

CAST
Barry Andrews...Jon Pigeon
James Booth...Nutbrown
Sally Faulkner...Cheryl Bascombe
Billy Hamon...Keith Furey / Keith's parents
Ben Aris...Trampas B. Hilderbrand
Ronnie Brody...Neighbour
Freddie Earl...Cowboy
Bill Maelor-Jones...Lecturer
Brian Murphy...Caretaker
Chic Murray...Fred
Marje Lawrence...Caretaker's wife
Graham Stark...Hotel M.C.
Katya Wyeth...Wendy
Rita Webb...Tea lady
Gennie Nevinson...Vera
Juliette King...Heidi
Jo Peters...Deidre
Jean Collins...Miss Bagnell
Sally Harrison...Woman on video tape
Mike Grady...Boy Scout
Robert Dorning...Man at party
Marianne Stone...Consultant
Mary Maxted...Girl in sunglasses
Bob Godfrey...Postman
Steve Amber...Policeman
Penny Croft...Traffic Warden
Geraldine Hart...Mrs Watchtower
Andrea Lawrence...Mrs Nutbrown
Gracie Luck...Mrs Hilderbrand
Heather Deeley...Girl in lecture theatre
Suzanne Bass, Bobbie Sparrow &
Glenda Allen...Nutbrown's girls
Steve Farnham & **Lynne Worral**...Young couple
Andy Dempsey & **Drew Wood**...Young men
Monika Ringwald, David McGillivray, Lindy Benson
Tim Blackstone, Caroline Davies, Eva Lewis,
Denise Denny, Laurie Goode, Michael Cox,
Andy Cromarty & **Gerry Crampton**...Party guests

CREDITS
Director...**Joseph McGrath**
Producer...**Malcolm Fancey**
Co-Producers...**Laurence Barnett** & **John Lindsay**
Photography...**Ken Higgins**
Editors...**Jim Atkinson** & **John Carr**
Music...**Cy Payne**
Art Direction...**Tony Curtis**
Screenplay...**David McGillivray**
Based on an idea by **Laurence Barnett**

An ANTLER FILM Production
Distributed By NEW REALM

Opened 26th February 1976
Classic Moulin, Great Windmill Street

Intimate Games

Great Britain / 1976 / 90 mins / cert X

Suzy Mandel and Heather Deeley

By 1976 the name 'Mary Millington' was synonymous with British porn and David Sullivan's publications in particular. It seems particularly odd then that the first movie to utilise her new surname had absolutely no connection whatsoever with her parent company *Roldvale*. Rather *Podenhale Film Productions* got there first, nearly a year before *Come Play With Me* was unleashed on a not so unsuspecting public (with publicity material erroneously claiming that it was the debut double M feature).

 Intimate Games does not unveil Mary with a flurry of trumpets or anything else for that matter and she was strangely absent from the movie's pre-release material. The film's main selling points were its other female stars, notably Suzy Mandel, Heather Deeley and Anna Bergman. Little did anyone know that in a matter of months Mary's cinematic fame and popularity would eclipse that of all her co-stars.

 The year of the film's release saw the staging of the Olympic Games in Montreal; not to be outdone, Britain launched its cinema counter-offensive with games of a far more personal nature. The movie poster - incidentally not featuring Mary - was even a pastiche of the five ringed Olympic symbol, with the stars' heads (and chests) popping out from the circles. That, however, was the full extent of any sporting analogy, *Intimate Games* being a different ball game entirely.

 Set in a large but rather sparsely attended university (which, judging by the exterior shots, can't make up its mind whether it's based in Oxford or London!), the film begins with stoney-faced psychology lecturer Professor Gottlieb instructing his students on their Christmas vacation project. No surprises here, it's a thesis on sexual fantasies! The randy students need little encouragement in that department and waste no time

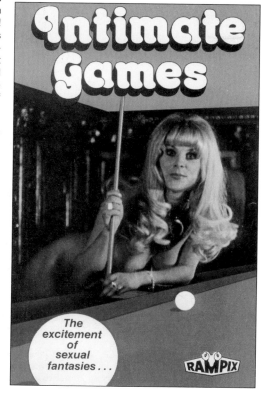

getting down to the matter in hand back at their halls of residence. A healthy mass-debate ensues, so to speak, with some peculiar fantasies emerging from the minds of the over-grown pupils (who, incidentally, come across like members of a more sexually-aware *Fenn Street Gang*). From there on in, it's *Carry On Campus* all the way! John (Peter Blake) admits to kinky dreams about the players' changing room at Leeds United FC whilst Suzy (Anna Bergman) seems obsessed with sucking her friends' thumbs - the deeper significance of that is lost on no-one. Meanwhile the university's very own blonde bombshell, Cathy (Felicity Devonshire) ends up seducing shy, stuttering Benny, in order to satisfy her yearning for an 'enormous chopper'. Although most of the 'enquiries' are carried out in strict boy/girl pairings, Erica (Suzy Mandel) and her room-mate Marion (Heather Deeley) give lesbian sex a go, just for the hell of it. *'This isn't lesbian seduction is it?'* trembles Deeley, to which Mandel soothingly replies, *'No darling. It's an experiment!'* Their poorly-lit, slow-motion tussle is a less than satisfying experience for the cinema audience, but actually turns out to be the only sensitive scene in the whole movie. To their great relief, the girls realise that they are not dykes (Heaven forbid!) but are both totally 'normal', apart from the fact that they like shagging each other from time to time!

After their practical research sessions on campus, the students return to their respective homes and wisely embark on a series of interviews with the aim of building up various case studies. Subjects include a jockey (rubber-faced Johnny Vyvyan) who desires saddling up a fat woman rather than a horse; bird-fancier Hugh Lloyd who dreams about pink tits instead of grey pigeons; Ex-*Avenger* Ian Hendry as a snooker player wanting the end of his cue 'chalked'; and glamorous char woman Joyce Blair (sister of nimble-footed Lionel) who fantasises about being the next Marilyn Monroe and taking on three men at once. Mary's own brief scene appears in one of these little vignettes. A mop-topped garage mechanic called Joe recalls his misspent youth singing in the church choir. The 'smashing bird' of his attentions is a certain Miss Millington. She

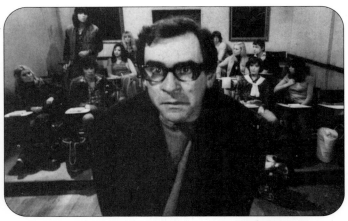

George Baker gets stressed-out in **Intimate Games**

may well look sweet and innocent, but Joe takes his chance and has a fumble 'round the back of her gown during the Sunday service (resulting in her singing totally out of tune). Mary's scene is hardly very funny but is notable as her one and only film role where she actually keeps all her clothes *on!*

Viewing the film today, the most shocking revelation of *Intimate Games* is not the sexual jiggery-pokery on show, but the participation of dashing stage and television favourite George Baker in the role of the sexually frustrated psychology professor, (incidentally, the actor has been known to leave the film off his CV in recent years). When his character suffers a mental breakdown through over-work, he imagines his lecture hall full of naked students and makes a pathetic lunge at the heaving bosom of Heather Deeley. Watching him being carted off in an ambulance, frothing at the mouth, is an experience even the most loyal *Inspector Wexford* fan would find hard to appreciate!

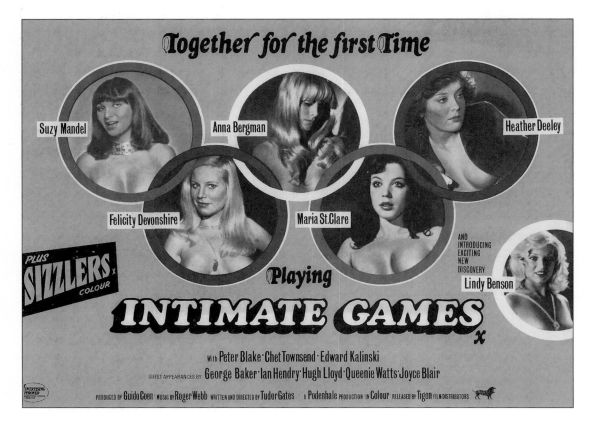

Reviews

'The young actors have vitality and charm. The guest stars have my sympathy.'
Screen International. 24 April 1976.

'A cast of fresh faced girls and clean limbed young men cavort through this grindingly unfunny British sex comedy in the apparent ignorance of the debilitating constraints of its coy, assembly line plot. The discomfort of troupers like George Baker and Ian Hendry at participating in this tedious nonsense is, however, as apparent as the absence of passion from the decorous dimly lit lesbian love making.'
Monthly Film Bulletin. June 1976.

Tit Bits

● Opening on three separate screens in London's West End, *Intimate Games* eventually ran for 9 weeks solid at the Moulin complex taking £22,737. On its initial release the film enjoyed the company of an American support feature called *Sizzlers* (1975), which suitably alluring title masked the disturbing tale of three escaped convicts who break into a correction school for teenage girls. Because Tigon retained the distribution rights to *Intimate Games* it was later reissued with *The Playbirds* in 1979 as a *'Tantalising Mary Millington Double Bill'*.

● Hugely underrated blonde character actress Claire Davenport suffers the indignity of being ridden like a racehorse in *Intimate Games*. Claire, famed for her tremendous height and weight, was regularly called upon by comedy directors in the 1970s whenever they required an actress for the strenuous roles of 'fat woman' or 'bossy wife'. Best remembered as Dick Emery's domineering wife in his BBC sketch show, Claire also played topless or boob-centric parts in films such as *The Bawdy Adventures Of Tom Jones* (1975), *Adventures Of A Plumber's Mate* (1978), and *Carry On Emmannuelle* (also 1978). She was re-discovered in the late Seventies by legendary arthouse director Derek Jarman. In his kinky adaptation of Shakespeare's *The Tempest* (1979), she can be seen breast-feeding a grown man. Claire reached the pinnacle of her career four years later when she played a giant slug in *Return Of The Jedi* (1983).

● Before working on both *The Sex Thief* (1973) and *Intimate Games*, director Tudor Gates (aka Teddy White) had been employed as screenwriter on a trio of red-blooded Hammer Horrors - *Lust For A Vampire* (1970), *The Vampire Lovers* (1970) and *Twins Of Evil* (1971) - as well as writing the cult Jane Fonda movie *Barbarella* (1967). His final film script was for one of the very last British sex comedies: the silly but enjoyable *Sex With The Stars* aka *Confessions Of The Naughty Nymphos* (1980).

INTIMATE GAMES
Great Britain / 1976 / 90 mins / Cert X

CAST
George Baker...Professor Gottlieb
Suzy Mandel...Erica
Anna Bergman...Suzy
Felicity Devonshire...Cathy
Heather Deeley...Marion
Maria St Clair...Jane
Peter Blake...John
Hugh Lloyd...John's Father
Queenie Watts...John's Mother
Ian Hendry...Uncle Rodney
Joyce Blair...Beryl
Chet Townsend...Nick
Edward Kalinski...Benny
Norman Chappell...Principal
Johnny Vyvyan...Jockey
Claire Davenport...Fat stripper
Mary Millington...Choir girl
Martin Neil...Joe
Susan Glanville...Frustrated housewife
Steve Amber...Imaginary lover
Barbara Eatwell...Pigeon girl
Forbes Collins...Squire
Lindy Benson...Blonde wife
Monika Ringwald...Naked secretary
Normaline...Hazel the maid
John Benson...Executive
Michael Clarke...Gay motorist
Guy Standeven...Psychiatrist
Dudley Stevens...Prisoner
Jonathan David...Interrogator
Peppi Borza, **John Melainey** & **Roger Finch**...Dancers

CREDITS
Director...**Tudor Gates**
Producer...**Guido Cohen**
Production Supervisor...**Martin Campbell**
Assistant Director...**Nick Farnes**
Photography...**Frank Watts**
Editor...**Pat Foster**
Camera Operator...**Ian Miller**
Art Direction...**Tony Curtis**
Sound Recording...**David Lawton**
Music Composed & Conducted by **Roger Webb**
Sex aids supplied by **Item**
Original Story & Screenplay...**Tudor Gates**

Produced by PODENHALE PRODUCTIONS LTD
Distributed by TIGON

Opened 16th June 1976
Classic Moulin, Great Windmill Street

come play with

suzy mandel

*One of Suzy's appearances on the cover of **Playbirds**, as part of the relentless publicity drive for **Come Play With Me***

A brunette with a cherubic face, a well-educated air and a dash of arrogance, Suzy Mandel became one of the most recognisable sex film actresses of the 1970s, competing with Sue Longhurst as probably the most accomplished actress working in the genre. Film credits could never quite remember how many letter L's she had at the end of her name, but the cinema-going public loved her regardless. Although she wasn't best known as a porno magazine model, Suzy nonetheless appeared as a topless covergirl on several of David Sullivan's publications, particularly during 1977 and 1978 when she featured in the producer's first two movies. Her pulling power at the box office is well illustrated by the fact that she shares equal space with Mary on the startling posters for *Come Play With Me* and *The Playbirds*.

Directors were confident about giving Suzy big speaking parts - she plays one of the leads in *Intimate Games* with great aplomb - but she was understandably better known for her shape (although the close up of her dimpled bum in *The Playbirds* is an absolute shocker!). Suzy went on to become a regular in *The Benny Hill Show* from 1974 and a move into films was inevitable. After starring in six sex comedies between 1976 and 1978, she bade farewell to the UK and emigrated to America with her wealthy businessman husband.

Stateside, she landed the lead role in the acclaimed sex musical *Blonde Ambition* (produced and directed by the infamous Amero brothers), in which she was required to do a strip whilst skating on an ice rink! She also performed in hardcore sex scenes for the first time, although Suzy later claimed, rather contentiously, that these had been faked with a body double. Now retired from the acting profession she currently resides in New York.

Suzy's movies include: *Intimate Games* (1976), *Confessions Of A Driving Instructor* (1976), *Come Play With Me* (1977), *Adventures Of A Plumber's Mate* (1978), *The Playbirds* (1978) and *You're Driving Me Crazy* (1978). In the USA she starred in *Blonde Ambition* (1980), *The Private Eyes* (1980) and *The Mistress Of The Apes* (1981).

*right: Suzy as Lena Cunningham in **The Playbirds** (1978)*

Keep It Up Downstairs

Great Britain / 1976 / 90 mins / cert X

'It didn't take a shilling. They spent a fortune on it and although Mary made it about the same time as *Come Play With Me* I said it was a joke. Ours made a fortune and theirs took nothing. It was a flop.'
(David Sullivan on *Keep It Up Downstairs*)

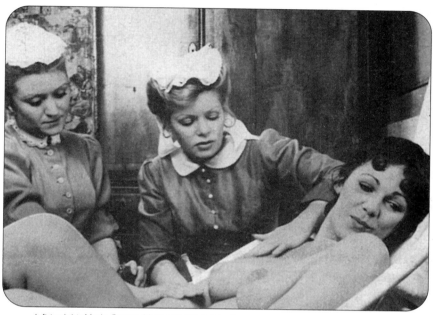

left to right: Maria Coyne, Mary and Olivia Munday

Whatever David Sullivan thought of *Keep It Up Downstairs*' takings at the box office (and his prediction came true, it was indeed an expensive flop, running for only one week in the West End), the film itself is in a wholly different league from his own first attempt at film-making. *Keep It Up Downstairs* is unusual for a British sex film in that it enjoys a period setting, 1904, and is all the better for it. With the directorial duties in the capable hands of Robert Young, the movie is definitely the best looking and most professionally photographed entry in the 1970s sex film canon.

This spoof on TV's *Upstairs Downstairs* and other historical dramas was produced by the Pyramid Film Company, formed in 1970 by a surprisingly odd pair of bedfellows. The company's directors were Hazel Adair, co-creator of the most spoofed soap opera of all time, *Crossroads*, and sporting commentator Kent Walton. Starting out as a disc jockey in the 1950s, Walton presented the first television pop show, *Cool For Cats*, before finding his vocal talents exploited as the voice of Saturday afternoon wrestling. In order to preserve their dubious reputations Adair and Walton adopted a joint producer pseudonym for their early sex films: *Clinic Xclusive* (1971) and *Can You Keep It Up For A Week?* (1974). But in 1975 they were both 'outed' in the press and by the time *Keep It Up Downstairs* was released everybody knew about their X-rated business interests.

Producer-writer Adair, obviously not wanting to stray too far from safe ground after the success of comedy *Can You Keep It Up For A Week?*, not only recycled half that movie's title for her new historical sex comedy, but half the cast as well. *Keep It Up Downstairs* is by far the superior production, but perversely enough might just have suffered from being a little too classy for the typical sex film audience.

The story is concerned with the saucy goings-on at an English stately home, Cockshute Towers, at the turn of the century. Lord and Lady Cockshute (Mark Singleton and Sue Longhurst) are in debt to the tune of £100,000, the family jewels are made of paste, and they stand to lose their ancestral estate unless they can come up with a get-rich-quick scheme as soon as possible. The only one in the household with any brains is conniving sex-mad butler, Hampton (handsomely played by Neil Hallett), and it is he who is called upon to find a solution to their problems. A plan is hatched to arrange a financially advantageous marriage between the Cockshute's entrepreneurial but boring son Pereguine (Jack Wild) and the daughter of a rich American couple Daisy and Francis Dureneck (Diana Dors and John Blythe), who are in Britain for a holiday.

No man was asked to do so much, by so many, in so little time . . .

Can you Keep it up for a week? x

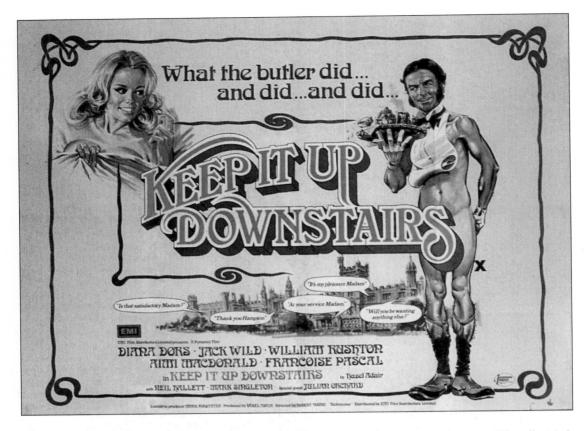

It is no wonder the family's finances are in such bad order since the Cockshutes have very little self control, even in their private lives. Nobody, it seems, can keep their hands to themselves. Hampton brings his mistress more than just breakfast in bed; Lord Cockshute tries it on with French maid Mimi (Francoise Pascal); bisexual Lady Kitty (Olivia Munday) enjoys the amorous attentions of the groom as well as the parlour maids, and Lady Cockshute is determined to seduce her step-son. *Keep It Up Downstairs* offers a consistent and balanced mix of sex and comedy with nicely well-rounded performances, plenty of nudity, lots of double entendres in the *Carry On* tradition and a bucketload of vulgar phallic sight gags (the barrel of a gun, coal tongs, even a bandaged finger). Some of the old jokes come straight out of the Mae West handbook, *'I've heard sex isn't good for one!' / 'It isn't, but it's marvellous for two!'* and *'I'm always telling him he's far too fat and how about that stomach? If that was on a woman you'd think she was pregnant!' / 'It was, and she is!'* There's even an actress and Bishop skit with guest stars Aimi MacDonald and Julian Orchard.

Gratifyingly for a sex comedy, the meshing of the straight cast and the sexual performers is spot on with Mary Millington and an oddly sparkling Diana Dors offering up the twin peaks of sensuality and laughs. Mary was given the underwritten role of saucy scullery maid Polly and despite her lack of lines she is the film's main focus of sexual interest. Mary peppers the proceedings with several substantial sex scenes. Her character makes love to the stable hand under the dining room table whilst the Cockshutes have a family conference above; she enjoys a topless fondle in a tree-house with both old smoothie John Bythe and the randy gamekeeper, Mellons (sex film regular Anthony Kenyon) and most impressively features in a surprisingly out-of-place lesbian threesome in a bath-tub, accompanied by eerie nursery music and an uncomfortable undercurrent of strained sexuality.

In one further scene Mary receives no credit whatsoever, as only her bottom appears. Although she had happily disrobed in several other British sex films, the Mauritius born actress Francoise Pascal always alleged that she had refused to go totally nude for *Keep It Up Downstairs*. In one scene her character Mimi attempts to beat a rug whilst leaning outside of one of Cockshute Tower's windows. The groom (Simon Brent) traps her in the window frame, pulls down her knickers and proceeds to have her from behind. Due to Pascal's supposed refusal to take her panties off, it was necessary to substitute Mary's bum for hers. 'It was so funny seeing my brown face outside, because I'd just got back from the South of France,' Pascal said. 'I'm knocking the carpet out and all of a sudden you see this little white bottom at the back!' Mary, however, told a different version of the story. 'They had to get me to double for Francoise's bum because the director complained how bloody spotty her backside was,' she laughed.

Reviews

'An unimaginative hotch-potch of all the most crudely obvious sight gags that can be got out of fumbling and feelings up, breast pawings and bottom pinchings. Only the glowing vitality of Diana Dors brings a spark of healthy vulgarity to the all pervading squalor.'
**Screen International.
27 March 1976.**

'A joyless romp that is soporifically heavy handed with its phallic imagery and double meanings, [with] endless references to 'big ones' and 'having it off.''
**Monthly Film Bulletin.
May 1976.**

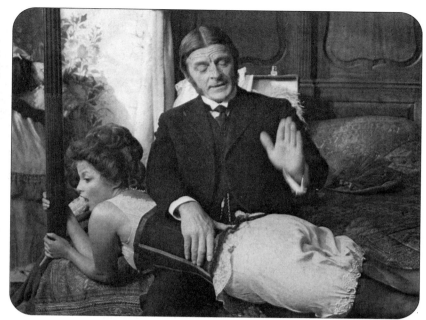

*Francoise Pascal was happy to be spanked with knickers on (above), but despite her porn starlet past, refused to bare her bottom for **Keep It Up Downstairs**. Mary made an uncredited second appearance in the film as a 'bum-double' (below).*

Tit Bits

● *Keep It Up Downstairs* was shot entirely on location in the impressive grounds and rooms of Knebworth House, a beautiful 15th Century stately home in Hertfordshire. In 1976 Mary Millington was blissfully unaware that her porn-star name was joining a historic guest list of past visitors that included Charles Dickens, Winston Churchill and Queen Elizabeth II. Thirteen years later the house was used as the exterior of Bruce Wayne's Gotham City mansion in *Batman* (1989). Knebworth, the family home of Lord and Lady Cobbold, is now open to the general public.

● Jack Wild who plays the ugly Pereguine, originally made his name as a child star in Lionel Bart's film version of *Oliver!* (1968), playing the part of the Artful Dodger. Back then he may well have been called upon to *'pick a pocket or two'* but by the mid-Seventies he was barely picking up any film roles at all. After his foray into soft-porn comedy he turned to drink (quite forgivably), but has now apparently found inner harmony as a born-again Christian.

● The musical score for *Keep It Up Downstairs* was co-written by Michael Nyman, best known for composing the scores for high-brow British director Peter Greenaway's films, including *A Zed And Two Noughts* (1985), *Drowning By Numbers* (1987) and *The Cook, The Thief, His Wife And Her Lover* (1989). The music was conducted by Cliff Adams, famous for his wholesome long running *Sing Something Simple* show on BBC radio.

● Quite without warning, *Keep It Up Downstairs* was slipped into the late night television schedules of BBC1 in October 1998. Firmly stamped with *'TV version'* the movie was edited by over-eager BBC staff and lost an entire four minutes of footage. Five sex scenes were heavily trimmed with Mary's explicit threesome and tree-house romps being excised completely.

KEEP IT UP DOWNSTAIRS
Great Britain / 1976
90 mins / Cert X

CAST

Neil Hallett...Percy Hampton
Diana Dors...Daisy Dureneck
Jack Wild...Pereguine Cockshute
Mark Singleton...Lord Cockshute
Sue Longhurst...Lady Cockshute
John Blythe...Francis Dureneck
Willie Rushton...Snotty Shuttleworth
Franciose Pascal...Mimi
Olivia Munday...Kitty Cockshute
Seretta Wilson...Betsy-Ann Dureneck
Julian Orchard...Bishop
Aimi MacDonald...Christabelle St Clair
Carmen Silvera...Lady Bottomley
Simon Brent...Rogers
Anthony Kenyon...Mellons
Sally Harrison...Maud
Mary Millington...Polly
Joan Newall...Mrs Burgess
Nigel Pegram...Count Von Schilling
April Olrich...Duchess
Peter Halliday...PC Harbottle / Old Harbottle
Maria Coyne...Vera
Craig Marriott...Newsboy
Heidi...Dog

CREDITS

Director...**Robert Young**
Producer...**Hazel Adair**
Executive Producer...**Mark Forstater**
Assistant Director...**Roger Simons**
Photography...**Alan Pudney**
Editor...**Mike Campbell**
Camera Operator...**Ray Andrew**
Sound Recording...**Robert Allen**
Music Composed & Arranged by
Michael Nyman & **Clare Moray**
Music Performed by
Keith Nichol's Cinema Orchestra
Conducted by **Cliff Adams**
Title Song *'Always A Pleasure'* Performed by
Neil Hallett
Screenplay...**Hazel Adair**

Produced by THE PYRAMID FILM COMPANY
Distributed by EMI

Opened 29th July 1976
ABC Cinema, Edgware Road

Private Pleasures

Sweden / 1975 / 92 mins (hardcore version) / cert X

The gaping divide between 1970s British and European erotica is amply demonstrated by the Swedish film *Private Pleasures*. Whereas British porn directors played for laughs, softening the reality of sexual relations with giggles and sniggers, across the sea our continental cousins had a much healthier approach. A movie like *Private Pleasures* wasn't viewed as pornography by the more enlightened and grown-up Scandinavians, but simply as a film that contains a bit of sex. Love-making is plainly part of life and the Swedes don't flinch at presenting it like any other human activity. The performers in *Private Pleasures* have intercourse 'for real', there is no old-fashioned British simulation here, and they have sex with each other in much the same way as they deliver their dialogue: with conviction and realism. The UK's unhelpfully restrictive sex laws meant that the prospect of a mainstream film showing hardcore sex sequences down at the local Gaumont would have been unimaginable. David Sullivan tried it with *Come Play With Me* only for the best stuff never to see the light of day. Admittedly John Lindsay was churning out his short 8mm loops, but technically this was still illegal. His output was inaccessible to the vast majority of the British public anyway. When the rest of Europe was happily producing big budget erotic movies like *Private Pleasures* and *Sensations*, how on Earth could the softcore silliness of *Confessions Of A Driving Instructor* ever seriously hope to compete?

Mary was modelling in Stockholm during the summer of 1975 when Danish director Paul Gerber asked her to appear in his new movie. She loved the free and easy attitude of the Scandinavians and the chance to star in a big screen arthouse sex film was too much of an opportunity to turn down. When Gerber asked if she would be comfortable appearing in a hardcore bi-sexual sequence she didn't even have to think about it, signing her contract there and then.

The film's original Swedish title was *I Nöd Och Lust* (which translates as *In Sickness And In Health*; any similarities to Alf Garnett were purely coincidental by the way) and the movie was filmed in two versions, a Swedish language one and another with the dialogue in English for the rest of the world. The latter version was renamed *Ceremony*. Yet again, in Britain the sex scenes were largely excised and the movie, missing several minutes-worth of footage, was predictably renamed *Private Pleasures,* which said rather more about the Soho fraternity than the film itself.

*Mary poses for **Playbirds** magazine outside the Chat Noir sex club in Stockholm. The club also featured in **Private Pleasures**.*

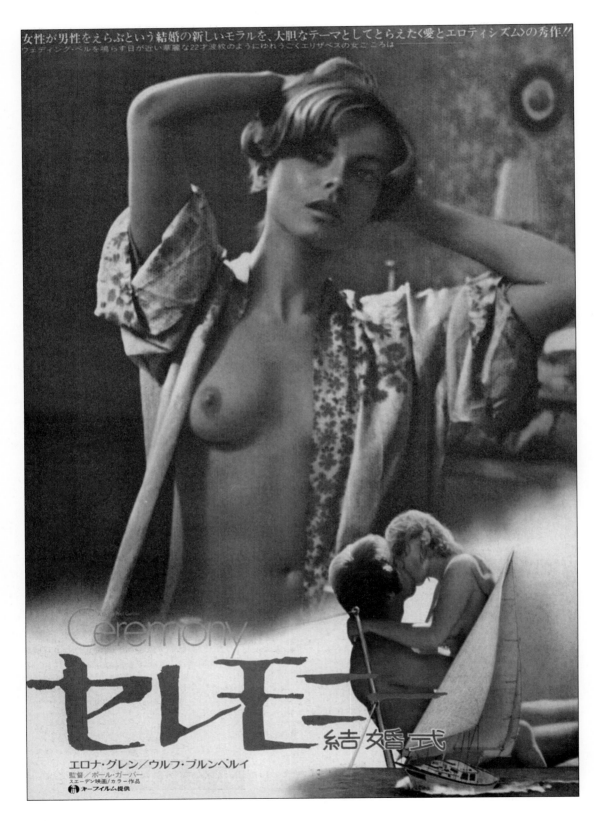

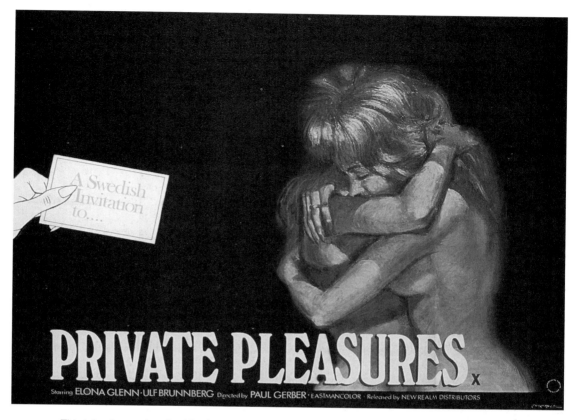

A Swedish Invitation to....

PRIVATE PLEASURES x

Starring ELONA GLENN · ULF BRUNNBERG Directed by PAUL GERBER · EASTMANCOLOR · Released by NEW REALM DISTRIBUTORS

This tale of sexual and spiritual awakening centres on the heroine Elizabeth, played by American actress Elona Glenn (known to everybody on set as 'Glenna'). On the eve of her wedding, Elizabeth is having second thoughts about her marriage to David (Ulf Brunnenberg). The audience see her previous sexual experiences, but it is not clear whether these are reality or fantasy. She has sex with a man beneath a lightbulb that swings in time to her orgasmic groans; then with another man on a yacht, in bright blinding sunlight, before following a 'heavy breather' into a sex cinema for a grope in the darkness. The sex scenes are blatantly hardcore but are tastefully handled by director Gerber, being neither gratuitous nor unpleasant.

Private Pleasures possesses all the hallmarks of European arthouse film-making. Abstract close-ups of body parts, underlit sequences, double reflections in glass, long periods of silence and nonsensical dialogue, but these distractions do nothing to diminish the impact of the stylish and highly-charged sex scenes. The final scene, featuring Mary, is the best. Alone in Stockholm one night, Elizabeth finds herself at the notorious real-life sex cabaret bar *Chat Noir* (where Mary had previously posed for the first issue of *Playbirds* magazine). She plucks up the courage to enter and bumps into her ex-boyfriend Erik (Ted Cegerblad), the sort of man who wears sunglasses in a night-club. Elizabeth explains to Erik that she wants to push the limits of her sexuality, and accepts his invitation to go back to his rural retreat for a threesome with his partner, played by Mary. Elizabeth is dubious at first but soon relaxes and allows Erik and Mary to take it in turns performing cunnilingus on her, before Mary sucks Erik off and, to the sound of tribal drums, Erik has his wicked way with Elizabeth. This one scene features the most erotic performance ever given by the British star. It is beautifully photographed and lit, with mesmerising close-ups of Mary's beautiful eyes and petite hands. The sequence is so elegant and arousing that one is almost taken unawares by Erik's raging erection suddenly ejaculating, in close up, across the screen.

Mary enjoyed making the film, but could never quite recall the movie's title. 'Yes I vaguely remember making it when I worked in Sweden two years ago,' she said in 1977. 'But I knew the girl star as Glenna. Good actress, never made a sex film before. Never been to bed with a woman before either. Nice girl though.'

In the UK the original print of *Private Pleasures* was butchered to such an extent that little of the true erotica remained. Mary's scene was heavily cut and one shot of her was 'double overlaid' so as to blur the edges of realism deemed unacceptable for a British audience. However, even in this compromised version the film proved to be a massive hit, despite minimal publicity about Mary's involvement in the final scene. It opened at the Soho Cinema, Brewer Street in November 1976, nearly 18 months after its European release, and broke the house record, taking £8,818 on its first week alone. It subsequently ran for 3 months, raking in £39,860.

Reviews

'Most of Elizabeth's private pleasures are kept so private that no voyeur worth his salt is likely to raise his eyebrows. Or anything else. A baffling intellectual exercise.'
Screen International. 4 December 1976.

'Warm title-cold film. Cold as in rigor mortis. The script takes some believing too, providing of course you manage to stay awake. For this is, above all else, a very slow and extremely boring sex movie. Writer-director Paul Gerber is attempting to say something about the needless rituals of marriage ceremonials; ancient traditions arranged, not for the couple involved, but for their folks and friends. Hardly a new line, but rarely depicted so heavy-handedly before, as Gerber tries to come on as a Bergman of TV commercials. His opening sex scene looks like a swinging electric light bulb advertisement.'
Cinema Blue #9. April 1977.

Tit Bits

● Prior to *Private Pleasures*, director Paul Gerber had another of his erotic socio-dramas released in the UK, that being *Nöeglehullet* aka *The Keyhole* (1974) starring Marie Ekorre. In the USA *Private Pleasures* was released, uncut, under the title *Liz*.

● Mary was so taken with her co-star Elona Glenn, that she told a journalist on her return to Britain she had rescued a dog and named it 'Glenna' in her honour.

PRIVATE PLEASURES
aka *I NÖD OCH LUST*
aka *CEREMONY*

Sweden / 1975
92 mins / Cert X

CAST
Elona Glenn...Elizabeth
Ulf Brunnberg...David
Per-Axel Arosenius...Karl Frederick Anderson
Marie Ekorre...Sister
Caroline Christensen...Mother
Ake Brodin...Priest
Jim Steffe...Man in cinema
Ted Cegerblad...Erik
Jane Sannemo de Lopez...Elizabeth's friend
Göran Söderberg...Father
Mary Maxted...Erik's girlfriend

CREDITS
Director...**Paul Gerber**
Producer...**Göran Sjöstedt**
Photography...**Lasse Bjorne / Jack Churchill / Paul Gerber**
Editor...**Thomas Holewa**
Sound Recording...**Lars Klettner**
Music...**Anders Henrickson**
Screenplay...**Paul Gerber**

Produced by PREMIAR FILM / SAGA FILM
Distributed (UK) by NEW REALM

**Opened 26th November 1976
Soho Cinema, Brewer Street**

come play with
tom chantrell

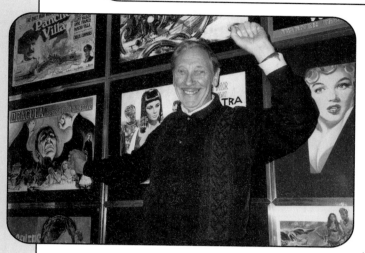

'I always drew on the poster what the potential filmgoer would want to see,' says artist Tom Chantrell. 'In fact I'd sometimes put so much information in the artwork that you wouldn't need to go and see the film at all. You could just stand back and look at the poster!'

Between 1972 and 1979 you would be hard pressed to find a sex film poster which was not signed at the bottom by Tom Chantrell. Probably the most prolific commercial artist in the world, he estimates that during the 1970s there were always six of his designs on the London Underground at any one time, multiplied hundreds of times through different tube stations. During his long career he has created in excess of 7,000 posters world-wide. Not only did he design and paint his posters, Chantrell would also do most of the lettering and even write the tag lines. All this work for a beautiful poster that, incredibly, only took one and a half days to produce.

Tom was born in 1916, the son of a Mancunian trapeze artist, and started sketching at the tender age of 5. By the time he was 14 he had won a world-wide junior prize to design a disarmament poster for the League Of Nations and after a move to London, and an estimated 35 part time jobs, he was employed to design his first cinema poster, *The Amazing Doctor Clitterhouse* (1939). So impressive was his artwork that between 1946 and 1972 Chantrell designed virtually all the British theatrical release posters for Warner's and 20th Century Fox. He was required to flare Kenneth Williams' nostrils on *Carry On Cowboy*, drip blood from Christopher Lee's fangs for the *Hammer Horrors*, even 'muscle up' Paul Newman's arms and give Jane Fonda bigger breasts! His work was nothing less than brilliant.

In the 1960s he established the Chantrell Studio Ltd to take on extra work from independent movie distributors including Tigon and David Grant's Oppidan company. *'King Of Sexploitation'* Grant put a lot of work his way, mainly rotten re-titled sex pictures from abroad, but Chantrell had the knack of making them look like they were worth seeing. One such film was the heavily-cut French picture *Pussy Talk* (1975). Preferring to work from stills, the artist discovered that, in this instance, he had no publicity material for reference, so was forced to use a model. He had previously met sex film actress Suzy Mandel in Grant's offices and came up with the idea that she should pose provocatively for him in a baby-doll nightie. 'Yes she was lovely. Of course she's all over the poster, but she's not in the film at all! It was tricks like this that could sell a movie,' he chuckles.

Tom Chantrell never turned down a project but this inevitably led to him painting posters for some incredibly tacky movies. Much of his 1970s *oeuvre* is comprised of films with titles like *Intimate Teenage Confessions*, *Virgin On The Run*, *Hollywood Hot Tubs*, *The First Nudie Musical* and *Dreams Of Thirteen*. Every Thursday the Advertising Viewing Committee would meet to run through the latest batch of posters from the various distributors. They would be forever asking him to 'clean up' his saucy artwork, whilst he continually tried to get ever more outrageous stuff past them.

In 1977 Chantrell produced perhaps the two most famous posters of his career, and they could not have been more different. The first was for George Lucas' *Star Wars*, the second for David Sullivan's *Come Play With Me*.

'Yes, *Come Play With Me* was hugely popular,' he recalls. 'After that was posted up all around the West End and the film was doing big business, all the other distributors would ring me up for something similar. Everybody wanted another *Come Play With Me*!'

The classic bold lettering of the film title flanked by the sexy images of Mary Millington and Suzy Mandel dressed as nurses became one of the definitive poster designs of the 1970s. It was so successful that Chantrell was signed up to design the posters for Mary's next two films as well. But did he enjoy the films he drew for?

'Oh God no! They gave me tickets for *Come Play With Me* but I thought it was dreadful,' he says. 'After that I said, 'PLEASE don't show me the next one!'

Tom Chantrell poster artwork for Mary Millington's movies includes *I'm Not Feeling Myself Tonight* (1975), *Private Pleasures* (1975) (which showed a lesbian clinch much toned down from the original artwork), *Come Play With Me* (1977), *The Playbirds* (1978), *What's Up Superdoc?* (1978) and *Confessions From The David Galaxy Affair* (1979). He also produced posters for *Come Play With Me 2* (1980), the *Emmanuelle In Soho* triple bill (1981) and his last for Tigon, *Hellcats ~ Mud Wrestling* (1983).

Let's Get Laid! and **Sex Farm**, *two further examples of Chantrell's distinctive sex film artwork*

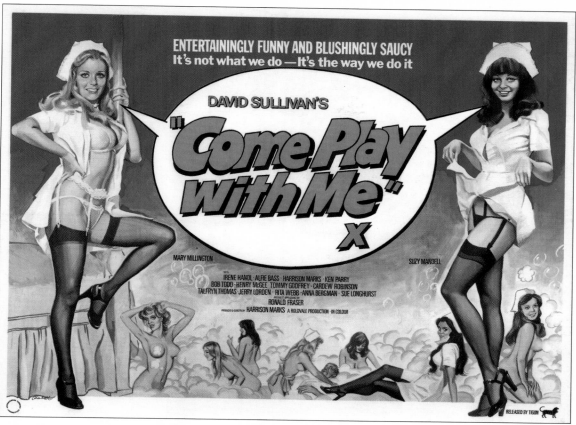

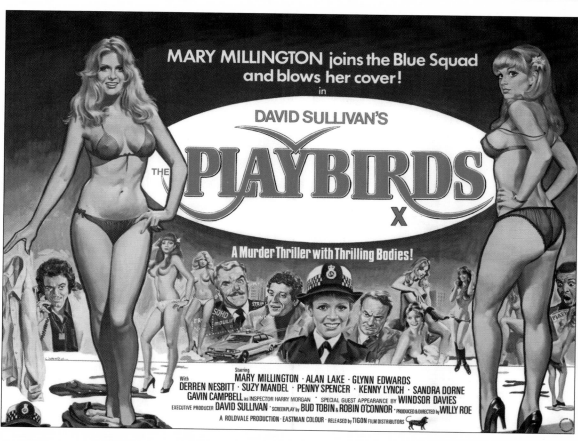

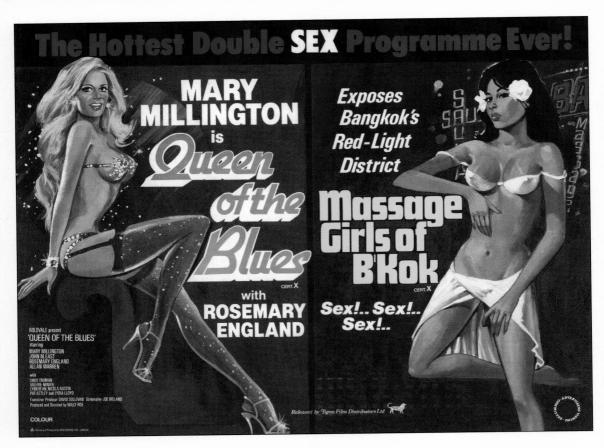

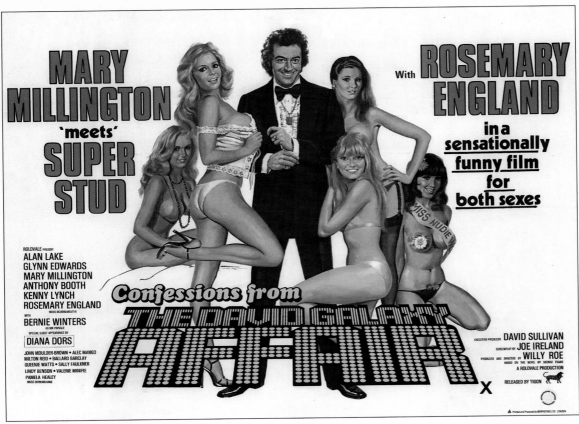

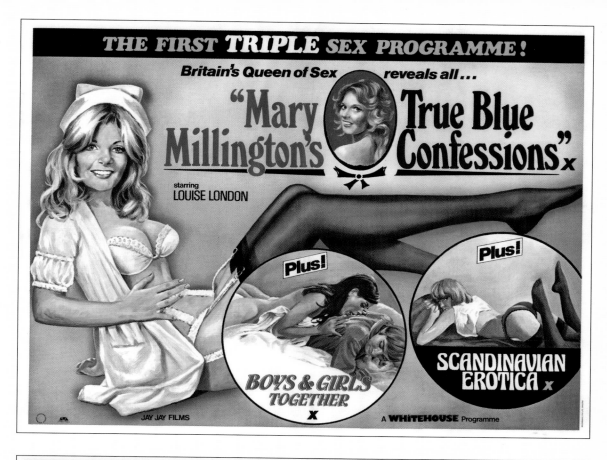

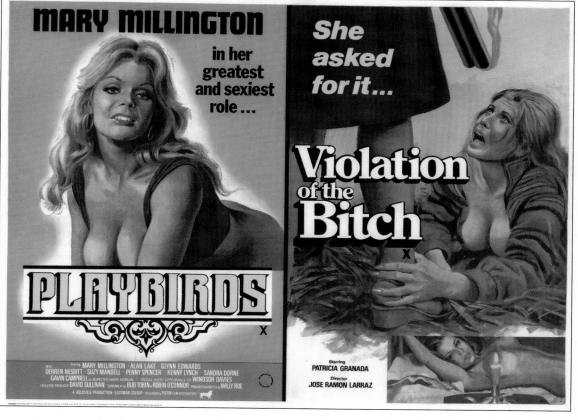

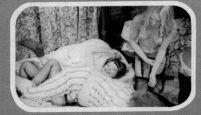
 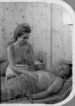

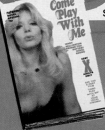

Come Play With Me

Great Britain / 1977 / 94 mins (softcore version) / cert X

'The making of *Come Play With Me* is the stuff of legend.'
(David Flint, Sex Film Historian)

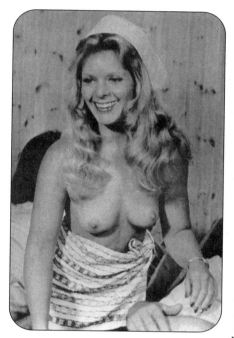

The announcement that 'upstart' porn publisher David Sullivan was to branch out into film-making was received by other exploitation producers - such as Derek Ford and Stanley Long - with some considerable derision. Happily for him, his critics all ended up with egg on their faces when *Come Play With Me* became the undeniable champ of British sex films. Whilst on the face of it an unremarkable film, *Come Play With Me* nevertheless reaped the rewards of a prolonged and intense marketing campaign. Sullivan's meticulous advertising strategy paid off in the most startling fashion. Securing a place in the annals of British movie history, *Come Play With Me* is not only the most profitable home-grown movie of all time (it cost just £120,000 and grossed well over £4,000,000), it also defiantly holds the record for the longest uninterrupted theatrical engagement *ever!* Mary Millington has to take most of the credit for the film's astronomical success, however inconsistent her role in the final product. She became *the* reason for seeing the movie, and Mary and *Come Play With Me* will be inextricably linked forever.

There is little doubt that *Come Play With Me* didn't actually showcase Mary's talents especially well. She suffers badly from being overshadowed by the 'straight' comedy actors in particular, and frequently by some of the other glamour actresses too, but this does surprisingly little to diminish her appeal when she does appear on screen. The plot of *Come Play With Me* concerns itself far too much with the septuagenarian cast and neglects the real selling points of the movie: in other words, the girls. The females are criminally ignored in favour of the cast's music hall tradition-alists which is a terrible shame, in fact the women are nothing more than a light French dressing on a salad of tired old vegetables. It is doubtful that producer David Sullivan and director George Harrison Marks ever really knew just what sort of film the other one envisaged. Marks wanted to make a nostalgic musical comedy, Sullivan, on the other hand, wanted give his audience a hard-on.

The story focuses on two banknote counterfeiters, Kelly (Alfie Bass) and Clapworthy (played by Harrison Marks himself) who, whilst on the run from their stupid East End gangland boss Slasher (Ronald Fraser), escape over the border to the Scottish Highlands and hide out at Bovington Manor health farm, owned by the down-at-heel Lady Bovington (Irene Handl). She is near to bankruptcy having failed in her business. With the arrival of the old lady's drippy nephew, Rodney (Jerry Lorden), and his troupe of strippers from France, Bovington Manor takes on an entirely new image; that of a high class brothel. And that's when the fun really starts. A silly sub-plot about the British government despatching a repressed homosexual agent called Podsnap (Ken Parry) to apprehend the forgers provides

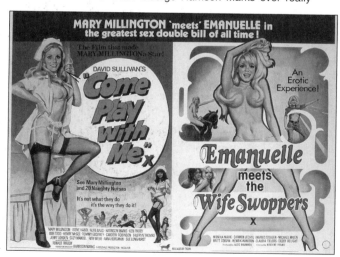

nothing more than an irritating distraction from the pretty faces and figures of the young women. Mary plays one of the strippers (Sue), but most of the action and dialogue is enjoyed by fellow glamour star Suzy Mandel (as Rena). The story races about in hundreds of desperate directions, the nadir of which is a jaw-dropping song and dance routine, (*'It's Great To Be Here!'*), in the grounds of the Manor involving Marks, Bass and the eleven girls.

Filmed during a particularly cold October and November 1976, the making of *Come Play With Me* was beset with problems from the very outset. 'We were booked to use Bushey Studios in Hertfordshire, but actually I was quite annoyed about it,' explained George Harrison Marks. 'There were two sound stages there and I had used the space before so I didn't bother sending the set designer down beforehand. But when we got there it turned out that we'd been allocated the smaller studio because that bloody Stanley Kubrick had all his props stored in the other one. I was fucking furious because it was such a tight squeeze.'

Most of the location work was done at the elegant eleventh century Weston Manor Hotel at Weston-on-the-Green, Oxfordshire, (doubling as the fictitious Bovington Manor). Harrison Marks had used the hotel - once the property of King Henry

A rude awakening for Harrison Marks and Alfie Bass: left to right - Mary, Suzy Mandel, Mireille Alonville, Nicola Austine and Pat Astley

VIII - seven years previously for his historical nudist pageant *The Nine Ages Of Nakedness* (1969), but the owners had little idea that explicit sex sequences were being filmed in their rooms this time around. Regardless, having the hotel's 37 bedrooms booked up for a month out of season (all the cast were staying there during each week of filming) was just too much to turn up their noses at. But not everybody was pleased about the arrival of eleven topless actresses and a handful of old comedy has-beens. 'Next to the hotel was an annexe, a lovely little bungalow for special guests,' chuckled Harrison Marks. 'When we arrived down there for filming with the full cast and crew there was a bit of argy-bargy. Rex Harrison from *My Fair Lady* was secretly staying there with a bit of crumpet! He was not happy about cameras being about and in the middle of the night him and his bird did a moonlight flit. Irene thought it was hysterical!'

The widely-reported scandal over the sex sequences in *Come Play With Me* was a storm in a tea cup according to Harrison Marks. He reckoned the likes of Alfie Bass and Ronald Fraser were actually rather excited by the prospect. 'They loved it,' he said. 'The only reason I got Fraser was because of the girls. When he got out of his cab from Oxford, his first words to me were 'Where are the birds George?' Despite his protests to the *News Of The World* about the sexual content of the picture, comedy actor Tommy Godfrey (who incidentally looked like a dead ringer for *Harrods* boss Mohammed El-Fayed) was only too happy to be photographed in a series of groping poses with a semi-nude Mary Millington prior to the movie's release.

Unfortunately the bad publicity surrounding the hardcore sex in *Come Play With Me* meant that Equity, the actors' union, were continually on the director's back, often turning up on set unannounced with the intention of seeing something 'unsuitable' being filmed. 'This Equity man turned up and it was all David Sullivan's fault because he kept putting out these terrible stories to the press. Equity had heard rumours of this, that and the other,' Harrison Marks recalled. 'I came out of my dressing room one day and told them that I'd just about had enough of them. There were enough problems directing the film without all that crap arguing with Equity. I said 'I AM NOT MAKING A PORN FILM,' but then they started speaking to some of the artistes including Alfie Bass. Now Alfie was wonderful at keeping a straight face. They asked him the usual bloody silly questions and Alfie said, 'Yes I'm sick of this movie. I'll be glad when I get off it.' The Equity man said 'Oh yes, why's that?' He was desperate to get me in trouble you see. Anyway Alfie replied, 'Well I'm staying in a room next door to Irene Handl's and she's fucking me stupid every night of the bloody week. She's keeping me awake and she's 74 you know!' The Equity man looked at him and pissed off.'

Irene did in fact have one of the worst reputations for naughtiness on set. Her demure 'granny-like' exterior hid a filthy mind lurking within. Irene's fruity language was liable to shock even some of the younger members of the cast. 'George told me that he had secured Irene for the film,' remembers Sullivan. 'He said that we couldn't have any nude girls in her scenes because she was 74 and he didn't want to offend the old girl. I thought this was tragic because we could have got some great publicity shots of her with Mary topless. Anyway a pal of mine called George Richardson, who was a bit of a cheeky photographer, went down on set and asked Irene if she minded having her photo taken with a couple of topless girls. Irene agreed straight away and said to him, 'If I was a bit younger I'd get my tits out with them!" That photo, showing Irene cheerfully pouring tea beside two pairs of perky breasts, was later splashed over the front page of *The News Of The World*.

The comedy cast had few inhibitions when it came to appearing in a film with additional sex scenes. 'Most theatrical people are quite liberal. It's just a pay day to them,' says Sullivan. Three of the four hardcore sequences were filmed on the same day. In the plot they centre around a swimming pool party held behind Bovington Manor (in reality at the back of Weston Manor Hotel). 'It was freezing,' remembers Sullivan. 'Even though the pool was heated I honestly thought we were going to get sued by actors with hypothermia.' One by one the girls pair up with the paying guests and retreat to various rooms in the Manor. Marks always claimed that the actresses concerned were not necessarily employed just because of their willingness to appear in stronger scenes, but this seems unlikely since only three (all with recognised backgrounds in hardcore porn) were singled out for the 'privilege'. Those involved were Italian-American actress Suzette Sangalo Bond, German pornographic model Sonia and English glamour girl Lisa Taylor. In particular, Sonia was after Harrison Marks like a dose of salts. 'George was bonking her and basically wanted to see her do some stronger stuff. He went to some party, had pulled her and taken her back to his house for sex,' laughs Sullivan. 'But he got so drunk that he couldn't do anything with her in the end. When he woke up in the morning he realised she'd nicked his wife Toni's mink fur coat. He had to run around London trying to get it back!'

Derek Aylward and Lisa Taylor in one of the legendary hardcore scenes

George Harrison Marks had no trouble attracting the big names for *Come Play With Me,* assembling the most complete cast of any sex comedy of the 1970s. Some of the stars had extremely impressive comedy CVs. 'Most of them were friends beforehand,' said Marks. 'Irene was adorable, gorgeous, but I had a bit of trouble with her scenes with Bob Todd (as the Vicar) and Ronald Fraser. They were both complete piss artists you see. At 6am they were already on the champagne and couldn't remember a bloody word of the script. In the scenes where they are in the hotel reception area with Irene I had to cut up their script and pin it to the desk!'

Due to the usual restrictions of a low budget film and the need to shoot as few takes as possible, there was rarely enough time to repeat dialogue that may have been delivered well below par. Part of the joy of watching *Come Play With Me* is spotting the actors' mistakes and embarrassing pauses. Jerry Lorden as Rodney really makes a meal of his scenes, but then he wasn't really an actor anyway, being an ex-songwriter for *The Shadows* and Harrison Marks's next door neighbour from St John's Wood in London! However he's not the worst by any means. Ken Parry seems to have particular difficulty concentrating on his lines and you can almost see his brain ticking over to get the words out in the right order. During one scene, Nosegay (played by comedy Welshman Talfryn Thomas)

chokes on his champagne and Parry struggles to stifle his real-life laughter. Even the normally reliable Irene fluffs a two-hander between herself and Bass when her lines clash awkwardly with his; but best of all is *Benny Hill Show* stooge Henry McGee as the deputy Prime Minister, looking straight into camera for help at the end of an especially painful opening scene.

When Sullivan saw the UK rough cut of the film (minus hardcore) he was not very pleased. 'I was a bit disappointed with it because it was a bit dated. I thought George hadn't put enough sex in it. There wasn't any nudity in the first 45 minutes, so we had to re-shoot scenes,' he says. *Come Play With Me*'s distributors, *Tigon*, were also a bit peeved at the lack of naked girls. Sullivan told his director what needed to be done but he was not impressed.

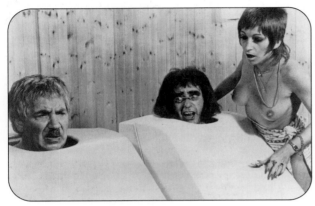

German porn starlet Sonia overheats Bass and Harrison-Marks

'Yeah whatever you bloody want, have it' Harrison Marks retorted and the next day he found himself on location at The Centre Sauna in Crown Hill, Croydon. The sauna (above the defunct Focus porn cinema), was one of David Sullivan's own businesses. offering a variety of 'services' including 'assisted baths' and 'topless haircuts'.

The sauna, plunge pool and gymnasium provided the perfect backdrop to film some additional 'health club' sex scenes, which were later intercut into the final print. Mary was called upon to take part in a lesbian scene on an exercise bench with fellow actress Penny Chisholm. The sequence, shot in two versions - *knickers on* and *knickers off* - would prove to be the very last hardcore sex scene Mary ever filmed. In the British cut of *Come Play With Me* the sequence still goes quite a long way by the standards of the day, showing Mary going 'all out' with her girlfriend, frantically kissing and caressing her. Penny Chisholm's flushed face is not just make-up either. In the overseas version of the film Mary's fingers do quite a lot more than just skirt around her co-star's genitalia. Even in its abridged form this short sequence (it lasts less than a minute) became the most whispered about and memorable attraction in the entire movie, and incredibly, the talk of the West End.

Come Play With Me was universally panned by the critics when released on April 28th 1977 at the Moulin Cinema, Great Windmill Street, Soho, but it appeared that no amount of bad-mouthing could deter Mary Millington fans from flocking to the cinema in droves. What's more, the movie seemed to weave a spell on all those who saw it, encouraging them to go back again and again. The success of the film took everybody by surprise but Harrison Marks was sure of his winning formula. 'It was similar to a *Carry On*, but I added a bit of tit and bum!' he said, but associate producer Willy Roe was not so convinced. When the film was in post-production at an editing suite in Greek Street, editor Peter Mayhew moaned to Roe that, 'In my opinion that film will set the industry back ten years.' Not very reassuring words, but few could have guessed that *Come Play With Me* would eventually run continuously in the West End for nearly four years. Sullivan had offered Roe a percentage of the film's takings, but Roe declined his offer, assuming the film's success would be short lived. Harrison Marks also believed the film would see-out its natural course within a few months, as British sex comedies invariably did. What nobody knew was that David Sullivan had signed a contract with the Moulin stating that just so long as takings did not fall below a certain level (a 'break figure' of £1,000) each week, then they would be obliged to keep *Come Play With Me* running.

Harrison Marks' story of how he sold his share of the film away is an oft-told tale. 'I had 25% of *Come Play With Me* and let's face it I had made a lot of money out of it, but after 9 or 10 months I was getting fed up having to trudge down to bloody Upton Lane each month to get my cheque off Dave,' he remembered. 'Dave knew my weaknesses and soon there was a bottle of scotch on the table. He told me he wanted to buy my 25% and for the next half hour we flung figures back and forth and eventually £12,000 was on the table. I had no grievance against him, but I was totally pissed. He didn't twist my arm but I signed it all away and it ran for another three bleedin' years!'

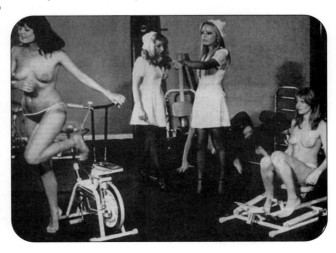

Reviews

'I fear George Harrison Marks must have been asleep like Rip Van Winkle while the sex film scene has rolled away from the nudist camps and strip clubs. I love him for sticking his neck out as a producer-director-writer and star, but it was a foolhardy venture.'
Screen International. 2 April 1977.

'I have few high hopes for David Sullivan's first movie. Financially it'll make a mint, as it's replete with an orgy rave up from sexy nurses who are really redundant strippers. But erotically, well George Harrison Marks wrote and directed, so forget it.'
Cinema Blue #9. April 1977.

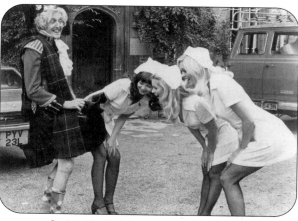

Cardew 'The Cad' Robinson flashes his sporran to a captive audience in **Come Play With Me**

'No synopsis could convey the complete incoherence of this screenplay. Combining elements of third rate music hall, inferior and outdated pop music, irrelevant comic song and inadequate dance with the lowest common denominator of the cheap British sex film, *Come Play With Me* is an invitation absolutely to be refused. It would appear that George Harrison Marks was attempting to make a mixture of an Ealing comedy and pornography without much interest in either.'
Monthly Film Bulletin. May 1977.

Tit Bits

● The bizarre song and dance sequence was choreographed by French dancer Mireille Alonville, who plays the part of Michelle in the film. She also featured in *Queen Kong* and *Adventures Of A Private Eye* (both 1977). In the late 1970s she joined *Pan's People* on *Top Of The Pops* as well as becoming a hostess on Ted Roger's dire Yorkshire Television game show *3-2-1* in 1978.

● Unsurprisingly, the appalling 'rock' combo *Coming Shortly*, who accompany the strippers from Paris, were actually a fake. Harrison Marks' limited budget could not stretch to hiring glam rock stars *Slade* or *The Rubettes*. 'I was left with no option,' he explained. 'I just got three or four out-of-work musicians together, put them in a room and said 'rehearse!' The band's flared-trousered rendition of composer Peter Jeffries's theme song is an (unintentionally) hysterical highlight of the film. Sadly, but quite understandably, it was never released as a single. Jeffries himself can be seen in the film, as the pianist at Ronald Fraser's strip-club.

● Not all the comedy players who appear in *Come Play With Me* were Harrison Marks' first choices. Alfred Marks was due to take the part of gangland boss 'Slasher', but pulled out when he was offered a theatre role in the USA. John Laurie (Private Fraser from *Dad's Army*) was offered the chance to play McIvor the butler, and originally accepted the part over lunch at *The Garrick*. Two days after Harrison Marks sent him the script, Laurie declined, giving the reason that at his age he 'couldn't do all the physical stuff!' David Sullivan wanted to attract a big comedy name for the film and offered Harry H. Corbett £5,000 for just ten days work and a specially-written part. Though Corbett was down on his luck after the cancellation of *Steptoe And Son* he refused to work for less than £7,000, so Sullivan was forced to knock the idea on the head.

● Despite being a quintessentially British comedy, Sullivan did manage to sell *Come Play With Me* abroad. 'We sold it to Australia, Hong Kong, South Africa and odd places like the Lebanon, but I think no-one could really understand the film outside of England,' he laughs.

● Even following the eventual death of the movie's main draw, *Come Play With Me* did manage to spawn two 'sequels', though in name only. Swiss-born Erwin C. Dietrich (aka Michael Thomas) was one of Europe's most prolific producers of sex films throughout the 1970s. He churned out dozens of hard and softcore movies, most of them junk, from his Zurich based *Elite Film Company*. A sort of European David Sullivan, he was dubbed the 'Pope Of Porn' by his German fans. Much of his output was cut down and distributed in the UK - often by *Tigon* or *Jay Jay* - and widely shown in cinemas across the country. All his films were misleadingly retitled for British release, for instance *Tanzerinnen fur Tanger* (1977) became raunchy *Confessions Of The Sex Slaves*. With home-grown sex movies becoming more of a financial risk, Sullivan was keen to buy up cheap European movies and release them himself.

Dietrich's *Les Bourgeoises de l'Amour* (1980) became *Come Play With Me 2* and two years later the catchy-sounding *Julchen und Jettchen ~ Die Verliebten Apothekerstöchter* (also 1980) became *Come Play With Me 3*. 'They were just exploitation films,' says Sullivan. 'You just bought a finished product, retitled it and dubbed it for the English market.' Neither *Come Play With Me 2* or *3* had the slightest thing in common with the original movie but that did little to deter the distributors from emblazoning Mary's name across the posters.

● *Come Play With Me* was not the first British film to dabble in hardcore footage for sale abroad. Morton M. Lewis's quite dreadful *Secrets Of A Superstud* (aka *It's Getting Harder All The Time*) (1975) starring Heather Deeley, was shot in two distinct versions: the slapstick saucy variety for the home market and a much stronger one for the rest of Europe, however this example was the exception rather than the rule. On occasion hardcore was added without the film-maker's knowledge. Martin Campbell's *The Sex Thief* (1973) was reissued in the USA in 1976 as *Her Family Jewels* with all kinds of stateside shagging inserted into the original narrative. In Britain, this version reappeared yet again ten years later on uncertified videotapes as *Handful Of Diamonds*.

● Right up until his death in 1997, the bed in which Harrison Marks slept each night was the very same one that actors Lisa Taylor and Derek Aylward used for their hardcore romp in *Come Play With Me*. Aylward was not, in fact, a seasoned skin flick performer but a 'proper' thespian who had been appearing in respectable movies since the 1950s. In 1954 he even starred in a religious film, *John Wesley*, about the founder of modern Methodism, but his conversion to X-rated movies was mainly due to his re-discovery by cult exploitation director Pete Walker. Aylward starred in such Walker-directed delights as *School For Sex* (1967) *Strip Poker* (1970) and *Cool It Carol* (also 1970) and with each successive movie he fine-tuned his preferred role of educated, middle aged lecher. *Come Play With Me* was the first time he was required to go 'all the way' and Harrison Marks recalled the fifty-two year old actor's enthusiasm for the scene. 'He loved it. I didn't have to persuade the old bugger at all. He hadn't been laid for years!' Aylward must have enjoyed the fringe benefits of his new job because he was soon posing naked with Mary in the pages of *Whitehouse* and starring, albeit anonymously, in a series of 8mm hardcore shorts including *Wet Dreams* and *Super Sex Shop*.

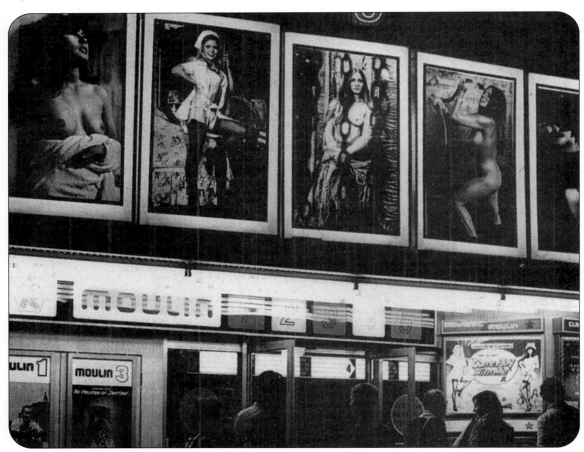

● Busty German porn star Sonia (aka 'Sonia Svenberger') shared her hardcore sex scene with Gordon Hickman, an old hand from John Lindsay's films. Sonia capitalised on her appearance in the movie by doing several photo shoots for Sullivan's publications and making her own copy-cat 8mm sex film called *Cum Lay With Me* the following year. From 1977 she continued to work with Harrison Marks on short films like *Rawhide* and *Lesson For Lolita* (both with fellow *Come Play With Me* actress Lisa Taylor). Sonia committed suicide in 1984.

● Once you have worked in porn it usually stays in your blood as Ernie Lewis' story testifies. Lewis was Harrison Marks' production manager on *Come Play With Me* but after further film work dried up he became a Methodist church caretaker in North London. Unbeknown to the vicar, the Rev Malcolm Wainwright, Lewis was running a lucrative sideline (on the church's telephone), offering his modelling services for spanking magazines and videos. When *The News Of The World* exposed him in 1994, the vicar expressed some surprise, saying, 'I didn't know anything about this. He only told me he'd worked on the wildlife movie, *Ring Of Bright Water* with Virginia McKenna!'

● The full line up of films showing at the revamped Moulin complex on 28th April 1977 were:
Screen One (250 seats) *Hardcore*
Screen Two (134 seats) *Come Play With Me*
Screen Three (100 seats) *The Violation Of Justine*
Screen Four (110 seats) *Vanessa*
Screen Five (84 seats) *Je T'Aime Moi Non Plus*
Even though *Come Play With Me* ended its continuous run on March 4th 1981 it still played on and off at the venue for some years afterwards. The Moulin sadly closed its doors, with little warning, on 10 April 1990. Due to the lack of new product it had still been playing 1970s sex films to the very last day. The site is now home to the ugly *WonderPark* amusement arcade.

● Other sex films tried to imitate *Come Play With Me*. German rubbish *Aus Dem Tagebuch Einer Siebzehnjhrigen* (1979) was renamed *Come Make Love With Me* for the UK and Walter Boos' sexploitation shocker *Nympho Girls* (1978) had the poster tag line 'Come Play With Us !'

● As for the original extended hardcore version of *Come Play With Me*, rumour has it that it was shown only once, by accident, in a late night show at a cinema in Swiss Cottage. Neither Harrison Marks nor David Sullivan ever saw it and though it was once missing presumed lost, the only surviving print - now sadly disintegrating - resides at a secret address in the faded sea-side resort of Westcliffe-on-Sea.

COME PLAY WITH ME
Great Britain / 1977 / 94 mins / cert X

CAST
George Harrison Marks...Cornelius Clapworthy
Alfie Bass...Maurice Kelly
Irene Handl...Lady Bovington
Ronald Fraser...Slasher
Tommy Godfrey...Norman Blitt
Ken Parry...Podsnap
Cardew Robinson...McIvor
Bob Todd...Vicar
Sue Longhurst...Christina
Jerry Lorden...Rodney
Henry McGee...Deputy Prime Minister
Rita Webb...Madame Rita
Queenie Watts...Cafe owner
Talfryn Thomas...Nosegay
Norman Vaughan...Seaside performer
Derek Aylward...Sir Geoffrey
Valentine Dyall...Minister for finance
Michael Balfour...Nosher
Milton Reid...Bouncer
Howard Nelson...Mr Benjamin
Thick Wilson...Mr Wilson
Suzy Mandel...Rena
Mary Millington...Sue
Pat Astley...Nannette
Suzette St Claire...Tina
Anna Bergman...Josie
Mireille Alonville...Michelle
Nicola Austine...Toni
Penny Chisholm...Tess
Marta Gillot...Petrina
Sonia...Mandy
Suzette Sangalo Bond...Patsy 'The Amazon'
Lisa Taylor...Sir Geoffrey's lover
Toni Harrison Marks...Miss Dingle
John Denny...Capital Radio DJ
Josie Harrison Marks...Josie (Brownie)
Billy Maxim...Welks seller
Michael Logan & Dennis Ramsden...Ministers
Deidre Costello...Blonde stripper

CREDITS
Director...**George Harrison Marks**
Producer...**George Harrison Marks**
Executive Producer...**David Sullivan**
Associate Producer...**Willy Roe**
Photography...**Terry Maher**
Editor...**Peter Mayhew**
Camera Operator...**Len Harris**
Sound Recording...**Bill Howell**
Choreography...**Mireille Alonville**
Music Composed & Conducted by **Peter Jeffries**
Songs:
'Come Play With Me', 'Pretty Girl', It's Great To Be Here'
All written by **Peter Jeffries**
Performed by **Coming Shortly**
Screenplay...**George Harrison Marks**

A ROLDVALE Film
Distributed by TIGON

Opened 28th April 1977
Classic Moulin, Great Windmill Street

come play with

anna bergman

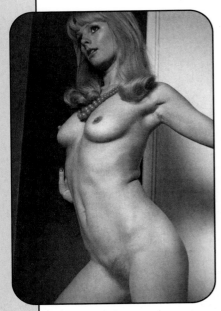

Swedish actress Anna Bergman proved to be the thorn in George Harrison Marks' side throughout the filming of *Come Play With Me*. Playing the part of Josie, one of the strip troupe, Bergman was the most vocal of the film's stars, complaining bitterly to both Equity and the press about the erotic content of the movie. Although Marks did not ask her to perform in any of the stronger sex scenes, he was more than a little surprised about her attitude towards nudity.

'That cow caused me so much bloody trouble. She was the one that set the ball rolling with Equity. She refused to strip off. The bloody point is when I was casting she turned up with a portfolio of nude pictures. I thought she looked fantastic, but when we started filming she turned around and said 'I won't go nude,' remembered Marks in 1997. The director pleaded with her to change her mind, but she was adamant. Worse was to come when Bergman discovered that hardcore scenes were to be intercut with the finished film. She was furious and was quoted in the *News Of The World* as saying, 'I'll ask for my part to be taken out. I'm very annoyed. I'm dressed all the way through and I don't wish to be associated with anything *nasty.*'

The Sun even reported that Bergman and fellow glamour actress Nicola Austine had stormed off the set. *The National News* went one step further and claimed they were sacked by the director! Marks later claimed this was all hype, although he did get his revenge on the temperamental Swede.

'I couldn't sling her off the film, but I got my own back. To begin with she had quite a chatty part in the movie, but I cut it back from 6 inches on the script to about half an inch,' he laughed. Not only that, but on one day of filming he kept her waiting for her call from 6.30am in the morning until 6.30pm at night. An agitated Bergman continually asked Marks when she was due to film her big scene until he casually informed her that it had been cut completely. 'She was absolutely livid,' he said.

Anna was born in Stockholm in May 1949, daughter of one of the most uncompromising and legendary film makers of all time, Ingmar Bergman. Her father encouraged her to study drama and she featured in a couple of small film roles before moving to London in 1967, intent on becoming a model. Her long blonde hair and beautiful looks rapidly brought her to the attention of Wardour Street and in 1975 she secured the lead in the cheekily-titled *Penelope Pulls It Off!* It was not her first nude role; she had happily bared all in the German film *The Crooked World Of Art* eight years previously. In March 1976 she told *Continental Film Review*, 'I was cast primarily for my name. I had a nude scene and Ingmar Bergman's daughter without her clothes on gave the film a lot of publicity. I didn't mind because it gave me a start. I'll only do nude scenes if it makes sense in the film's context.'

A good few directors must have read that article because, alas, the only films Anna was subsequently offered were ones that required her to remove her blouse! Her opposition to the nude scenes in *Come Play With Me* was predictably short-lived and Anna was soon happily stripping-off again (she even starred in two out-and-out hardcore movies in Denmark, for director Werner Hedman). Her film work took her across Europe, but back in Britain she enjoyed moderate success on television, notably in eight episodes of LWT's extremely politically incorrect sitcom *Mind Your Language* in 1977/1978. Needless to say, she played a Swedish-sexpot (imaginatively named 'Ingrid Svensen'), with the comedy emerging from her woeful interpretation of the English language.

She married a policeman, had a son, Mikael, and continues to act, even appearing in her father's last film *Fanny And Alexander* (1982). With a career lasting considerably longer than any of her contemporaries she briefly returned to the sex film fold in 1995 for the TV documentary *Doing Rude Things*.

Anna's film credits include: *The Crooked World Of Art* (1967), *All Change* (1968), *Penelope Pulls It Off!* (1975), *Adventures Of A Taxi Driver* (1975), *Intimate Games* (1976), *Come Play With Me* (1977), *Queen Kong* (1977), *The Wild Geese* (1977), *Agent 69 Jensen - I Skorpionens Tegn* aka *Agent 69 In The Sign Of Scorpio* aka *Emmanuelle In Denmark* (1977), *What's Up Superdoc?* (1978), *I Skyttens Tegn* aka *Agent 69 In The Sign Of Sagittarius* (1978), *Licensed To Love And Kill* (1979), *Blue Paradise* (1980), *Nutcracker* (1982), *Fanny And Alexander* (1982), *Ake And His World* (1984), *Dutch Girls* (1985), *Avalon* (1990), *Luigi's Paradise* (TV 1991) and *Doing Rude Things* (TV 1995).

The Playbirds

Great Britain / 1978 / 94 mins / cert X

'*The Playbirds* was very nearly a good film.'
(David Sullivan, Producer)

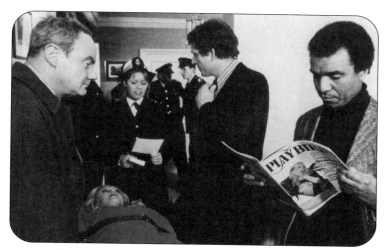

left to right: Glynn Edwards, a dead looking Pat Astley, WPC Mary Millington, Gavin Campbell and Kenny Lynch

Now this is more like it; a starring vehicle for Mary in which she was actually allowed to shine. The overwhelming commercial triumph of *Come Play With Me* prompted producer David Sullivan to get another movie off the starting blocks as soon as possible. The making of his next film - originally to be called *The Blue Girl* - was announced in *Screen International* in October 1977 and now more than ever, Mary was preparing to be a 'real' movie star.

Although Sullivan continued to be delighted with the healthy box office receipts of his first film he still thought that *Come Play With Me* was a little old-fashioned. He wanted the follow-up to have a lot more Mary and a lot more sex. To this end he hired Willy Roe, associate producer of *Come Play With Me*, to direct the new movie and give it an added injection of whoomph! Legend has it that it was Mary herself who made the suggestion to Sullivan about calling the new film *The Playbirds*. Never one to miss a cross-marketing opportunity involving his best selling magazine, he readily agreed to the idea. Another consideration was that *The Playbirds* would have to be significantly cheaper than *Come Play With Me*. Sullivan wanted to avoid a repetition of the escalating budget that the last film had suffered and was anxious not to breach the £100,000 mark. In a further attempt to cut costs, the schedule was ruthlessly pared back. *The Playbirds* was shot at break-neck speed in just twenty days. Sullivan was intent on pushing the boundaries of low-budget film-making to the bitter limit. Filming started in the Winter of 1977, with location shooting at Sunningdale, Putney Bridge, Soho, Maida Vale and Newmarket racecourse, plus studio work at Bushey.

In complete contrast to the slapstick tomfoolery of *Come Play With Me*, the only laughs to be had in Mary's new film are purely accidental. Publicity material described *The Playbirds* as a 'murder thriller with thrilling bodies' and indeed the tone was considerably darker than that of its predecessor. One critic even likened it to a porno version of *The Sweeney!* The plot, co-written by Joe Ireland and Willy Roe threw up a few shocks right from the outset, none more so than the casting of Mary as a Metropolitan policewoman. She could not believe her luck at getting the chance to play a 4'11" copper. ('It's bizarre, because I'm so tiny,' she quipped.) Her hatred of the law was by this time well documented and she relished the opportunity to take a tongue-in-cheek swipe at Scotland Yard. Here the most notorious and visible anti-censorship campaigner in Britain was playing a policewoman who happily strips off and poses explicitly for a jazz mag. What could be more fun! Whilst filming in Soho she really played up to the role, refusing to remove the uniform between takes and kidding members of the public that she actually was a WPC. She kept the hat after filming was completed and would leave it on the back seat of her car when she parked on double yellow lines in the hope of deterring traffic wardens from giving her a fine!

Mary's performance as diminutive WPC Lucy Sheridan is spirited, albeit a little self conscious, but she acquits herself quite well in her role. Hours of coaching by her close friend John M. East had paid off and although her delivery is frustratingly flat her cheerful personality comes across really well in all her scenes. And *scenes* in the plural is most definitely the case here. Unlike many of her previous and subsequent movies, in which Mary made only fleeting appearances, *The Playbirds* features her firmly at the hub of the story. For the first time, the audience really gets their money's worth of Millington magic.

Mary's character is a policewoman on the West End beat who yearns for more excitement than can be found simply plodding the pavements. She moans to her startled Police Commissioner boss (played by Windsor Davies from TV's '*It Aint Half Hot Mum*'), '*I want to make the most of my police training. At the moment I feel like a traffic warden!*' Well, she doesn't have to wait too long for the action to hot-up as very soon Scotland Yard detectives

are called upon to investigate a series of gruesome murders. In a nasty bit of blurring between reality and fiction, cover girls from *Playbirds* magazine are being killed off one by one. Lanky real-life girlie mag model Pat Astley gets it in the neck from a mysterious stranger whilst she makes a cuppa at her Marble Arch flat, just after she has completed a nude modelling assignment. Before long another couple of girls get the chop too and detectives Jack Holbourne (Glynn Edwards) and Harry Morgan (Gavin Campbell, amazingly later to appear as a presenter on Esther Rantzen's *That's Life!*) are left scratching their stupid heads, hoping to find a solution to the problem. Inspector Holbourne quickly becomes bored with the case, choosing to listen to the racing from Newbury on the radio rather than coping with the dead woman lying on a stretcher beside him. More preoccupied with nags than birds, he is an old-school detective, dismissive of his sidekick's reliance on computer methods to solve crimes. But then again you'd be dubious too, as the antiquated Scotland Yard computers are the size of telephone boxes and do nothing but spew forth reams of blank paper all day.

Under suspicion for the crimes are: dopey, ugly-faced soft-porn photographer Terry Day, currently working on a theme of 'orgies through the ages'; kinky Tory MP George Ransome who adores pornography in private but is a fully-paid-up member of the 'Decency League' in public, and a limping, sandwich-board carrying, religious zealot called Hern (Dudley Sutton). Prime suspect though is Harry Dougan (Alan Lake), a ruthless, horse racing obsessed, millionaire porno publisher who likes to audition new models in his own inimitable style. Sounds familiar? Well, only a fool would fail to recognise the autobiographical references to David Sullivan's own life. But what does Sullivan himself think of the likeness? 'Lake *is* playing me,' he reluctantly admits, 'but only vaguely.'

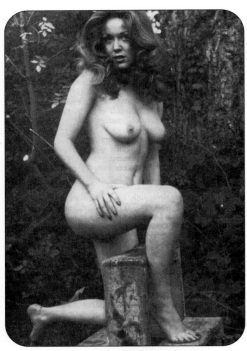
Playbirds lovely, Gloria Brittain

The next *Playbird* cover girl to emerge is Lena Cunningham (Suzy Mandel). She is a petulant, spoilt, vicar's daughter who only got into porn, we later learn, in order to pay for an abortion. Regardless, the film's male romantic interest Gavin Campbell falls under her spell and then puts her under 24 hour watch. This budding love affair goes a bit pear-shaped when Lena falls foul of the fearsome 'Chopper' (as the media have nicknamed the serial killer), becoming the fourth unfortunate victim.

Straining at the bit to get more involved in the case, Mary offers to go undercover to help apprehend the killer, but before assigning her to the case, her superiors are anxious to see if she has the necessary 'attributes' to

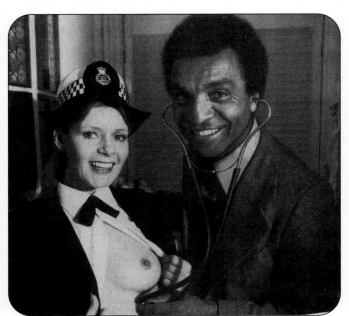

be a *Playbirds* model. In a curious piece of Metropolitan Police procedure Mary agrees to an audition, stripping to her birthday suit in front of stony faced Edwards and Campbell. Her stupefying performance immediately secures her the job but the WPC's desire to get an accurate feel for her new porn career rapidly goes a bit too far when she poses as a prostitute at a massage parlour (actually *Nicole Sauna* on Kentish Town Road), screws a couple of unattractive men and has her first lesbian experience all in the space of one evening! Now that is dedication to the job! Her saucy occupation soon brings her to the attention of Alan Lake who needs little persuasion to line her up as the next 'Playbird Of The Month', but in order to maintain her deception, Mary has to go undercover in Lake's bed to show him just how grateful she really is.

All goes according to plan, Mary is a big hit with the porn magazine buying public and the entrapment is nearly complete. After the *Playbirds* annual bash at Lake's Sunningdale mansion, Bible bashing weirdo Hern is arrested and charged with the murders, but in one of the

biggest climactic cop-outs in movie history the grand plan goes strangely awry. Back at her flat, Mary takes a bath and is astonished to find the culprit waiting for her. As she is strangled in her bath water the man reveals himself to be Hern's twin brother. Go figure! This laughably silly downbeat ending was, amazingly, all Sullivan's idea and has the appearance of being tacked on in a desperate last minute attempt to increase the thrill factor.

Rubbish ending aside, producer Sullivan, director Roe and star Millington had created a deliciously fruity slice of the sex film cake, baked with exactly the right ingredients: unbelievable sex, cheap thrills, goggle-eyed gimmickry, camp mischief, crap car chases and lashings of Britain's number one pin-up all mixed together to create a movie which is devilishly good fun. Ripe for rediscovery, *The Playbirds* is a masterpiece of British sexploitation; essential cult viewing with its many faults and funny predictability making it all the more addictive more than twenty years on. If just one British sex film could be preserved in a time capsule in the *Blue Peter* garden then this would have to be it!

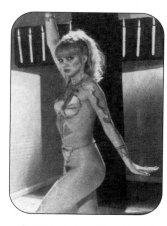

Lena Cunningham (Suzy Mandel) performs a witchcraft dance for Alan Lake's magazine in the film **The Playbirds**

Reviews

'The trimmings are of striptease, nudity, sex and a touch of the kinky, but otherwise these ingredients are but condiments to what is otherwise, in acting and in style, for all the world like an old time British second feature transplanted to the 70s.'
Films Illustrated. July 1978.

'The cast, with perhaps the possible exception of Gavin Campbell, might have done well to heed the plea of the photographer in the film who urges, 'C'mon folks, put some life into it.'
Screen International. 12 August 1978.

Tit Bits

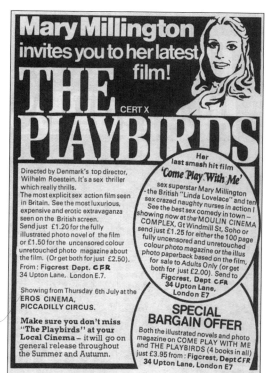

● More than a few film reviewers likened the style of *The Playbirds* to that of a British 1950s 'B' movie, an understandable comparison. The film bears an uncanny resemblance to the 1959 shocker *Cover Girl Killer* (directed by Terry Bishop) starring a young Harry H. Corbett as a deranged, short-sighted strangler intent on knocking off all the young lovelies gracing the cover of a soft porn magazine called *Wow!* As in *The Playbirds*, the magazine's publisher is suspect number one, until the real killer is apprehended.

● British sexploitation films had to be made on a low budget because of their relatively limited market, and as a rule our home-grown sex films did not travel well to territories where hardcore pornography was the norm. Thus *The Playbirds*' intended audience was always in the forefront of director Willy Roe's mind. Hoping to include some more elaborate and artistic scenes in the narrative, Roe was forced to cut them from the final print because they sat awkwardly with the rest of the film. He did, however manage to sneak in a couple of paraphrased references to The Bible and Ulysses and some more highbrow dialogue. At one point in the film Derren Nesbitt's character, Jeremy, attempts to justify his liking for porno mags by suddenly saying: *'The joys and pleasures and agonies and ecstasies of sexual attraction has, for years, been the main topic of poets, philosophers and painters!'* Got that?

● Despite being better known for playing underworld villains and vicious crooks in a variety of police dramas and thrillers, *The Playbirds* was not Derren Nesbitt's first taste of sex films. In 1974 he adapted his dull novel *The Amorous Milkman* into an even more boring feature film. The movie, which he both directed and

produced, featured husband and wife porno double-act Dors and Lake, and is a laboured and unfunny affair. (A British Film Institute reviewer commented 'This is British graffiti at is worst'.) Successfully managing to curdle his own milk, Nesbitt even makes an uncredited cameo appearance himself *à la* Alfred Hitchcock!

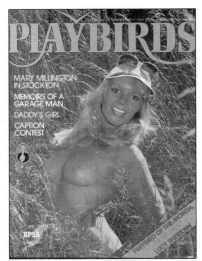

● Britain could boast two English alternatives to Marilyn Monroe during the 1950s; both were buxom blondes who thrived on bad publicity. They were Sandra Dorne and Diana Dors. Twenty years later the two stars had seen better days, bigger film roles and smaller waistlines. Coincidentally, the actresses' penultimate cinema parts were in Mary Millington movies. Dorne appeared in the disappointingly throwaway role of Alan Lake's secretary in *The Playbirds* whilst Dors was seen dreadfully over-acting in *Confessions From The David Galaxy Affair*.

● When, in the film, Mary's character Lucy succeeds in becoming a cover model for Dougan's *Playbirds* magazine, a real-life copy of *Playbirds* was used (issue number 21 to be exact), showing Mary wearing a sun visor in a field of long grass near Dorking. A second unit cameraman was sent to Sullivan's magazine printing plant in Carlisle to film some footage showing the cover and these shots were later intercut into the rest of the movie. It was another brilliant marketing ploy by Sullivan and one that paid off handsomely; 98% of the print run of that single issue sold out immediately.

*Playbirds issue 21, as seen in **The Playbirds** movie*

● The horse, *Mr Playbird*, featured racing at Newmarket and Kempton Park in the film was owned by Sullivan. Realising that he could not advertise his magazines and films on television or radio, he started to name his growing stable of thoroughbreds in a suitably cheeky way. Joining *Mr Playbird* were *Miss Park Lane*, another named after

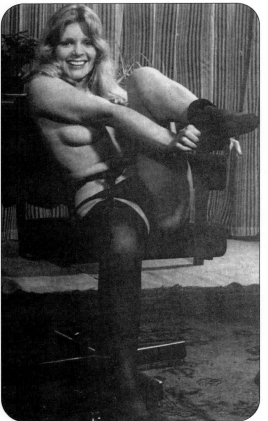

Mary herself and even one called *Come Play With Me*. On 24th August 1977 *Come Play With Me* won its very first race at odds of 10-1. *Playbirds*, the movie, also contains a little in-joke when a voice heard in the background over the tannoy asks a certain David Sullivan to come to the owners' enclosure!

● *The Playbirds* was released at the Eros Cinema in the hot July of 1978, running for 34 unbroken weeks until 21st February 1979, during which time it took £177,808. The film was reissued in May 1980 and became one half of a double feature alongside surreal Spanish sex drama *La Visita del Vicio* (1978), crudely and unappealingly retitled *Violation Of The Bitch* for UK audiences. A later video reissue of Mary's film became known as *Secrets Of A Playgirl*. In the early 1980s *The Playbirds* was successfully sold to US cable television and remains Mary's best known movie across the Atlantic.

● Actress Penny Spencer appears in *The Playbirds* in a rather insignificant nude role of giggling Police Sergeant Andrews. Spencer was best known for playing teenage crumpet Sharon in the sit-com *Please Sir!* between 1968 and 1970, before she handed her role over to Carol Hawkins. Penny had previously appeared, fully covered up, in Denis Norden's Victorian prostitution comedy *The Best House In London* (1968), but later decided to take off her clothes in order to 'further her career'. She landed a lead role in the 1976 psychiatric sex romp *Under The Doctor* (aka *The Way You Smile*) in which she is seen taking a stroll down Kensington High Street in a see-thru blouse, much to the astonishment of real-life West End shoppers!

● Eagle-eyed viewers may notice that during Mary's striptease sequence her knickers change from black to white to black again!

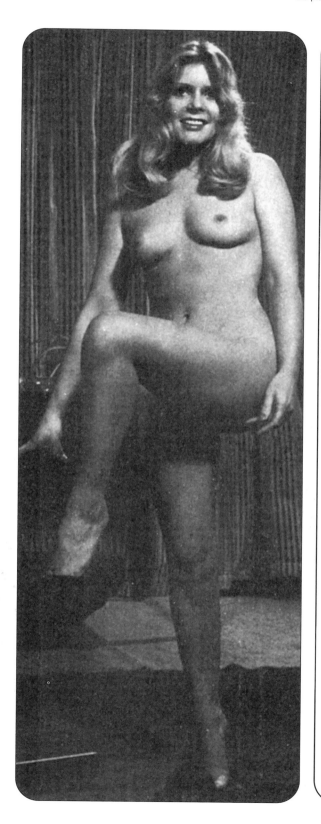

THE PLAYBIRDS
Great Britain / 1978
94 mins / cert X

CAST
Mary Millington...WPC Lucy Sheridan
Alan Lake...Harry Dougan
Glynn Edwards...Chief Supt Jack Holbourne
Gavin Campbell...Insp Harry Morgan
Suzy Mandel...Lena Cunningham
Windsor Davies...Assistant Police Commissioner
Kenny Lynch...Police Doctor
Derren Nesbitt...Jeremy
Dudley Sutton...Hern
Ballard Berkeley...Trainer
Alec Mango...George Ransome MP
Pat Astley...Doreen Hamilton
Sandra Dorne...Dougan's secretary
Penny Spencer...Sergeant Andrews
Michael Gradwell...Terry Day
John M. East...Radio interviewer
Anthony Kenyon...Dolby
Ron Flanagan...Det Wilson
Susie Silvey...WPC Taylor
Derek Aylward...Older massage man
Debra...Foxy
Tony Scannell...Man at depot
Gordon Salkilld...Police photographer
Howard Nelson...Caped man
Nigel Gregory...1st Expert
Tom McCabe...2nd Expert
Pat Gorman...3rd Expert
Gloria Brittain...Crucifix model
Suzette Sangalo Bond...Poolside party girl
Julian Wilson...Voice of racing commentator

CREDITS
Director...**Willy Roe**
Producer...**Willy Roe**
Executive Producer...**David Sullivan**
Assistant Director...**Nick Farnes**
Photography...**Douglas Hill**
Editor...**Jim Connock**
Camera Operator...**Brian Elvin**
Sound Recording...**Cyril Swern**
Music Composed by **David Whitaker**
Title Song *'Playbirds'* Performed by **John Worth**
Screenplay...**Bud Tobin** & **Robin O'Connor**
(**Joe Ireland** & **Willy Roe**)

A ROLDVALE Film
Distributed by TIGON

**Opened 6th July 1978
Eros Cinema, Piccadilly**

come play with

pat astley

Unfortunately for Pat Astley, her character gets murdered in the first few minutes of *The Playbirds*, but she does get to play a corpse a bit later on. Sadly this was a fairly typical example of the direction taken by Pat's cinema career. The forgotten star of British sex films, she was rarely given the amount of screen time she deserved and in several of her films she appeared completely uncredited. To add insult to injury, even when she was mentioned she frequently had her surname misspelt *Ashley*.

A statuesque blonde with big square shoulders, Blackpool-born Pat towered over the rest of the Seventies glamour girls but her average acting ability and slightly 'vacant look' often saw her relegated to the second division. After a move to London, in the early part of the decade, she made fleeting appearances in hardcore 8mm shorts, including some made by John Lindsay and George Harrison Marks. Titles included *Nymphomania*, *Doctor Sex* and *End Of Term*; in the latter her patience is tested to the limit by smarmy sex film actor Tim Blackstone and a vibrator! She went on to feature in numerous photo sets for porno magazines and on a number of occasions posed with Mary Millington in explicit lesbian shoots.

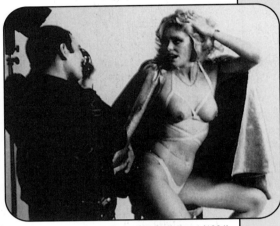

above: Pat in ***Don't Open Till Christmas*** (1984)
left: ***Queen Of The Blues*** (1979)

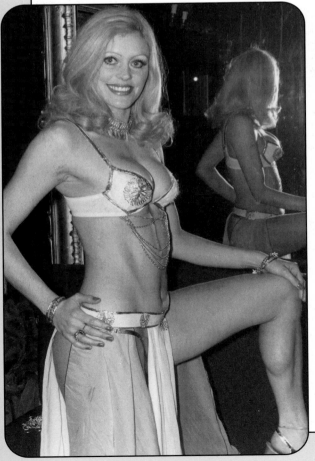

Throughout the 1970s she could be seen regularly at the local Odeon in a wide variety of tiny roles working alongside the better known Fiona Richmond, Mary Millington, Suzy Mandel and Rosemary England. In 1979's *The World Is Full Of Married Men* she enjoyed more screen time than usual playing a good-time girl opposite Nicola Austine; together they even dance in silhouette under the end credits. Five years later she did finally secure a sizeable acting role and proved to be the most watchable thing in the low budget horror movie *Don't Open Till Christmas*. But luck was against her again; the film is perhaps the most frustratingly inept British movie of all time. It sank without a trace.

For a short time Pat was a household face, if not name; she appeared, uncredited again, in the 1977 season of classic sit-com *Are You Being Served?* as Young Mr Grace's leggy nurse. She never got to speak a single line and rumour has it that she was dropped from the show when producers found out about her previous acting form. Now living back in Lancashire, Pat has completely retired from acting and works part-time in a shop.

Look out for Pat in *I'm Not Feeling Myself Tonight* (1975), *Come Play With Me* (1977), *Let's Get Laid* (1977), *You're Driving Me Crazy* (1978), *The Playbirds* (1978), *Rosie Dixon ~ Night Nurse* (1978), *The Stud* (1978), *Queen Of The Blues* (1979), *The World Is Full Of Married Men* (1979) and *Don't Open Till Christmas* (1984).

What's Up Superdoc?

Great Britain / 1978 / 93 mins / cert X

To many of Mary Millington's admirers *What's Up Superdoc?* is the forgotten film of her later career. It is somewhat bemusing to see Mary's name so far down the list of credits for a 1978 movie, especially after the massive degree of success enjoyed by her two previous films. However, she had actually filmed her tiny *What's Up Superdoc?* cameo just months before *Come Play With Me*'s release and consequently she was not a famous big screen name at that stage of her career. It was a further year before the film saw the light of day and it would have been stretching even British sex comedy credibility to credit the movie, containing Mary's eighteen-second scene, as a bona fide 'starring vehicle'.

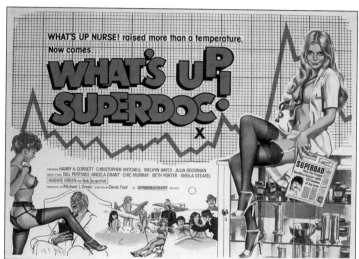

Superdoc? was the pseudo-sequel to 1977's comedy hit *What's Up Nurse?*, a British comedy which saw fit to plagiarise the title of Barbra Streisand's 1972 movie hit, and chronicled the sexual escapades of a wet-behind-the-ears doctor in Southend On Sea. The film is memorable only for featuring out-of-work *Carry On* stars Peter Butterworth and Jack Douglas who would have normally turned down such a 'lower-than-low-brow' script had a *Carry On* been made that year, (the only other major star from that series to make the transition to sex film was Charles Hawtrey in 1969's saucy sci-fi *Zeta One*). Whatever the reason, *What's Up Nurse?* was a hit, especially in the North of England, and making a follow-up seemed the natural thing for director Derek Ford to do.

The sequel sees the hero, Doctor Robert 'Sweeny' Todd settled at a smart practice in London and most strangely of all, sporting a new face. The previous actor, Nicholas Field, wisely left sex films to become an interior designer, leaving the door open for *It Ain't Half Hot Mum* actor Christopher Mitchell to take over the role. Although Mitchell's dopey TV persona was that of 'butter wouldn't melt', he had actually appeared in sex films before, including *A Promise Of Bed* (1969) and *The Sex Thief* (1973). This, however, was his first shot at playing a bed-hopping lead.

The plot is downright stupid, but *What's Up Superdoc?* is surprisingly good-natured, eminently watchable and, noticeably, a big improvement on the first instalment. This time around Doctor Todd is approached by glamorous Annabel Leith (played by Julia Goodman), a director of the Artificial Insemination Donor Service (A.I.D.S, with hindsight not a very good acronym). She reveals to him that his sperm donations, made during his days as a thrusting young medical student, have led to him fathering 837 babies, all boys and all with exceptional IQs. Annabel explains that as he has proven himself to be the superman among donors, he is perfectly qualified to take part in her new research project. Before long the story is leaked to *The Daily Mirror* by Annabel's vengeful secretary and suddenly every woman in the country is after the fertile Doctor Todd. Of course this is where the plot comes badly unstuck; just because our hero has a high sperm count it doesn't necessarily follow that he's going to be any good in the sack, or even particularly well-endowed. Still, this is good old British Comedy Land, so thousands of randy women fall over themselves to sleep with him, pursuing him throughout London waving test-tubes! Even gay men are gagging for a piece of the action. Why this chubby sexual bore is so damned attractive is anyone's guess; Christopher Mitchell's distinctly uncertain acting aside, in one scene you can actually see him straining to hold in his pot belly.

Todd is finally forced to go into hiding at the Royal Garden Hotel with a bodyguard (Harry H. Corbett) to protect him, but his sudden rampant sex drive inspires him to escape to Soho where he visits a lesbian floor show at The Raymond Revue Bar, before ending up teetering on a ledge outside a prostitute's window above Walker's Court. When he eventually gets home Todd submits to a shambolic television interview in an attempt to dissuade his army of stalkers, but he is suddenly (and this is where it gets *really* crap) kidnapped by a gang of piss poor 'American' gangsters, headed by *Dad's Army* star Bill Pertwee no less, who want Todd to impregnate Pertwee's daughter Julie (Maria Harper). He understandably refuses to do it and in a vain attempt to make him ejaculate (I kid you not) Todd is tempted by various nubile young women, including two insatiable French maids (Anna Bergman and Nicola Austine) and an amorous stripper (*Whitehouse* magazine model Vicki Scott).

The last temptation occurs whilst Todd is having breakfast. As he serves himself some very predictably shaped sausages and eggs Mary Millington slinks in, naked save for a gold chain around her midriff and a waistcoat completely open for all to see. Looking uncharacteristically plump, she offers him some alcohol, hoping to get him in the mood, but he rejects her advances by pouring it down the front of his tracksuit bottoms and cooling his ardour. Mary's scene seems to be over as quickly as it begins and not for the first time in her career her single line of dialogue, *'Good morning Doctor. Would you like a little drink of champagne?'* is dishearteningly dubbed, this time by a would-be Fenella Fielding impersonator. From the point of view of her fans, her appearance is hardly up there among her greatest moments and one cannot help wondering why more wasn't made of her cameo.

By comparison with its naughty film compatriots, *What's Up Superdoc?* is a pleasingly good-looking sex comedy chock-a-block with amusing sit-com set pieces and titillating nudity. Sadly the preponderance of masturbation and sperm jokes do leave a nasty stain after a while, and this as much as anything else must have contributed to its disappointing performance at the British box office. The film's commercial failure was made all the more noticeable after the great achievement of its predecessor *What's Up Nurse?* Mary Millington could quite easily have been the movie's saving grace had she been elevated to a central role, or just promoted more effectively, but of course at the time nobody had the slightest idea just how big she would later become. Despite the fact that Mary was riding on the crest of a showbiz wave during the autumn of 1978, when the film was released, no bright spark at the distributors saw fit to surreptitiously slip *'Featuring Mary Millington'* onto the cinema poster. Had they done so, the queue outside the Regal would undoubtedly have been a darn sight longer and *What's Up Superdoc?* might have been giving *Come Play With Me* a serious run for its money.

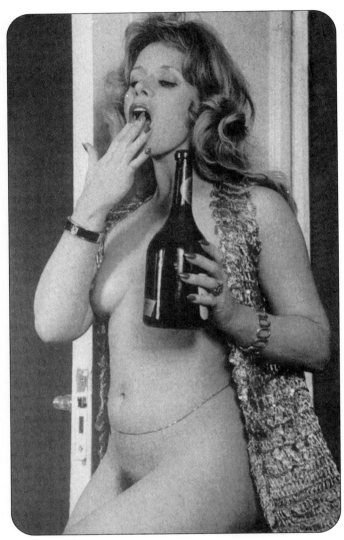

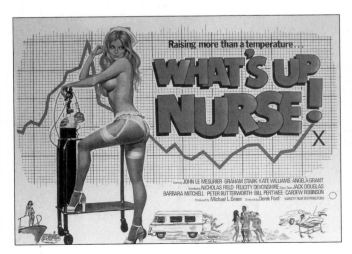

Review

'I confess that my heart sank when it was first revealed that the hub of the plot was to be artificial insemination, and my hackles bristled briskly at being told that Robert's super status as a stud was in part related to his inability to father girls. However having dutifully eaten the tasteless crusts I found that what followed was more agreeable. More a succession of sketches than a story, Derek Ford's screenplay ranges from the coy to the clever.
**Screen International.
30 September 1978.**

Tit Bits

● Derek Ford originally intended to make his *'What's Up'* films into an ongoing series (not necessarily following a medical theme each time), somewhat like the *Carry Ons*. This idea was stalled in its tracks after the comparative failure of *Superdoc?* at the box office and the escalating production costs of British movies in general. In any case, the advent of video cassettes in the late 1970s had already announced the death knell for softcore sex films at the cinema. Ford did not leave the film-making industry totally though, he was a screenwriter as well as director. Among his later projects were the financially disastrous *Heavy Metal* (1980), starring Irene Handl and real-life motorbike stunt-rider Eddie Kidd, and atrocious slasher flick *Don't Open Till Christmas* (1984), easily a contender for the worst British film ever. Derek Ford died from a heart attack in May 1995 at his home in Bromley, Kent.

● Smarmy *Opportunity Knocks* presenter Hughie Green makes a cameo appearance as television presenter Bob Scratchitt, who interviews Doctor Todd on his LWT programme. When the interview disintegrates on air, Green opines to his producer, *'How could you put me on the air live with a guy who wanks for a living?'* Those members of the cinema audience agog at the gameshow host's over-the-top acting may have been interested to know that he had actually started off his career as an actor forty years earlier. His early cheesy film appearances included *Mister Midshipman Easy* (1935) and *Melody And Romance* (1937).

● Even though it is one of the last fully-fledged sex comedies, *What's Up Superdoc?* does contain one very memorable scene of unadulterated home-grown erotica. Added purely as 'padding' (it has little to do with the film's plot), the four minute sequence was filmed on location at the 'world famous' cabaret venue *The Raymond Revue Bar* in Brewer Street, London and shows a performance by lesbian speciality act, The Blue Angels. Delicately choreographed and tenderly executed, the two virtually identical women, wearing cropped blonde wigs and diamante G-strings and chokers, go through the motions with elegance and precision. Sitting rather uneasily with the slapstick jokery of the rest of the movie, the sequence nonetheless has a powerful impact on the proceedings, and by way of an added bonus provides Mr Raymond with yet another blatant piece of advertising for his establishment.

● *What's Up Superdoc?* must be the only British sex comedy to enjoy the patronage of *Stax* recording legend, and *South Park* star, Isaac Hayes. Well sort of. The U.S. soul singer, famed for the 1971 hit *Theme From Shaft* had his suggestive sounding tune *Hold On, I'm Coming* re-recorded as the movie's title song. Bizarrely, elsewhere in the film some of composer Frank Barber's score is sneakily recycled from Irene Handl's gentle 1973 TV spin-off, *For The Love Of Ada.*

WHAT'S UP SUPERDOC?
Great Britain / 1978 / 93 mins / cert X

CAST
Christopher Mitchell...Dr Robert Todd
Julia Goodman...Dr Annabel Leith
Harry H. Corbett...Sgt Major Goodwin
Bill Pertwee...Woodie
Chic Murray...Bernie
Angela Grant...Kim
Hughie Green...Bob Scratchitt
Melvyn Hayes...Pietro
Ronnie Brody...The Boss
Beth Porter...Melanie
Sheila Steafel...Dr Pitt
Marianne Stone...Dr Maconachie
Maria Harper...Julie
Milton Reid...Louie
Sue Upton...Marlene
Nora Llewellyn...Monika
Lisa Taylor...Wife
Ronald Alexander...Husband
Julie Kirk...Dr Todd's receptionist
Fay Hillier...Raymond's Revue Bar stripper
Jack Silk...PC Robinson
Geoffrey Leigh...Hermann
Mary Millington...Girl with champagne
Anna Bergman...1st Maid
Nicola Austine...2nd Maid
Vicki Scott...Stripper in house
Alison Begg...Girl up tree
Peter Greene...Man in audience
Norman Lawrence...Solicitor
Jackie Moran...Make-up girl
Ian Ford...Boy in park
The Blue Angels...Speciality act

CREDITS
Director...**Derek Ford**
Producer...**Michael L. Green**
Assistant Directors...**Gordon Gilbert** & **Victor Priggs**
Photography...**Geoffrey Glover**
Editor...**David Campling**
Sound Recording...**Roger Johnson**
Music...**Frank Barber** & **Paul Fishman**
Title Song *'Hold On I'm Coming'* written by **Isaac Hayes** & **David Porter**
Performed by **Fingers**
Screenplay...**Derek Ford**

A BLACKWATER FILMS Production
Distributed by ENTERTAINMENT

Released September 1978

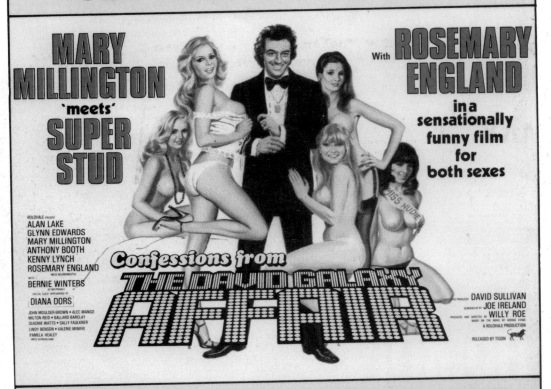

SEE NEARLY TWO HOURS OF SEXSATIONALLY FUNNY,
NON-STOP PORNO! BE ONE OF THE FIRST
PEOPLE IN BRITAIN TO SEE

CONFESSIONS FROM

THE DAVID GALAXY AFFAIR

SHOWING FOR A SEASON AT THESE CINEMAS!

LONDON

Eros, Piccadilly Circus, Thursday June 28th – continuous performances from
11.00am daily, late show nightly, showing 7 days a week, continuous performances.

BLACKPOOL

Studio Cinema, from July 5th.

GT. YARMOUTH

Empire Cinema (late night shows only) from July 5th.

Confessions From The David Galaxy Affair

Great Britain / 1979 / 96 mins / cert X

**'Mary's films didn't just appeal to the 'dirty mac' brigade.
Limousines and Rolls Royces would pull up outside the cinemas.'**
(Willy Roe, Director)

With the returning leads of Alan Lake, Mary Millington, Glynn Edwards and Kenny Lynch, plus small roles for Alec Mango and John M. East, it would seem on the face of it that *Confessions From The David Galaxy Affair* was a sequel to *The Playbirds*, but it's not. 'It was never envisaged as a sequel,' says director Willy Roe. 'We just called up the usual suspects. They understood what we were doing and we could travel much faster with actors who already knew one another.' Actually, it is a shame that the film is not a follow-up, as *David Galaxy* is a sore disappointment and what's more, a missed opportunity: if actor Dudley Sutton was allowed to play his twin brother in *The Playbirds* then imagine the fun possibilities had Mary been given free reign to play the long-lost sister of WPC Sheridan - out for revenge in a second instalment!

Mary shares a thought with PM Tony Blair's father-in-law, Tony Booth

As it is, *David Galaxy* fails to consolidate on the comedy appeal of *Come Play With Me* and the thrills and spills of *The Playbirds*. It is an odd kind of hybrid without excitement or focus, even pinching its *Confessions* prefix from the well-known sex comedy series starring Anthony Booth and Robin Askwith. Those films had petered out in 1977 but, coincidentally, Booth himself has a supporting role in this one, although Alan Lake (as David Galaxy) makes a poor replacement for Askwith.

Despite the promising title, Lake, as a womanising astrologer, confesses to nothing of any interest. From his prison cell home he recounts the sorry tale of how he came to be there. The stargazer revels in his reputation as a stud and gambler living it up in a smart Docklands penthouse (curiously with an exterior in Kensington!), entertaining a string of women including a misty-faced married MP, numerous beauty competition contestants, a traffic warden, a moody psychiatrist and a couple of randy lesbians(!) It beats me why this guy is so popular with the women. His character is even less attractive than flamboyant ladykiller *Jason King* and that's saying something. Galaxy is cocky, smug, over-confident and an admirer of puerile racist jokes. Not only this, but he calls his apparently large (we never see it) penis 'Fido', something which his air-headed girlfriends find simply irresistible. He's the archetypal Seventies hero; big lapels, gold medallion, mirrored headboard - a complete and utter prick.

Par for the course, Lake's acting is nothing short of deplorable. The screenplay by Joe Ireland (aka George Evans) sadly gives him free range to be as annoying and unwatchable as possible. His performance is self-indulgent and incredibly gruelling to endure. Seeing him go through his full repertoire of jokes and impressions (Basil Rathbone, a Pakistani, John Wayne, a Jamaican, Harold Wilson, Mohammed Ali etc.), probably does most to alienate audience sympathies. Rolling his bulging eyeballs and mugging for the camera, Lake's performance is most memorable for its rotten comic timing. His impersonation of a camp homosexual is so poorly executed and bewildering to watch that it's best to cover your eyes and block your ears for the duration of the scene. When his character muses *'I should have been an actor, not a Shakespearean actor though. I've never been very fond of the old bard. I mean it's a bit unbelievable isn't it?'*, it could almost be Lake himself speaking.

Galaxy is under investigation by Chief Inspector Evans (played by Glynn Edwards in identical fashion to his role in *The Playbirds*) for his role as a getaway driver in a Securicor van robbery in 1974 in which a guard was killed. He refutes the charge, but his alibi for the day in question is far from watertight. It's not surprising to learn that Galaxy

can't find anyone to stick up for him; even his elderly mother (Queenie Watts in a tiny cameo for which she got paid £75!) hates his guts and would rather see him go to jail. When he eventually does get sent down for five years, still pleading his innocence, everyone can breathe a huge sigh of relief all round. The verdict is just what the cinema audience have been waiting for, it's just a pity the sentence wasn't twenty years.

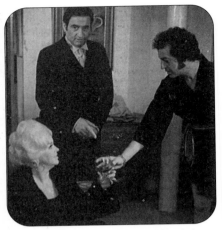

Diana Dors, Bernie Winters and Alan Lake

Mary is *David Galaxy*'s one saving grace. She appears as the beautiful society woman, Millicent Cumming who, in an surprising sub-plot, enjoys all the trappings of a charmed life but has one little problem: she has never achieved orgasm despite sleeping with hundreds of men. A glum-looking Mary meets her friend Steve (Anthony Booth) at *The Concordia* restaurant and is reluctantly persuaded by him to meet 'super-stud' David Galaxy, the obvious solution to her medical complaint. In a tasty comedic moment she consults her busy diary and explains, *'I could fit him in nicely on Wednesday week!'*. The appointed time rapidly comes around, but unbeknown to Mary, smarmy Steve has bugged Galaxy's bedroom and placed a bet on whether she will actually 'come' or not. After a prawn cocktail washed down with a quick Campari and soda Mary inevitably finds herself in Galaxy's mirrored bed and the two get down to business. This scene, the one that Lake's wife Diana Dors hated so much, is easily the most explicit in any 1970's British sex comedy. Lake even agreed to take off his underwear and director Willy Roe remembers that Mary's lack of inhibitions encouraged him to help make the lengthy scene more realistic, though his modesty is always concealed by a conveniently placed duvet.

Mary's character energetically grunts from one position to another, finally achieving what she has always dreamt of, much to the delight of Steve and his friends who have been listening to the romp back at the *Concordia*. Although Mary had shared a bed scene with Lake the year before in *The Playbirds*, the two sequences were miles apart in terms of passion and raw energy. One press release insinuated (in common with the rumours about Marlon Brando and Maria Schneider in *Last Tango In Paris*) that the two main players were not actually 'faking' at all. This sort of gossip infuriated Dors and did nothing but hammer home the fact that she and her husband were trapped in a frustrating cycle of low budget films.

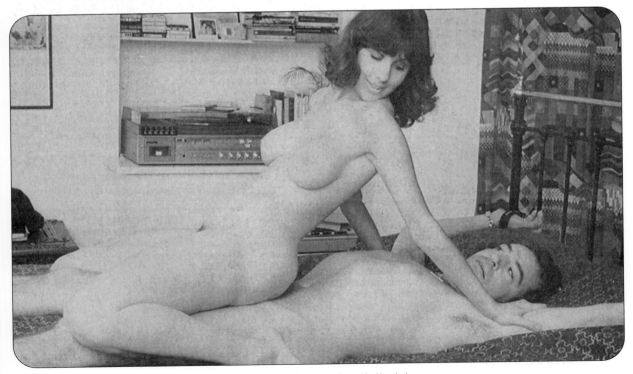

Rosemary England gets to grips with Alan Lake

In fact, the veteran actress managed to wangle a small featured role for herself in *David Galaxy* as Jennie Stride, the rich new owner of Galaxy's apartment block. Unfortunately, Dors makes a meal of playing the stern businesswoman, but does get to share a couple of scenes with her real-life husband. Despite her professional reputation Dors was often told to tow the line as she was inclined to ham it up (especially with co-star Bernie Winters) at every available opportunity. Much to Mary's disappointment her part did not involve any screen time with her acting heroine.

Confessions From The David Galaxy Affair was a resounding flop when released at the Eros Cinema, Piccadilly in the summer of 1979. The decision to focus the story on an irritating performance by Alan Lake rather than the real draw, Mary Millington, proved to be a costly mistake for David Sullivan. Once again it seemed that the producer and director both wanted totally different things from the film. *David Galaxy* took less in its opening week than either of its predecessors and at another West End cinema it closed after only two weeks. Exactly a month after her first personal appearance at the Eros with fellow model Rosemary England, Mary was

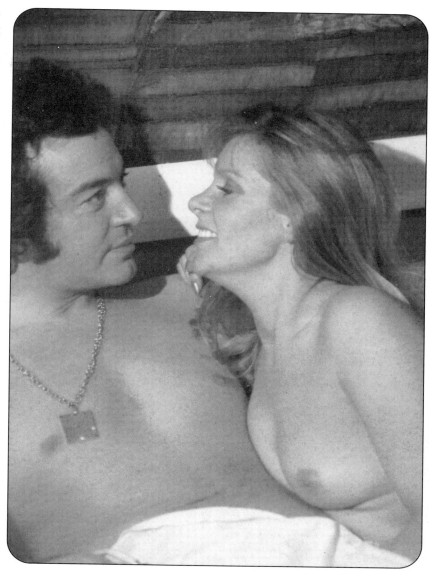

back again, trying to drum up trade with cinema manager Brian Rahmi. She failed miserably. Sullivan refuses to lay the blame on anyone's doorstep, however. Had his original idea for the film gone to plan *David Galaxy* may well have been the biggest movie of his career. 'I wanted Sylvia Kristel from *Emmanuelle* starring alongside Mary,' he explains with a smile. 'I offered her £10,000 for a single day's work, which was a lot of money in those days. I even told her that she didn't actually need to be nude because all I wanted it to say on the cinema poster was, 'The world's two greatest sex symbols in one film!' Kristel told me: 'I don't make sex films anymore.' She was living with that Ian McShane at the time and she suddenly thought she was going up market. I thought it would be a marketing concept. You think to yourself you've conned them once, how am I gonna con them again?'

Review

'With its barely identifiable semblance of plot, a level of comic invention exemplified by having the hero interrupt his love-making by breaking wind, and a dramatic context that amounts to little but the endless offering and pouring of drinks, this erotic 'thriller' proves squalidly unwatchable.'
Monthly Film Bulletin. August 1979.

Tit Bits

● *David Galaxy* was such a big disappointment at the box office that its distributors *Tigon* saw fit to change its title to the snappier, more astrological sounding, *Star Sex*. It was reissued under this title in October 1980 as part of a double bill with Robert Montero's Italian sex farce, *Caligula's Hot Nights* aka *Le Caldi Notti Di Caligula* (1977). The new tactic didn't work especially well. Punters thinking that they had come across a 'lost' Mary Millington film were sorely mistaken. Repackaged chocolate boxes still contain the same old hard centres.

● The cinema poster for *David Galaxy* shows a picture of an uncommonly busty Mary. For some strange reason this picture turned up seven years later on the video cover of innocuous Norman Wisdom comedy *What's Good For The Goose* when it was reissued in 1986 by Foxtrot Films, as *Girl Trouble*. There can be no doubt that an appearance in a Mary Millington film would have given Norman's career a much needed boost back in the 1970's, but sadly the pairing never materialised.

● John Roach, who plays the tiny part of a prison warder, was not actually an actor but, John M. East's personal driver. His lack of experience did nothing to deter Roldvale from hiring him for their next five films, playing a variety of roles including 'Man wanking in porno cinema' (*True Blue Confessions* 1980) and 'Referee in a woman's mud wrestling match' (*Hellcats ~ Mud Wrestling* 1983*)*. Also enjoying a cameo role, as one of Galaxy's cronies, is Count Luigi Deanjioy in a sepia-tinged flashback sequence filmed at an Irish pub in Kilburn High Street. Deanjioy had a reputation during the Seventies as an international playboy and was well-acquainted with a host of dodgy European Royals.

● Mary Millington's real-life favourite Italian restaurant, *The Concordia* in Craven Road, Bayswater, is used extensively as a location in *David Galaxy*. A visually stunning eating place with a sophisticated atmosphere, *The Concordia* became one of the 'in' places to dine out at during its Seventies heyday. Strangely enough it became a popular sex film locale, featuring in several movies

Willy Roe directing

including *The Playbirds* (1978), *Emmanuelle In Soho* (1981) and the execrable *Perils Of Mandy* (also 1981), for which it formed the background to Gloria Brittain's dreadful striptease. In 1995 one of the owners of the *Concordia*, Lillo Militello, was closing up after a long evening when he claimed to have seen an apparition of Mary sitting in what used to be her favourite seat. 'I was shaking because I was very, very frightened,' says Lillo. 'But she turned to me and said, 'I'll see you again' before disappearing.'

● Actress Valerie Minifie (playing a *Concordia* patron who very nearly succumbs to the 'Galaxy charm') shares a brief scene in the film with Alan Lake. Valerie returned - propping up the bar again - in *Queen Of The Blues*, but these movie appearances are probably best forgotten. From 1992-1998 she became better known as Martin Clunes' dizzy secretary, Anthea, in the popular sit-com *Men Behaving Badly*. Coincidentally, in 1999 she had a cameo role in LWT's Diana Dors biopic, *The Blonde Bombshell*, playing opposite actor Barnaby Kay in his role as Alan Lake.

● From 1979 onwards, one of the more popular models in Sullivan's publications was Vicki Scott, a petite Scottish girl with short curly hair and a cheerful personality. Vicki started off as a lingerie model and magazine pin-up before finding herself in great demand for small roles in a variety of sex films including *Let's Get Laid* (1977), *Adventures Of A Plumber's Mate* (1978), *What's Up Superdoc?* (1978) *Confession From The David Galaxy Affair* (1979), *The Great British Striptease* (1980) and *Emmanuelle In Soho* (1981). In 1979 she featured in the infamous British video *Sex Freaks*, as a Marylin Monroe lookalike paired with the dubiously-endowed 'Long Dong Silver' from Dagenham, before turning up three years later scrapping (with her real-life sister) in *Hellcats ~ Mud Wrestling* (1982). She retired from modelling, returned to Scotland and apparently became a nurse.

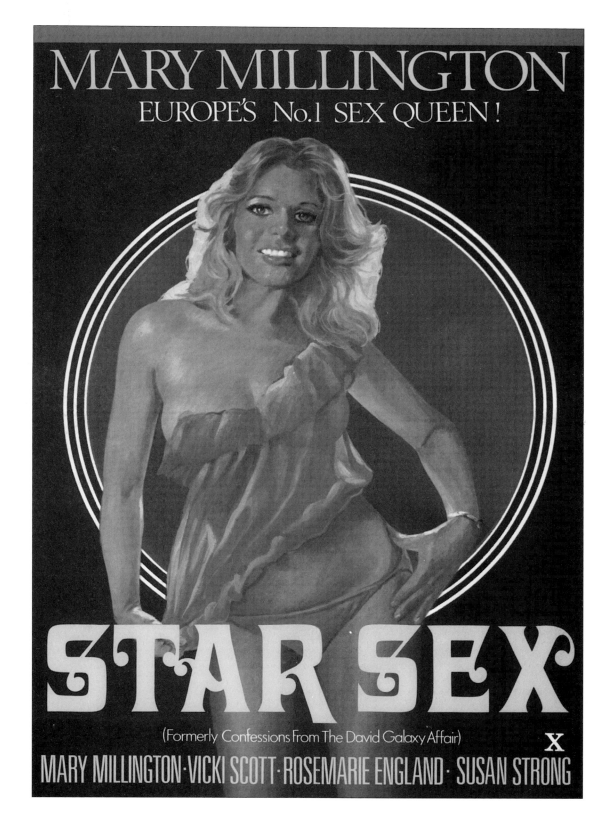

CONFESSIONS FROM THE DAVID GALAXY AFFAIR
aka *STAR SEX*
Great Britain / 1979 / 96 mins / cert X

CAST

Alan Lake...David Galaxy
Glynn Edwards...Chief Inspector Evans
Anthony Booth...Steve
Diana Dors...Jennie Stride
Mary Millington...Millicent Cumming
John Moulder-Brown...Sergeant Johnson
Bernie Winters...Mr.Pringle
Kenny Lynch...Joe
Rosemary England...Sandra
Sally Faulkner...Amanda
Queenie Watts...David Galaxy's Mother
Milton Reid...Eddie
Cindy Truman...Anne (traffic warden)
Maria Parry...Susan Carter MP
Ballard Berkeley...Judge
Alec Mango...Cllr. Pembleton
Barbara Eatwell...Kate (1st lesbian)
Vicki Scott...Charlotte (2nd lesbian)
Faith Daykin...Julia Shorthouse
Penny Kendall...Angela Kripp
Pamela Healy...Gina Kirby
Valerie Minifie...Sylvia
Jeanette Caron...Edie
Tina Kirsch...Jill (nurse)
John M. East...Willie
Luigi Deanjioy...Luigi
George Lewis...George
Steve Kane...Steve
Diana Hicks...Steve's girlfriend
Lindy Benson...Evelyn
Claire Nicholson...Janet (Mrs Stride's secretary)
Lou Soames...Girl in bar
Arnold Locke...1st Lawyer
Tony Lang...2nd Lawyer
George Ballentine...Clerk of Court
Eric Kent...Policeman
David Roy Paul...Policeman #2
John Roach...Warder

CREDITS

Director...**Willy Roe**
Producer...**Willy Roe**
Executive Producer...**David Sullivan**
Assistant Directors...**Peter Dolman** & **Peter Jacobs**
Photography...**Douglas Hill**
Editor...**Jim Connock**
Camera Operator...**Brian Elvin**
Sound Recording...**Cyril Swern**
Music...**David Whitaker**
Title Song *'His Name Is Galaxy'* Performed by **Diana Dors**
Screenplay...**Joe Ireland**
Based upon the novel by **George Evans**

A ROLDVALE Film
Distributed By TIGON

Opened 28th June 1979
Eros Cinema, Piccadilly

come play with

david whitaker

Diana Dors was famous for a multitude of things but singing was definitely not one of them. Nevertheless, she was asked to lend her dubious vocal talents to the opening theme tune to *Confessions From The David Galaxy Affair*. The man responsible for coaxing this jaw-dropping performance from the actress was David Whitaker.

Born in Kingston in 1931, Whitaker was classically trained at London's Guildhall School Of Music. He went on to become one of British cinema's most well known names with credits as a composer, arranger and songwriter on dozens of movies throughout the 60s and 70s.

Whitaker not only scored the theme and incidental music to *David Galaxy* but was also responsible for the annoyingly catchy musical scores of two more Millington movies. The OTT, singalong, club singer appeal of *The Playbirds* theme is irresistibly camp, but even this pales in comparison to the deliciously sexy tunes that invade every corner of *Queen Of The Blues*; his strong melodies are easily the sexiest part of the entire film. Some of his music was later successfully recycled for the dodgy 1980 tribute film *Mary Millington's True Blue Confessions*.

His many other considerable achievements include the music for cult horror flicks *Scream And Scream Again* (1969) and *Psychomania* (1972) plus a couple of Hammer Horrors, *Doctor Jeckyll And Sister Hyde* (1971) and *Vampire Circus* (1972). Comedies such as Jerry Lewis' *Don't Raise The Bridge, Lower The River* (1968) and *That's Your Funeral* (1972) also benefited from the Whitaker touch.

The multi-talented maestro is now living in the English countryside and has recently been rediscovered by a new generation of musicians, collaborating on projects with the likes of Mick Hucknall's *Simply Red* and the album *Moon Safari* by wacky French instrumentalists *Air*.

Typically lurid artwork for Hammer's **Vampire Circus** *(1972) -*
one of the many British movies for which composer David Whitaker provided the score

come play with
rosemary england

Rosemary England's star shone for less than two years, but in that short time what an impression she made! The only one of David Sullivan's models who achieved anything approaching the degree of popularity enjoyed by Mary Millington, she came to him with an enviable pedigree. Rosemary was an ex magician's assistant from Bournemouth who modelled regularly for the British tabloids throughout the late 1970s under her real name of Jada Smith. For a time, she was one of Britain's most successful beauty queens with titles under her belt such as *Miss Southern Television*, *Miss Southampton*, *Miss Bournemouth*, *Miss Poole*, *Miss Weymouth* and *Miss Beautiful Eyes*. Whilst her eyes were, indeed, very beautiful, her obvious appeal was in different areas; a wavy haired brunette with an elegant face, huge breasts and a big peach-shaped bum, she looked like an upper-class girl from the pony club. She even sounded like Daddy's spoilt little girl, speaking with probably the poshest voice in British glamour.

Sullivan secured her as a model for his magazines in the winter of 1978 and, seeing her huge potential as an 'English Rose' type, gave her the moniker Rosemary England (sometimes *'Rosemarie'*). Within a matter of months she was making regular appearances as cover girl on his *Playbirds*, *Whitehouse* and *Cockade* magazines and appearing in countless explicit photo shoots. She featured in dozens of ungracious poses with Mary Millington and the two models became uneasy friends, though Mary was paranoid that the newcomer might steal her thunder. Indeed for a time her exposure in Sullivan's titles caused some to wonder whether she might eventually overshadow her little blonde stablemate.

Never one to pass up a good thing, the publisher quickly installed her as a featured player in his movies. Her first role, rather unsurprisingly, was as a randy beauty contestant in *Confessions From The David Galaxy Affair*. Having firmly established her name in the consciousness of his readership Sullivan promoted Rosemary almost as much as Mary in the publicity blurbs for the film's 1979 summer release. Her likeness and name were emblazoned all over the advertising material and she was even required to make public appearances and sign autographs at cinema showings. Sullivan was not adverse to pulling the wool over his public's eyes though; whilst promoting *Queen Of The Blues* he booked Rosemary to appear at Odeons in Glasgow and Bristol on the same day. John M. East was aghast at the plan. 'That's impossible. They're at different ends of the country!' he remonstrated, to which Sullivan replied, 'Don't worry, today we've got TWO Rosemary Englands!'

Rosemary understood the pressures models were often put under, and the suicide of Mary Millington proved to be too close to home. In 1980 she parted company with Sullivan and his magazines for good. By the end of that same year she was calling herself Poula Grifith-Jada and after starring in only one further film, she seemingly disappeared. Starting her movie career at the tail end of the British sex film boom, Rosemary never really had the opportunity to go all the way to the top. Had she been discovered earlier she may well have been a force to be reckoned with.

Her current whereabouts is unknown but David Sullivan has his own theory about what she might be doing now. 'It was always her dream,' he reveals, 'to run a cosy B&B in Bournemouth.'

Rosemary England's brief filmography is: *Confessions From The David Galaxy Affair* (1979), *Queen Of The Blues* (1979) and *Sex With The Stars* (1980), the latter credited as Poula Grifith-Jada.

Queen Of The Blues

Great Britain / 1979 / 62 mins / cert X

Oh dear. Some things promise so much, but deliver so very little. That was certainly the case with Mary Millington's final movie for David Sullivan. Filmed only a couple of months after *David Galaxy* had been put to bed, *Queen Of The Blues* also marked an important change in Sullivan's policy on film-making. Shot on a very tight schedule of only two and a half weeks and made for a fraction of the cost of *Roldvale*'s previous films, it runs for just over an hour and was described by director Willy Roe as 'nothing more than a glorified short'. 'I'd lost confidence in film-making,' says Sullivan. 'There were fewer cinemas showing sex films by 1979 and we had to concentrate on making cheaper productions. It was far more of a risk putting two hundred grand of your own money up front and then the film taking a beating.'

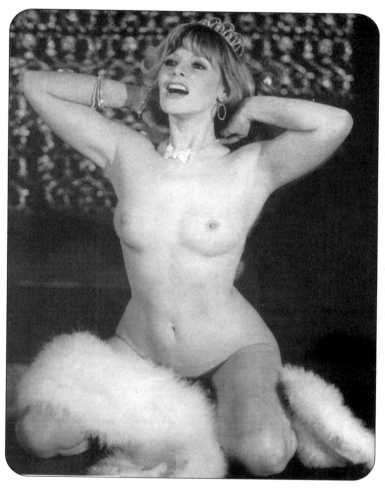

Hampered by its significantly pared-down budget, *Queen Of The Blues* took a critical beating for one crucial reason in particular. Set at the fictional Queen Of The Blues Club in the heart of Mayfair, ('*licensed to sell booze and boobs*' as one character puts it), the film is more or less a record of the artistes stripping on the stage. The big problem is that for much of the movie you have trouble seeing the girls at all. John M. East, who starred opposite Mary in the film explains, 'David Sullivan made the point that the striptease was mostly filmed in longshot. The one thing the punters wanted to see was the girls' tits and bums. They didn't want to see me they wanted to see the girls. *Queen Of The Blues* was boring and badly filmed.'

East is right; some of the strippers are filmed on stage at such a distance that the average cinema-goer would need a pair of binoculars in order to even see a nipple. The camera is often near stationary, mimicking the viewpoint of a strip-club regular sitting in the cheap seats right at the back of the room. Worst of all, despite her being top billed, and playing the title role, Mary's star quality is really not utilized. Joe Ireland's abysmal script spends too long faffing about with the uninteresting characters (like East's annoying compère) and not enough time on the glamorous ones. 'Mary's not in it very much because of the plot. It's very simple,' Sullivan explains, which rather begs the question as to why the script wasn't just rewritten in order to provide greater provision for Mary. After all, *she* was the lone reason anybody was going to see the film anyway! Unbelievably, the script was actually redrafted at one stage, but for all the wrong reasons. Willy Roe had originally wanted to make the movie on location at Harry Green's *Office Club* in Avery Row, Mayfair (incidentally, the club's logo was a pair of naked breasts resting on a typewriter!), because it offered him more space to manoeuvre his cameras, but this idea fell through when the venue demanded too much money. Changing location to the smaller but more user-friendly *Burlesque Club* in Mayfair (a popular spot for film crews) meant that the *Queen Of The Blues* script was allegedly 'totally over-hauled' to compensate.

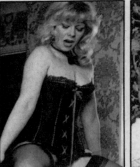
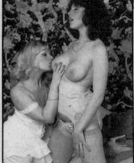

Roe often worked 14 hours a day in order to complete the movie and remembers being particularly high on adrenaline throughout the production. Sullivan was eager to get the film wrapped as quickly as possible because he had already decided to release it as part of a double bill, with a confusingly-edited Hong Kong porn film called *Massage Girls Of Bangkok*. Previously some of his films, like *Come Play With Me*, had been stuck on a double bill with dubbed foreign product by the distributors who were then able to take 40% of the total takings. The shrewd businessman knew that by cutting out the middle man and buying up cheap support movies for a only a couple of grand, he could be in full control of the situation.

Queen Of The Blues' very minimal plot involves the Carter Brothers (the most unlikely pair of siblings you're ever likely to meet since one is over six foot tall and the other barely five!), played by John M. East and one-time child star Allan Warren. The two of them have invested their randy old uncle (Ballard *'Fawlty Towers'* Berkeley) Fred's money into an ailing gentleman's club in the West End. Uncle doesn't actually seem to be too interested in his nephews' endeavours since he spends most of his time sat up in bed reading porno mags or groping his housekeeper. Once open, the venue, newly christened *The Blues Club*, finds itself

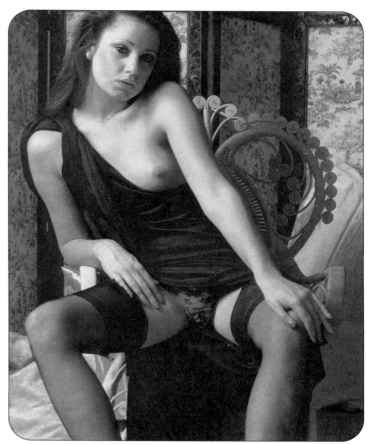

*Faith Daykin in a publicity shot for **Queen Of The Blues***

in trouble with local protection racketeer Rex Roscoe, who sends round his heavy breathing thugs (played by *'Hi De Hi'* star Felix Bowness and barrel-shaped Milton Reid) on a daily basis, demanding payment.

The main attraction at the club is Mary Millington, playing a star stripper also called Mary (she doesn't even bother taking off her real-life MM necklace for the part), who spins around on stage so fast that it looks like she might topple over at any moment. A vision of glamour in tiara, voluminous white cape, fur stole and silver underwear, she whisks her clothes off like a naughty ethereal princess. Thankfully Mary does her turn in close-up, as does Rosemary England who is dressed in fetish nurse gear, but the remainder of the on stage action isn't worth mentioning. Regardless of what they see, the *Blues Club* patrons enthusiastically clap and laugh at all of the acts (including East acting as the club MC) until it feels like we're seeing the same clip of film over and over again. Which, in actual fact, we are! The late Jim Connock's editing on *Queen Of The Blues* is quite terrible; it looks like he knocked it up in a Wardour Street editing suite on a wet Sunday afternoon. We repeatedly see the same faces in the strip club audience, in the exact same seats and identical clothes, supposedly on different nights (indicating permanent residencies by some of them, rather than casual visits). The editing is so slipshod that during one sequence actress Nicola Austine is seen stripping on stage before we cut to an audience reaction shot revealing...yes, Nicola Austine sitting with John Roach happily applauding herself. And this is a film that got a cinema release. I ask you!

Slap-dash continuity notwithstanding, *Queen Of The Blues* opened on 26th July 1979, only three weeks before Mary's tragic suicide. The film was an immediate success at the 211 seat Centa Cinema, Piccadilly, taking nearly a grand more in its first week than the much bigger budget *David Galaxy* had done exactly one month earlier. Not only did *Queen Of The Blues* set a new house record for the cinema, its colossal take of £7,470 meant it had taken more money in one week than any other movie in London so far in 1979, an amazing feat for such a low-budget British picture. Whilst the news of Mary's suicide was greeted with mass grief by the denizens of Soho, it actually assisted the film's success all the more, with takings up dramatically as Mary's fans flocked to see their idol for the last time (or so they thought). It ran for fourteen consecutive weeks before transferring to the Moulin for another twelve.

Review

'This kind of cheapo quickie plunges me into deepest gloom, [but] on the credit side Rosemary England strips with grace and Mary Millington performs her energetic gyrations with a cheerful and infectious enthusiasm.'
**Screen International.
4 August 1979.**

Tit Bits

● *The Burlesque* may have been second choice as location, but it had previously lent itself well to exploitation film-making. Its twinkling stage and distinctive red and gold decor provided a backdrop for the chorus-line girls in *Adventures Of A Private Eye* (1977) and for the strippers in *Come Play With Me*. Most memorably, it appeared in the deliriously camp horror flick *The Devil Within Her* (1975) showcasing the incredible sight of 'stripper' Joan Collins dancing with a deformed dwarf! In real life the club (situated at

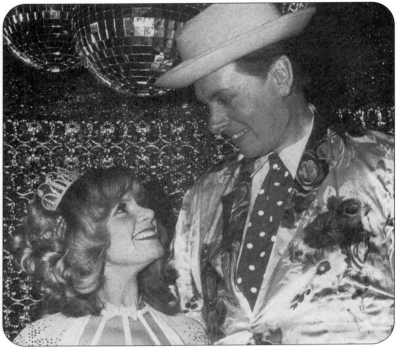

*Mary with John M. East on the set of **Queen Of The Blues***

14/15 Bruton Place, Mayfair) boasted beautiful hostesses, live bands and the exciting prospect of 'striptease to recorded music, each night from 10.30'. With the very last sparkly bra being flung into the audience during the politically correct 1980s, *The Burlesque* closed and the site now sadly lies derelict.

● Although legendary 'Cheeky Chappie' comedian Max Miller died in 1963, his famous ill-fitting flowery suit makes a comeback in *Queen Of The Blues*, worn by his great friend John M. East, who makes a valiant attempt at capturing Miller's saucy humour. *'She's very sexy that Queen Of The Blues,'* East's character says. *'I came into the club the other day and she said, 'I love that rose in your buttonhole.' I said 'Listen darling, put your hand in the pocket and you'll feel the stalk!'*

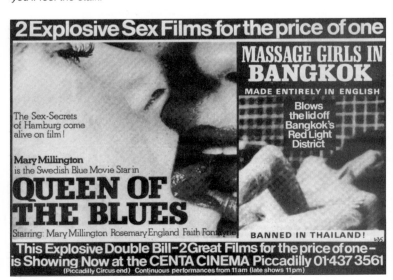

● The release of *Queen Of The Blues* in July 1979 meant that four separate Mary Millington films were all playing concurrently within the space of just half a mile. Over the road from *Queen Of The Blues* at the Centa Cinema, *Playbirds* was showing at the Eros, Piccadilly Circus. Up Great Windmill Street *Come Play With Me* was still packing them in, and round the corner from there *Erotic Inferno* was still playing on screen 2 at the Astral in Brewer Street. Another record for the West End.

● *Queen Of The Blues* was reissued in December 1981 at the Eros as one half of a double bill with transsexual jungle shocker *I'm Coming Your Way*.

● The role of Rex Roscoe's henchman, Richard, was taken by stocky, bald-headed actor Milton Reid. Born in India in 1917 to a Scottish father and Mongolian mother, he started off as a wrestler, using the name *'The Mighty Chang'* before taking up acting in his mid-thirties. His unmistakably menacing appearance and huge bulk led him to be typecast as thugs and heavies for the entirety of his career in films and television. Milton looked like he was born to play an exaggerated *James Bond* baddie and he eventually got the chance, not once but three times, in *Doctor No* (1962), *Casino Royale* (1967) and *The Spy Who Loved Me* (1977), as well as becoming a mainstay of British horror and comedy films for over twenty years. Reid's mere presence in a film was often more important than his acting abilities; consequently his characters were rewarded with little, if any, dialogue. He starred in over 100 movies, including *The Camp On Blood Island* (1958), *Beserk!* (1967) and *Doctor Phibes Rises Again* (1972), but at least half of all his appearances, like his role as the executioner in *Carry On Henry* (1971), went uncredited. Before Reid retired in his early sixties he had become firmly ensconced in the quaint world of British sex films, appearing four times with Mary Millington in *Come Play With Me* (1977), *What's Up Superdoc?* (1978), *Confessions From The David Galaxy Affair* (1979) and *Queen Of The Blues* (1979). Curiously he also appears grappling with a naked woman in the publicity photographs for a 1979 hardcore 8mm short called *Bustman's Holiday*.

● After finishing *Queen Of The Blues*, director Willy Roe made just one further contribution to sexploitation cinema, this time in the role of producer on Roldvale's *Boys And Girls Together* (1979). Another 'elongated' short (it only runs for 57 minutes) the movie contains easily the most bizarre images ever collected in a British sex film. Filmed entirely on location, it tells the story of a six person multi-cultural household in Hampstead. The flat sharers hail from America, India, England, Germany, Singapore and the West Indies and before long they are all getting down to business in every possible sexual variation. As well as the, by now, standard heterosexual and lesbian encounters, *Boys And Girls Together* is also brave enough to show men's genitals for a change, as well as depictions of gay male sex (one of David Sullivan's pet hates). Other scenes include a naked black guy doing press-ups on top of a mirror, a white girl slipping onto the handle of a toilet brush and Asian actress Cherry Patel masturbating with a carrot whilst staring at a poster of rock star Roger Daltrey! *Boys And Girls Together* was initially previewed alongside Boney M's silly *Disco Fever* movie, before being assigned support duty on *Mary Millington's True Blue Confessions* (1980).

QUEEN OF THE BLUES

Great Britain / 1979 / 62 mins / cert X

CAST
Mary Millington...Mary, Queen Of The Blues
John M. East...Mike Carter
Allan Warren...Tony Carter
Ballard Berkeley...Uncle Fred
Lynn Dean...Lucille
Rosemary England...Jill
Felix Bowness...Eddie
Milton Reid...'Brother' Richard
Robert Russell...Rex Roscoe
Valerie Minifie...Enid
Harry Littlewood...Derek
Geraldine Hooper...Receptionist
Cindy Truman...Mirabelle
Pat Astley...Rosetta
Nicola Austine...Teresa
Faith Daykin...Charmaine
Lydia LLoyd...June
Rosalind Watts...Jane
Fiona Sanderson...Valerie
Steve Kane...Alfredo

CREDITS
Director...**Willy Roe**
Producer...**Willy Roe**
Executive Producer...**David Sullivan**
Assistant Directors...**Victor Priggs** & **Guy Sinclair**
Photography...**Douglas Hill**
Editor...**Jim Connock**
Camera Operator...**Brian Elvin**
Sound Recording...**Stan Phillips**
Music...**David Whitaker**
Screenplay...**Joe Ireland**

A ROLDVALE Film
Distributed By TIGON

**Opened 26th July 1979
Centa Cinema, Piccadilly**

come play with
nicola austine

Sometimes called Nicky or Nicole Austin, this giggly, cheeky-faced glamour girl holds the record for the most appearances in British sex films. She was a popular face in the movies for nearly 15 years yet still managed to remain relatively anonymous. Like fellow actress Pat Astley she never progressed beyond small supporting roles, but Nicola could always be relied upon to brighten up any scene in which she featured. Her acting was often apologetic and flighty but her excitable wide-smiling characters were unmistakable, regardless of her ever-changing hair colour.

Before she entered films Nicola was an accomplished and much sought-after model, her face enlivening hundreds of magazines, catalogues and advertisements. She became the obligatory *Sun* page three girl for a while before modelling for record and book covers: her swim-suited form adorns the sleeves of Damil's *Stereo Gold Award Top Hits*, Deacon's *Pick Of The Pops* and Hallmark's *Top Of The Pops* record series; and her chest bursts forth from the

jacket of Timothy Lea's novelisation of *Confessions From a Driving Instructor*. Although she occasionally appeared topless as a cover girl on several David Sullivan publications, Nicola was definitely not from the school of hardcore pornographic modelling.

Nicola was a firm favourite of directors Stanley Long and Derek Ford, who hired her several times and often teamed her up with Pat Astley and Anna Bergman in her later films. She revealingly played herself in Peter Cook and Dudley Moore's filthy *Derek And Clive Get The Horn* in 1979 but had to wait until the following year to claim her sexiest role ever as the insatiable Mrs Doyle in *Sex With The Stars*. To date her final big screen appearance was as Anna Bergman's lesbian lover in the trashy Joan Collins/Carol White flop *Nutcracker*.

Her films include: *Secrets Of Sex* (1969), *Permissive* (1970), *Suburban Wives* (1971), *Up Pompeii* (1971), *Not Tonight Darling!* (1971), *The Love Box* (1972), *Commuter Husbands* (1972), *On The Game* (1973), *Vampira* (1974), *Come Play With Me* (1977), *Adventures Of A Private Eye* (1978), *What's Up Superdoc?* (1978), *Queen Of The Blues* (1979), *Derek And Clive Get The Horn* (1979), *The World Is Full Of Married Men* (1979), *Sex With The Stars* (1980) and *Nutcracker* (1982).

The Great Rock 'n' Roll Swindle

Great Britain / 1979 / 104 mins / cert X

'See the film that incriminates its audience. Starring Sid Vicious, the John Travolta of punk and Mary Millington, fully cantilevered and gorgeous ~ she thought she'd tried everything until she met the Sex Pistols.'
(*Great Rock 'n' Roll Swindle* publicity 1980)

If truth be told, Mary would probably have preferred to be offered a part in the Bee Gee's *Sergeant Pepper's Lonely Hearts Club Band* (1978) rather than the Sex Pistols' film, since disco was much more her bag than punk rock. With hindsight though it was probably the right decision, since *The Great Rock 'n' Roll Swindle* became not only one of the most critically applauded popular music films of all time but also served as a delicious self-indulgent climax to the excesses of the 1970s. Sadly, Mary never saw its completion. She filmed her scenes in the spring of 1979, but the finished film did not see the light of day until the following year, nearly ten months after her death.

The story behind the making of the Sex Pistols' film is almost as interesting as the movie itself. The Pistols' Svengali-like manager Malcolm McLaren had long dreamt of bringing his ugly musical creations to the cinema screen and after much deliberation enlisted cult American director Russ Meyer to do the dirty work for him. Meyer, famed for his back catalogue of sex comedies like *Vixen* (1968) and *Up!* (1976) starring hugely-endowed, gravity-defying female stars, met McLaren as early as July 1977 to discuss the proposed movie. The screenplay, *Who Killed Bambi?*, was written by Pulitzer prize-winner Roger Ebert, and a fine supporting cast were soon assembled, but lack of finance, qualms about Meyer's particular style of film-making and the withdrawal of parent studio 20th Century Fox led to the collapse of the entire project. Even McLaren wryly commented that the original script was 'so disgusting it just couldn't possibly be made.' Next up for consideration was the master of British exploitation films Pete Walker, slated to direct a script written by *Eskimo Nell* writer Michael Armstrong. His witty screenplay, called *A Star Is Dead*, never saw the light of day either and it finally took Richard Branson's company Virgin to pick up the pieces in 1978 by hiring fresh-faced National Film School graduate Julien Temple to helm the movie.

Temple became writer-director-producer of the film, newly entitled *The Great Rock 'n' Roll Swindle*. He was unwavering in his strong outlook for the movie. 'I wanted it to be very stylised,' he told *Screen International,* 'a kind of vandalised documentary if you like.' Stylish it certainly was, with Temple creating a heady, intoxicating mix of archive newsreel footage, fantasy sequences, live action and animation. The result is a sort of nightmarish comic horror film delivered with the speed and clarity of a *Tom And Jerry* cartoon. In recounting the rise and fall of the *'most notorious, filthy, disgusting, dirtiest rock 'n' roll band in the whole bloody world'* Temple shows a maturity and understanding of the mechanics of film-making far beyond his years. The movie is neither a regular documentary re-telling of the story nor a straightforward piece of fiction; instead it is somewhere in-between.

From the opening sequence showing McLaren in close-up wearing an almost featureless rubber bondage mask, the movie sets its own uniquely funny and frightening agenda. The Pistols' impresario plays himself as he chronologically charts the meteoric rise and subsequent destruction of his infamous band. Recounting the sorry story to his attentive sidekick Helen Wellington-Lloyd, McLaren illustrates how he manipulated the British media through a series of clever 'swindles' and made close to a million pounds. Intertwined with this are the fictitious sexual adventures of lead guitarist Steve Jones as a shady Private Eye type character skulking around the seedier recesses of London's West End.

The film offers up so many wonderfully treasurable moments that it is difficult to chose one over another, but especially memorable are Sue Catwoman garrotting a relic from the glam rock era in a railway compartment, in a tasty pastiche of an Agatha Christie mystery; Jones visiting the 'Cambridge Rapist Hotel' in Kings Cross where he sees a middle aged man being whipped in a bedroom to the strains of Tweety Pie's *'I tawt I taw a puddy tat'* and lastly Malcolm McLaren flyposting the family vaults in Highgate Cemetery whilst crooning *'You need hands'*. All quite brilliant and brutally droll.

Steve Jones' leisurely Soho preamble eventually takes him to the hallowed auditorium of the Moulin Cinema in Great Windmill Street. Rudely pushing past disgruntled audience members he seats himself and settles down to watch the film, which just so happens to be footage of his very own trip to Rio de Janeiro to meet ex-train robber Ronnie Biggs. Mary plays a cinema goer sitting in the stalls with her possessive boyfriend (played by Sixties crooner Jess Conrad). When she realises that the man sitting next to her is the same rock star she is watching on the screen she makes an instant beeline for him. *'Gee I'd really fancy a Sex Pistol,'* she coos. *'You don't look anything like Johnny Rotten.'* Her cursory knowledge of punk does not impress Jones much and a jealous Conrad forcibly

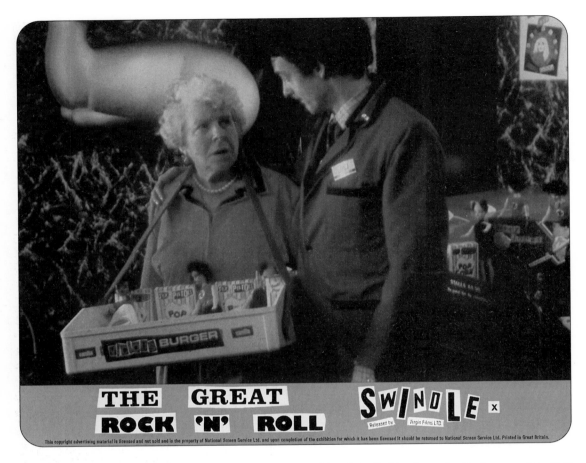

THE GREAT ROCK 'N' ROLL Swindle x

Released by Virgin Films LTD.

This copyright advertising material is licensed and not sold and is the property of National Screen Service Ltd. and upon completion of the exhibition for which it has been licensed it should be returned to National Screen Service Ltd. Printed in Great Britain.

drags her out of the cinema. After quietly sneaking back in, Mary is invited by Jones to clamber over the other aggrieved punters and sit with him. They then proceed to have rather uncomfortable looking sex between the stalls whilst Mary continually asks him questions about his career. *'How much bread did you get from EMI?'* and, as he goes down on her, *'Hey Steve, how did you get thrown off A&M?'*, her spread-eagle legs draped over the chair in front. The rest of the audience continues to watch the screen, blithely unconcerned by the sexual shenanigans but Irene Handl is priceless as the old cockney usherette shining her torch on Jones' bare bum. *'Oi Sex Pistol,'* she shouts. *'Pack it in will you. You're annoying our clientele!'*

These scenes were filmed entirely on location in the foyer and screen one of the Moulin and Mary was paid a hefty £1,000 for a single days work. She loved the part and particularly relished the opportunity to act alongside Irene again. Her sequence is punctuated with 33 individual cutaways as the picture continually switches back to the action on the cinema screen.

By the time the completed film was ready for release Mary Millington was not the only deceased name on the cinema poster. Just weeks before she had filmed her part at the Moulin in March 1979 The Sex Pistols' bass guitarist Sid Vicious had been found dead in suspicious circumstances. On October 12th the previous year Vicious had apparently murdered his girlfriend, Nancy Spungen (who also briefly appears in *The Great Rock 'n' Roll Swindle*) and whilst out on $50,000 bail he died from a heroin overdose at a Greenwich Village party on February 2nd 1979. He was just twenty one. Vicious had already filmed most of his scenes for the movie, but director Temple and his crew were understandably shocked by the news. Actual reports of his crime were incorporated into the sequence filmed at the Moulin when foyer vendor Tadpole (played by Edward Tudor-Pole) sees a television newsflash about the punk idol. The similarities between Mary and Vicious are undeniable. Both were products of the decadent fast-living, drug infested 1970s and both died tragically young with the maximum amount of press coverage. They existed on the outer fringes of manufactured showbusiness but the tabloids adored them for their reliable newsworthiness. Whilst it was Mary's dream to be a proper actress it was Vicious' to be a competent musician. It is ironic then that they should both bow out of the public arena in the same vehicle. *The Great Rock 'n' Roll Swindle* was a huge critical and commercial success on its release in May 1980. It was enormously well received at both the Berlin Film Festival and the L.A. Filmex, and Virgin had to set up their own distribution company just to deal with the world-wide demand

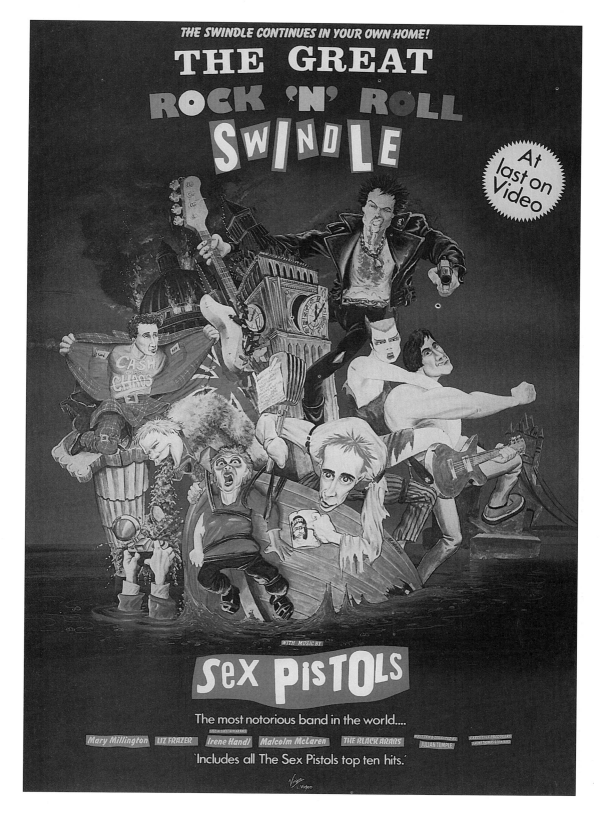

for the movie. Back in London the film broke box-office records, opening simultaneously at three West End cinemas and entering the London film chart at number three. Mary's swansong could not have been more bitter-sweet, she had appeared in the most acclaimed film of her career but her suicide robbed her of the plaudits she had waited so long to collect.

Review

'The Great Rock 'n' Roll Swindle is the 'Citizen Kane' of rock 'n' roll pictures. An incredibly sophisticated, stupefying, multi-layered portrait of the 1970s phenomenon known as the Sex Pistols. The most imaginative use of a rock group since the Beatles debuted in 'A Hard Day's Night.'
Variety. 5 March 1980.

Tit Bits

● From a purely historical point of view, the establishing shot of the Moulin Cinema in *The Great Rock 'n' Roll Swindle* serves as an invaluable record of what the exterior of the establishment looked like in March 1979. The Moulin's trademark rotating illuminated signs promote *The Playbirds* and two full-colour shots of Mary plus imported sex films *Young Lady Chatterley*, *Candida Erotica* and *Private Nurse*. The other signs are mock-ups for *Who Killed Bambi?* and *The Great Rock 'n' Roll Swindle*.

● The film was accompanied by a soundtrack album (the sleeve of which featured stills from the movie) and its triumph at the Classic Cinema, Oxford Street was certainly not harmed by a giant tie-in promotion in the window of the nearby Virgin Megastore. The double album peaked at number 16 in the charts.

● To date, director Julien Temple has yet to better his debut film. Other movies followed, such as *The Secret Policeman's Other Ball* (1982), *Absolute Beginners* (1986) and *Earth Girls Are Easy* (1989) but none have come near to enjoying the huge success of his first. *Absolute Beginners* - which incidentally re-united three of Mary's *Rock 'n' Roll* co-stars: Irene Handl, Jess Conrad and Edward Tudor-Pole - was spectacularly hyped by the British press but failed dismally at the box-office. Hoping to repeat the success of his first feature, Temple began work on a 'sequel' to *Swindle*, entitled *The Filth And The Fury*, in 1999.

THE GREAT ROCK 'N' ROLL SWINDLE
Great Britain / 1979
104 mins / cert X

CAST
Malcolm McLaren...The Embezzler
Steve Jones...The Crook
Sid Vicious...The Gimmick
Johnny Rotten...The Collaborator
Paul Cook...The Tea Boy
Helen Wellington-Lloyd...Embezzler's confidante
Mary Millington...Mary
Jess Conrad...Jess
Irene Handl...Cinema usherette
Edward Tudor-Pole...Tadpole
Liz Fraser...Woman in cinema
Ronald Biggs...The Exile
Sue Catwoman...Young punk girl
Johnny Shannon...Martin Boorman (Nazi)
Peter Dean...Nightclub doorman
Faye Hart...Woman at Mamie Records
Jerzimy...French singer
Dave Dee & Doug D'Arcy...Record executives
Tona DeBrett...Singing teacher
Glen Matlock...Ex-Pistol
Nancy Spungen...Sid's girlfriend
With
The Black Arabs featuring **Mr Superbad**

CREDITS
Director...**Julien Temple**
Producer...**Julien Temple**
Executive Producers...**Don Boyd** & **Jeremy Thomas**
Photography...**Adam Barker-Mill** / **Willie Patterson** / **Nick Knowland** / **John Metcalfe**
Editors...**Richard Bedford** / **Gordon Swire** / **Mike Maslin** /
Crispen Green / **David Rae** / **Bennie Pokrzywa**
Sound Recording...**Brian Paxton**
Animation supervised by **Animation City (London)**
Original Music Performed by **The Sex Pistols**
Screenplay...**Julien Temple**

A MATRIXBEST / KENDON FILMS Production
Presented by BOYDS Co. And VIRGIN
Distributed by VIRGIN FILMS

Opened 15th May 1980
Classic, Oxford Street

Mary Millington's True Blue Confessions

(Incorporating '**Mary Millington 1946-1979 Prologue**')
Great Britain / 1980 / 6mins & 39 mins / cert X

'No fiction could do justice to her own life story.'
(John M. East, *True Blue Confessions*)

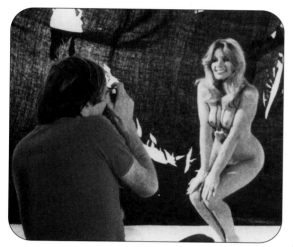

No sooner had Mary completed *Queen Of The Blues* than her next starring vehicle was already being lined up by David Sullivan. In fact the title, *Funeral In Soho*, had been revealed to the press the previous December and was originally scheduled to precede *Queen Of The Blues*. With a screenplay written by Willy Roe and Mary's then-biographer David Weldon, *Funeral In Soho* was a 'work in progress' that apparently failed to progress very much. A gangster thriller set in the seedy underworld of London's West End, the film was to start with an elaborate murder and the subsequent funeral. Mary was to play the lead role, a *'femme fatale'* supported by an 'all star cast'. The project was abandoned when Mary died and the script was left unfinished. Roe is of the opinion that it was cannibalised by John M. East before eventually seeing the light of day as the movie *Emmanuelle In Soho* in 1981. Quite how this alleged porno film-noir metamorphosed into a comedy about strippers in see-through mackintoshes, though, is anybody's guess.

After Mary's shocking and unexpected death in August 1979, Sullivan publicly announced his intention to cease film production for 'the next twelve months' as a mark of respect to his late girlfriend. But nobody really expected the king of British sex films to keep to his word and by the spring of 1980 a new movie was already rolling. Not just any old movie either; Sullivan was moving away from sex comedies and thrillers into hitherto uncharted territory: the pseudo-documentary. The resulting film, *Mary Millington's True Blue Confessions*, emerged as the most criticised and hated film of Sullivan's movie career, and more than ever before he faced charges of exploitation, vulgarity and tastelessness.

Sullivan is adamant that the movie possesses none of those qualities, but should any blame be apportioned it is most certainly not at his doorstep. 'People think that film was exploitation, but it really was quite the opposite,' Sullivan guiltily defends himself. 'I only made *True Blue Confessions* because John East bullied me into making it. He said 'You should really make a tribute to Mary.' I rushed it out not to make money, I just wanted to make her more famous in death than in life.'

Shot over just three days and with a minuscule budget of £24,000, *True Blue Confessions* was virtually all John M. East's handiwork. He pitched the idea for a film (utilising clips and out-takes from Mary's previous movies and interviews with those who knew her) to Sullivan at his Upton Lane offices. Sullivan was initially unconvinced by the proposition, but his persistent friend eventually managed to persuade him of the commercial potential of a 'new' Mary Millington film. The deciding factor was that East had access to a previously unbroadcast radio interview with Mary which he had conducted at the BBC in 1978. In it Mary describes her move into pornography, and talks candidly about her great love of all things sexual, her bisexuality and her frustrations regarding the British laws on censorship. East was convinced that a film using Mary's own voice to tell her story plus a narration by himself, would be a huge money-spinner.

Whilst *True Blue Confessions*' directorial duties are officially accredited to small time film-maker Nick Galtress, East claims credit for ninety percent of the film. By 1980, established Roldvale director Willy Roe had moved on to pastures new and Galtress' name was simply bought to avoid union problems. The producer, David C. Kenten, was a television executive wanting to cut his teeth on cinema films but apart from the library and rostrum camera work he left East to get on with it by himself. The film is a two part portmanteau, comprising an unassuming six minute prologue followed by a further 39 minutes of interviews and dodgy 're-enactments' from Mary's years as a glamour model.

East's galloping tabloid-style commentary fails to shed much light on Mary's life, preferring instead to pile more rumour and myth onto a story already straining credibility. Sensational comments like *'Mary rose to stardom on her delectable back'* and *'lesbian parts satisfied her'* achieve little more than old fashioned titillation. East poses the oft-asked question, *'What was Mary really like?'* but plainly any Millington fan would have learnt considerably more about Mary's life by reading the newspaper reports at the time of her suicide. The myth is sustained at all times. Mary is called a *'sex goddess'* and a *'tormented woman'* and at no point is reference made to her role as wife and family member. Even in death the preservation of her promiscuous image and her scandalous existence remained an important selling point for the British sex industry. In life Mary was reticent when it came to talking about her family background and personal life, even to her friends and colleagues in the business. Sullivan and East had only thumb-nail sketches of her personal history up until her meeting with them. But even the title of the tribute's first section, *Mary Millington 1946-1979 Prologue*, is sloppily researched, succeeding in getting her birth year wrong.

The prologue itself acts as little more than a six minute advert for those of Mary's films still showing in Soho at the time of *True Blue Confessions'* release. All the tantalising tit-bits from her most famous movies are trotted out as a stark reminder of how luscious and alluring she was. Her pre-Sullivan movies are, unsurprisingly, absent and the true purpose of the prologue is painfully pressed home when *Come Play With Me* is described as her *'first cinema film'*. Predictable clips include the lesbian seduction scene from *Come Play With Me,* an extended version of the photoshoot sequence from *The Playbirds* and Mary's enthusiastic strip from *Queen Of The Blues*. At the end of the flesh parade the audience is reminded that we can still see Mary's talents committed to celluloid. Mention of *The David Galaxy Affair* is conspicuous by its absence, (perhaps even Sullivan realised he was flogging a dead horse with that one).

As the prologue fades so the main attraction begins; Mary's very own 'confessions' told in her very own words coupled with the memories of her friends. John Lindsay, interviewed on the premises of his hardcore cinema club *Taboo*, recalls their first meeting and remembers telling her that in his films there was *'no faking'* before presenting a peculiarly sexless sequence of Mary at a canal lock, taken from one of his 8mm shorts (according to East it was the only 'clean' bit he could use). An uncomfortable-looking Tom Hayes, manager of Soho's *Exciting Cinema Club* is up next, getting tongue-tied and nervous as he states, *'We believe very strongly that the general public should be able to see pornography, excluding animals and children.'* A serious-faced David Sullivan is filmed looking at photographic transparencies of Mary and likening oppressive English attitudes towards porn to living in Russia. Although his sentences appear jumbled and unrehearsed, his is the only interview bearing traces of genuine loss and anger at the death of his friend.

Interviews and commentary aside, *True Blue Confessions* basks resplendent in its surroundings with a series of appalling 'recreations' from the sexier moments of its star's life. Mary's supposed first lesbian encounter in the Dorking boutique (as told in her specious 'autobiography') is alluded to with a stilted scene of girlie-groping filmed in a Kings Cross sex shop and featuring willowy, brunette-haired actress Geraldine Hooper from *Queen Of The Blues*. Other re-enactments follow, increasing the nudity content of the 'tribute' ten-fold and culminating in an orgy at Mary's Walton-on-the-Hill home. This faked sex party involves a lot of top-heavy women aimlessly rushing around the lounge and up the stairs. An unattractive, laughing goon makes love to a woman in a bath filled with filthy water, a clumsy lesbian threesome takes place in a bedroom and *Whitehouse* model Faith Daykin makes a hopeless stab at playing Mary herself. It really is a case

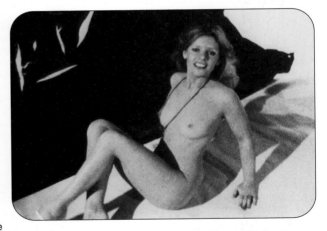

of seeing is disbelieving. The makers of *True Blue Confessions* felt that if the film was to succeed it would have to contain some 'fantasy' material. 'It was a nice tribute,' Sullivan said in 1986, 'though I had to put a bit of nudity in it.' East goes further, acknowledging that the unrelated sex scenes were a dubious method of illustrating Mary's life, but claiming it improved the look of the documentary. 'Yes it had extraneous sex scenes, but I do think, for a short film, it was exceedingly well-made for what it was.'

It wasn't just the semi-fictional elements of the film that pushed the limits of believability either. A heartfelt interview with Mary's friend and ex-lover Kathy Green is undertaken whilst she pretends to give a 'relaxing' breast massage to a naked woman lying on her bed!

The exterior of Mary's house and some of the rooms were used as a location for the movie, but the sex sequences were all filmed in David Sullivan's apartment in Woodford Green and the two shoots were later spliced together. In a surprisingly uncharacteristic move, Mary's husband Robert Maxted (who had continued to live at the house after Mary's death) gave John M. East full access to the home he had shared with Mary, and most worrying of all, even the bedroom where Mary killed herself on August 19th 1979. 'We had to pay to film in the house. I thought how friggin' mercenary can you be?' recalls Sullivan with bare-faced cheek. 'I had to pay Maxted around £750 or

£1,000.' Several friends of the couple were furious to see Maxted seemingly 'selling out' to his wife's boss, especially over his co-operation with the filming of one particularly distasteful scene.

Mary's bedroom had been left virtually untouched since her death but that was to change with the arrival of East and his cameraman John Shann. In an odious attempt to document Mary's suicide East ruffled the sheets on Mary's bed, sprinkled it with paracetamol tablets and laid one of her negligées and her last note to David Sullivan beside them. Accompanied by urgent music, the camera zooms down the landing and into her room before coming to rest on her bed. 'It was very eerie, somewhat unreal,' he remembers. 'I found the pills in her drawer and stripped back the bed sheet myself. Disturbing the mattress I discovered a stash of pornographic magazines of the most lurid kind. The most obscene things I've ever seen.' Obscene yes, but perhaps not as ghoulish as disrespecting the death bed of a supposedly close friend. Just to add further insult a trembling female voice-over implausibly reads extracts from the note (being careful to delete the potentially-libellous section about the 'nazi tax man'). But worse was yet to come.

In one of the most unbelievably crude and squalid pieces of British film-making, East thought it 'artistic' to have a model lying in a coffin in order to brutally drive home the point that Mary was dead. *'Earth to earth, ashes to ashes, dust to dust'*, the voice-over intones. This one scene above all others created outcry and disgust among critics and friends alike. Director George Harrison Marks had been distraught at Mary's death and *True Blue Confessions* appalled him. 'I hated it so much. It was a nasty piece of work,' he said. 'The bit with that girl lying in the coffin was diabolical. It was sick.' Amazingly, the scene had been filmed in a real mortuary in Palmers Green with glamour model, Marie Harper, appearing as Mary's corpse. As in life, Mary's death had been absorbed into the ever-grinding machine of the sex industry. Even some of the tribute's stars were repulsed by the finished movie. Actress Geraldine Hooper had gone to the opening night of the film with her sister Alison and later told East that she thought it was 'made in extremely bad taste.'

True Blue Confessions was created with one goal in mind: to be sensational. The film's standards of taste and decency sink below any recognisable limit, but it doesn't masquerade as anything other than what it is: cheap sexploitation. It feebly tries to come across as a 'tribute', only to betray the woman it's supposedly eulogizing. Mary might actually have enjoyed the mindless recreations of her mythologised sex life - another extension of the game she loved to continually play with the media - but one doubts that she would have approved of any exploitation likely to upset her family and friends, and what about the use of her mother's photograph in the film? As a record of the dying days of British sex films, of the unending lengths some would go to in the name of cinema thrills, the movie makes oddly fascinating viewing, even if an unnerving sense of sadness pervades its every corner. Sometimes distressingly gruesome, at others utterly compelling, *True Blue Confessions* laments the passing of British pornography's most valuable sexual asset, so much so that when the closing titles say *'Sadly....The End'* you realise what a tremendous commercial loss Mary's death was to one pair of men in particular.

Review

'Unique among British sex movies for its seriousness of tone and purpose, this portmanteau tribute invites charges of sensationalism and Sunday tabloid sexploitation. But since this is the name of the game the charges will not actually stick. Even death has some commodity value in the sex market, as the film acknowledges with a shot of an actress playing Mary Millington in her coffin. Inevitably the career of Marylin Monroe is alluded to, but the likeness is shallow and no artefact in the entire Marylin nostalgia business could match the necrophiliac charge of this film.'
Monthly Film Bulletin. November 1980.

Tit Bits

● When East delivered *True Blue Confessions* to film distributors *Jay Jay* he was understandably concerned that the film suffered from a lack of production values. They told him it was made so cheaply that it was going to look terrible on the big screen. East was desperate to include some extra location work and happened to notice an article in the *Evening Standard* about a new gay disco, *Heaven*, which had just opened in London. East was immediately on the 'phone to them and the owners agreed to let him film there on the condition that the club was given a mention. Hence the finished film includes a lengthy sequence of gay men energetically dancing to Hi-NRG (including a brief

appearance by androgynous 80s pop star 'Marylin'). Needless to say, the footage sticks out like a sore thumb. 'It was totally irrelevant to Mary,' East says. 'I filmed there all night and said something like *'Mary would have loved the place.'* Ridiculous really. It had no relevance.'

● Although the film purports to provide an accurate record of the interior of Mary's house (the decor would now be considered 70s kitsch), there is one display of blatant fakery. Going against Mary's final wishes, Bob Maxted had dispensed with his wife's beloved dogs, Tippi and Reject. In *True Blue Confessions*, two huge, panting brown alsatians are shown sitting on the leather sofa. East's commentary states that *'Mary's dogs still pine for their mistress.'* In reality the animals had been hired from a friend of David Sullivan's for the afternoon.

● *True Blue Confessions* was released with two supporting films (David Sullivan invented the triple-bill for UK cinemas), Roldvale's own *Boys And Girls Together* (1979) and Joe D'Amato's *Scandinavian Erotica* (1980), (as the latter film's title suggests, it was shot on location in Italy!) Opening on October 30th 1980 at the recently refurbished and renamed Cinencenta Cinema in Piccadilly, the film broke all previous house records and went on to run for 27 consecutive weeks taking a total of £73,042. Even as late as 1984 the film was still showing occasionally at some West End venues.

● The film became a substantial hit on video when issued by Hokushin in 1981 with both prologue and feature seamlessly edited into a single film entitled *The Naked Truth*.

● Half Italian actress Faith Daykin (aka Faith Fonteyn) had the daunting task of playing Mary Millington in *True Blue Confessions*. The film's outrageous publicity material claimed she was 'Mary's amazing double' despite the fact she looked nothing like her. Faith was one of the later additions to Sullivan's 1970s stable of models, and was undoubtedly also one of the prettiest. Her stunning blonde looks, rose bud lips, button nose and youthful innocence proved to be a surefire hit with the readership of *Whitehouse* magazine. She made just five movies in two years: *Confessions From The David Galaxy Affair* (1979), *Queen Of The Blues* (1979), *Paul Raymond's Erotica* (1980), *True Blue Confessions* (1980) and *Sex With The Stars* (1980), before marrying a dentist and leaving the glamour industry forever. Another of Sullivan's post-Millington 'finds' with a made-up name, Louise London, also makes an uncredited appearance in the documentary, in the inept lesbian scene.

MARY MILLINGTON'S TRUE BLUE CONFESSIONS

Incorporating
MARY MILLINGTON 1946-1979 PROLOGUE

Great Britain / 1980
6 mins & 39 mins / cert X

CAST
John M. East...Narrator
Faith Daykin...Mary
Geraldine Hooper...Boutique owner
Mike Gallagher & **Louise London**...Party guests
John Roach & **Gavin Clare**...Men in cinema
Marie Harper...Mary in coffin

FEATURING INTERVIEWS WITH

John Lindsay
David Sullivan
Tom Hayes
Kathy Green
and
Rex Peters

CREDITS
Directors...**Nick Galtress** & **John M. East**
Producer...**David C. Kenten**
Executive Producer...**David Sullivan**
Photography...**Richard Crafter** & **John Shann**
Editor...**Roy Deverell**
Sound Recording...**Brian Harvey Garrett**
Music...**De Wolfe**
Costume...**She & Me**
Lingerie...**Silver Rose**
Original Millington Footage...**Taboo Films**
Concept and Script...**John M. East**

A ROLDVALE Film
Distributed by JAY JAY

Opened 30th October 1980
Cinecenta Cinema, Piccadilly.

Mary Millington's World Striptease Extravaganza

Great Britain / 1981 / 46 mins / cert X

There are two types of sexploitation films. Some are brash, upfront and with few pretensions, like *Mary Millington's True Blue Confessions* and then there are those which are repugnantly dishonest; movies trading on falsehoods and treachery, determined to squeeze the very last drop of essence from their performers and every last cent from the punters who pay to see them. *Mary Millington's World Striptease Extravaganza* is one of the latter variety and what a stinker it is too. Whilst Sullivan is not blameless for this monstrosity - after all he put up the money - it is producer and star John M. East who stands at the forefront of the sorry proceedings.

After the success of Roldvale's first non-Millington film, *Emmanuelle In Soho*, it would have been reasonable to assume that Mary's memory had been laid to rest once and for all, and that any money-making opportunities had finally run their 'natural' course - after all she had been dead for two years. Sadly this was not the case. *Mary Millington's World Striptease Exravaganza* has absolutely nothing to do with her, yet has her name and face plastered all over it. This is a very nasty and misleading piece of sexploitation indeed. The movie masquerades as a genuine fly-on-the-wall 'documentary' purporting to tell the story of a big prize striptease contest being filmed 'live' at *The Burlesque* cabaret club in London. Needless to say this is not the case. Everything is staged, the strippers are not professionals and the outcome is wearily predictable.

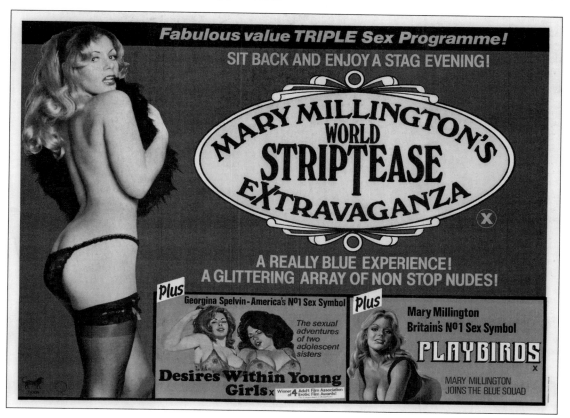

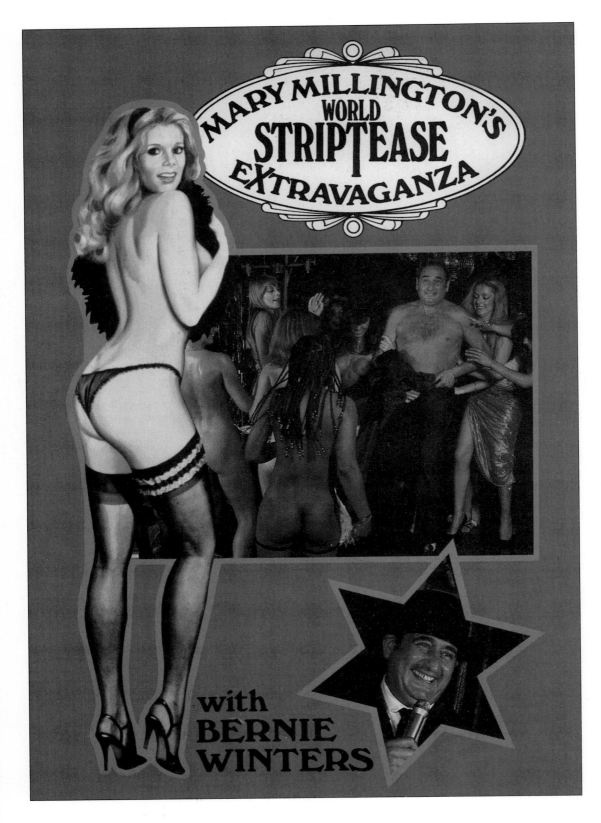

MARY MILLINGTON'S WORLD STRIPTEASE EXTRAVAGANZA

with BERNIE WINTERS

John M. East oversees the evening's events, starting with a nonsensical speech, the sentiment of which sticks in one's throat. Looking awkward and quite obviously reading off a cue card, his tone is embarrassingly false. *'Welcome to the Mary Millington World Striptease Extravaganza. Mary Millington, who died tragically a few years ago, made a profound impact as a stripper,'* he says sombrely before introducing a 55 second re-edited clip of Mary disrobing, taken from 1979's *Queen Of The Blues*. The blurring of fantasy and reality is immediately apparent. Quite simply Mary was *not* a stripper; a model, porn star and actress yes, but night-club act, no. If anyone was fully aware of this it was her friend East himself. Later on he refers to Mary again as *'the great stripper'*, suddenly fact becomes confused with myth and the Millington story takes another unsavoury twist.

The *Queen Of The Blues* clips merely act as a peg from which the rest of the film can be hung. East's slight assurances, in a 1981 interview in *Park Lane*, that the film's title was chosen after 'extensive market research' and *'Mary Millington's World Striptease Extravaganza* will be a fitting testimonial to our foremost sex goddess', is pure, unadulterated bullshit of the very worst kind. After the strange appeal of *True Blue Confessions*, by 1981 a respectful line really should have been drawn under the legend of Mary Millington.

The rest of the film is a shambles. 'Family entertainer' Bernie Winters, fresh from his role in *Confessions From The David Galaxy Affair*, nervously takes centre stage and presents each of the female strippers in turn. Despite his spiel describing how the seventeen contestants have been gathered from around the globe, it is painfully obvious that they all hail from the UK. Winters announces that the prize is £1,000, a film contract and an all expenses holiday to Jamaica. We all know he's lying through his teeth. Coming onto the stage in pairs, the girls' erotic stripteases leave a lot to be desired, and the camera lingers over impersonal close-ups of jerking vaginas and bouncing breasts. Glamour model Gloria Brittain from *The Playbirds* writhes about on the floor like a performing seal; Angie Quick aka Mandy Miller wears exactly the same outfit and wiggles to music used in her own film *Emmanuelle In Soho*, and top heavy Katrina 'from New Zealand' looks like her dancing hasn't progressed much since the sixth form disco. There wasn't a genuine stripper among them and David Sullivan still remembers the tension that day; 'They were all actresses, but they all desperately wanted to win,' he says. 'You couldn't believe it. It was a feature film not a documentary. There was no prize!'

The Burlesque audience seem to love Winters' puerile and often racist jokes, laughing and cheering him throughout. In fact some of the club patrons don't seem to have shifted from their seats in two years since various shots of the laughing crowd are cheaply edited in from *Queen Of The Blues*. It's not just scenes from Mary's last film that are ransacked either. In what BFI film reviewer Martyn Auty called a 'fascinating moment of genre accident' one of the strippers, Kathy Green (Mary Millington's real life ex-girlfriend), recalls screwing one of the judges in a 90-second flashback, *'Oh fuck, I've got to win this bloody prize. I think I deserve it after that fantastic blowjob I gave him last night.'* We are then presented with a sex scene pinched from *Emmanuelle In Soho* to illustrate her point (about as far removed from 'documentary' as you can get). Kathy eventually does 'win' the contest but not before all the contestants rush back on stage to strip and maul a very sheepish-looking Winters. In 1981 the comic told a *TV Times* interviewer that his ambition was to appear in a big budget Hollywood film. After his appearance in *World Striptease Extravaganza* he, quite deservedly, never made a movie again.

Review

'Live striptease is surely enough of a rip off without the distanciation of filming the act. In theory it is the presence and proximity of performers and spectators in the strip club that provides the *frisson* of gratification. When the act of stripping becomes a cinematic experience the nature of the voyeurism is bound to alter. The point is self evident from the title: Mary Millington will go on being used as long as her name brings in money; sexploitation does not stop at the grave.'
Monthly Film Bulletin. May 1982.

Tit Bits

● *Mary Millington's World Striptease Extravaganza* was released as the main attraction in a triple bill alongside a reissue of *The Playbirds* (1978) and the American porno classic *Desires Within Young Girls* (1977), the latter cut down at the command of the BBFC by a whopping 39 minutes. The three movie programme played for seven weeks at the Eros and a further eleven at the Moulin. As a video reissue the film was briefly retitled without the Millington prefix, as *Miss International Striptease Extravaganza*.

● In common with *Queen Of The Blues*, *The Burlesque* in Mayfair was not the preferred location for filming. Originally the movie was to have been shot at the much larger Wimbledon Theatre in south west London but after a very public outburst from local residents the idea was abandoned in favour of the friendlier venue. The row was documented in an article in *The Sun* published in April 1981, headlined *'Deuce Of A Row Over Strippers: Show Is Common Says Wimbledon'*. Mayor Vince Talbot angrily told reporters that striptease was 'totally unsuitable' and that respectable Wimbledon ratepayers would 'be against a show like this being put on'.

● It wasn't just the venue that was second choice either; David Sullivan had initially wanted blue comedian Jimmy Jones to be the striptease evening's compère, but he had asked for £2,000, a laughable amount for such a low budget short. Bernie Winters was hired for a menial £400 but doggedly refused to use the near-the-knuckle gags East had scripted for him, consequently delivering a feeble, unfunny routine of his own.

● After *Mary Millington's World Striptease Extravaganza*, David Sullivan stumped-up the cash for just two further films, both of them poorly-made 'documentary' shorts. The first was *Hellcats ~ Mud Wrestling* aka *The Hellcat Mud Wrestlers* (1983). Made on location at a Croydon night-club, the film starred an enormous 6'2" tall, twenty stone American female wrestler called Queen Kong (famed back in the States for fighting defanged bears!), and her sadistic sidekick Shelly Selina Savage doing battle with the English 'Roldvale Girls' in a childrens' paddling pool full of mud. That's it really. John M. East comperes the whole thing but the home-grown talent takes a mighty bashing. Despite one of the BBFC censors telling East that the movie was 'The most appalling film I've ever had the misfortune to sit through in my life. You have brought the British film industry to the lowest depths of depravity', the film did quite well as a support picture at London's Eros Cinema.

A follow-up was soon rushed into production, this time with Queen Kong taking on Sullivan's models in a boxing ring. *The Female Foxy Boxers* (1983) unsurprisingly fell foul of the censors when they objected to one particular scene showing a topless (and slightly bloody) fighting bout. The BBFC told Sullivan that the mix of titillation and violence was not acceptable and they demanded nearly seven minutes of cuts. This left the film's distributors with a major problem as all support movies had to run for a minimum of 40 minutes and *The Female Foxy Boxers* now clocked in under 38. Reluctant to bin the entire film, Sullivan had the remaining footage re-edited and tacked onto *Hellcats ~ Mud Wrestling*, thus creating a 'new' expanded feature engagingly called *Queen Kong ~ The Amazonian Woman*. It was released straight to video in 1984.

● Following his experience with *cinema verité*, the ever-ready Sullivan decided to return to the more fertile ground of honest-to-goodness pornography. During the early 1980s he produced a series of cheap video compilations (some starring Kathy Green and John M. East). The sex scenes in both the *Playbirds Video Show* and *Whitehouse Video Show* carefully trod the thin line between hard and softcore. The series ran to several volumes, but all the episodes are dreadful.

MARY MILLINGTON'S WORLD STRIPTEASE EXTRAVAGANZA

Great Britain / 1981
46 mins / cert X

CAST
Introduced by **John M. East**
Compèred by **Bernie Winters**
With
THE ROLDVALE STRIPTEASE GIRLS:
Kathy Green (Brighton)
Julie Lee (Hong Kong)
Angie Quick aka **Mandy Miller** (Islington)
Gloria Brittain (Spain)
Maxine (Botswana)
Chantel (Australia)
Katrina (New Zealand)
Vicky (Turkey)
Vicky 2 (Sweden)
Samantha (USA)
Joy (Wales)
Rita (France)
Christina (Holland)
Helena (Greece)
Carol (New Zealand)
Marie (Sweden)
Shereen (South Africa)
And
John Roach...Mr Hare
Christine...Drag Act

CREDITS
Director...**Roy Deverell**
Producer...**John M. East**
Executive Producer...**David Sullivan**
Photography...**Julian Doyle**
Editor...**Roy Deverell**
Camera Operator...**David Norton**
Sound Recording...**Simon Okin** & **D. Vroegindeweij**
Lighting...**Tim Spencer**
Music...**De Wolfe** & **Barry Kirsch**
Script by **David Sullivan**

A ROLDVALE Film
Distributed By TIGON

Opened 25th March 1982
Eros Cinema, Piccadilly

come play with

julie lee

Anyone brave enough to watch *Mary Millington's World Striptease Extravaganza* may notice a stunningly beautiful oriental woman twirling a parasol and attempting to strip at the same time. One may be forgiven for thinking she is just another of the many turns on the Burlesque stage that night, after all she has no lines and her screen time is limited. Yet here was the woman groomed to inherit the porn star mantle from the late Mary Millington. Her name was Julie Lee, and her downfall was even more rapid than that of her predecessor.

Born in Yorkshire in 1955 to a Chinese mother and English father, Julie's real surname was Moxon. She was a starstruck youngster who loved to show off whenever possible, and harboured dreams of becoming a famous actress or model. The bright lights of London were irresistible and Julie knew that in order to chase her ambition she would have to leave her native Sheffield behind. By the mid 1970s, she had moved to the capital and immediately set about getting herself noticed, going to West End night-clubs, cadging invites to showbusiness parties and generally attempting to be seen in the right places at the right time. Julie's tremendous drive eventually led to her finding a suitable agent and then changing her name to the more racially-stereotyped 'Lee'. Nude modelling work followed, but Julie yearned to be a movie-star. She was almost embarrassingly confident in her looks and saw no possible reason why she shouldn't become very famous indeed.

Attending the Cannes Film Festival in May 1979, Julie attempted to gain maximum exposure by doing the old 'topless on the beach' routine and announcing to the press that she had been offered roles in two British sex comedies, *Weekend Bangers* and *The Ups And Downs Of A Soccer Star*, both slated for shoots in the late Summer. Upon her return to the UK neither film materialised. She had learnt her first valuable lesson; the film industry is full of bullshit. Julie continued to do modelling work and entered as many beauty competitions as she possibly could; never once giving up hope. She was a finalist in the less-than-prestigious sounding *Butlin's Miss She* contest, but failed in her attempt to become *Miss Lovely Legs ~ Great Britain*.

Lee was desperate to mix with the rich and influential, and her introduction to David Sullivan, through a friend, proved to be a godsend. Though Sullivan readily admits to having a penchant for blonde Anglo-Saxon women, he was intrigued by this mixed-race beauty and they soon became lovers. Some of Lee's associates have called her 'persistent almost to the point of annoyance' and Julie was well aware that with Sullivan's help she was half way to becoming a star. Mary Millington was gone and John M. East immediately saw the potential in Sullivan's new companion. 'She was very beautiful, stunning. David really wanted her to have the same appeal as Mary,' he says.

The script for Mary's unfilmed project, *Funeral In Soho*, had been sitting on a shelf for two years. Without a star it was redundant, but suddenly Sullivan had a new face for his movie and publishing empire. Over the course of a weekend John M. East rewrote the script and fashioned a new story with greater emphasis on nudity, but to the detriment of any sort of decent plotline (he was wise enough to use the pseudonym 'Brian Daly' to at least apportion half of the blame). Thus *Emmanuelle in Soho* was born. Mary's lead role was to be taken by Julie, but in the excitement everybody had overlooked one crucial thing. Julie Lee could not act.

Julie Lee (centre) immortalised by Tom Chantrell in the 'Emmanuelle' triple bill poster from 1982

'Julie desperately wanted to do it and was happy to take her clothes off, but she couldn't act. She was the worst!' Sullivan comments. 'Her acting really was lamentable,' East readily agrees. Eventually a compromise was worked out. Julie would take the supporting role of wannabe dancer Kate, whilst the less memorable, but slightly better actress, Angie Quick (renamed Mandy Miller) would play the sluttish Emmanuelle. Filmed in the spring of 1981, with a considerably pared-down budget, director David Hughes had to make sure Lee's scenes were kept relatively short because of her inability to remember and deliver lines. Actually, the character of Kate proves to be more pivotal to the plot than Emmanuelle's, but the film continually disappoints. Lee's flat broad Yorkshire accent is funny rather than sexy; the male lead, Keith Fraser, behaves like he's acting in a school play; and the dismal dance routines performed by naked women in transparent mackintoshes are positively awful.

Needless to say, Sullivan relentlessly promoted the film in his magazines and against all odds it initially looked like being a hit. The film's distributors, Tigon, took the unusual step of premiering *Emmanuelle In Soho* outside of Greater London to capitalise on the Northern appeal of the movie's star. Sunning herself in the film's publicity and loving every minute of it, Lee needed little persuasion to travel back to Sheffield for the UK première on Saturday July 4th 1981 at the town's Classic cinema. The posters outside the picture house boasted *'With Sheffield's Own Sex Superstar In Attendance!'* Julie saw this as affirmation that she had finally 'arrived' on the movie scene and that her doubters back home had been proved wrong.

Opening five days later at the Eros Cinema Piccadilly Circus, *Emmanuelle In Soho* was a substantial hit, but having said that, ticket sales still paled in comparison with Mary Millington's debut Roldvale release.

Lee was keen to start work on another movie, but Sullivan was more than a little reluctant. Her second film, *Mary Millington's World Striptease Extravaganza*, went into production at the end of 1981. However, Lee was not asked to take a pivotal role in the movie and, by order of the director, she was not given any dialogue. Her name did not even appear on the cinema poster. All other film offers had dried up but Lee was still confident that something bigger was just around the corner. Sadly, all that awaited Julie was escort work. Her move from socialising with Arab ministers and American oil barons to becoming a high class call-girl came as no particular shock to her friends. She was prepared to sleep with, as one confidante called it, 'anyone half famous'. At one celebrity party Julie attended, she threw herself sexually at Bernie Winters, begging him to make her famous. Her attitude to success gradually became more ruthless. David Sullivan remembers one conversation that they had: 'She said she'd not marry a man unless he put half a million pounds into her bank account.'

Her wait was short-lived. After meeting a wealthy Egyptian businessman she agreed to marry him on payment of £1,000,000 and, in a publicity stunt organised by John M. East, signed the deal in front of waiting photographers at the *Concordia* restaurant in Bayswater. Her new suitor also agreed to buy her a £20,000 Mercedes sports car and set her up in a house in Virginia Water. Julie had attained a fortune at last, but real fame still eluded her.

Soon both her films were running simultaneously in the West End. In particular, *Emmanuelle In Soho* appeared in a variety of double and triple bills and was screened at the Moulin for 25 consecutive weeks. The movie was also a surprise success in Hong Kong where Lee's Chinese roots were fully exploited for publicity purposes. Back home in Britain, *Emmanuelle In Soho* and *World Striptease Extravaganza* continued to do slow but steady business throughout 1982 and 1983, whilst Lee attempted to supplement her income with personal appearances and modelling.

On Wednesday May 4th 1983 she was placed second in another tacky beauty contest, this time at a Maidenhead night club. She was furious at failing to win yet again and with a girlfriend in tow she decided to drive home in the early hours of Thursday morning. As they travelled at tremendous speed past the Datchet junction on the M4, she lost control of her Mercedes and it careered off the motorway. The car skidded violently, hit a lamp-post and ploughed down 50 yards of fencing before exploding. Passing motorists dragged the two women from the wreckage but when Thames Valley police officers arrived on the scene they were shocked at the severity of Julie's horrific burns and head injuries. She was rushed to Wrexham Park Hospital in Slough where she survived, terribly disfigured, for only four days. At the age of only 28 the glamour industry had lost another big name model. Back in London, rumour was rife that Julie had been the victim of a contract killing. Not only had she been two-timing her husband-to-be with another rich businessman, she had apparently also got heavily involved in drug trafficking.

The news of her death was greeted with disbelief by all of those close to her. 'She was such a beautiful girl, but she was the sort of person who wouldn't have wanted to live,' Sullivan says, referring to her terrible injuries. 'Her looks were absolutely everything to her.'

Doing Rude Things

Great Britain / 1995 / 48 mins

Doing Rude Things was a light-hearted look at the British sex film industry, commissioned as part of the celebrations surrounding the centenary of moving pictures. It finally surfaced on BBC2's *'Forbidden Weekend'* in May 1995. Televised over three consecutive nights during the Spring bank holiday, *'Forbidden Weekend'* promised to show the late night viewer treats never before seen on terrestrial television. These included, for the first time ever, the uncut versions of Ken Russell's notorious 1971 movie *The Devils* and Nic Roeg and Douglas Cammell's vicious, drug-fuelled fantasy *Performance* (1970). Alongside big premières such as these, the channel showed several documentaries which sought to examine the changing attitudes of both the general public and the British Board Of Film Classification towards sex and violence on film. The centrepiece of the weekend was Saskia Baron's excellent two

BBC TELEVISION present a MARK FORSTATER Production **"DOING RUDE THINGS"**
starring ANGUS DEAYTON, PAMELA GREEN, GEORGE HARRISON-MARKS and many others
Music by TOBY LANGTON-GILKS Art Director RACHEL RAYNARD Photography by JON LANE
Edited by CHARLIE WARE Produced by PAMELA WALDEN Directed by KRISTIENE CLARKE
NOW SHOWING

part documentary *Empire Of The Censors*. However, for many viewers, the more highbrow strands of the season paled into insignificance next to the prospect of seeing a naked Jill *'Gentle Touch'* Gascoigne romping with Robin Askwith in a clip from *Confessions Of A Pop Performer* (1975). Because of the British public's predictable love of smut, and thanks to several tantalising trailers during the week preceding transmission, *Doing Rude Things*, a tongue-in-cheek examination of big screen bonking, was the ratings hit of the weekend.

Singled out as 'Pick Of The Day' in virtually all the daily and Sunday newspapers, director Kristiene Clark's funny documentary was based upon David McGillivray's 1992 book of the same name. McGillivray, a writer-director-actor who was a regular film reviewer in the BFI's Monthly Film Bulletin throughout the 1970s, is a self proclaimed fan of low budget British film making and has every reason to be. Having worked on both sides of the camera, for such sexploitation directors as Pete Walker, Stanley Long and John Lindsay, McGillivray's energetic and honestly written book on the British sex industry was just aching to be made into a television special.

Doing Rude Things was brought to life by some of the stars and directors of the movies themselves, reminiscing about the laughable innocence of Fifties nudist films and following the trail up to the bigger studio-backed sex comedies of the late Seventies. Unsurprisingly, several prolific sexploitation names declined to appear in the documentary, including the aforementioned Stanley Long and Pete Walker, as well as Derek Ford, who apparently all objected to the less than serious tone of the piece; but veterans George Harrison Marks, Pamela Green, Robin Askwith and Anna Bergman, amongst others, all agreed to interviews on camera. Most fascinating of all were the long-unseen clips from nearly 30 sex films made between 1958 and 1980. The standout sequence is the unintentionally hysterical nude snowball fight from 1963's *Eves On Skis*.

Filmed on location at the Prince Charles Cinema off Leicester Square in London's West End, Angus Deayton provided the droll commentary between archive clips and interviews, purportedly being shown on the cinema's Screen One to a goggle-eyed auditorium filled with scoutmasters, policemen, nuns, clergymen, a high court judge and a host of men in 'dirty raincoats'. The abundant sense of fun is prevalent throughout, but no examination of British pornography would have been complete without serious reference to Mary Millington. *Doing Rude Things* devoted a sizeable chunk of its running time documenting Mary's involvement in the dying days of home-grown sex films, using never-before-televised excerpts from her David Sullivan-produced films. Significantly, after years in the

wilderness, Mary Millington movies had suddenly become 'fashionably retro' with a kinky kitsch appeal stamped all over them. The films were derided during Mary's lifetime, but now, in 1995, the time was right for their long overdue re-appraisal. The legendary *Come Play With Me* was illustrated with four clips including her 'famed' lesbian sex scene at the sauna, whilst *The Playbirds* and *True Blue Confessions* are also represented. In summing-up David McGillivray pays tribute to Britain's first lady of sex by commenting, '*If Mary hadn't died she would have gone on, and to who knows what? I think she would have become a very, very big star indeed. As it was, because she died so young, she was only ever a raunchy British sex symbol.*'

When first transmitted at 10pm on Monday 29th May 1995, *Doing Rude Things* proved unequivocally that the great British public still enjoy the potent mix of sex and comedy, earning itself 4.93 million viewers. The programme became BBC2's most watched programme of the week, resolutely beating Angus Deayton's other programme, the popular news satire quiz, *Have I Got News For You* into second place.

Reviews

'What could have been quite a sordid subject is handled tastefully. If there is anything to shock, it is the size of some of the flares the actors were wearing in the Seventies.'
Daily Mail. 27 May 1995.

'We Brits may have had a stiff upper lip but our efforts at erotica were always pretty limp. You can see far harder stuff on *Eurotrash* each week.'
Sunday Times. 28 May 1995.

Tit Bits

● *Doing Rude Things*' co-producer Mark Forstater had twenty years earlier acted as executive producer on Mary Millington's *Keep It Up Downstairs* (1976), several clips of which are used in the documentary. His most famous Seventies comedy was *Monty Python And The Holy Grail* (1975).

● Joanna Lumley, star of *The New Avengers* and *Absolutely Fabulous*, made a long-forgotten sex comedy in 1970 called *Games That Lovers Play* (in which she co-starred with her then-husband and *Are You Being Served?* co-creator, Jeremy Lloyd). A sequence from that film showing her topless entwined with another actress was all set to be screened in *Doing Rude Things* until Lumley found out and, apparently, asked for its immediate removal.

● Author David McGillivray makes an uncredited cameo appearance in the documentary as a High Court judge visiting the Prince Charles cinema. Also in the audience is actor Scott Woods as a Church Of England Bishop. Woods attracted a lot of tabloid attention in 1996 when his distinctive looking eyes were used in the Conservative Party's much criticised 'Demon Eyes' election campaign.

DOING RUDE THINGS
Great Britain / 1995 / 48 mins

INCORPORATING CLIPS FROM
Percy (1971), Eskimo Nell (1974), Confessions Of A Window Cleaner (1974), Xcitement (1958), Witches Brew (1958), Peeping Tom (1959), The Window Dresser (1961, Travelling Light (1959), Sunswept (1961, Eves On Skis (1963), Naked As Nature Intended (1961), Sweet And Sexy (1967), Naughty (1971), The Nine Ages Of Nakedness (1969), The Playbirds (1978), The Stud (1978), Penelope Pulls It Off (1975), Keep It Up Downstairs (1976), Come Back Peter (1969), Hugs & Kisses (1968), The Sex Thief (1973), Her Private Hell (1967), Loving Feeling (1968), Confessions Of A Pop Performer (1975), Confessions Of a Driving Instructor (1976), Come Play With Me (1977), Mary Millington's True Blue Confessions (1980, Snow White And The Seven Perverts (1973), Man Alive ~ Xploitation (TV1975)

FEATURING INTERVIEWS WITH
(In Order Of Appearance)
Pamela Green
George Harrison Marks
Edward Craven Walker
David McGillivray
Kenneth Penry
Ray Selfe
Anna Bergman
Sue Longhurst
Francoise Pascal
Donovan Winter
Norman J. Warren
Bachoo Sen
Robin Askwith
Presented by **Angus Deayton**

CREDITS
Director...**Kristiene Clarke**
Producers...**Mark Forstater** & **Pamela Walden**
Associate Producer...**Doug Manuel**
Photography...**Jon Lane** & **Owen Skurfield**
Editor...**Charlie Ware**
Researcher...**Rebecca Sinker**
Music...**Toby Langton-Gilks**
Title Song *'Doing Rude Things'* Performed by
Ginger Muff
Script by
Harry Thompson / **Richard Preddy** / **Gary Howe**
Based upon the book by **David McGillivray**

A MARK FORSTATER Production
Presented by BBC Television

First transmitted MONDAY 29th MAY 1995 BBC2 10pm

Sex and Fame - The Mary Millington Story

Great Britain / 1996 / 52 mins

'It became less a lurid story and more a poignant one. It really was not about sex, but rather about tragedy.'
(Jim Adamson, *Speakeasy Productions*)

The first serious attempt to document and contextualise Mary's life, *Sex And Fame* was originally commissioned by Channel Four for their late night *Red Light Zone* strand on Saturday evenings in 1995, a series of sexually explicit films and documentaries much criticised by the National Viewers And Listeners Association. However, after discussions with the channel's controller of arts and entertainment, Stuart Cosgrove, it was decided that a far more satisfactory slot could be found to tell Mary Millington's remarkable story.

Running from October 5th to November 2nd 1996, Channel Four's *Fame Factor* zone sought to offer five weeks of diverse programming exploring the darker side of stardom. Cosgrove set out to explain the series' objectives: 'Fame is one of the great addictions of the 20th century. Like drugs, it has an uncanny habit of leading to self-destruction. We will examine stardom in all its glittering power.'

There were over 2,000 separate submissions from independent production companies for the *Fame Factor* strand; Channel Four chose just eight, seven half-hour programmes and another to fit an hour long slot. The prime spot was given to award-winning Perth based *Speakeasy Productions* and their idea for a documentary on Britain's foremost glamour and porn star.

'The idea for the series was to explore the more corrosive aspects of fame,' says *Speakeasy* producer-director Jim Adamson. 'Here was a woman who really was an icon of the Seventies, as far as the sex industry was concerned, and who was actually destroyed by the fame itself and that's why I think it slotted in quite well. Through *Sex And Fame ~ The Mary Millington Story* we were able to look at interesting subtexts rather than just the sleazier subtexts.'

Filming started in February 1996 and the edit was complete by August, but the proposal and research were worked on for about a year prior to this. The documentary combined a mixture of talking heads, location work and film clips from the archives. John M. East, David Sullivan, David McGillivray and even the elusive John Lindsay were called upon to shine their own individual light on the Millington phenomenon.

Scenes from *Come Play With Me*, *Confessions From The David Galaxy Affair* and *Queen Of The Blues* were likely to offend only the staunchest born-again Christian viewers, but rare footage showing sex scenes from *Miss Bohrloch* caused particular concern in some circles. Adamson was accused by some of littering the programme with gratuitous clips and photographs, but such critics rather missed the point. Clearly Mary was a woman unashamed of sex and nudity and to illustrate her life whilst avoiding nakedness would have been impossible not to say childish. Adamson quite rightly says: 'It's a difficult problem to avoid being gratuitous. Many people think of Mary as a soft porn

actress, but she also made hardcore. To some degree you have to show that.' To the documentary-makers themselves the fact that Mary had appeared in explicit 8mm movies was a revelation; neglecting the evidence of this period of her life would have meant telling only half the story.

'We had frame-by-frame discussions with the Channel Four lawyers over *Sex And Fame*'s content and what constitutes taste and decency. Mainly it was the problem of showing hardcore pornography,' explains Adamson. Whilst some of the shots of genitalia were 'pixilated' in order to render them 'inoffensive', the scenes remaining are easily the most sexually explicit ever to be shown on terrestrial television. 'We had to negotiate with the lawyers over what we were able to show,' laughs Adamson. 'They said, 'You can have the wank, but you're not having the blowjob!'

The second problem *Speakeasy* had to overcome was their insinuation that Mary had sex with Harold Wilson. Although this is now well documented, the film-makers still decided to tread cautiously, only briefly showing a slow motion film clip of Wilson lighting his pipe. Originally the documentary had incorporated a shot of a *Sunday Sport* headline linking Mary to Wilson but the Channel Four lawyers asked for it to be removed.

Alongside archive footage of Mary at the 1978 Cannes Film Festival originally shown on BBC2's *Arena*, and David Sullivan defending *Come Play With Me* on *Nationwide* in 1977, *Sex And Fame* also incorporated newly filmed sequences. Location work was done at *The Concordia* restaurant, David Sullivan's Theydon Bois mansion, South Holmwood, Walton-on-the-Hill and Cheltenham Spa - sex in the suburbs indeed - and the documentary attempted to illustrate the apparent ambivalence between Mary's public face and private life, and her struggle for acceptance.

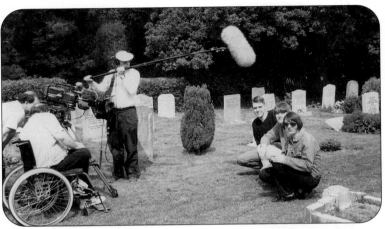

Location filming at Mary's graveside in South Holmwood, Surrey

Unfortunately, one particular day's filming proved to be totally unusable. Tipped off that there was to be a *Pique Porn Party* organised by outrageous promoter Matthew Glamorre at the Mildmay Tavern in North London, celebrating what would have been Mary's 50th birthday on June 1st 1996 (wrong, as Mary's half century was November 1995) the film crew - with John M. East in attendance - arrived to document the party. Instead of the much vaunted 'cabaret tributes' they were met by a desperate bunch of strippers and dancers, as well as legendary gay porn star turned poet Aiden Shaw and hardcore stage act Sandra Lester with her unusual 'cucumber routine'. I'm sure you can guess what that involved. East was furious. 'A complete waste of time and totally unacceptable for television broadcast!' he commented. *The Daily Sport* wasted no time in reporting the evening's events in lurid detail, giving the story front page coverage in their own inimitable way, 'Channel Four Strip Show Sex Shock!' However the strippers were left more than a little disappointed when not one minute of the show was used in the documentary.

Whilst David Sullivan emerged as a likeable and credible contributor to the programme and Mary's friend, journalist Colin Wills was moved to tears by a touching account of reading her final letter, other interviewees do not present themselves so favourably. Publicist John M. East delivers his stories like a well-rehearsed raconteur and his recollection of Mary's last phone call is especially hard to believe. *The Scotsman* wrote on October 2nd 1996 that, 'He talks like a man who has told his tale over a thousand late night cognacs, though perhaps he only polishes it in private so he can continue to see his reflection in it'.

Both informative and thought provoking, *Sex And Fame ~ The Mary Millington Story* only failed to deliver with regard to the disappointing lack of information on her childhood and early career. The parallels with Marilyn Monroe are perhaps a little over-stated (especially considering that there is little evidence to suggest that Mary ever looked to the American actress for inspiration), and questions regarding her first forays into the sex industry remain largely unanswered. A couple of factual inaccuracies aside - her father John Klein (not mentioned by name) died when she was 27 not whilst Mary was in her teens and her Old Bailey trial took place in 1977 not 1978 - *Speakeasy*'s film is an extremely enjoyable re-telling of her incredible life. Viewers were obviously in agreement as the documentary attracted an audience of 1.8 million for its first late night slot on October 12th and virtually doubled it to an impressive 3.2 million for a welcome repeat the following January.

Press reviews were excellent but one disgruntled viewer wrote to the *Radio Times* happily trotting out the tired old anti-porn clichés. '*Sex And Fame* marked yet another of Channel Four's plunges into the steamy swamp of titillating tabloid bruising. I must plead with their programme makers to spare us this packaging of soft pornography as a documentary,' he wrote. As for Mary, I suspect she would have loved every minute. She had finally become an *icon*.

Reviews

'Producer-director Jim Adamson's film is compelling. It doesn't just report Millington's rise and fall, it also says so much about coy British attitudes to sex. *The Mary Millington Story* treads a thin line between being tacky and being informative; ultimately it is both. *Daily Mail* readers will tune in their droves, in the name of research of course.'
Time Out. October 9-16 1996.

'Mary Millington was a woman so embedded in the 1970s that she should have been born with a pair of furry dice; she was also Britain's first porno star. In the words of her many admirers (there exists a Mary Millington fanclub, by the way, staffed by alarmingly young members!), she took 'porn out of Soho and into Esher'. A fascinating trawl through Britain's burgeoning porn industry and its friendly reception in the suburbs.'
Independent On Sunday. 13 October 1996

Tit Bits

● To coincide with the televising of *Sex And Fame*, David Sullivan's publications were back to their old tricks again. In *The Sunday Sport* on October 13th 1996 a quarter page advertisement offered Mary's 'full uncut sizzling skin flicks in all their <u>hardcore</u> glory!' It should come as no surprise that the 'explicit' films on offer were the distinctly soft *Come Play With Me* and four others all for the bargain price of £9.95 each.

● Sullivan enjoyed *Sex And Fame* and suggested to Channel Four that they might like to follow the documentary with one of Mary's films. It has always been his dream to see *Come Play With Me* on television, but the channel were not interested, claiming that it did not fit in snugly with the rest of the *Fame Factor* strand. At the time of writing *The Great Rock 'n' Roll Swindle* is only one of two Millington movies to have been shown on terrestrial TV. The other is the cut-down BBC version of *Keep It Up Downstairs*.

● Because of the nature of the documentary some viewers were predictably shocked (though why they were prepared to wait up until 11.25pm to do so is anyone's guess), but surprisingly most of the complaints generated concerned the use of music. Apparently purists could cope with scenes of unsimulated oral sex, but Mozart's Requiem as a backing track was just too much to bear!

● At the time of filming *Sex And Fame* on location at South Holmwood Church in Surrey, the vicar of St Mary Magdalene's announced to his congregation that a documentary 'was being made about a famous person who used to live nearby'. Nobody twigged that it was about Mary, especially the Reverend. When the programme eventually turned up on television the vicar was more than a bit embarrassed. 'I mean it was a bit blue wasn't it!' one villager commented.

SEX AND FAME - THE MARY MILLINGTON STORY

Great Britain / 1996
52 mins

INCORPORATING CLIPS FROM

Miss Bohrloch (1970), Oral Connection (1971), The Devil In Miss Jones (1972), Response (1974), Come Play With Me (1977), The Playbirds (1978), The David Galaxy Affair (1979), Queen Of The Blues (1979), The Great Rock 'n' Roll Swindle (1979), True Blue Confessions (1980)

FEATURING INTERVIEWS WITH

David Sullivan
John M. East
John Lindsay
Colin Wills
Eve Vorley
Suzie Hayman
Davis McGillivray
Simon Sheridan
and
Jonathan Davis
Narrated by **Hillary Neville**

CREDITS

Directed...**Jim Adamson**
Produced...**Jim Adamson**
Executive Producer...**Richard Belfield**
Associate Producer...**Geoff Holder**
Editor...**Magnus Wake**
Camera...**Tim Collins**
Sound...**Peter Sainsbury**
Film Researcher...**Sophie Hamilton**
Script by **Jim Adamson** & **Geoff Holder**

A SPEAKEASY Production in association with
FULCRUM
Presented by CHANNEL FOUR

First transmitted SATURDAY 12th OCTOBER 1996
C4 11.25pm

Repeated THURSDAY 16th JANUARY 1997
C4 10pm

Mary's films were still being shown in London cinemas as late as 1985

APPENDIX 1

Other David Sullivan-related movies

The following films are listed in date order of their UK cinema release.

COME PLAY WITH ME 2
Switzerland / 1980 / UK version 84 mins / cert X

CAST Simone Sanson *(Aunt Jeanne)*, Brigitte Lahaie *(Florence)*, Celina Mood *(Julie)* with Nadine Pascal, Will Stoer and Hansruedi Isler.

CREDITS An Elite Film Production. Distributed (UK) by Tigon. Original title: *Les Bourgeoises de l'Amour*. Produced and Directed by Erwin C. Dietrich. Executive Producer (English version)...David Sullivan. Photography...Peter Baumgartner. Music...Walter Baumgartner. *'Come Play With Me' Theme* by Peter Jeffries. English titles by Rebel Films. Screenplay by Manfred Gregor (aka Erwin C. Dietrich).

Opened 31st July 1980. Classic Cinema, Praed Street, London.

BOYS AND GIRLS TOGETHER
Great Britain / 1979 / 57 mins / cert X

CAST Roger Furse *(Don, USA)*, Cherry Patel *(Lily, India)*, Helen Fitzgerald *(Jenny, UK)*, Christine Maskelle *(Ilsa, West Germany)*, Paul Ong *(Jat, Singapore)* and Anthony Thomas *(Leroy, West Indies)*.
CREDITS A Roldvale Production. Distributed by Jay Jay. Produced by Willy Roe. Directed by Ralph Lawrence Marsden. Photography...Stewart Neale. Sound Recording...Peter Mandel. Sound Mixer...Rod Guest. Editor...Wulfert Bodo Rintz. Musical Director...Sean Ore. Songs: *Love Can Be So Elusive*, *Sometime Love*, *Boys And Girls Together*, *When With Your Girlfriend* and *Cruising Beat* all composed by Clift Ritchard (sic). Performed by Nuefrunt.

Opened 30th October 1980. Cinecenta, Piccadilly, London.

EMMANUELLE IN SOHO
Great Britain / 1981 / 65 mins / cert X

CAST Mandy Miller aka Angie Quick *(Emmanuelle)*, Julie Lee *(Kate Benson)*, John M. East *(Bill Anderson)*, Keith Fraser *(Paul Benson)*, Gavin Clare *(Adie Cole)*, Tim Blackstone *(Derek)*, Geraldine Hooper *(Jill)*, Anita Desmarais *(Sheila)*, Georges Waser *(Tom Poluski)*, Erika Lea *(Judy)*, Kathy Green *(Sammy)*, Suzanne Richens *(Suzie)*, John Roach *(Albert)*, Linzi Drew *(Pink-haired party guest)* with Vicki Scott, Louise London, Natalie Newport, Marie Harper, Samantha Devonshire, Carla Lawrence, Ruth Chapman and Kalla Ryan *(Showgirls)*.

CREDITS A Roldvale Production. Distributed by Tigon. Produced by John M. East. Directed by David Hughes. Executive Producer...David Sullivan. Assistant Director...Peter Jacobs. Photography...Don Lord. Camera Operator...David Morton. Sound Recording...Simon Okin. Music Composed and Conducted by Barry Kirsch. Choreography by Anita Desmarais. Screenplay by Brian Daly and John M. East.

Special UK première 4th July 1981, Classic Cinema, Sheffield.

Opened 9th July 1981, Eros Cinema, Piccadilly, London.

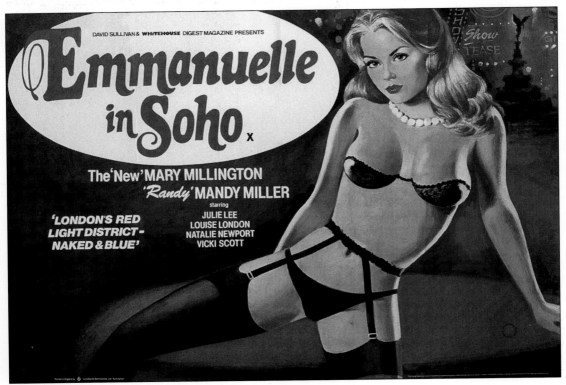

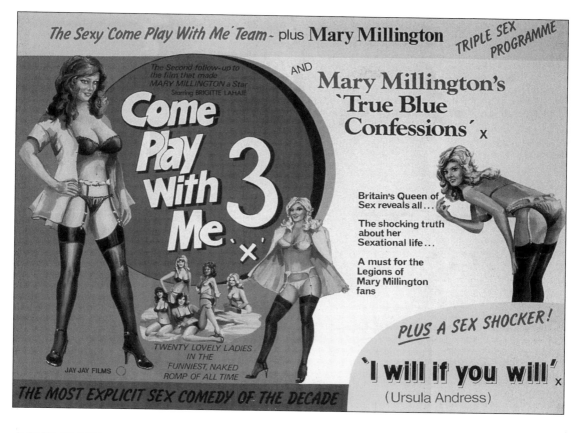

COME PLAY WITH ME 3
Switzerland / 1980 / UK version 65 mins / cert X

CAST Brigitte Lahaie *(Jenny)*, Ella Rose *(Juliet)*, Jane Baker *(Miss Brown)* with Barbara Moose, Mike Montana and Nadine Pascal.

CREDITS An Elite Film Production. Distributed (UK) by Jay Jay. Original title: *Julchen und Jettchen ~ Die Verliebten Apothekerstöchter.* Produced and Directed by Erwin C. Dietrich. Photography...Peter Baumgartner. Music...Walter Baumgartner. Original story by Erwin C. Dietrich. Screenplay by Christine Lembach.

Opened 8th July 1982. Classic Moulin, Great Windmill Street, London.

HELLCATS ~ MUD WRESTLING
Great Britain / 1983 / 45 mins / cert X

CAST John M. East *(Interviewer)* with Queen Kong, Shelly Selina Savage, 'Hungry' Helen Hammer, Vicki Scott, Rose Rock and Miss Deathwish. Sandy *(Compère)*, John Roach *(Referee)*, Hal 'The Animal' Stone *(Himself)* and Jock McPherson *(Promoter)*.

CREDITS A Roldvale Production. Distributed by Tigon. Produced by John M. East. Directed by Alan Hall & David Sullivan. Executive Producer...David Sullivan. Music by De Wolfe & Barry Kirsch. Devised by David Sullivan & John M. East.

Opened May 1983. Eros Cinema, Piccadilly, London.

APPENDIX 2

Mary Millington Videos

Eskimo Nell, **Come Play With Me**, **The Playbirds**, **Confessions From The David Galaxy Affair**, **Queen Of The Blues**, a shortened version of **Mary Millington's True Blue Confessions** plus **Hellcats ~ Mud Wrestling** and Julie Lee's **Emmanuelle In Soho** are all available on the Medusa Pictures label.

What's Up Superdoc? is available on the Entertainment In Video label.

The Great Rock 'n' Roll Swindle is available on Virgin Video.

Erotic Inferno, **I'm Not Feeling Myself Tonight**, **Intimate Games**, **Keep It Up Downstairs**, **Private Pleasures**, **Mary Millington's World Striptease Extravaganza**, **Come Play with Me 2** & **3** and **Boys And Girls Together** are all currently unavailable in the UK.

1985

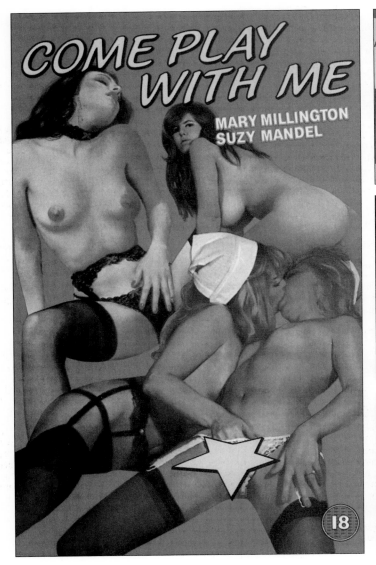

1997

1979

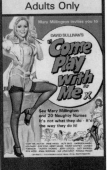

1986

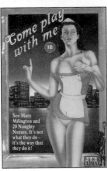

NOTES

Chapter One : Devoted

1. *The Amazing Mary Millington* Futura 1978
2. *'Thoroughly Sexy Millie'* Photoplay July 1978
3. *'Thoroughly Sexy Millie'* Photoplay July 1978

Chapter Two : Fields

1. *The Amazing Mary Millington* Futura 1978
2. *The Amazing Mary Millington* Futura 1978
3. *'Thoroughly Sexy Millie'* Photoplay July 1978

Chapter Three : Sex Is My Business

1. *Mary Millington's True Blue Confessions* Roldvale Ltd 1980
2. *'Thoroughly Sexy Millie'* Photoplay July 1978
3. *'Thoroughly Sexy Millie'* Photoplay July 1978
4. *Mary Millington's True Blue Confessions* Roldvale Ltd 1980
5. *Sex & Fame: The Mary Millington Story* Speakeasy Productions 1996
6. *The Amazing Mary Millington* Futura 1978
7. *Mary Millington's True Blue Confessions* Roldvale Ltd 1980
8. *The Pornbrokers* Elmside Film Productions 1973

9. Linda Lovelace was a curly haired ex-Catholic Girls School pupil whose ambition was to become a nun, but a chance meeting with bar owner and photographer Chuck Traynor changed her life. He became her pimp and persuaded her to appear in a series of low budget sex films (including the notorious canine sex flick *'Dogarama'*). Lovelace hit the big time in 1972 after being cast as the lead in *Deep Throat*, for which she paid $1,200 to play a woman who discovers that, by a quirk of nature, her clitoris is situated, not between her legs, but at the back of her throat. Cue endless bouts of fellatio. Very soon everyone in America knew who Miss Lovelace was. In May 1973 she even appeared as the covergirl on style magazine *Esquire*. That same year she starred in *Deep Throat (Part Two)* before publishing her infamous 'autobiography' *Inside Linda Lovelace* in 1974. Several other movies followed including *Hot Neon* aka *Linda Lovelace For President* (1975), a softcore comedy that enjoyed a lengthy run at The Soho Cinema in London's Brewer Street. After a messy divorce from the manipulative Traynor she left the porn industry, remarried, became a mother and claimed she had been 'forced at gunpoint' to make the sex movies. Gerard Damiano, the director of *Deep Throat*, has always refuted this.

10. In the late 1960s and early 1970s London's West End was not only a hot bed for pornography, but also for police corruption. A huge number of officers from the Obscene Publications Squad (OPS) had 'special arrangements' with the Soho fraternity. Mass bribery was the name of the game, with Metropolitan officers taking back-handers of up to £10,000 a month from the pornographers in order for them to avoid being raided. This unholy collusion between the law and the lawbreakers was an open secret but it wasn't until 1977 that the full scale of dishonesty was finally revealed. The celebrated prosecution of Det Supt Bill Moody and Commander Wallace Virgo was followed by the dismissal of 80 officers who had worked at sometime in the OPS. Incredibly, a further 300 officers left voluntarily.

11. John Lindsay in *Vibrations* Volume 5 Number 1.

12. Other well known private cinema clubs in London included *The Albatross* in Plashet Grove E6, *Swedish Paradise* in Brewer Street W1, *The Cin Cinema* Old Compton Street W1, *The Sophisticate* in Eversholt Street NW1 and *Adults Only* in Grays Inn Road NW1.

13. Ava Cadell's career is one of the most varied and surprising of any Seventies British sex star. After moving to England from her native Budapest in the late 1960s she starred in a dozen or so hardcore shorts for John Lindsay and appeared as a Page Three Girl in *The Sun*. Ava then transferred to bit parts in mainstream British sex comedies including Lindsay's own *The Hot Girls* (1974), plus *Confessions Of A Sex Maniac* (also 1974) and *The Ups And Downs Of A Handyman* (1975). After David Sullivan's *National News* magazine rather hypocritically exposed her hardcore porno past in 1976, she made only one further film in the UK, Norman J. Warren's camp sci-fi romp *Outer Touch* aka *Spaced Out* (1979). After moving to the USA in 1980 she modelled for *Miner's Make-Up* and secured tiny, often non-speaking parts, in TV shows like *The Fall Guy* and movies such as *Smokey And The Bandit Part 3* (1983), *The Jerk, Too* (1984) and Schwarzenegger's 1985 hit *Commando*. In the latter she was billed as 'Girl in bed'. A load more duff movies followed in straight-to-video release, before Ava became a hostess on the *Playboy Movie Channel*. Now a certified Clinical Sexologist and calling herself 'Dr Ava' she describes herself as a 'taller, more sensual, younger version of Dr Ruth', which isn't that difficult actually. She is now based in Los Angeles and has an office in Sunset Boulevard. Ava writes and lectures on all aspects of human sexuality, but these days her clothes stay firmly on.

14. *Sex And Fame: The Mary Millington Story* Speakeasy Productions 1996
15. *The Amazing Mary Millington* Futura 1978

Chapter Four : Playbird

1. *The Longford Report* Coronet 1972

2. As well as nicking the magazine title *Private*, David Sullivan also had some of his other products and companies sound not dissimilar to their hardcore European contemporaries. He advertised *Jans Braun* Films (Lasse Braun), *Milton* sex aids (Berth Milton) and even *British Colour Climax* (Color Climax)

3. In 1974, twenty nine of John Lindsay's films were seized from various locations around the country and he was tried at Birmingham Crown Court. He pleaded not guilty to the charge of conspiring to publish obscene films. The jury failed to come to a unanimous verdict, but on his retrial he was acquitted. He was tried again at the Old Bailey in London three years later and was found not guilty for a second time. Lindsay was not frightened by the prospect of prosecution, in fact whenever a high court judge described his films as 'filthy' in the press, demand for them leapt. In 1983 he finally fell foul of the courts and was sent to prison.

4. *Mary Whitehouse: Who Does She Think She Is?* New English Library 1971
5. *Private* magazine issue 16 (1974)

6. It would be a mistake to assume that David Sullivan only promoted female models in his publications. Men such as *Bert Shaft*, *John Dick* and *Big John English* also graced his pages. Their jokey names indicate their natural 'attributes'. Most bizarrely of all, in 1977 a transsexual called *Chrysis St Laurent* became a cover girl for *Whitehouse* magazine.

7. David Sullivan in *Video Viewer* Volume 2 Number 11 (May 1983)
8. David Sullivan in *Video Viewer* Volume 2 Number 11 (May 1983)

9. In issue 10 of *Playbirds* Doreen Millington 'appears' to go nude but the pictures are all heavily doctored. Posing in sexy underwear and a feather boa Doreen is noticeably not wearing nail varnish. However, in close-up shots purporting to show her holding open her vagina, a pair of hands sporting red nail varnish have miraculously materialised. A stand-in was used to fake all the 'intimate' shots.

10.Many of the photoshoots in Sullivan's magazines were taken at his Woodford Green flat. His migraine inducing black and white striped wallpaper, Wurlitzer jukebox, 'naked lady' mirror and multi-coloured bathroom suite are visible in all his publications right up until 1982.

11. David Sullivan in *Video Viewer* Volume 2 Number 11 (May 1983)

12. On several occasions Sullivan's magazines had to print apologies to pubs, restaurants and other businesses after Mary had posed provocatively, without permission, outside their premises. Sometimes the fictional stories that accompanied the pictures actually described the businesses' owners in false sexual situations.

13. In a bid to stop competitors cashing in on the success of *Playbirds* and *Whitehouse* and attempting to imitate their style, all Sullivan's publications included a small painted cameo showing Mary with a feather boa draped around her shoulders on their covers, to prove that they were 'authentic' Millington. *'Beware, other magazines may appear similar but their contents are tame and rubbish!'* warned Mary.

14. *Titbits Magazine* Issue 4758 (2-8 June 1977)
15. *Titbits Magazine* Issue 4758 (2-8 June 1977)

Chapter Five : Queen Of The Blues

1. The original *Emmanuelle* (1974), based on the book by Emmanuelle Arsan, became one of the most successful sex films of all time playing to an estimated 400 million people throughout Europe. Directed by Just Jaeckin, the film made 21 year old Dutch actress Sylvia Kristel (in the title role) a worldwide star. The inevitable sequels followed, but Kristel soon tired of being typecast as a nymphomaniac. In *Emmanuelle 4* (1984) she left the series after her character has plastic surgery, emerging as a totally different actress! After the failure of Kristel's acting career during the late 1980s she was forced to return to soft-porn in the straight-to-video release *Emmanuelle Forever* (1994). There was little or no continuity between the episodes and by the time *The New Adventures Of Emmanuelle In 3-D* (1996) had come along our heroine was cavorting with aliens in outer space! The films spawned dozens of unofficial spin-offs including the *Black Emmanuelle* series (1975-80) starring Laura Gemser and even more rubbishy efforts like *Yellow Emmanuelle* (1977), *Carry On Emmannuelle* (1978), *Emmanuelle Meets The Wife Swappers* (1978), *Emmanuelle's Silver Tongue* (1980) and David Sullivan's own *Emmanuelle in Soho* (1981).

2. Lasse Braun's *Sensations* (1975) was filmed on location in Belgium, Holland and the UK eventually costing over $170,000. The director used British technical expertise to make the film; consequently the end credits are largely anonymous. Before its premiére at Cannes it had a closely-guarded unveiling in a Wardour Street preview theatre. Despite Britain's oppressive anti-porn laws, Braun made ten more 8mm loops with exclusively British casts in London during 1977. The shorts were edited into two features called *Sex Maniacs* and *Sin Dreamer*.

3. The decline in British feature film production during the Seventies is well illustrated by the once prolific Rank who between 1970 and 1979 financed only 42 feature films, ten of those being *Carry Ons*.

4. Quentin Falk in *Cinema TV Today* 25 January 1975

5. David McGillivray in *Screen International* 14 August 1976

6. George Harrison Marks' feature films include *Naked As Nature Intended* (1961), *The Chimney Sweeps* (1963), *The Naked World Of Harrison Marks* (1965), *Pattern Of Evil* (1967), *The Nine Ages Of Nakedness* (1969) and *Come Play With Me* (1977). In 1968 he also acted in Gunther Siegmund's German sex comedy *Otto And The Nude Wave*. After completing *Come Play With Me* Harrison Marks returned to Germany, and using a directorial pseudonym, made five feature length hardcore movies, (he was unable to recall their titles).

7. *Mary Millington's True Blue Confessions* Roldvale Ltd 1980
8. *The Amazing Mary Millington* Futura 1978

9. David Sullivan persisted in marketing all of his films with the promise that the cinema-goer would get to see genuine 'hardcore'. In May 1981 he very nearly came unstuck when James Ferman, the head of the British Board of Film Censors (BBFC), threatened to withdraw the already granted X certificate from Sullivan's sex comedy *Emmanuelle In Soho*. Ferman had grown increasingly worried about the hoodwinking of the general public perpetrated by the explicit photographs in Sullivan's magazines which purported to show actual scenes from the film. He apparently told his board of examiners: 'We've got to teach Sullivan a lesson. We've got to show him that we are serious.' An angry Sullivan, fearing that *Emmanuelle In Soho* was not going to secure a release, responded with a full page advert on page 3 of *Screen International* on May 30th 1981. He claimed that whenever stronger pictures were printed in his publications, it was made abundantly clear that they were from the (oft-mentioned, but obviously faked) 'overseas version.' More problems loomed on the horizon when officer Alan Sharpe from Westminster Trading Standards threatened to press charges against Sullivan for not making *Emmanuelle In Soho* pornographic enough! He was apparently unhappy about the film not living up to its extravagant claims. Through some fast talking and careful negotiation the matter was finally resolved and the movie became one of the biggest releases of that summer.

10. *Monthly Film Bulletin* July 1978
11. *Mary Millington's True Blue Confessions* Roldvale Ltd 1980

12. The Columbia Pictures-produced *Confessions* movies had overtaken the less raunchy *Carry Ons* in the popularity stakes by the mid 1970s. Based on the sensationally successful paperback novels (1971-79) by Christopher Wood (aka Timothy Lea) and produced by the cigar-chomping Greg Smith, the films relied on the acting teamwork of Robin Askwith, Anthony Booth, Bill Maynard, Sheila White and Doris Hare (her role was played by Dandy Nichols in the first instalment). The series ran to four episodes: *Confession Of A Window Cleaner* (1974), *Confessions Of A Pop Performer* (1975), *Confessions Of A Driving Instructor* (1976) and *Confessions From A Holiday Camp* (1977). The following year Smith tried to recreate the formula but this time from a female perspective. However, *Rosie Dixon ~ Night Nurse* (1978), based upon the novel *Confessions of A Night Nurse*, arrived a bit too late in the day and Columbia subsequently backed out of the sex film market for good. Incidentally, the other British comedies *Confessions Of A Sex Maniac* (1974), *Confessions Of An Odd-Job Man* (1975) and *Confessions Of The Naughty Nymphos* (1980) are horses of an entirely different colour, being just independently made films later re-titled to cash in on the original series.

Chapter Six : Prostitute

1. Police raids were not only confined to London. In 1975 Carlisle CID raided the printing works where all of David Sullivan's magazines were produced. After a tip-off from Scotland Yard a certain Chief Inspector Shannon seized the printing plates for the first issue of *Playbirds* and the magazine very nearly never saw the light of day. However, after the plates were examined by police officers they were returned unmarked to Sullivan.

2. *Mary Millington's True Blue Confessions* Roldvale Limited 1980
3. 'Thoroughly Sexy Millie' *Photoplay* July 1978
4. *The Amazing Mary Millington* Futura 1978

5. Eric Miller in *Playbirds Special Edition* magazine 1979

6. After Mary's death, Sullivan's magazines launched a short lived fund called *The Mary Millington Campaign For Freedom In Publishing*. The blurb said that it was Mary's 'dying wish' to see pornography legalised in the UK and invited readers to send donations of money to help the cause.

7. Gilbert Oakley D.Psy. was a married father and author of dozens of books including *Sex Power Over 40* and *Success Through Self Analysis*. He was also one of the founders of *Here's Health* magazine. During the mid-1970s he added his intellectual weight to a huge number of sex related articles in *Whitehouse* and *Playbirds*.

8. David Reed in *National News* Issue 8 (1977)
9. Graham Baker in *The Daily Telegraph* December 1st 1977

Chapter Seven : 'The Police Have Beaten Me'

1. Quote from *Diana Dors ~ Only A Whisper Away* Javelin 1987
2. Quote from *Diana Dors' A to Z Of Men* Futura 1984
3. 'Thoroughly Sexy Millie' *Photoplay* July 1978
4. David Weldon in *Playbirds Special Edition* magazine 1979

5. The Video Recordings Act of 1984 gave the British Board of Film Classification (BBFC) the authority to classify video tapes. The Act, introduced in response to the 'video nasty' furore of the early 1980s, forbade the hire or sale of any pre-recorded video cassette that had not been passed by the board. Classification involved labelling the films as suitable for viewing by persons above or below a certain age, hence U, PG, 15 and 18. Sex tapes were rated R18 (Restricted) and could only be sold from licensed sex shops.

6. Doreen Millington in *The News Of The World* June 15th 1980
7. *Sex & Fame : The Mary Millington Story* Speakeasy Productions 1996

Chapter Eight : Saint Mary

1. John M. East in *The Daily Mail* August 20th 1979

2. Mary's face and body still had considerable value to David Sullivan, even after her death. As well as numerous 'tribute' magazines, there were regular reprints of her photographs (all purporting to be her very 'last photoshoot'), Mary 'look-a-like' competitions and articles about her promiscuous lifestyle. In an ever-increasing attempt to breathe new life into his stable of publications, Sullivan launched a fresh title in the winter of 1979 with an added gimmick - a masturbatory device. In other words a flexi-disc record of models recounting their 'sexy escapades'. As in life, Mary was called upon to launch issue number one of *'Listen With Playbirds'* . Her photograph appeared on the cover of the magazine and her voice featured on the first disc. These were not 'Mary's final and frankest words' however, but merely a poor taste revamp of one of her mail-order sex audio cassettes from 1977. By 1980 *Whitehouse* magazine had gone one step further by offering readers another flexi-disc of 'totally hot sexual experiences'. This time around it wasn't even Mary's voice, but an actress pretending to be her. It was to cause widespread outrage, particularly in the tabloids. In *The News Of The World* in the June of that year Doreen Millington was quoted as saying 'This is disgusting exploitation', whilst Diana Dors chipped in, 'I think it's appalling and ghoulish.' In 1981 the successor to Sullivan's *National News* came out. The first issue of the *Whitehouse Adult Newspaper* had Mary, again, on the cover and inside an article aimed to tell *'The real truth about the death of Mary Millington'*. Six years later, in 1987, Sullivan was still trading on her name, this time in his *Sunday Sport* newspaper. Over the course of four weeks in June and July, reporter Charles Renfrew serialised Mary's 'secret diary' that had apparently been found 'stuffed behind a water purifier in her Spanish Villa'. Not surprisingly it was all an elaborate fabrication, but it provided the paper with ample opportunities for some pretty salacious headlines.

3. David Sullivan in *Video Viewer* Volume 2 Number 11 (May 1983)

4. Mary's husband, Robert Maxted, eventually re-married and sold the house in Walton-On-The-Hill. He has since changed his name by deed-poll.

All interviews for this book were undertaken by the author during the period 21 January 1997 to 23 May 1998.

INDEX

INDEX

INDEX

**Wes Craven's
Last House on the Left**
The Making of a Cult Classic

Making Mischief
The Cult Films of Pete Walker

Cine East
Hong Kong Cinema
Through The Looking Glass

Flesh & Blood
Sex, Death and Movies

Cannibal Holocaust
and the savage cinema of
Ruggero Deodato

Beyond Terror
The Films of Lucio Fulci

Art of Darkness
The Cinema of Dario Argento

Ten Years of Terror
The British Horror Film 1970-1979

To receive details of these and other books in the acclaimed range of **FAB Press** publications, please send us a self-addressed, stamped envelope. Alternatively check out the FAB Press website at: www.fabpress.demon.co.uk

**PO BOX 178
GUILDFORD
SURREY, GU3 2YU
ENGLAND, UK**